"If they shot it, he shot it! Nat Butler is, without a doubt, on the Mount Rushmore of NBA photographers. We are now blessed with all of the angles of a colorful past, thanks to Nat's access and amazing talent."

—DARREN ROVELL, sports collector and broadcaster

"A wonderful walk down memory lane with first-person coach and player quotes reminiscing about some of the greatest moments in NBA history. A must-have for every NBA fan!"

—AHMAD RASHAD, broadcaster and recipient of the 2024 Curt Gowdy Media Award

"I have always been in awe of Nat's skill in capturing all aspects of the game we love in a single image. Whether it's a memorable portrait, an iconic moment, behind-the-scenes coverage, or a chaotic locker room celebration, Nat is a master of our craft and responsible for helping to preserve the visual history of our league."

—ANDREW D. BERNSTEIN, team photographer for the Los Angeles Lakers and Los Angeles Clippers and recipient of the 2018 Curt Gowdy Media Award

"Images of your favorite player raising the Larry O'Brien Trophy or dunking on their longtime rival are what we remember long after a game has ended, the champagne stops flowing, and the smell of cigars fades from championship locker rooms. The lasting impact of Nat Butler's photography is clear when you look at how many athletes today re-create the poses that he snapped, instants that would have faded from our collective memory had it not been for Butler's click. Butler's masterful eye has captured some of the sport's biggest, most memorable moments. What a treat to see the NBA through his lens."

—MALIKA ANDREWS, journalist, host of NBA Today and NBA Countdown, and Sports Emmy Award winner

"Nat Butler has spent a career bringing the NBA to life with his amazing pictures. He has captured some of the most iconic moments and legendary players with his extraordinary skill. But it's his love of the game and the people who play it that comes shining through with each photograph. Looking at these spectacular photos brings back so many memories for me. Thank you, Nat!"

—MIKE BREEN, longtime NBA play-by-play and sports commentator and two-time Sports Emmy Award winner

"I think that '96 draft was the deepest draft. I played against most of those guys in college, and I knew that we were going to be a really talented group. We had a good makeup with size, with forwards and bigs, with Camby in the middle. And we were definitely strong on the perimeter with myself, Iverson, Ray Allen, and Marbury and those guys. Looking at that picture, I think what stands out to me is to see the great careers from guys that we didn't expect to have phenomenal NBA careers. Obviously, Kobe is at the top of that list. We didn't expect a high school kid to be an all-time great. We didn't expect to see Steve Nash be an all-time great. My last surprise of that draft was Jermaine O'Neal. We didn't expect some of these guys to have those remarkable careers." —Kerry Kittles

"SLAM was everything. Let me just put this out there: I was the first rookie to get SLAMADAMONTH out of that class. I got the SLAMADAMONTH when I dunked in a preseason game against the Rockets. So for me, that was everything. That was awesome. There's not a lot of things I can say I did the first or was best in that class because it's such an iconic, incredible, great class that kind of changed the NBA, but to just to be able to say I was the first one out of that group to get SLAMADAMONTH means everything to me." —John Wallace

"This brings back memories. I even have that framed in my house." —Marcus Camby

FRONT ROW *(left to right)*: Ray Allen, Kerry Kittles, and Samaki Walker

BACK ROW *(left to right)*: Marcus Camby, Stephon Marbury, Kobe Bryant, Shareef Abdur-Rahim, Jermaine O'Neal, Steve Nash, John Wallace, and Antoine Walker

NBA Rookie photo shoot; Orlando, FL; September 20, 1996

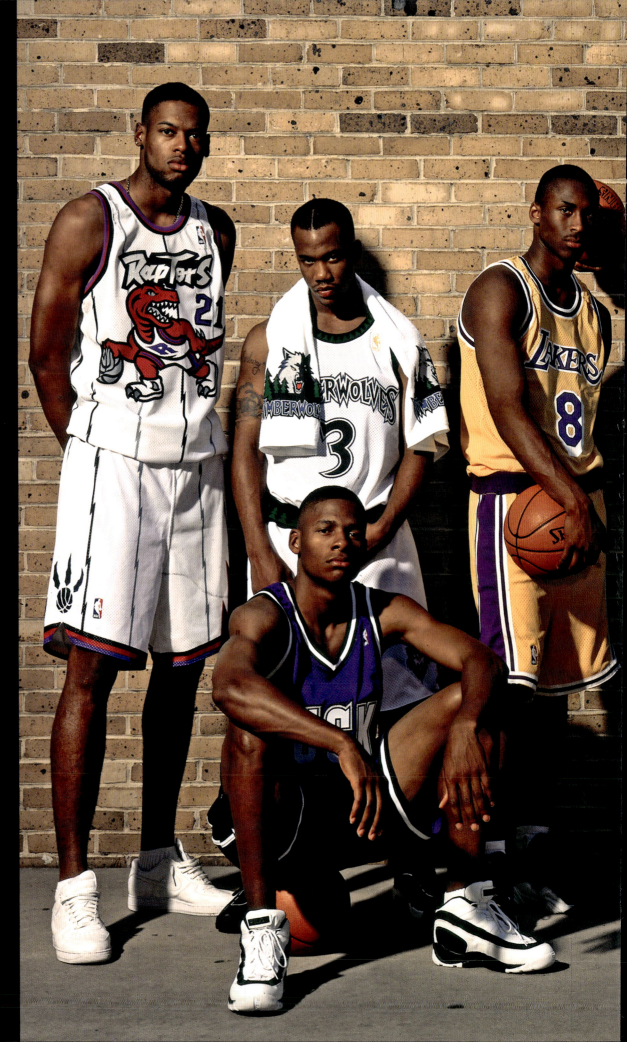

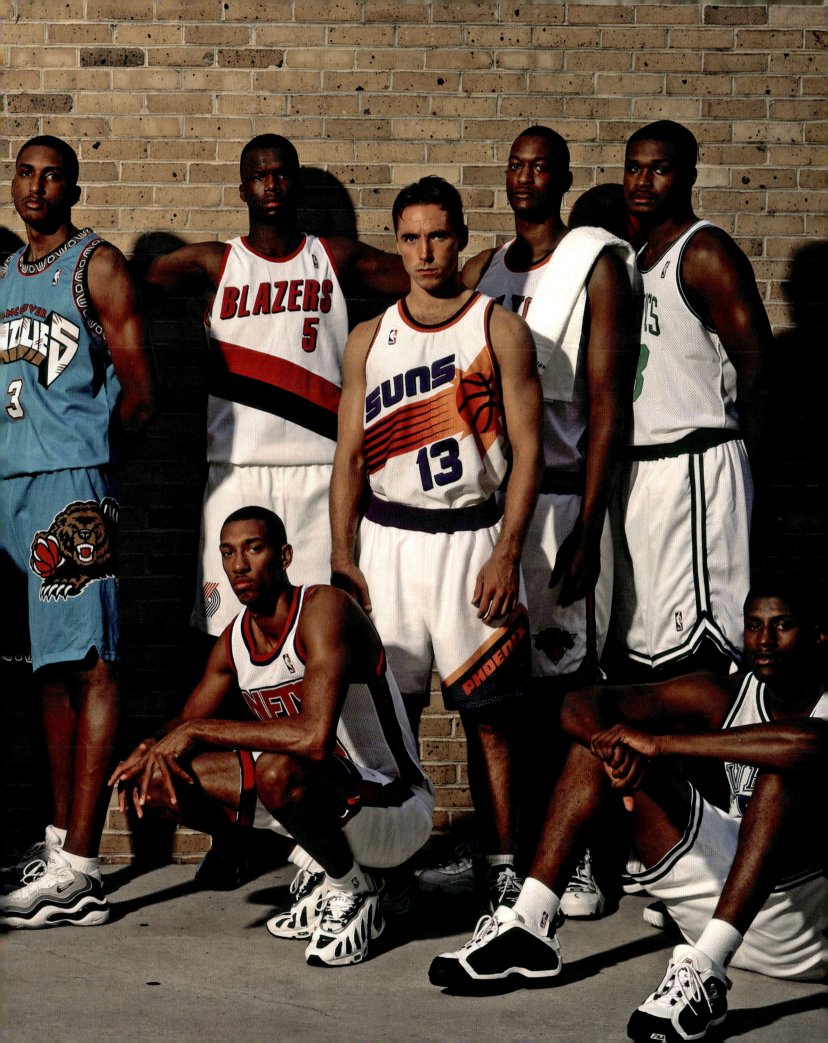

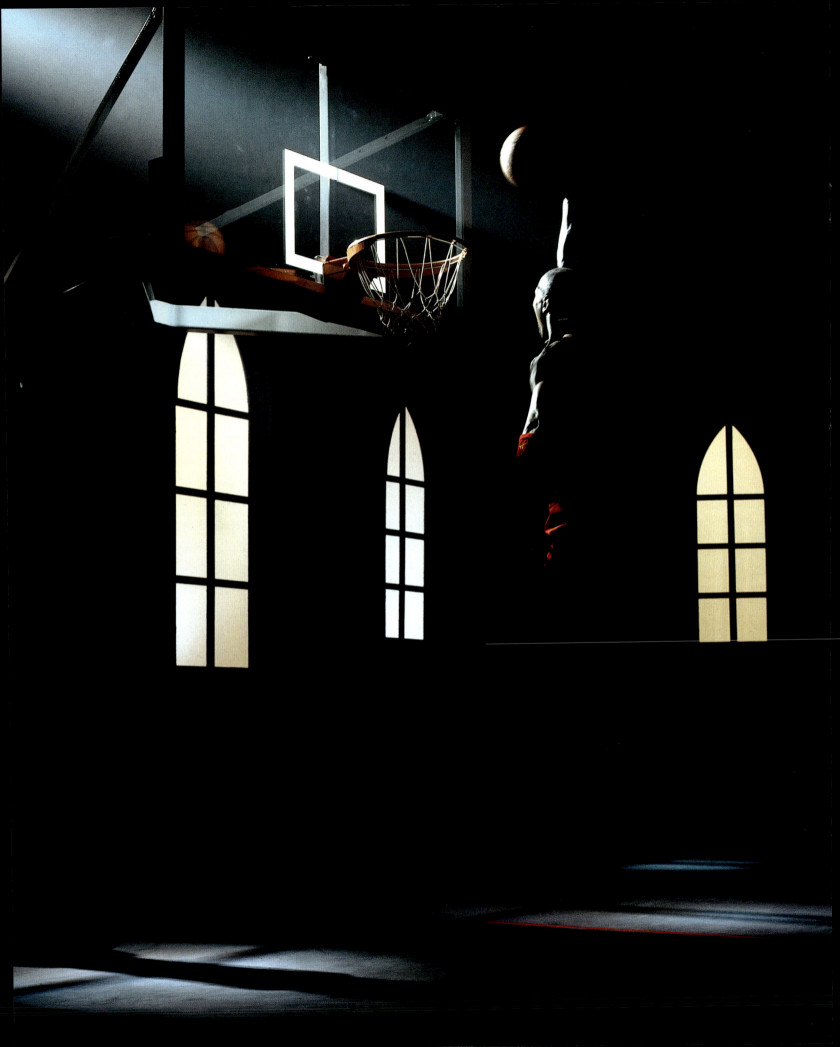

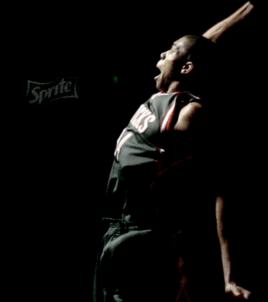

CONTENTS

Foreword by NBA Commissioner Adam Silver ▪ 10
Foreword by Patrick Ewing ▪ 12
Preface by Nathaniel S. Butler ▪ 14
Introduction by Dave McMenamin ▪ 16

COURTSIDE

Allen Iverson ▪ 24
Alonzo Mourning ▪ 29
Andre Iguodala ▪ 30
Anfernee "Penny" Hardaway ▪ 31
Anthony "Spud" Webb ▪ 33
Ben Wallace ▪ 35
Bill Russell ▪ 36
Blake Griffin ▪ 38
Brandon Jennings ▪ 40
Carmelo Anthony ▪ 42
CELTICS ▪ 46
Charles Barkley ▪ 48
Chris Mullin ▪ 51
David Robinson ▪ 52
Dee Brown ▪ 54
Dennis Rodman ▪ 56
Dennis Smith Jr. ▪ 60
Derrick Rose ▪ 62
Dirk Nowitzki ▪ 64
Dominique Wilkins ▪ 69
Donovan Mitchell ▪ 70
Dražen Petrović ▪ 72
Dwyane Wade ▪ 76
Earvin "Magic" Johnson ▪ 85
Gary Payton ▪ 89
Giannis Antetokounmpo ▪ 90
Grant Hill ▪ 98
Hakeem Olajuwon ▪ 102

Isiah Thomas ▪ 104
Jamal Crawford ▪ 105
Jamal Murray ▪ 106
James Harden ▪ 108
Jason Kidd ▪ 109
Jayson Tatum ▪ 110
Jeremy Lin ▪ 112
Joel Embiid ▪ 114
John Starks ▪ 115
Julius "Dr. J" Erving ▪ 116
Kareem Abdul-Jabbar ▪ 118
Karl-Anthony Towns ▪ 120
Kawhi Leonard ▪ 122
Kevin Durant ▪ 124
Kevin Garnett ▪ 130
Klay Thompson ▪ 134
KNICKS ▪ 136
Kobe Bryant ▪ 139
Kyrie Irving ▪ 150
Lamar Odom ▪ 158
Larry Bird ▪ 159
LeBron James ▪ 162
Luka Dončić ▪ 176
Manu Ginóbili ▪ 178
Manute Bol ▪ 179
Mark Jackson ▪ 180
Michael Jordan ▪ 182
Nate Robinson ▪ 194

NBA 50 ▪ 196
NBA 75 ▪ 198
Nikola Jokić ▪ 200
Oscar Robertson ▪ 205
Patrick Ewing ▪ 206
Paul Pierce ▪ 214
Ray Allen ▪ 216
Reggie Miller ▪ 218
Russell Westbrook ▪ 222
Scottie Barnes ▪ 223
Scottie Pippen ▪ 224
Shaquille O'Neal ▪ 227
Shawn Kemp ▪ 233
SPURS ▪ 234
Stephen Curry ▪ 238
Stephon Marbury ▪ 247
TEAM USA ▪ 248
Tim Duncan ▪ 250
Tracy McGrady ▪ 254
Trae Young ▪ 256
Tyrone "Muggsy" Bogues ▪ 258
Victor Wembanyama ▪ 259
Vince Carter ▪ 260
WARRIORS ▪ 268
Wilt Chamberlain ▪ 270
Yao Ming ▪ 272
Zion Williamson ▪ 276

Afterword by Spike Lee ▪ 278
Index ▪ 282
Acknowledgments ▪ 284
Colophon ▪ 286

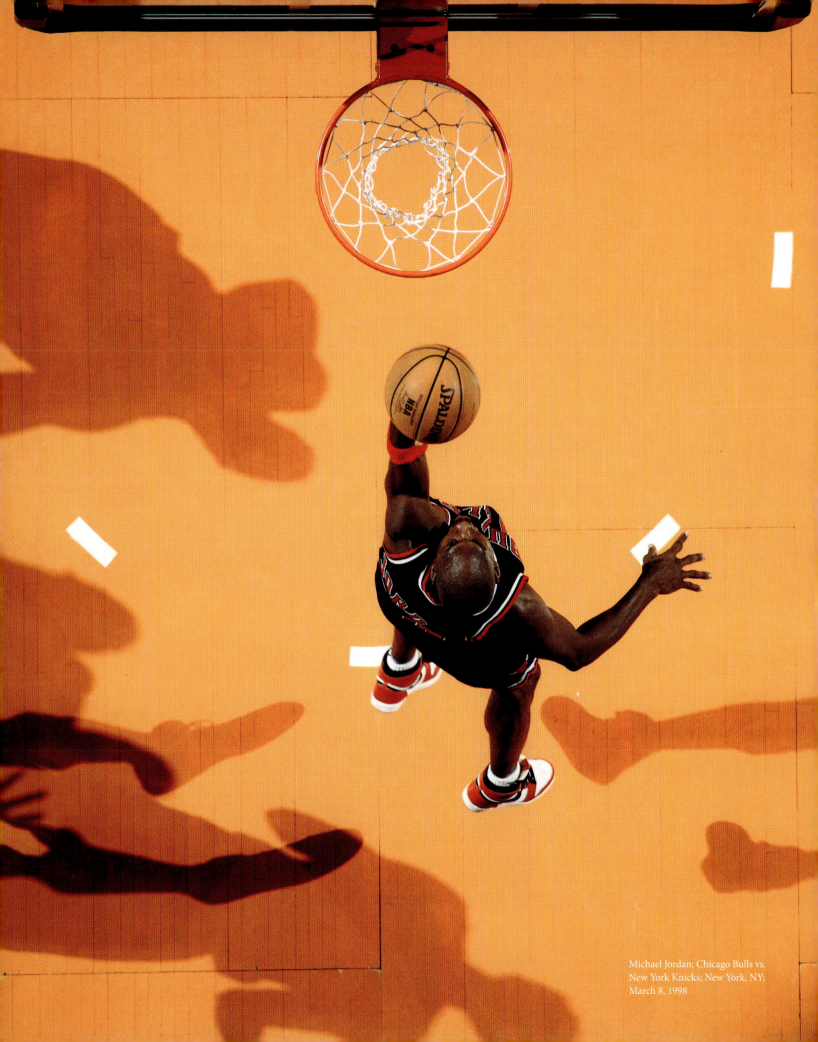

Michael Jordan; Chicago Bulls vs. New York Knicks; New York, NY; March 8, 1998

FOREWORD by NBA Commissioner Adam Silver

The NBA's most iconic players and teams from the past forty years are captured in *Courtside*. It's a project that my friend, colleague, and legendary photographer Nat Butler is uniquely suited to curate. And I know firsthand it was a true labor of love for Nat – a lifelong basketball fan – to put this extraordinary collection of his images together.

Nat joined the NBA in 1984, right as the league was ushering in a new era. Generations of players left their mark on the sport over the course of the following four decades – and Nat has had a front-row seat to witness and document it all. From intense NBA Finals series and star-studded All-Star Games to intimate behind-the-scenes moments and dreams coming true at the NBA Draft, Nat has been a constant presence and familiar face at our biggest and most defining events. Nat has covered thousands of games while building strong relationships with countless players and coaches.

What has stood out to me in watching Nat in action over these many years is his remarkable commitment to his craft. He's meticulous in his approach – always searching for the perfect angle to capture the perfect shot. He's traveled the world with his camera to provide our fan base with amazing images of the game, highlighting the passion, athleticism, and drama that make NBA basketball so special. And thanks to the advent of digital and social media, Nat's photos are now disseminated in seconds to a worldwide audience of NBA followers exceeding one billion people.

As Nat knows well, there's a story behind every photo. And that's what this book is: a compelling story of the NBA told through Nat's photography. He brings you with him courtside, where he's chronicled NBA history one captivating image at a time. Enjoy every click!

Bill Russell and Michael Jordan;
Chicago, IL; May 18, 1998

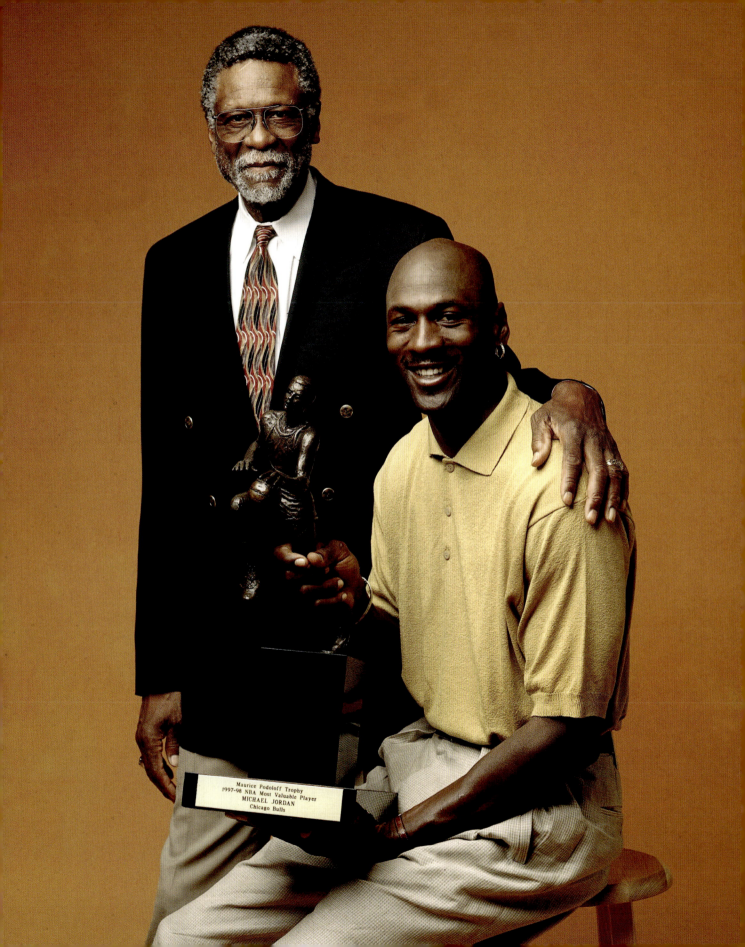

FOREWORD by Patrick Ewing

It felt like for every major moment of my career, I'd turn around, and Nat would be there.

In my early days with the New York Knicks at Madison Square Garden, battling with the best big men in the universe, legends like Hakeem Olajuwon and David Robinson and Shaquille O'Neal, Nat was there capturing every elbow I threw when jostling for position and every bead of sweat that formed on my forehead.

When I was a part of the best group of basketball players ever assembled, the Dream Team in the 1992 Olympics, Nat was there, bringing our images from Barcelona to the world.

Posing alongside my guys John Starks and Charles Oakley for our group portrait when we all made it to the All-Star Game in 1994 in Minneapolis, Nat was the guy who told us to say, "New York tough" as we stared into the camera.

In 1994, we won a dramatic Game 7 against the Indiana Pacers, and I celebrated by jumping up on the scorer's table at MSG for one split second. *CLICK*. Nat was there, capturing my euphoria.

Back in the summer of 1996, Nat had me meet him at Liberty State Park at dusk for a photograph that still gives me goosebumps. I was looking sharp and handsome in my nice suit. The New York City skyline was looking magnificent. The Twin Towers are standing tall and proud in the distance behind me – forever my NBA at 50 portrait.

Nat was there to see the fire in my eyes just before tip-off, when Michael Jordan came to town.

People might not remember it, but Nat was there when I was coaching MJ on the Washington Wizards. I have the photos to prove it.

Sliding on my Hall of Fame blazer for the first time in Springfield in 2008 – Nat took that photo.

My son, Patrick Jr., sliding on his Knicks jersey for the first time in training camp in 2010? Nat took that, too.

Group portraits of the greatest fifty players in NBA history when we congregated in Cleveland in 1997 and the NBA at 75 all-time team, back in The Land a couple decades later . . . Nat again – surprise, surprise – orchestrating and documenting notable gatherings in NBA history.

Thank you, Nat, for being there.

We've shared some special moments, man.

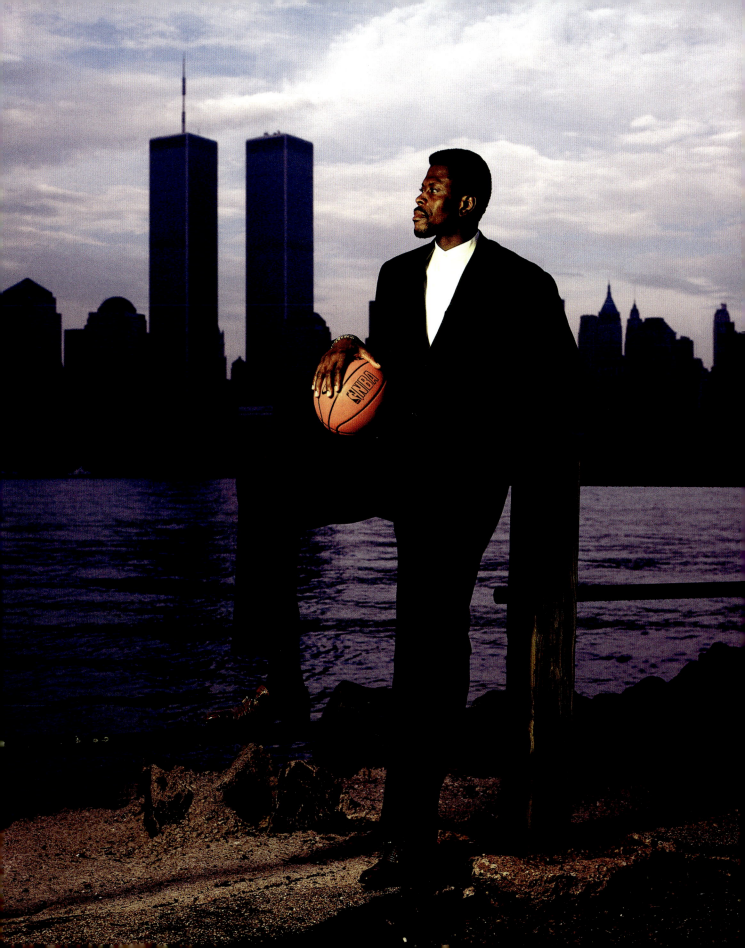

PREFACE by Nathaniel S. Butler

I grew up in the film era.

I couldn't look at the screen on the back of the camera to see if I got the image right away. I had to manually focus the lens. I had to manually set the exposure. I had to "click" one frame at a time; there was no motor drive to shoot twelve to fifteen frames per second. I couldn't fix something in Photoshop afterward. If I did get a great shot, I may have inadvertently chopped off a guy's foot. I never wanted to chop off a hand or the ball at the top of the frame, but it happened all the time because I was not using a zoom lens. It was much more of a cerebral approach, and I loved that aspect of it.

Those were the tools available to me on June 9, 1987 – just a few years into my career as an NBA photographer – when I was shooting Game 4 of the Finals at Boston Garden between the Celtics and their rival, the Los Angeles Lakers. That night, Magic Johnson hit one of the biggest shots of his life, and I was the guy who took the photograph. I guess you could call it one of the biggest shots of my life, too.

The fluid sequence – a running, one-handed hook shot by Johnson over Celtics Hall of Fame big men Kevin McHale and Robert Parish, to salt the game away and bring Los Angeles one win from clinching the championship – was distilled down to a split second captured on my camera to be remembered forever.

That is, as long as I got it.

I remember running out of the arena immediately after the game to a hotel to develop the film, to find out if I did, in fact, get Magic's "junior, junior skyhook" in frame. The adrenaline was flowing. I hoped I got it. I thought I got it. I didn't want to jinx it until I actually developed the film. When I held up that film and saw a frame like that, it was just a big sigh of relief. I did it. I captured a historic moment like that. And then I felt the rush. There's nothing like that rush.

In those days, the newspapers had darkrooms in all of the arenas. Typically, I was traveling and was a guest in those arena darkrooms, so if I chose to use them, I'd be stuck in there, as one couldn't just go in and out. I needed a legit darkroom. Emphasis on *dark*. So, instead, I would bring gear with me and set up a darkroom in the hotel. I was developing things, obviously, in the dark, hoping not to knock my knee into the side of the toilet, hanging rolls of film with clothespins on the shower rod above the bathtub.

I'd literally stay up all night, developing the film from the previous night's game and probably leaving a bathroom or two smelling pungent from the chemical solution. I'm sure there was an occasional hotel staffer who wondered what went on there. A lot of late nights. But a lot of great memories.

This book is a collection of the results from forty years of nights like that one when a junior, junior me snapped that photo of the junior, junior skyhook. From Finals game action to posed rookie portraits. From film to digital. From buzzer-beating 3s to soaring slam dunks. From the Boston Garden to Madison Square Garden. I have long heard people say, "Oh, you took that shot? That's your photo? Wow, I remember having posters and trading cards of that."

Over the years, I have been approached by countless people asking, "When are you going to make a book?" Typically in the past, I dismissed the notion, because I felt that my best work was yet to come. When I realized that January 2024 would mark the fortieth anniversary of my career with the NBA, I finally thought, *Why not now?* In gathering imagery for this project, one constant has become abundantly clear – my passion for the game of basketball is stronger now than ever before. I can only hope that you enjoy looking at and reflecting upon these moments as much as I have.

This is my life's work from behind the lens.

"I mean, he actually fouled me. He fouled me, and the referee was just like everybody else—being a fanboy. And he called a foul on me when he should have called an offensive foul with [James's] elbow." —Damon Jones

LeBron James; Cleveland Cavaliers vs. Miami Heat; Miami, FL; February 3, 2005

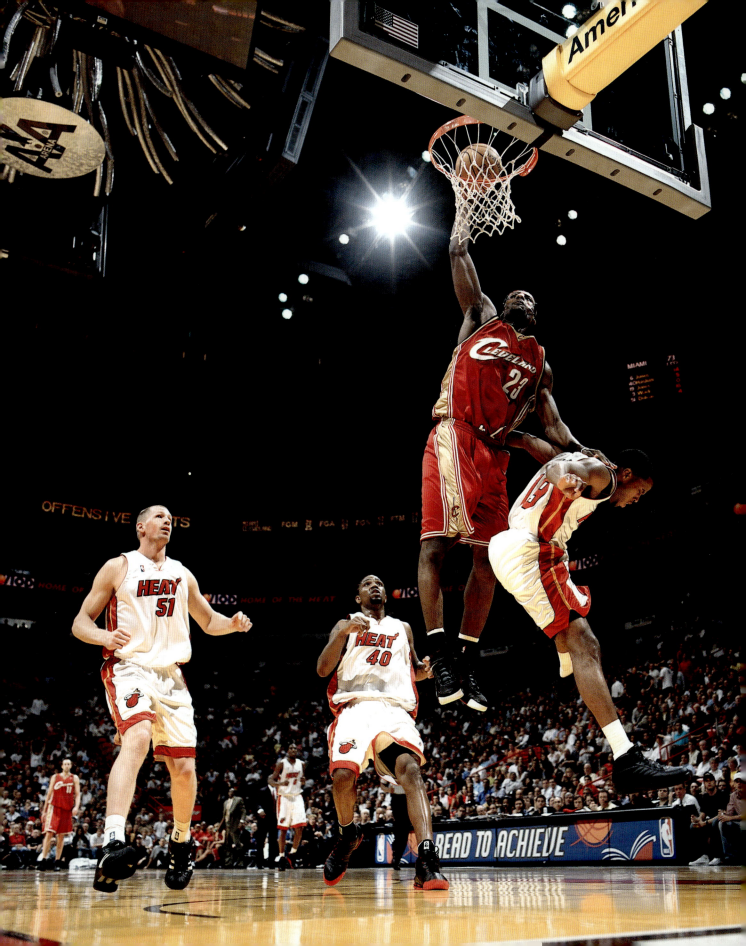

INTRODUCTION by Dave McMenamin

For forty years, Nathaniel S. Butler – or Nat, as he's known to his countless friends and colleagues – has navigated the hustle and bustle of New York City to arrive at the corner of Eighth Avenue and Thirty-Third Street and clock into work with his trusty camera at his side.

Only Butler doesn't report to your typical office building.

"There's just something about Madison Square Garden that is truly magical," Butler says.

For four decades Butler has captured the action on the basketball court inside the "World's Most Famous Arena" on his camera, and those images have made their way around the globe. "The Garden is bigger than basketball," Butler says. "An Ali-Frazier fight. Concerts. The Beatles and Elvis. And I think that does lend to the aura of the building . . . it is bigger than basketball. I happen to be focused on the basketball part."

Focus is an appropriate word choice. Butler has been tasked with framing seven-foot men with forty-inch vertical leaps moving at breakneck speeds in focus in his camera lens and knowing the precise moment to get the shot.

It's an occupation he's been training for since he was a child growing up in Montauk, out on Long Island. "It was just a little fishing community," Butler says. "I was literally the only one that played basketball. I would travel around twenty miles to find a game."

When he wasn't playing hoops, he was working for his dad's fishing business. Butler saved up his earnings to buy himself a Nikon FM2 when he was twelve years old. "Like someone would remember their first car, I remember my first camera," Butler says.

He would fill his days going to school, searching for pickup basketball games, working for his dad, and snapping pictures of sunrises, sunsets, and fishing excursions. Thursdays were

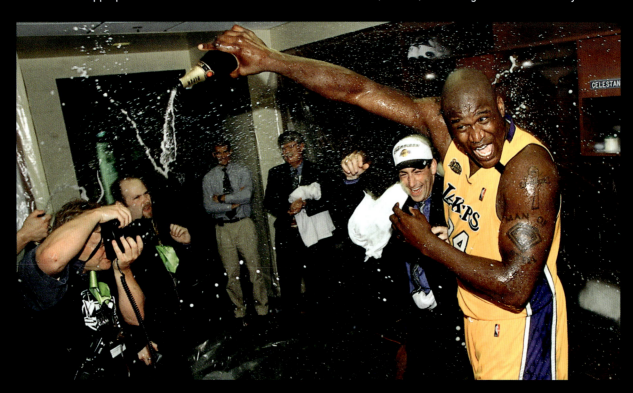

"Nat Butler has always been one of my favorite photographers. He's always been hospitable with the pictures, and I have a lot of them in my house . . . this one is during my first championship. I was so happy, whoever was in the way got doused with champagne."
—Shaquille O'Neal

Shaquille O'Neal; Los Angeles Lakers; NBA championship win; Los Angeles, CA; June 19, 2000—an excited Shaq pours celebratory champagne on Nathaniel Butler after the Lakers NBA championship win

special. That's when Butler would run to the mailbox to find his weekly *Sports Illustrated* magazine delivery. He would fill his nights tuning into New York Knicks games on the radio as he admired the photos torn from those pages, which he covered his bedroom walls with like posters. "It was the Walt "Clyde" Frazier era. The good Knicks teams of the '70s. And like every kid had, I was in the driveway counting down '5, 4, 3, 2, 1,' pretending I was Walt Frazier against Jerry West. And I loved Jerry West, so I was a little bit conflicted there. I wanted to play like Jerry West and be cool like Walt Frazier. . . . I failed on both accounts," Butler adds, with a self-deprecating laugh.

No, Butler might not have gone on to be known as "The Logo" like West or speak with dazzling diction like Frazier, but he succeeded in nurturing his passions and creating a path so he could keep basketball and photography as foundational pieces throughout his life.

After high school, he enrolled at St. John's University. While Butler had a solid high school hoops career, he knew his limitations when it came to competing with the best in the Big East. "We're talking Chris Mullin, Mark Jackson, Walter Berry," Butler says. "I was friends with those guys, hung out with them, but was not good enough to be on the team. So I started taking pictures."

St. John's played their biggest battles at The Garden when behemoths like Georgetown, Villanova, and Syracuse came to town. Butler chronicled his school reaching the No. 1 national ranking, working nights and weekends as an apprentice for *Sports Illustrated*. While the magazine pages featuring the works of guys like Walter Iooss Jr., Manny Millan, and Heinz Kluetmeier were still tacked up in his bedroom back home, Butler was now working side by side with those photographers. "It was an invaluable experience learning from those masters," Butler recalls. "I just felt comfortable in that world. I would assist those guys and help them at the crazy, big events they were covering. And then I'd go back to St. John's, shoot the game; develop my film; go to practice; shoot practices . . . over and over again, working on my craft. Just like lawyers don't argue a case in front of the Supreme Court a year out of law school, photography is like any other profession that you have to develop and work at."

While Butler was in his last semester at college, he started working for the National Basketball Association under longtime public relations guru Brian McIntyre. "It was an internship before internships were the industry standard," Butler explains. "My office was three doors down from David Stern's office. It was a unique time for the league. Former commissioner Larry O'Brien was on his way out. David was on his way in."

Butler was assigned grunt work, but he found glory in it. "As part of my duties, David would have every NBA city's newspaper delivered to the office, and I would go in at six o'clock in the morning and do clips from every newspaper," Butler says. "The three papers in LA; three in New York. Denver. Chicago. I was fascinated by how the league was covered. I would read the stories, of course. Not just because that's what Stern wanted a summation of, but because I was interested. But the real treat for me was looking at the photos accompanying the stories in the newspapers. There was excellent photography in the *Los Angeles Times*, the *Chicago Tribune*, the *Washington Post* . . . I was in heaven doing that."

While the league now had a budding photographer as an intern in Butler, it did not have a photo department. NBA Entertainment had just started on the video side and would find great success with *Michael Jordan's Playground* and *Michael Jordan: Come Fly With Me* VHS tapes, but there was no in-house still photography system. So Butler and another young shutterbug, Andrew D. Bernstein – known to his friends and colleagues as Andy – put their heads together. "I said, 'I sort of need a job when the internship ends – why don't we create a photo department for the NBA?' As crazy as it sounds, that's sort of how it all started," Butler explains.

Bernstein, who was inducted into the Naismith Memorial Basketball Hall of Fame in 2018 as a Curt Gowdy Media Award winner, would be based in Los Angeles and keeping tabs on the Lakers and Clippers. Butler got New York and the Knicks and The Garden, and later, Brooklyn and the Nets and Barclays Center. "It was a joy to help create NBA Photos with Nat back in the mid 1980s," Bernstein says. "His vision and deep love for the game of basketball, plus his unmatched talent as a photographer, made us a great duo on both coasts." Then, as the NBA evolved, going from tape-delayed playoff games being aired on television to prime-time appointment viewing, so did Butler's execution. The beauty in building a department from the ground up was Butler had the freedom to experiment. "Lighting an arena like Madison Square Garden is not an easy undertaking, by any stretch," Butler says. "But we had the supplemental lighting. And how the pictures look, that's something I take great pride in. I went to great lengths. I couldn't control the players. I couldn't ask them to pose. But I could do certain things to get the lighting right. And along those lines, I worked and developed a remote system that is now considered pretty standard."

Butler spent nearly two years fabricating a multi-camera remote triggering system and tinkering with how radio frequencies transmit in an arena. "It might work fine at two o'clock, and then when there are twenty thousand people in the arena at seven o'clock, it malfunctions," Butler says. "Why? Well, the human body is made up of 60 percent water. It doesn't work with water. And then you figure out that challenge, and time goes by, and the next hurdle is twenty thousand people on a cell phone frequency. It's constantly evolving, and that's one of the things that I enjoy. I enjoy the challenge, and while you're not re-creating the wheel, you are definitely always looking for improvements and little things to enhance the ultimate product." As the NBA expanded its photo department with shooters in cities around the country, Butler took pride in seeing other photographers incorporating his innovations into their work – be it through his remote system or shooting high-quality strobe images with handheld cameras.

"Nat Butler has been doing this for a long time," says Noah Graham, an NBA photographer based in the Bay Area. "He's in the 'legend' space, as far as can I tell. And we all kind of watch as we are going through it – similar to the way basketball players watched Kobe, as photographers, we watch the generation in front of us. And he is a generational talent; he's still doing incredible things, and we've all had his example to look at. It's an honor to know him; it's an honor to learn from him and call him a colleague."

"When I got to meet Nat for the first time, he took me to a Nets game, and I sat with one of his Hasselblad remotes," adds Joe Murphy, who started in the licensing arm of NBA Photography before becoming the team photographer for the Memphis Grizzlies. "Nat was above and beyond; he was one of the best guys to watch because you could tell the work ethic that he always had – it didn't matter if it was Game 6 of the Finals or a Tuesday night game at The Garden against the Dallas Mavericks, he put in the same commitment each time. He put up the same type of remotes, and he provided the same type of coverage. I knew right away that this was the way to do a game. When I finally started with the Grizzlies, he was absolutely someone that I modeled myself after."

After shooting thousands of games and millions of images, Butler has stayed sharp by embracing the technological advances over the years – shooting digital to satisfy the immediate need for NBA content – but never settling for the instant gratification of a beautiful photo being as beautiful as he is capable of capturing. "I'm frequently asked what my favorite photo that I've taken is," Butler says. "And sure, there are different images that are a 'favorite' for a short period of time. But then I'm onto the next one. It's a little bit obsessive in a way. You're always searching for that next great moment, you know? That's what I do. That's what I love. I love the challenge of that."

And while the aesthetic is always important to him, so is the history behind what he's seeing. "We are there to document things," Butler says. "And it's an editorial type of documentation. Obviously, it's a live sporting event. You're not telling the player, 'Oh, I missed that. Can you go do that again?' We don't touch up in Photoshop, either. Whatever we shoot, that's what we get – the way it comes out of the camera. And there are ethical guidelines, too. Digitally, we don't enhance it. We're not using AI."

Butler found himself seated courtside for history on June 18, 2013. It was Game 6 of the NBA Finals between the Miami Heat and San Antonio Spurs. The Spurs led 3–2 in the best-of-seven series. A win by San Antonio would not only mean a fifth ring for Tim Duncan and Gregg Popovich, but a second Finals loss in three years for LeBron James, Dwyane Wade, and Chris Bosh. Abject failure for "The Heatles."

As the game dwindled down inside of 10 seconds remaining, with the Spurs holding a 3-point lead and arena workers crouched at the corners of the court, holding yellow rope to set up for the postgame trophy ceremony, Butler was responsible for making sure his camera captured the scene forever. "You have to stay calm," Butler says. "You're in the moment. You have to be prepared. They're bringing the ropes up. In the back of your mind, you're ready for Popovich hugging Tim Duncan over to the left of the frame, over by the bench, or something like that. But, at the same time, the game's not over. And the game's never over when you have LeBron, D-Wade, Chris Bosh, Ray Allen. They're in the game. They're fighting until the end."

James missed a 3-pointer with 11 seconds left. Bosh grabbed the offensive rebound with 9 seconds left, and his pass out to Allen changed everything. "That particular picture [pages 216–217] just fell into place because I know Ray Allen," Butler says. "I know what he does. I see him when we're setting up our cameras three hours before the game – I see Ray Allen working on his game. So the key play was Chris Bosh grabbing the rebound. Ray was not phased at all. He's backpedaling, doing what he does. His shooting that, his making that, it was totally in character for me to see. That's what he does. I'd seen it countless times in the quietude of an empty arena."

Butler, anticipating the pass out to Allen, waited to take the photo. With 6.7 seconds left, with the ball just released

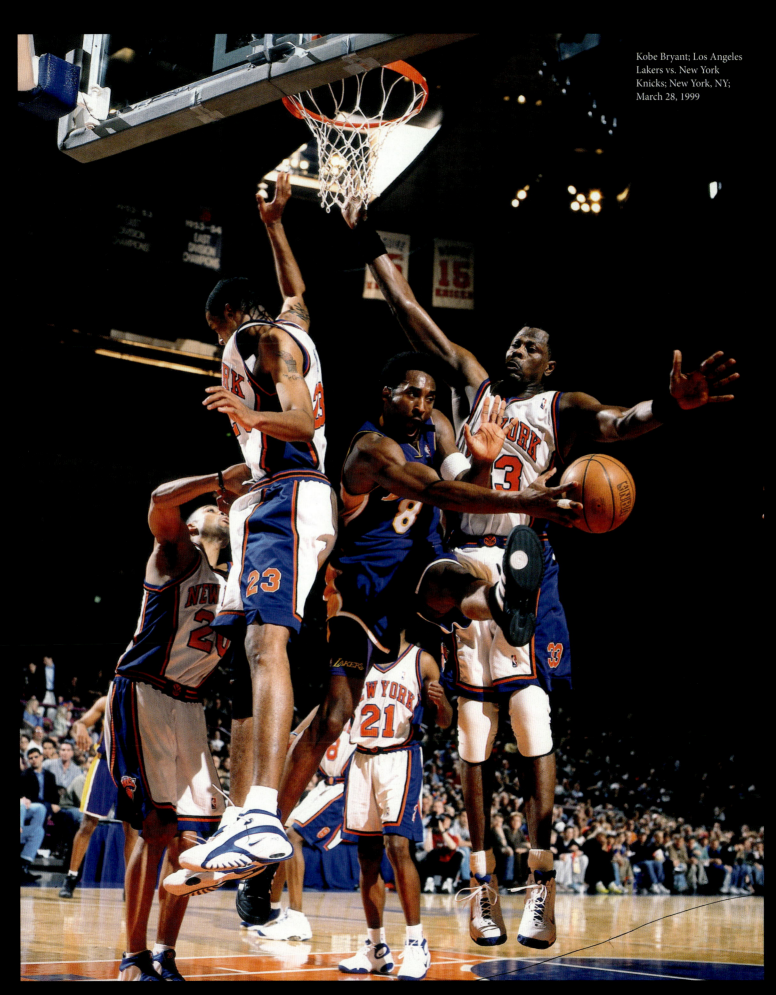

Kobe Bryant; Los Angeles Lakers vs. New York Knicks; New York, NY; March 28, 1999

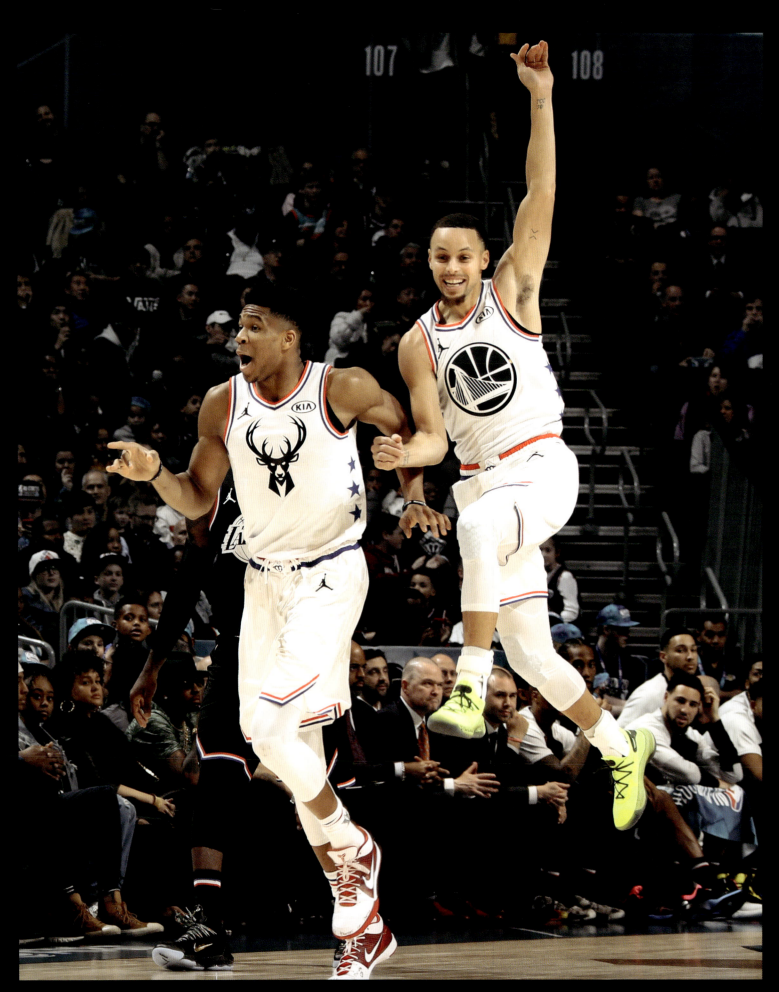

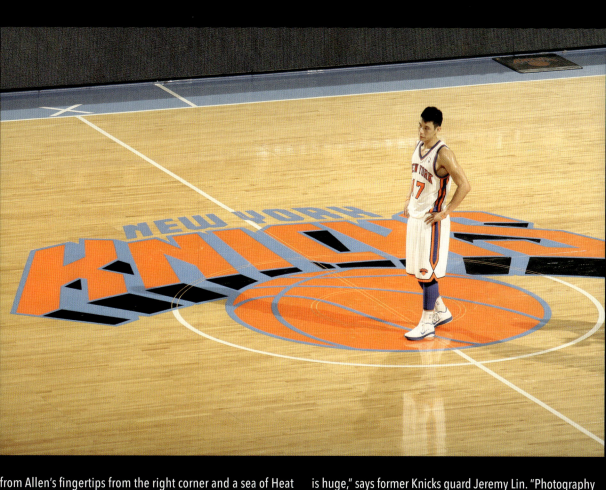

from Allen's fingertips from the right corner and a sea of Heat fans wearing white as the backdrop behind him, Butler got the shot. "Oftentimes in a regular season game, you'll see a team panic down the stretch," Butler says. "They take a bad shot, or someone would get that rebound and force something up. But the Heat kept it in their zones of professionalism. And I have to do the same. Now, that doesn't guarantee you get the picture. Just like him getting in position and shooting the shot doesn't guarantee he makes it. But you do your part. He's going to hit that big shot. And I was fortunate enough to stay within my comfort zone and get that photo."

A photo of the biggest game-tying shot in NBA Finals history.

"The historian in me feels compelled to point out that the shot didn't win the game," Butler says. "It just forced it into OT, where Miami prevailed." Butler's instincts prevailed, too: "I wasn't shooting on a motor drive. I'm shooting a single frame, one shot, and you just have to stay within yourself and be patient. And just get that moment when it happens."

The photos from those moments have padded Butler's portfolio, one so thorough and expansive that it would be hard to tell the NBA's story without it. "Nat's legacy of photography is huge," says former Knicks guard Jeremy Lin. "Photography has definitely solidified and cemented so many parts of basketball and NBA history. We're very grateful to Nat."

For Butler, who figures he would have found a way to spend his life around basketball as a video coordinator or an assistant coach, even if that timely internship working down the hall from David Stern never happened, there's a deep appreciation that his camera has kept him close to the game. "Still today, after forty years, I get excited when I walk into an arena and hear the bouncing of balls, squeaking of sneakers, and roaring of crowds," Butler says. "For the past four decades, I have had a courtside seat to some of the greatest moments in basketball history and have had the privilege of photographing some of the world's greatest athletes. The marriage between basketball and photography has been an unbelievable joy for me. And it's not something you start out saying, 'Oh, I'm going do this for forty years.' It just happens. You're enjoying it. You're fortunate enough to be doing something that you love. And the years do go by faster than we would all like. It is hard for me to conceptualize that it has, in fact, been forty years of me doing this.

"And it's been quite a privilege."

ABOVE: Jeremy Lin; New York Knicks vs. New Orleans Hornets; New York, NY; February 17, 2012

OVERLEAF: Michael Jordan; Chicago Bulls; 1987 NBA Slam Dunk Contest; Seattle, WA; February 7, 1987

OPPOSITE: Giannis Antetokounmpo and Stephen Curry of Team

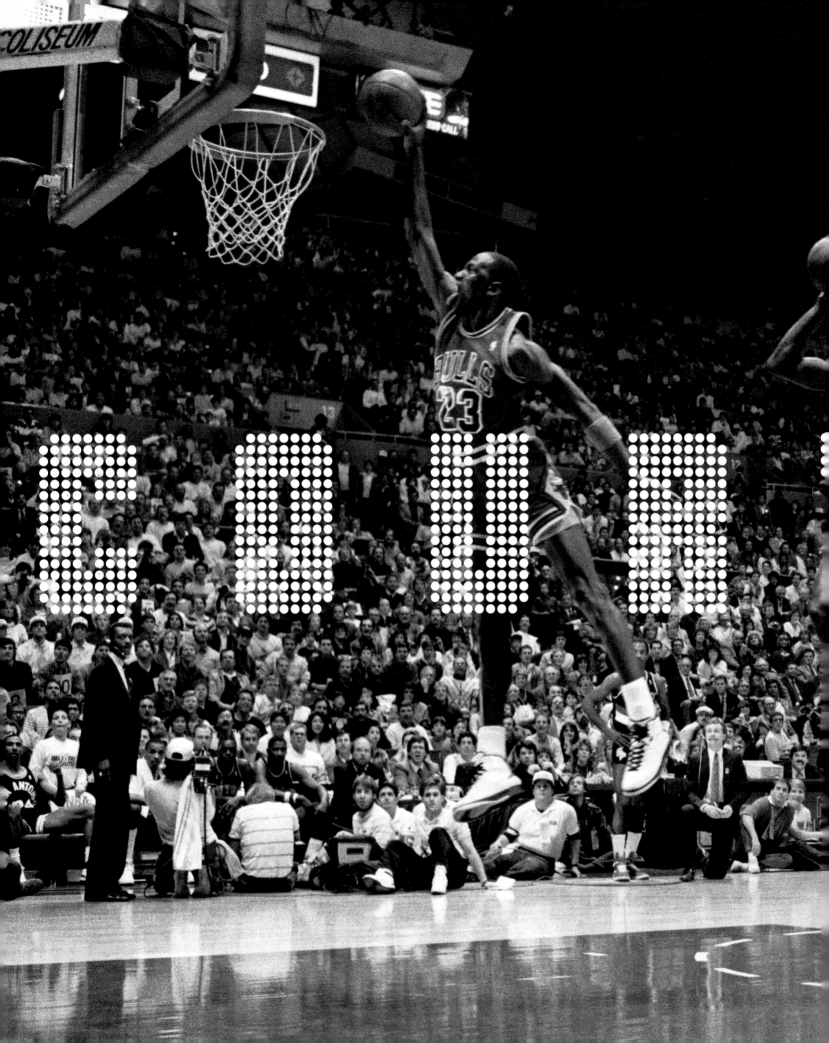

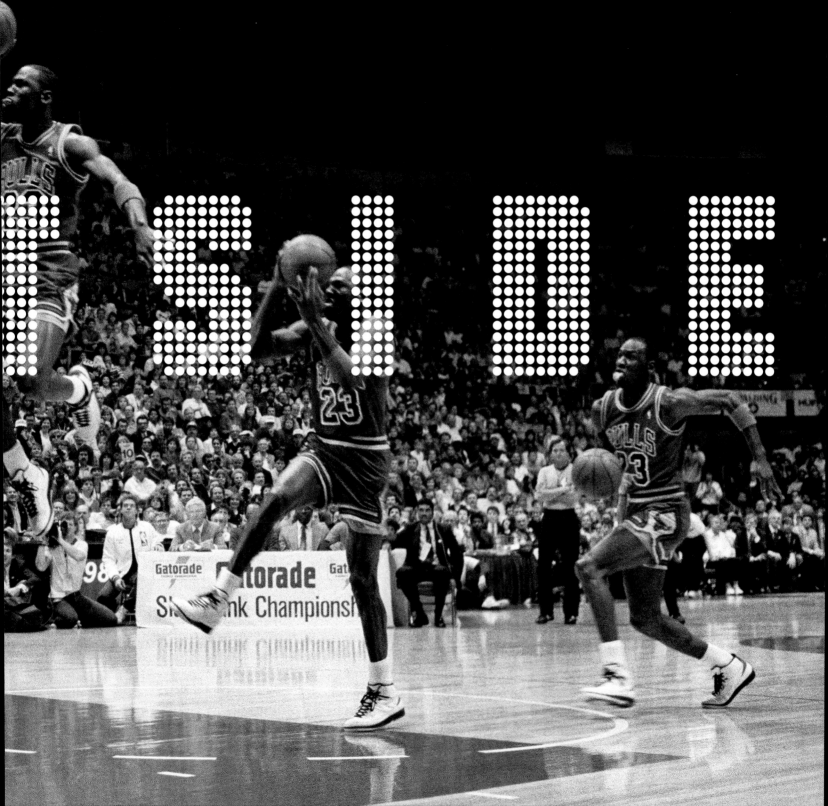

ABOVE: Allen Iverson; Secaucus, NJ; June 25, 1996
OPPOSITE: Allen Iverson; Philadelphia 76ers vs. Toronto Raptors; Philadelphia, PA; January 29, 1997

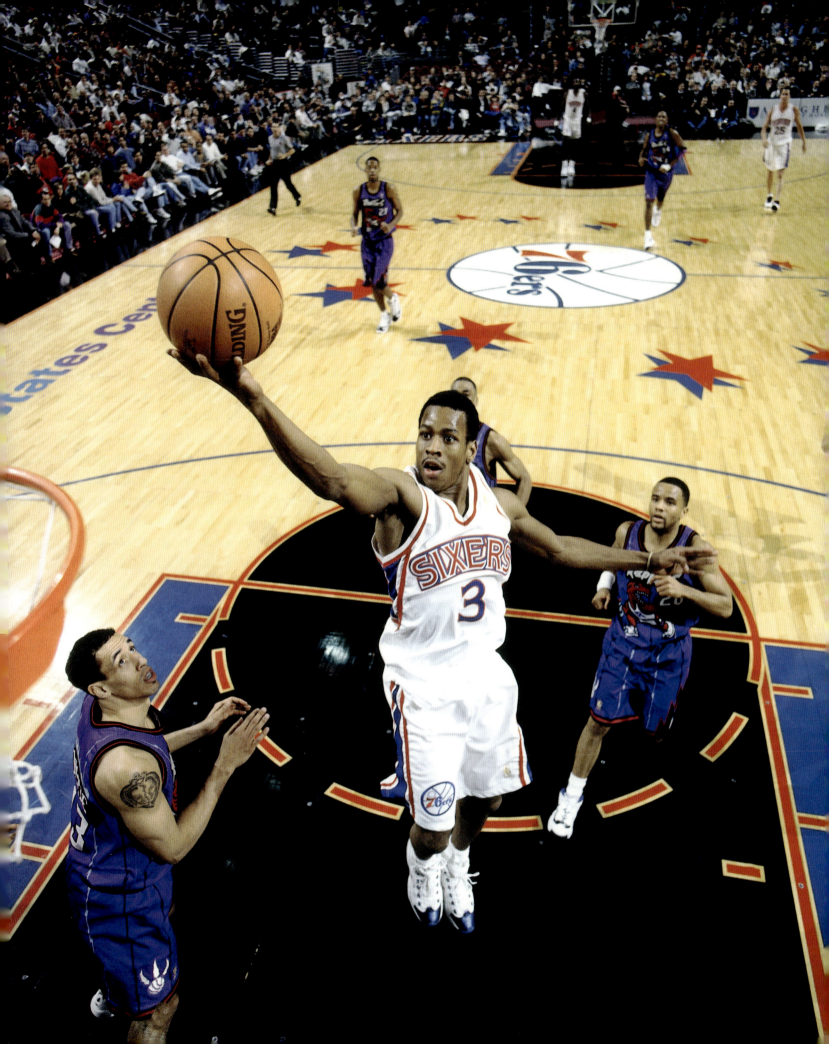

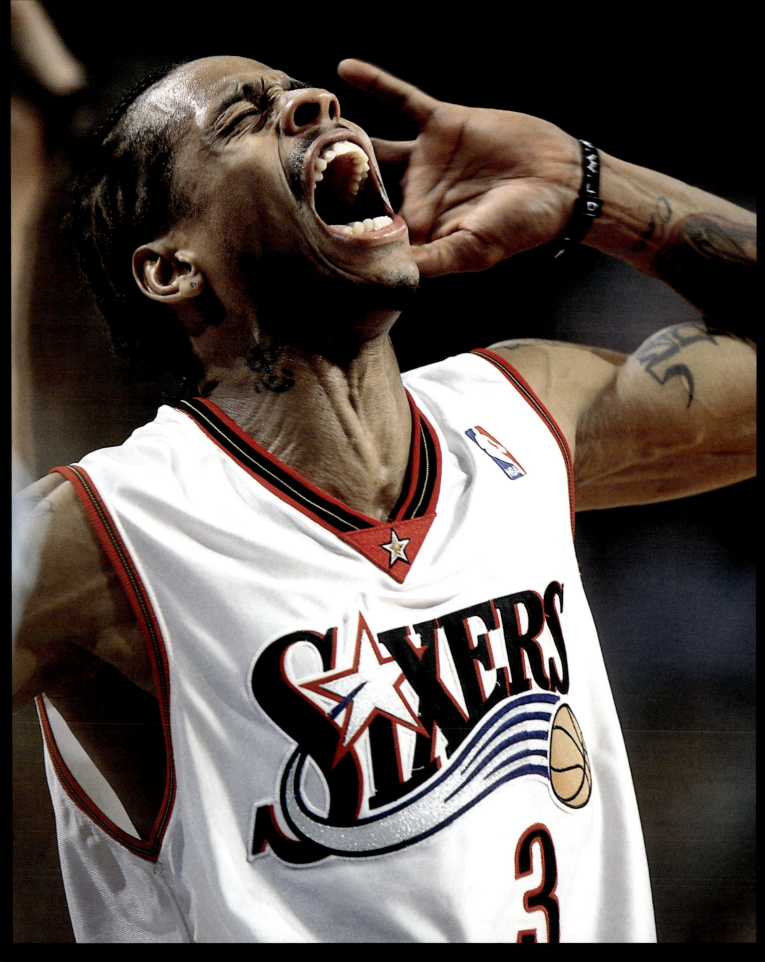

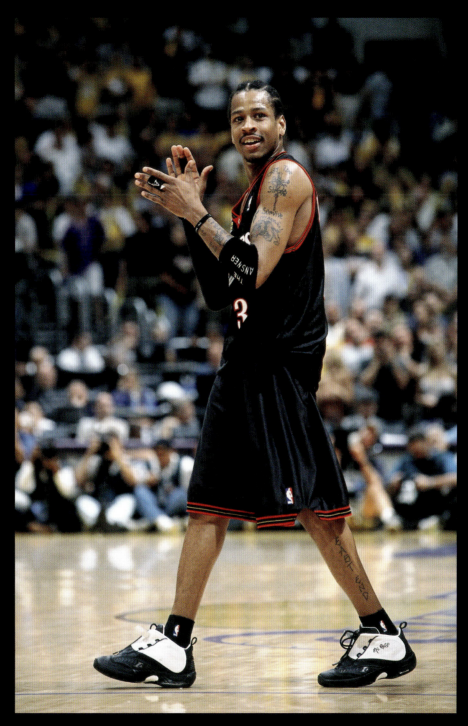

ABOVE: Allen Iverson; Philadelphia 76ers vs. Los Angeles Lakers; Game 2 of the NBA Finals; Philadelphia, PA; June 8, 2001

OPPOSITE: Allen Iverson; Philadelphia 76ers; Philadelphia, PA; 2001

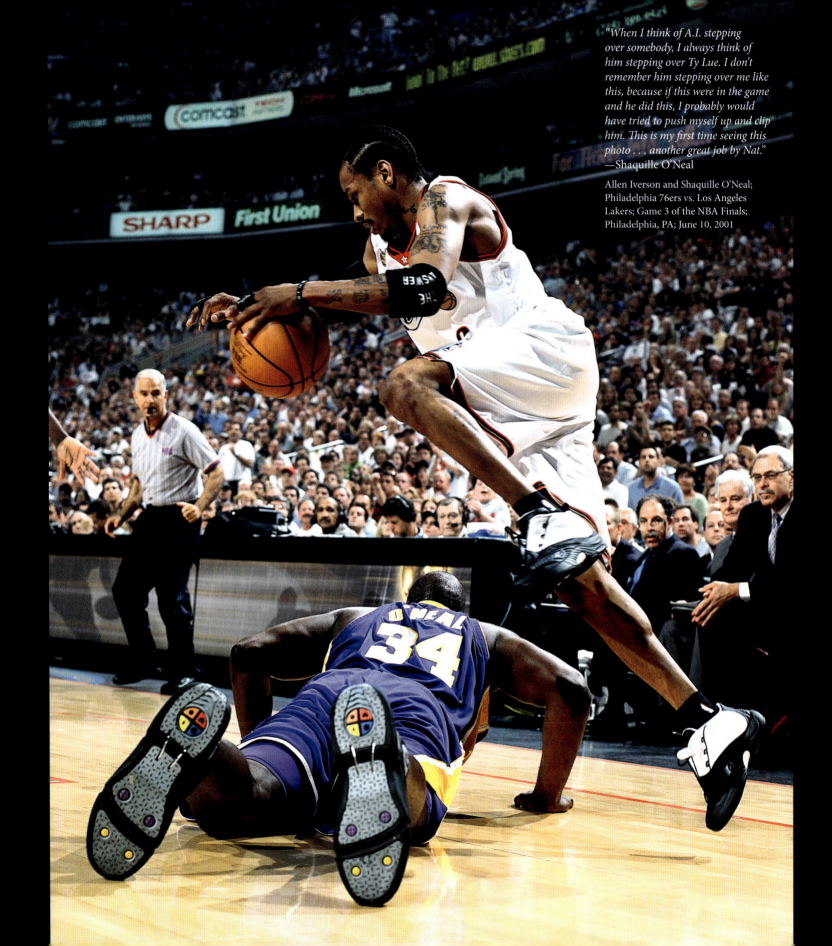

"When I think of A.I. stepping over somebody, I always think of him stepping over Ty Lue. I don't remember him stepping over me like this, because if this were in the game and he did this, I probably would have tried to push myself up and clip him. This is my first time seeing this photo . . . another great job by Nat."
—Shaquille O'Neal

Allen Iverson and Shaquille O'Neal; Philadelphia 76ers vs. Los Angeles Lakers; Game 3 of the NBA Finals; Philadelphia, PA; June 10, 2001

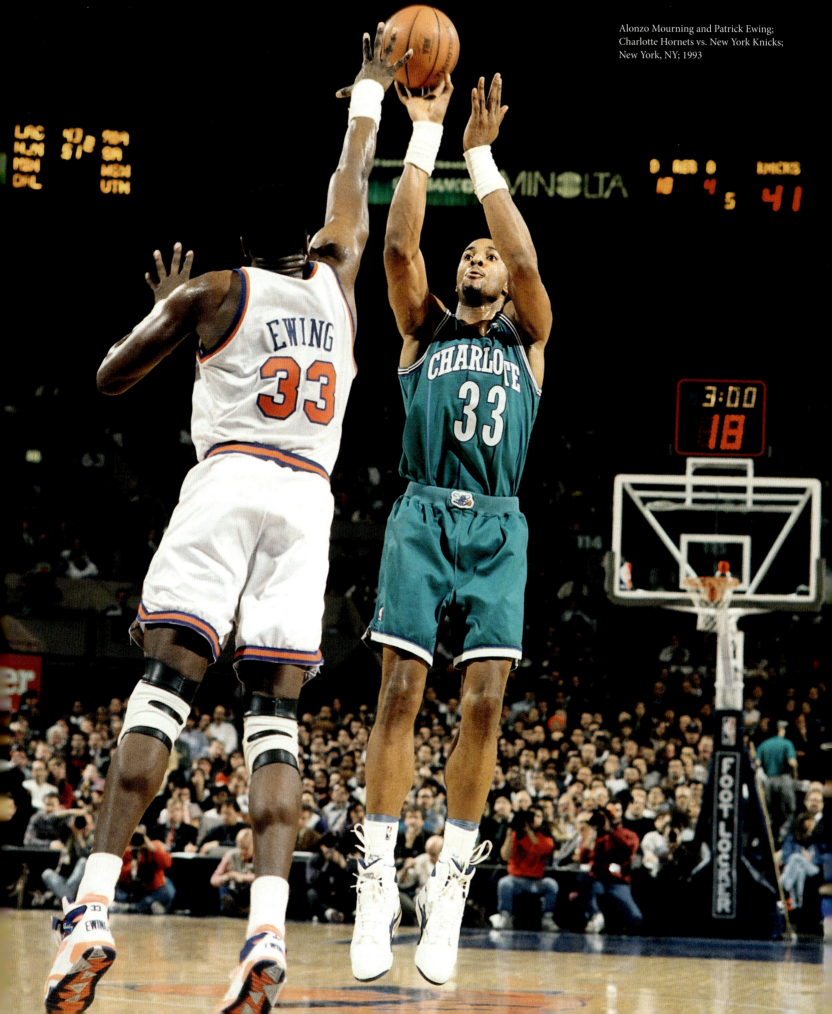

Alonzo Mourning and Patrick Ewing;
Charlotte Hornets vs. New York Knicks;
New York, NY; 1993

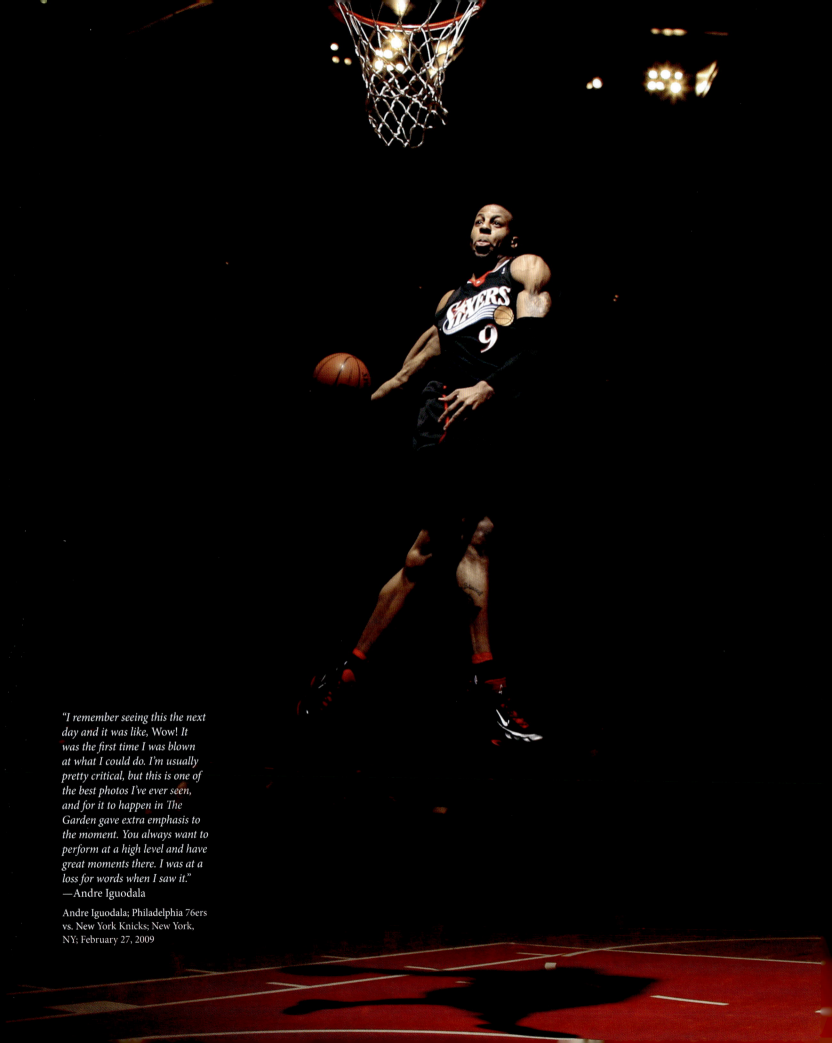

"I remember seeing this the next day and it was like, Wow! It was the first time I was blown at what I could do. I'm usually pretty critical, but this is one of the best photos I've ever seen, and for it to happen in The Garden gave extra emphasis to the moment. You always want to perform at a high level and have great moments there. I was at a loss for words when I saw it."
—Andre Iguodala

Andre Iguodala; Philadelphia 76ers vs. New York Knicks; New York, NY; February 27, 2009

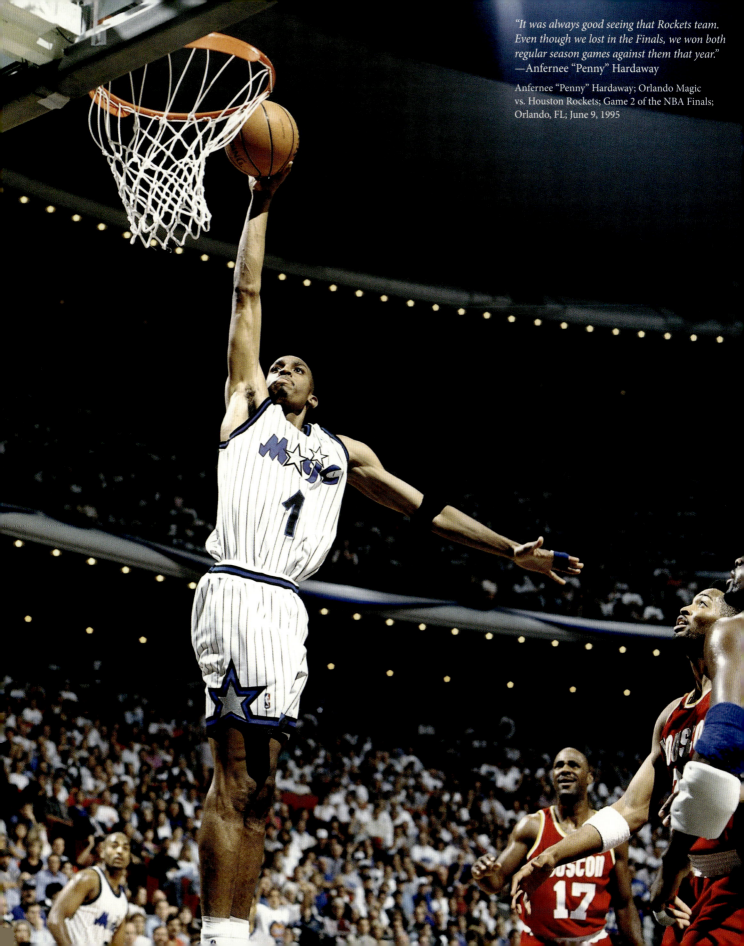

"It was always good seeing that Rockets team. Even though we lost in the Finals, we won both regular season games against them that year."
—Anfernee "Penny" Hardaway

Anfernee "Penny" Hardaway; Orlando Magic vs. Houston Rockets; Game 2 of the NBA Finals; Orlando, FL; June 9, 1995

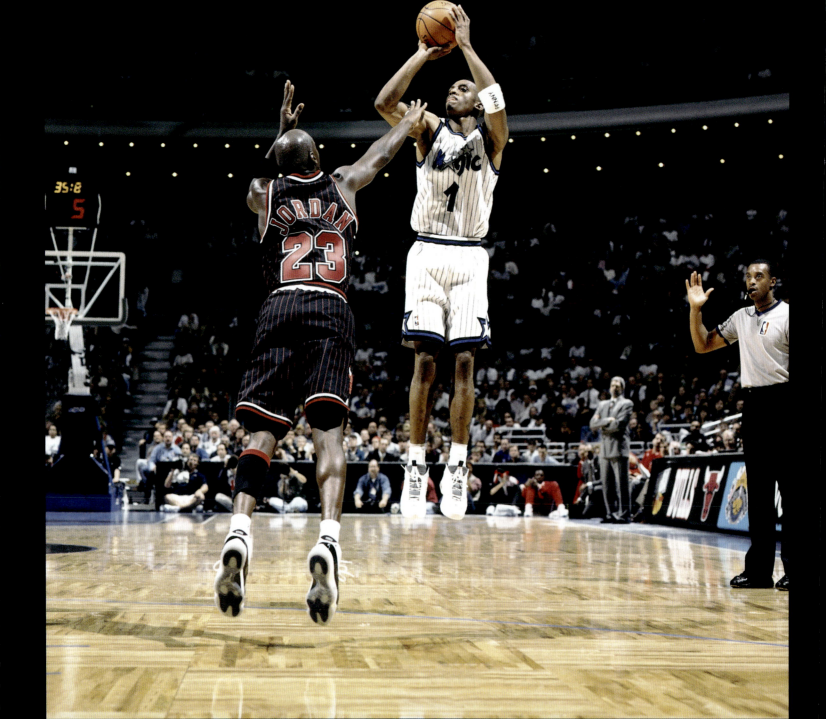

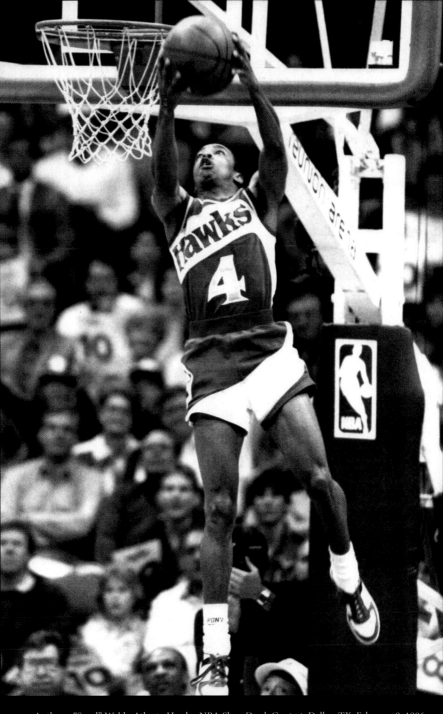

ABOVE: Anthony "Spud" Webb; Atlanta Hawks; NBA Slam Dunk Contest; Dallas, TX; February 8, 1986

"Obviously I made this shot—I remember it. But this is just iconic because it's MJ, and it's me in my prime playing against the GOAT. Just a special moment for me in that game—Shaq didn't play, and had to carry the load against a really good Bulls team, and we won." —Anfernee "Penny" Hardawa

OPPOSITE: Anfernee "Penny" Hardaway and Michael Jordan; Orlando Magic vs. Chicago Bulls; Orlando, Fl November 14, 1995

"I always made my living on the defensive end. That is what swayed me to want to play the way I played. When I came out with the headband, the armbands, the 'No-Fly Zone,' the other team knew it was going to be a tough night. No matter what happens on that floor, you've got to go out and get it. Ain't nothing promised. It doesn't matter where you start. It's all about the journey."
—Ben Wallace

Ben Wallace; Detroit Pistons; Auburn Hills, MI; March 13, 2003

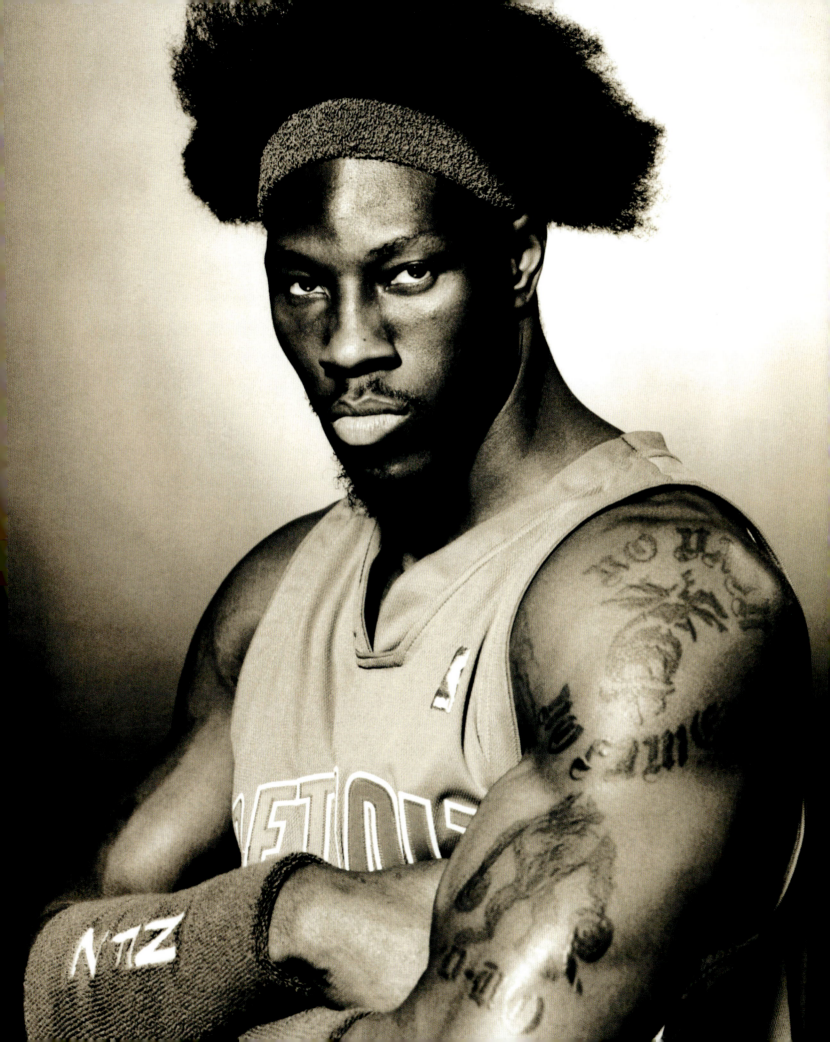

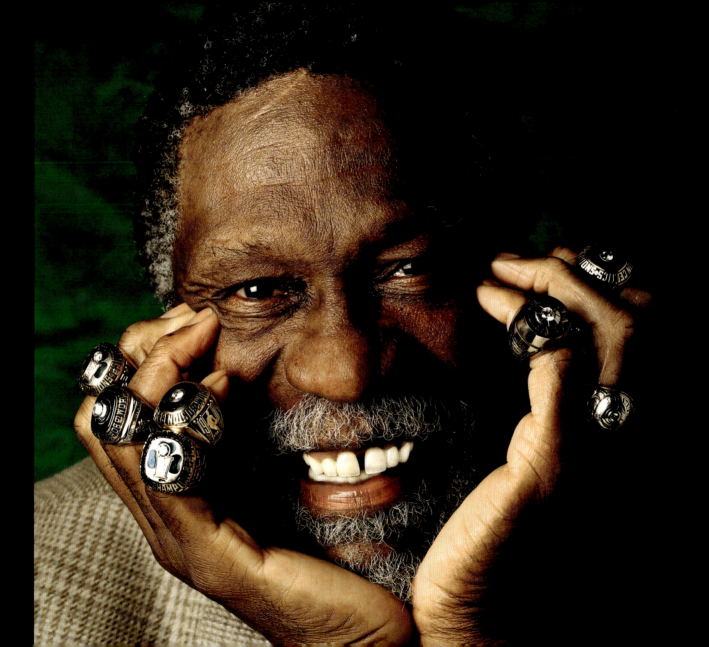

"Growing up, I would record the NBA dunk contest and rewatch it over and over again, dreaming of one day doing something that hadn't been done before. To be on that stage, living out exactly what I had envisioned since childhood, was one of the most surreal moments of my life."
—Blake Griffin

RIGHT: Blake Griffin; Los Angeles Clippers; NBA Slam Dunk Contest; Los Angeles, CA; February 19, 2011

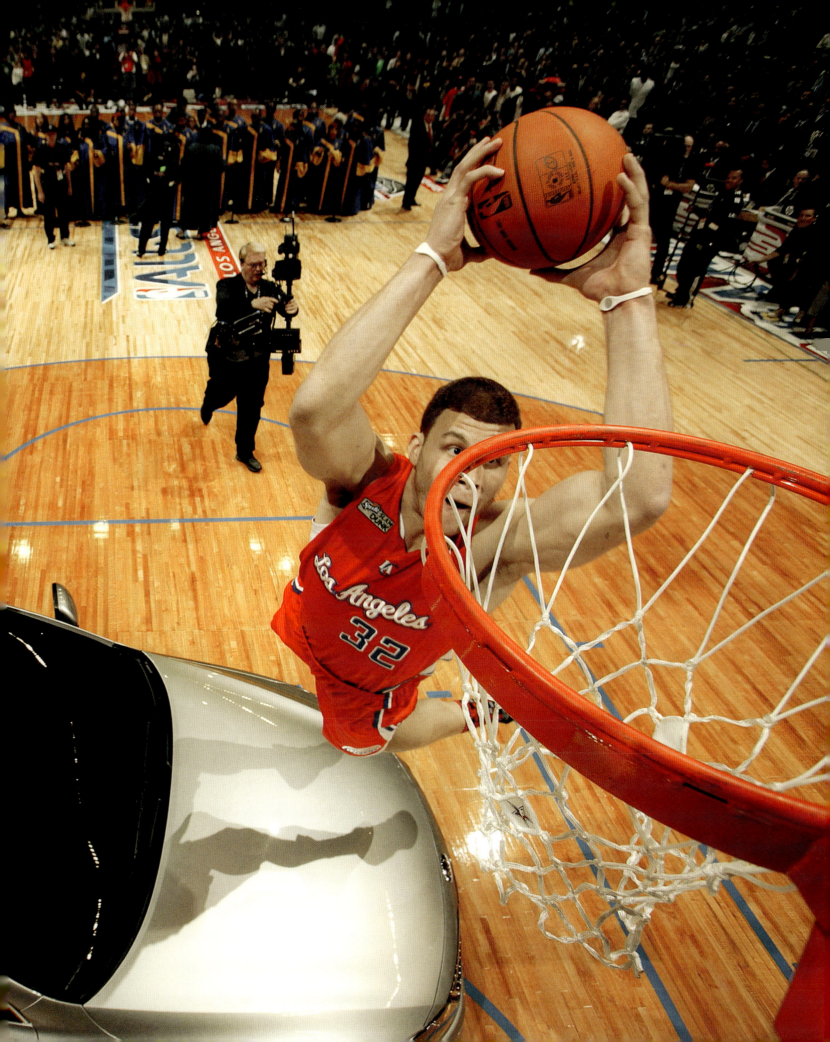

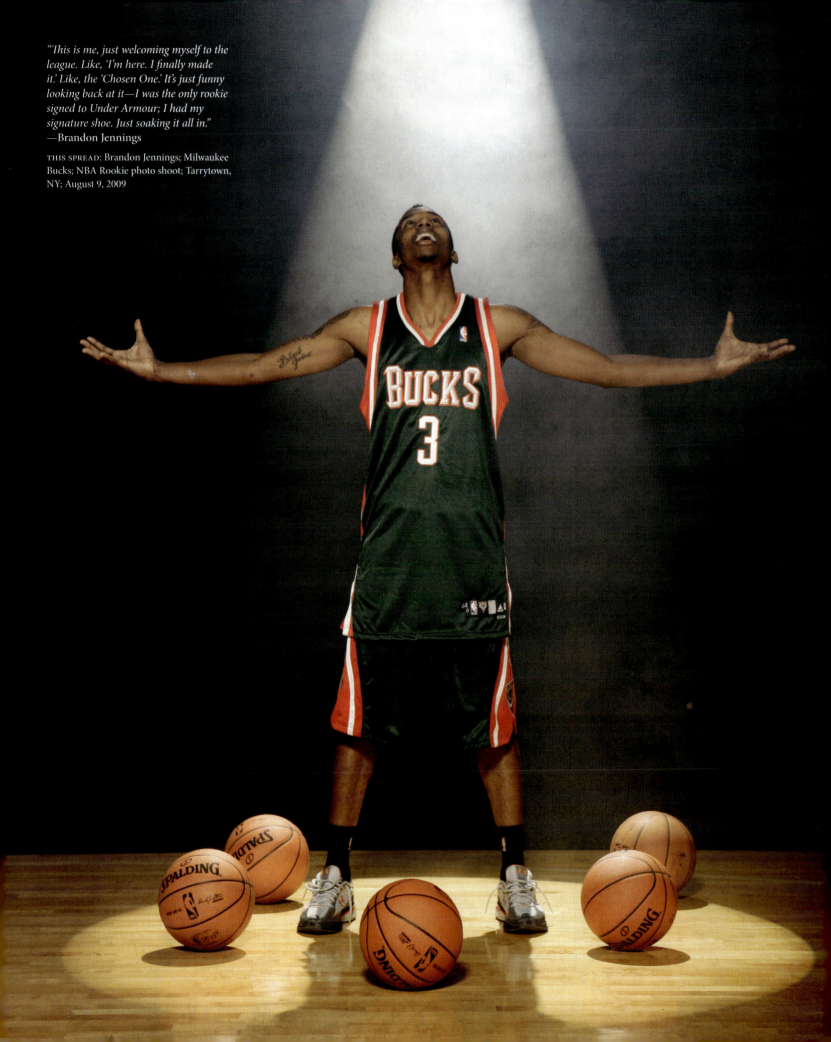

"This is me, just welcoming myself to the league. Like, 'I'm here. I finally made it.' Like, the 'Chosen One.' It's just funny looking back at it—I was the only rookie signed to Under Armour; I had my signature shoe. Just soaking it all in."
—Brandon Jennings

THIS SPREAD: Brandon Jennings; Milwaukee Bucks; NBA Rookie photo shoot; Tarrytown, NY; August 9, 2009

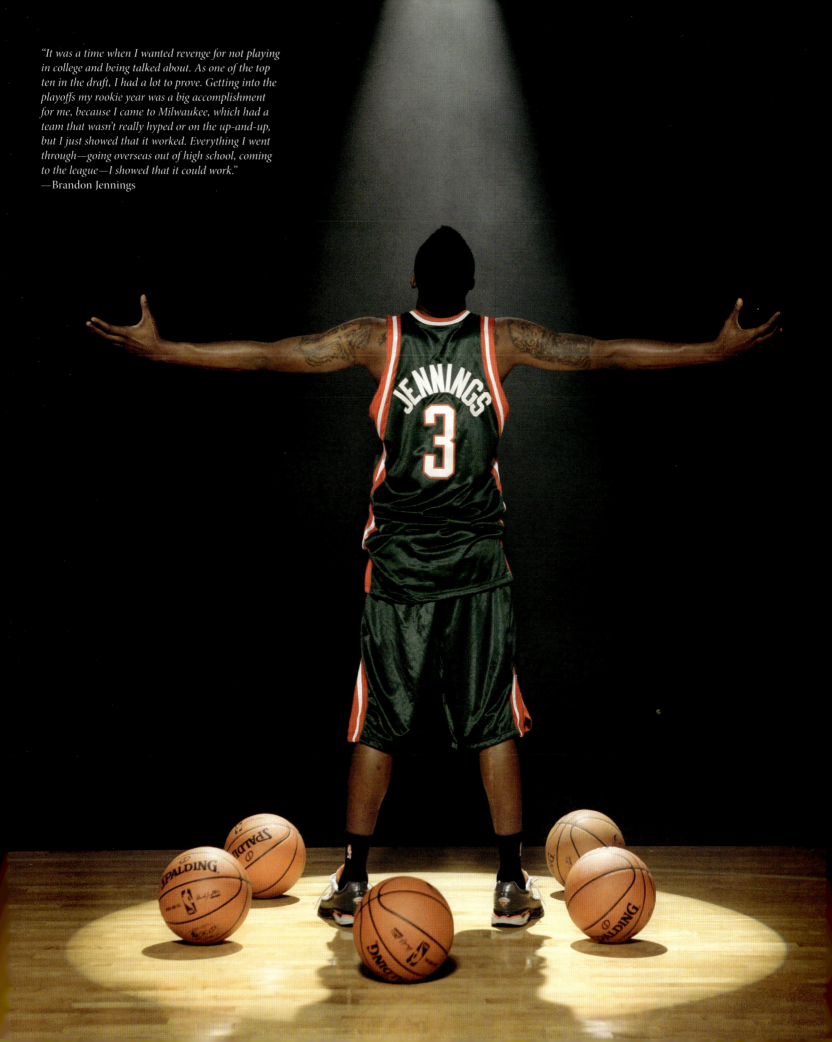

"It was a time when I wanted revenge for not playing in college and being talked about. As one of the top ten in the draft, I had a lot to prove. Getting into the playoffs my rookie year was a big accomplishment for me, because I came to Milwaukee, which had a team that wasn't really hyped or on the up-and-up, but I just showed that it worked. Everything I went through—going overseas out of high school, coming to the league—I showed that it could work."
—Brandon Jennings

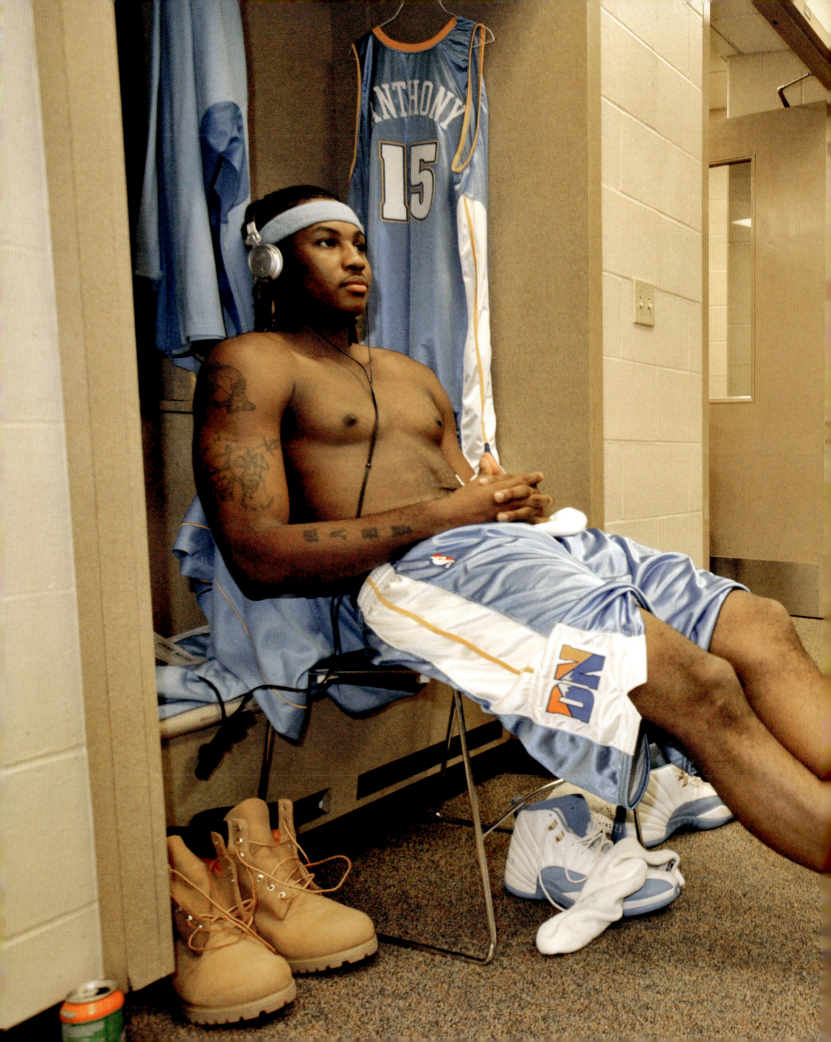

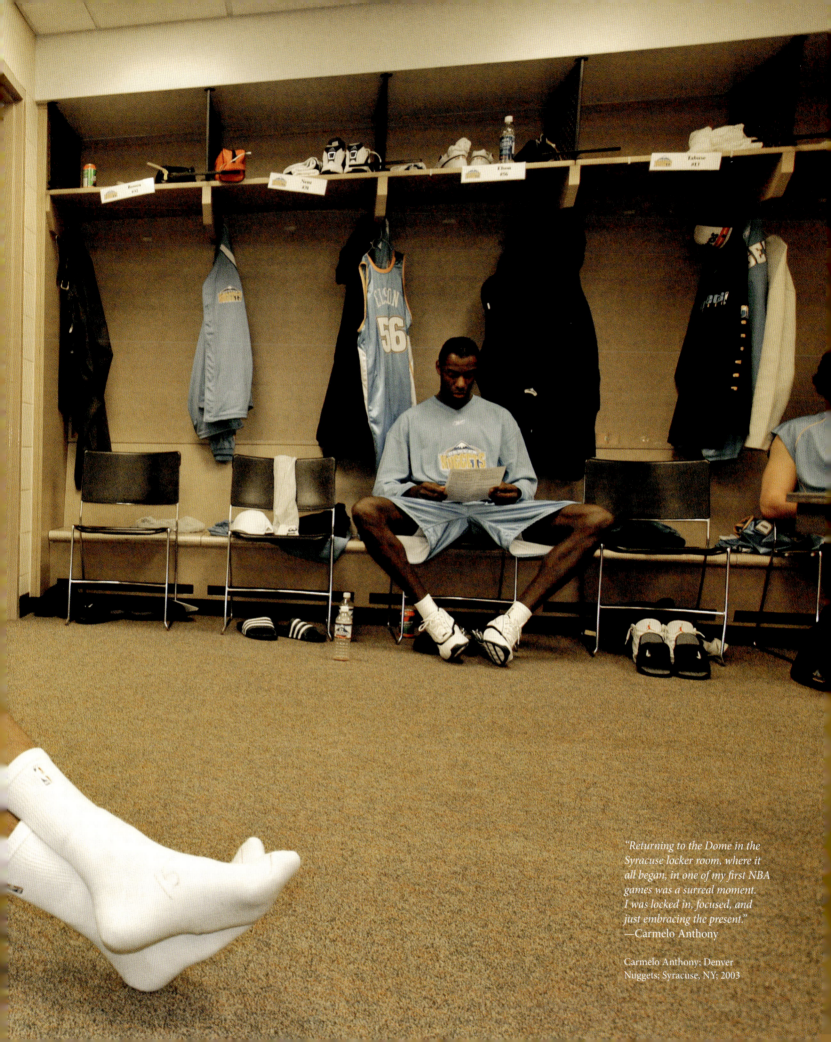

"Returning to the Dome in the Syracuse locker room, where it all began, in one of my first NBA games was a surreal moment. I was locked in, focused, and just embracing the present."
—Carmelo Anthony

Carmelo Anthony; Denver Nuggets; Syracuse, NY; 2003

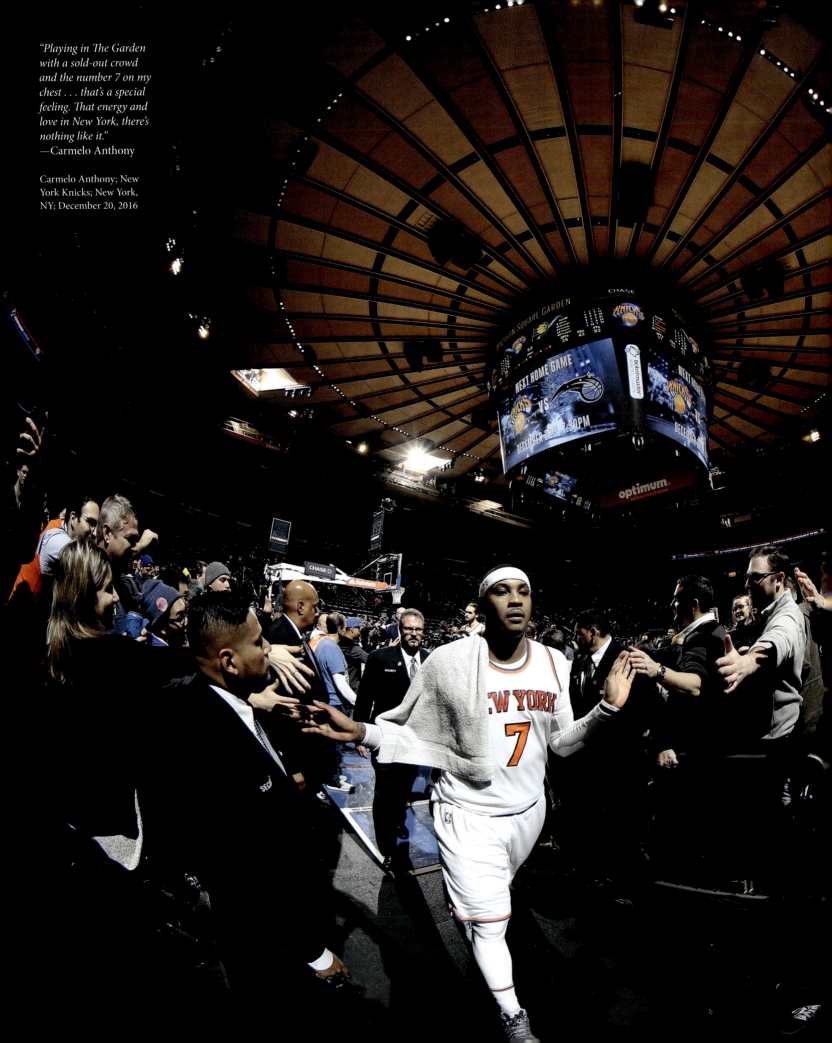

"Playing in The Garden with a sold-out crowd and the number 7 on my chest... that's a special feeling. That energy and love in New York, there's nothing like it."
—Carmelo Anthony

Carmelo Anthony; New York Knicks; New York, NY; December 20, 2016

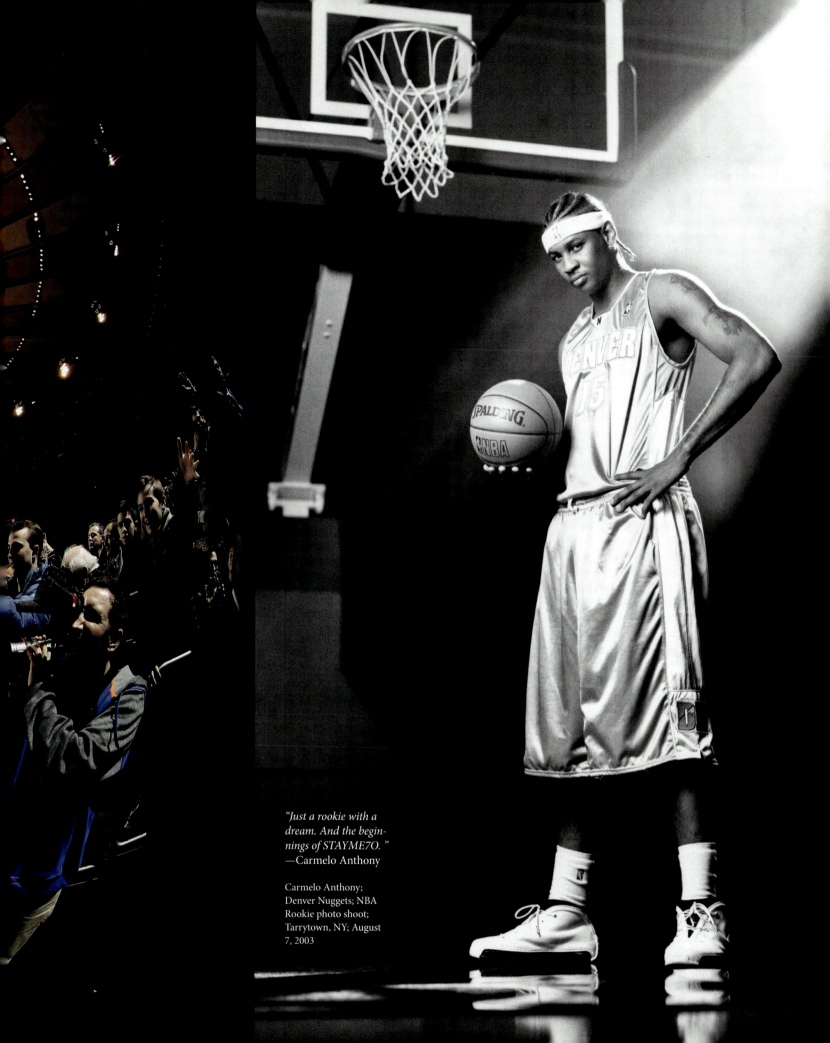

"Just a rookie with a dream. And the beginnings of STAYME7O."
—Carmelo Anthony

Carmelo Anthony; Denver Nuggets; NBA Rookie photo shoot; Tarrytown, NY; August 7, 2003

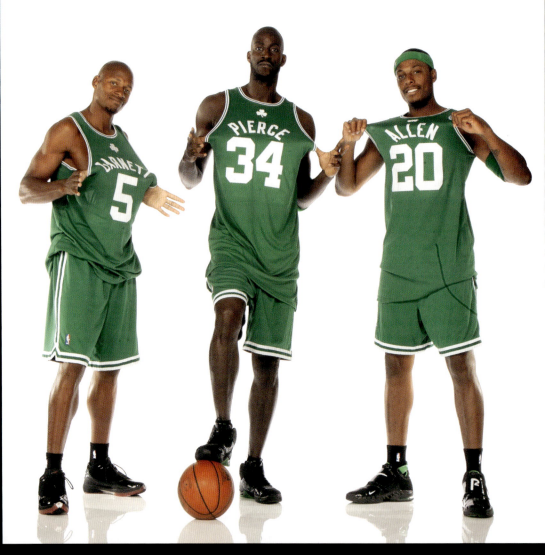

"Sports Illustrated *set the precedent for how you look at athletes. That was the sports bible. It went to the next level of amplifying the muscles, the fibers, and what made us professionals. And it separated us from the regular athlete. When you made* Sports Illustrated, *it was like, you that dude. You that girl. You feel me? And it made athletes look, no weird shit, but it made us look sexy."*
—Kevin Garnett

"If you've made the cover of Sports Illustrated, *you've made it. You're cracking."* —Paul Pierce

ABOVE: Ray Allen, Kevin Garnett, and Paul Pierce; Boston Celtics; Celtics Media Day; Waltham, MA; September 10, 2007

Paul Pierce: *"This is when we emulated The Beatles."*
Kevin Garnett: *"Wait . . . The C-eatles."*
Pierce: *"This is when we called ourselves 'The C-eatles.' Ray took that to Miami, by the way. Because they started calling themselves 'The Heatles.' You know that, right?"*
Garnett: *"He stole our shit, dawg?"*
Pierce: *"They took that. You all know that, right?"*
Garnett: *"Wow. Learn something every day."*

OPPOSITE: Kevin Garnett, Paul Pierce, and Ray Allen; Boston Celtics; Celtics Media Day; Waltham, MA; September 10, 2007

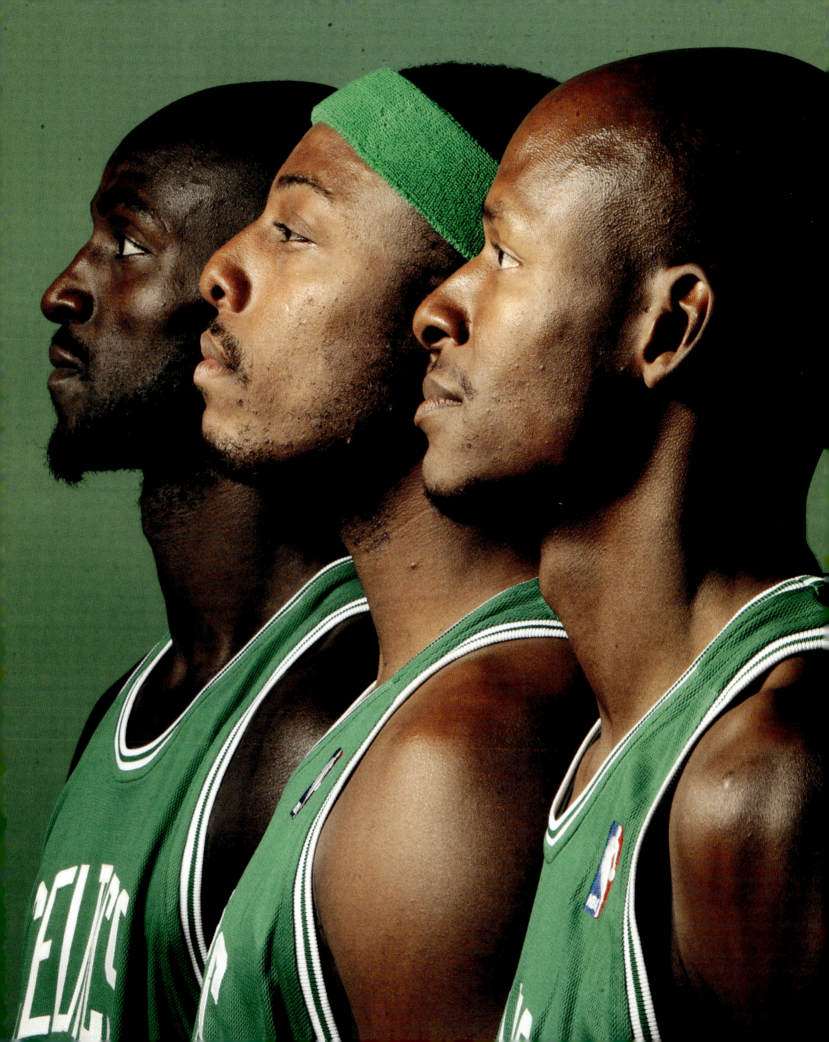

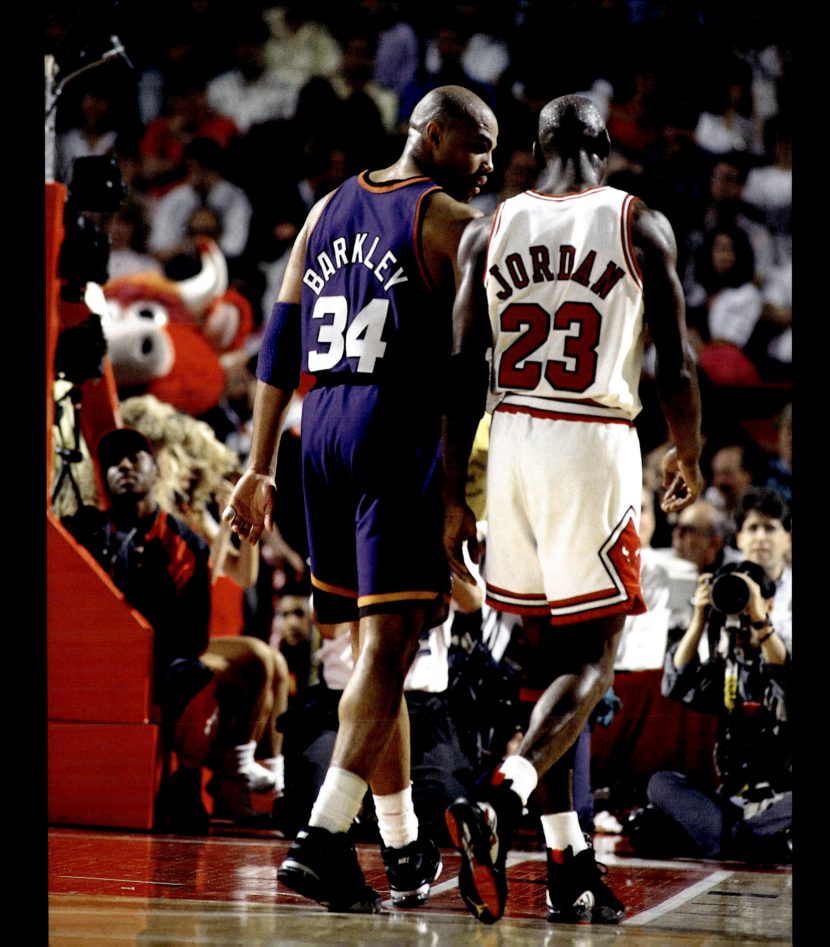

OPPOSITE: Charles Barkley; Phoenix Suns vs. Chicago Bulls; Game 5 of the NBA Finals; Chicago, IL; June 18, 1993

Charles Barkley; Philadelphia 76ers vs. Chicago Bulls; Philadelphia, PA; 1991

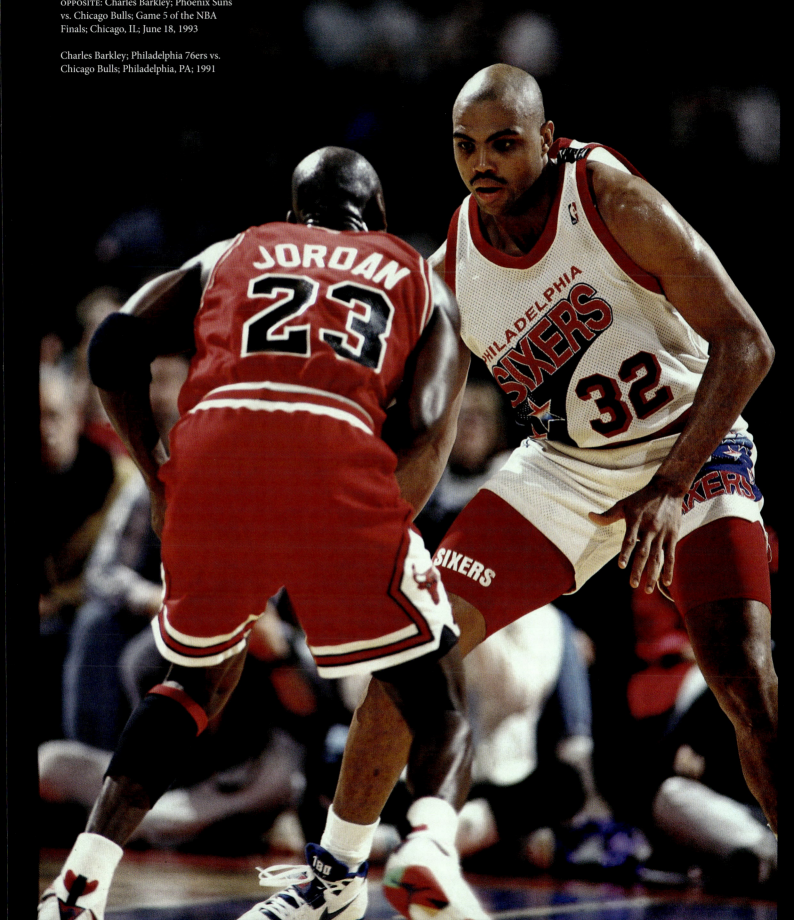

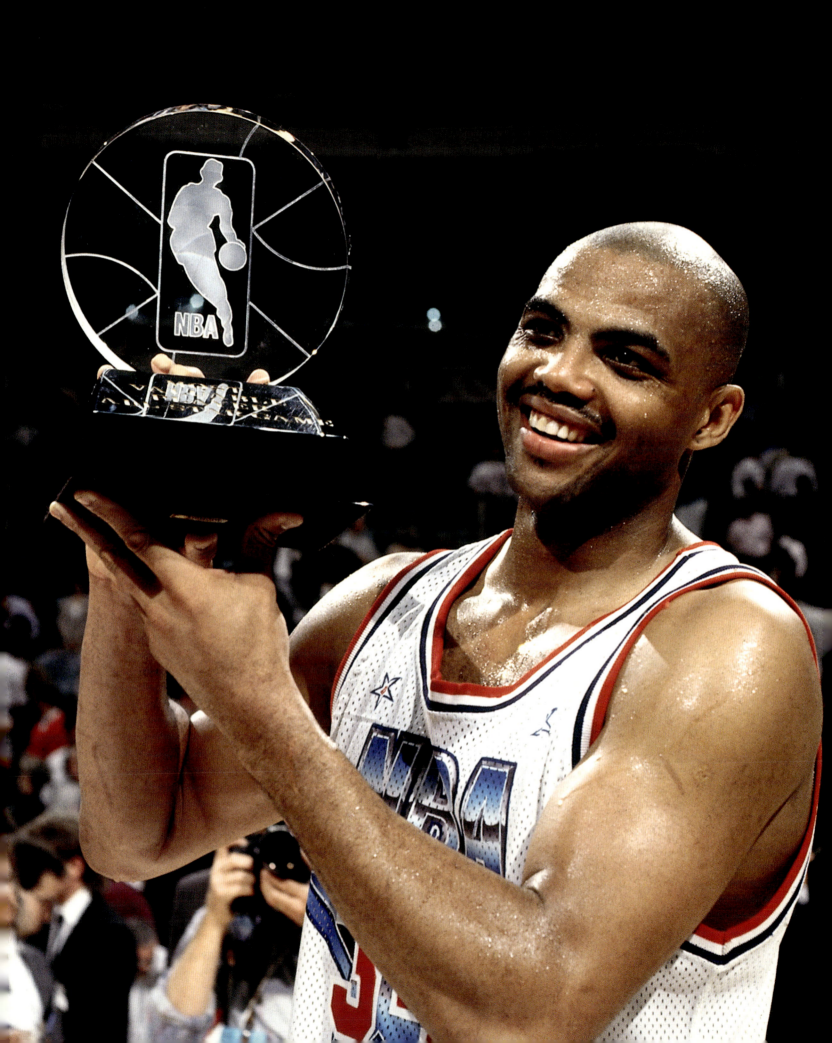

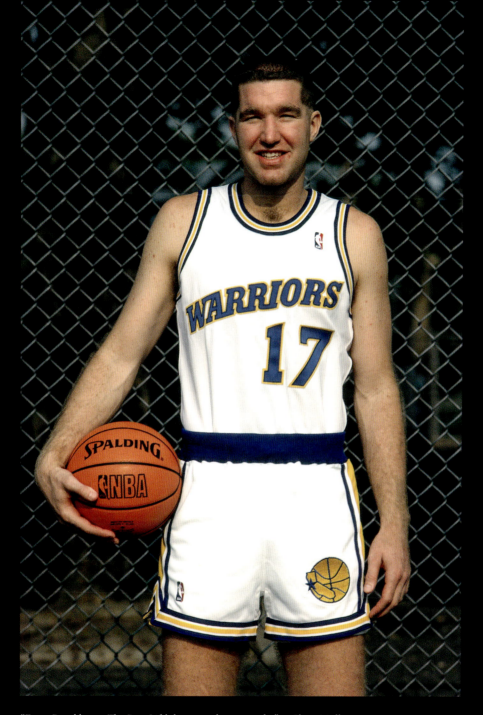

"From Brooklyn to The Bay. Life's been good to me so far." —Chris Mullin

ABOVE: Chris Mullin; Golden State Warriors; Jamaica, NY; 1986

OPPOSITE: Charles Barkley; All-Star Game MVP; Charlotte, NC; February 10, 1991

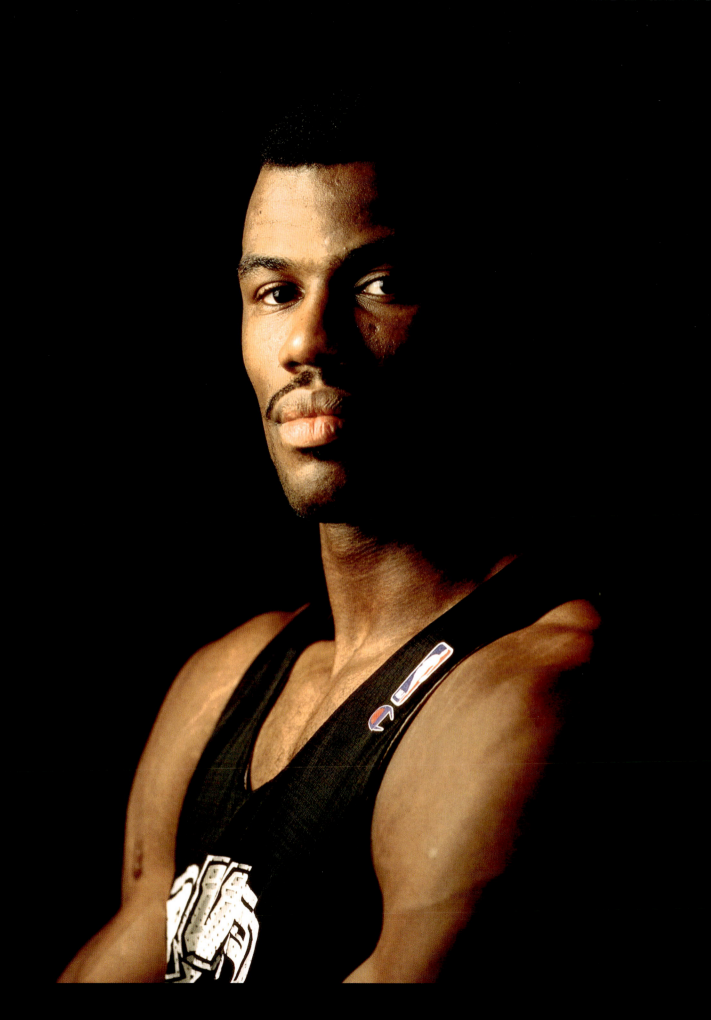

David Robinson; San Antonio
Spurs; San Antonio, TX; 1996

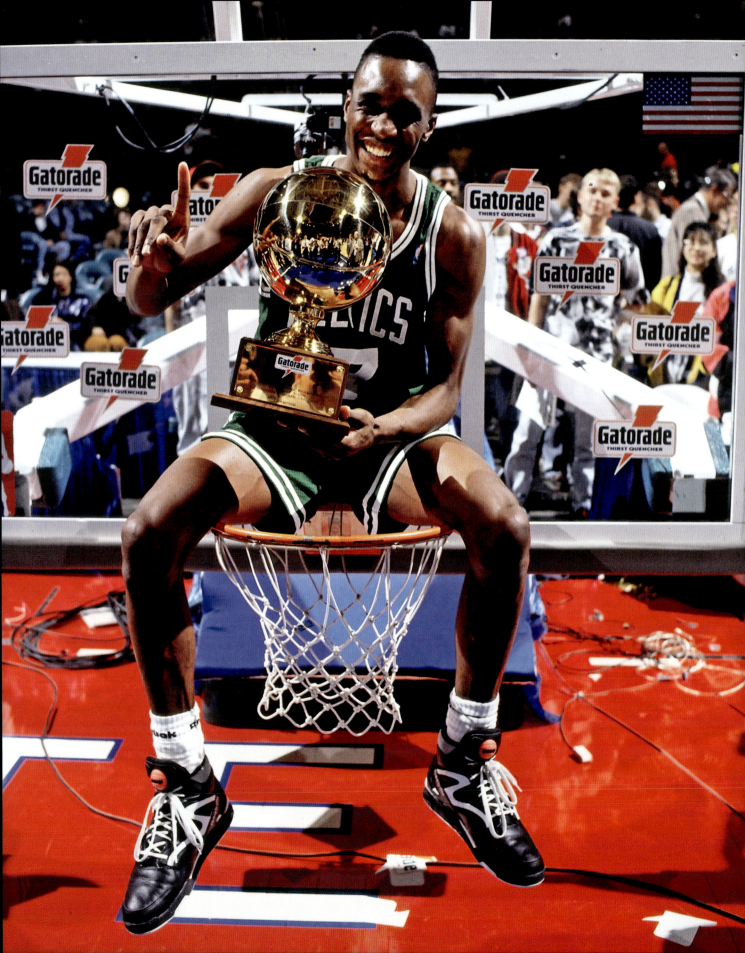

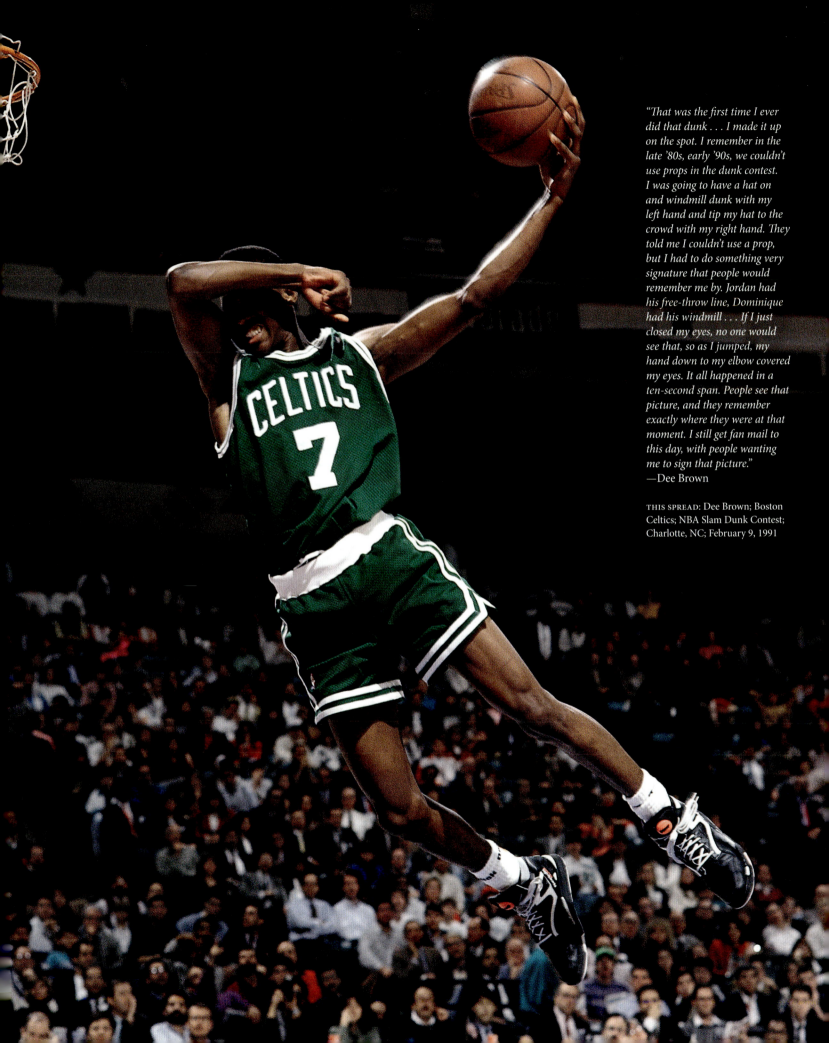

"That was the first time I ever did that dunk... I made it up on the spot. I remember in the late '80s, early '90s, we couldn't use props in the dunk contest. I was going to have a hat on and windmill dunk with my left hand and tip my hat to the crowd with my right hand. They told me I couldn't use a prop, but I had to do something very signature that people would remember me by. Jordan had his free-throw line, Dominique had his windmill... If I just closed my eyes, no one would see that, so as I jumped, my hand down to my elbow covered my eyes. It all happened in a ten-second span. People see that picture, and they remember exactly where they were at that moment. I still get fan mail to this day, with people wanting me to sign that picture."
—Dee Brown

THIS SPREAD: Dee Brown; Boston Celtics; NBA Slam Dunk Contest; Charlotte, NC; February 9, 1991

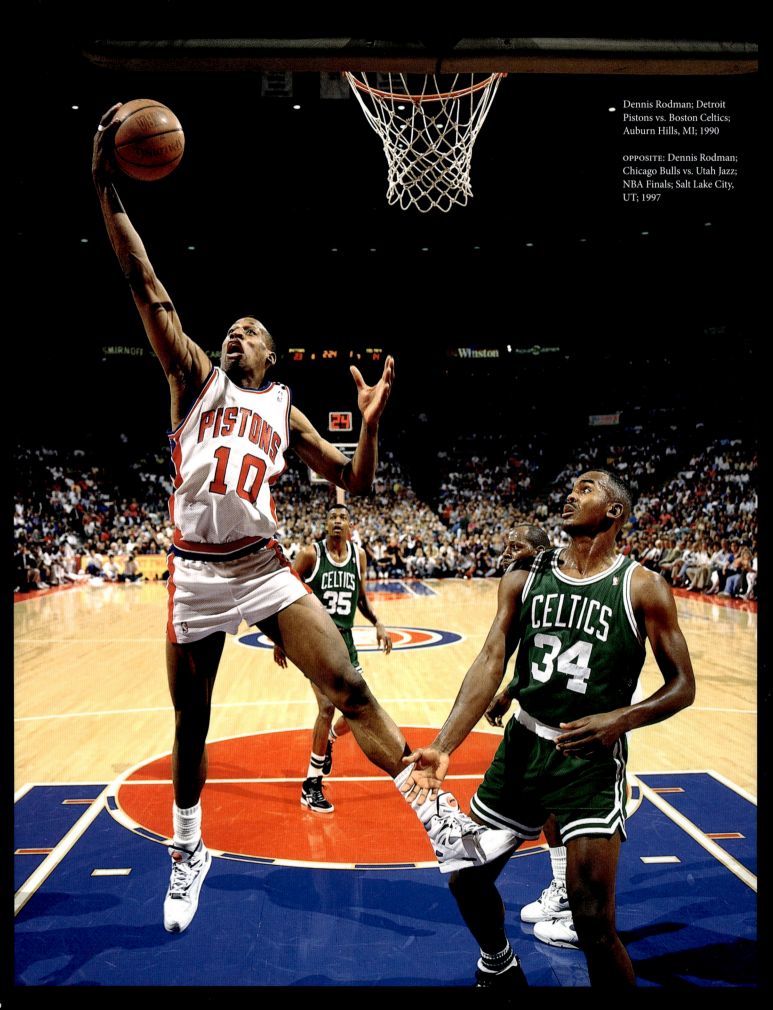

Dennis Rodman; Detroit Pistons vs. Boston Celtics; Auburn Hills, MI; 1990

OPPOSITE: Dennis Rodman; Chicago Bulls vs. Utah Jazz; NBA Finals; Salt Lake City, UT; 1997

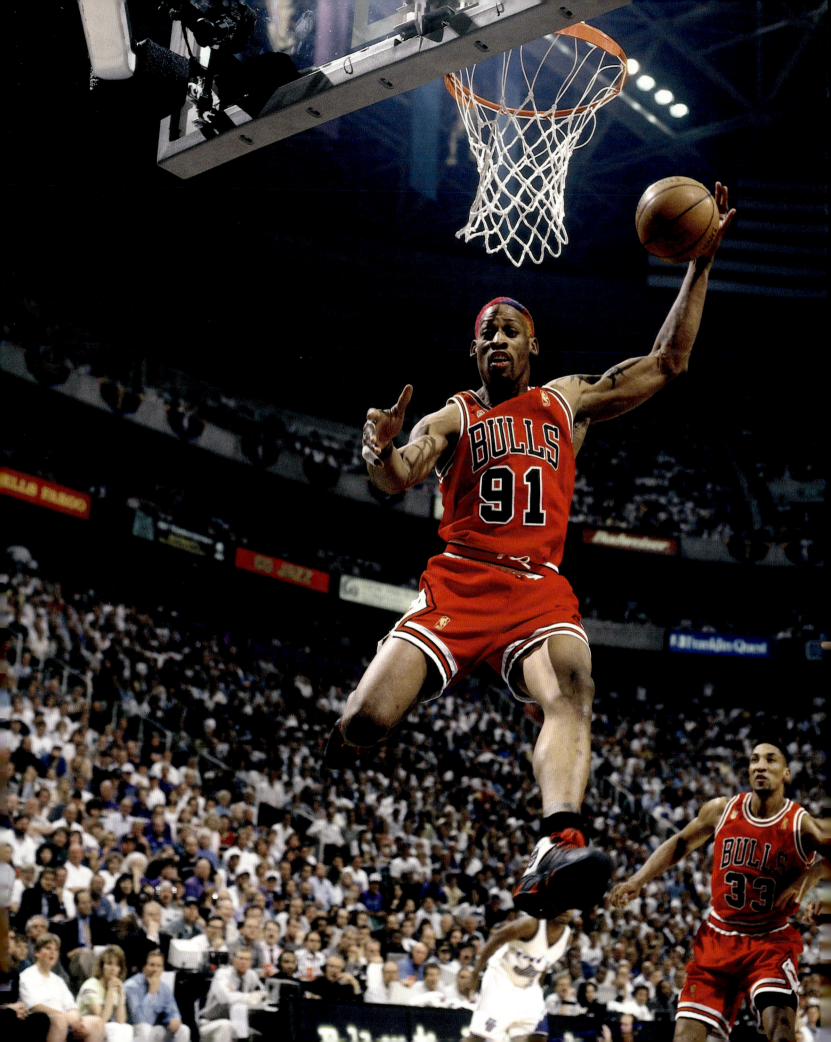

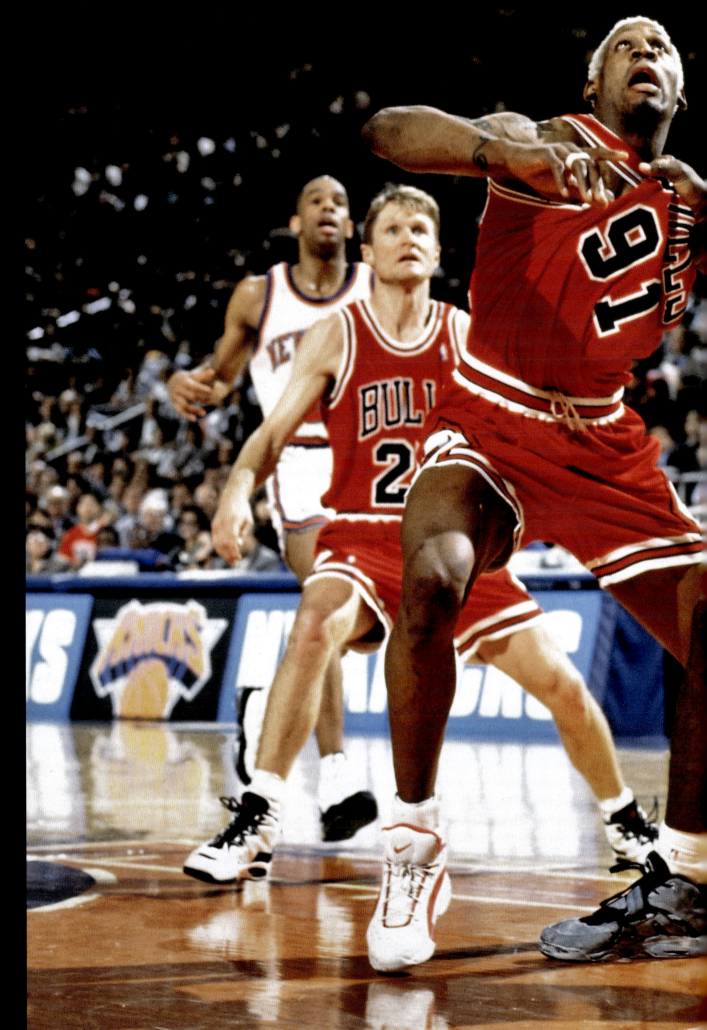

"Me and Dennis Rodman, we went at it on the court. He had energy like no other guy I played against. It was a battle every time I saw him. It was good, hard basketball when I played Dennis. He got crazy with some other guys, but he didn't get crazy with me. Point blank."
—Charles Oakley

Dennis Rodman and Charles Oakley; Chicago Bulls vs. New York Knicks; New York, NY; 1996

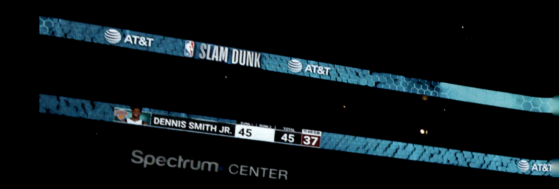

"We're from Fayetteville, and we came out to Charlotte. I was participating in the dunk contest and J. Cole had a halftime performance. I had him as part of my dunk contest, so it's like Fayetteville to the world—basketball, Fayetteville, and music. We both major in all three subjects. That's my brother."
—Dennis Smith Jr.

Dennis Smith Jr. and J. Cole; NBA Slam Dunk Contest; Charlotte, NC; February 16, 2019

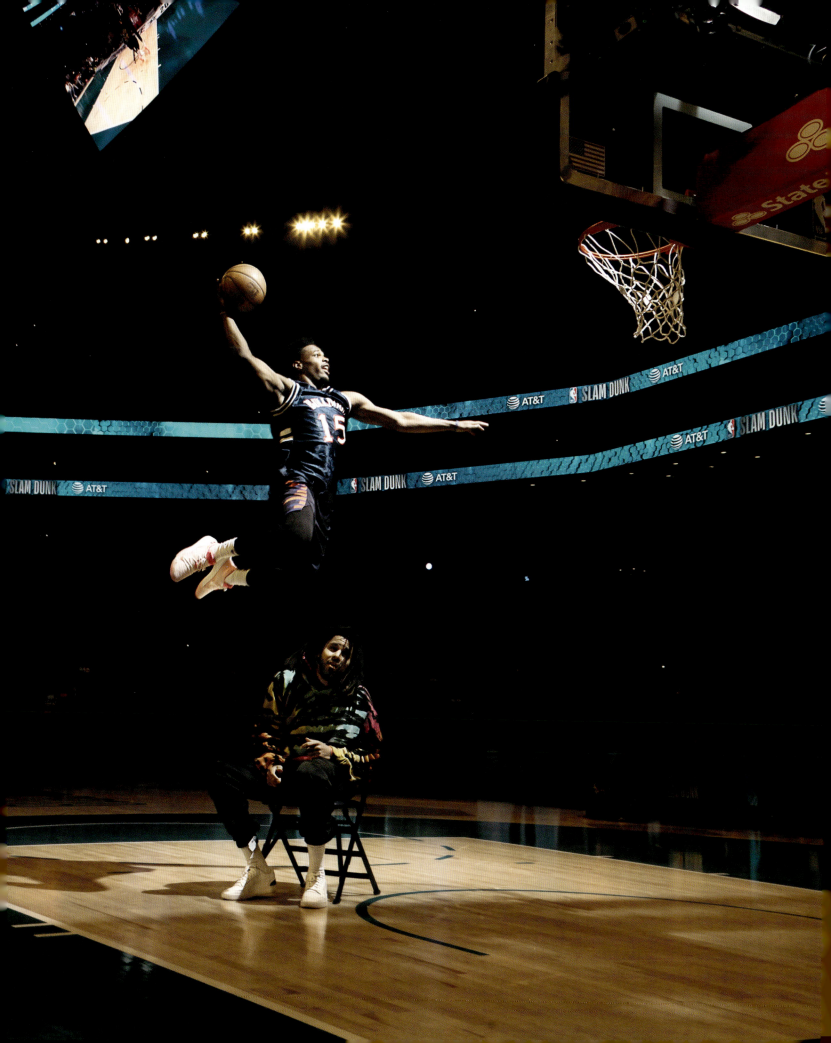

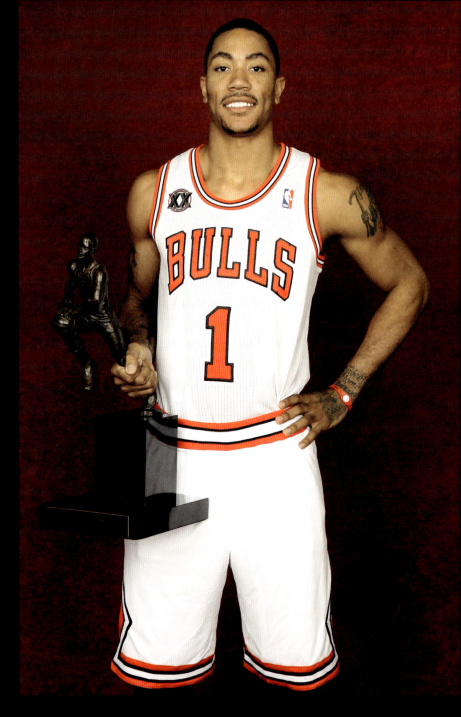

"I should have cherished it a little bit more. Whenever I looked at those photos, I always kept it to myself. K.I.M.—keep it moving. That's what me and my agent always said, but looking back, those are times I probably should have soaked in a little bit more." —Derrick Rose

ABOVE: Derrick Rose; Chicago Bulls MVP Award; Chicago, IL; May 3, 2011—becomes the youngest MVP in NBA history

"That was the first time I ever took pictures on top of a mirror, but it came out in an opulent, lavish way. And everybody tries to remake that photo whenever I go to different teams, but it's hard because Nat was the first. I love that photo." —Derrick Rose

OPPOSITE: Derrick Rose; Chicago Bulls; NBA Rookie photo shoot; Tarrytown, NY; July 29, 2008

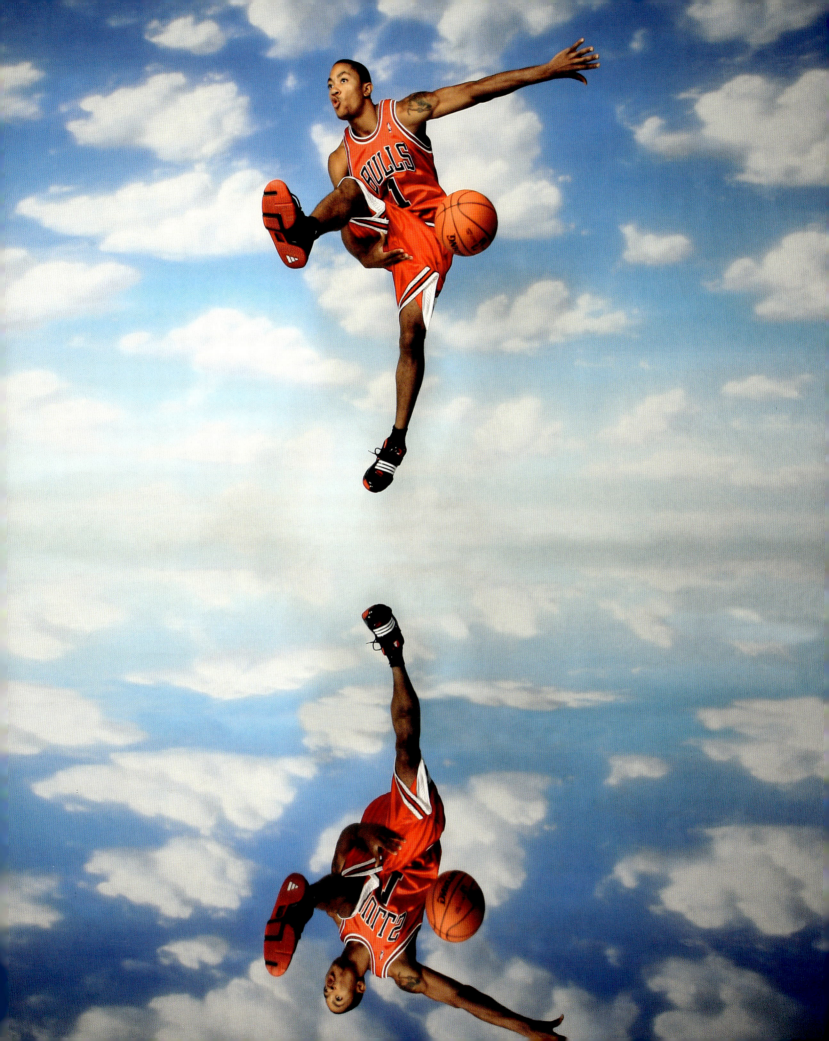

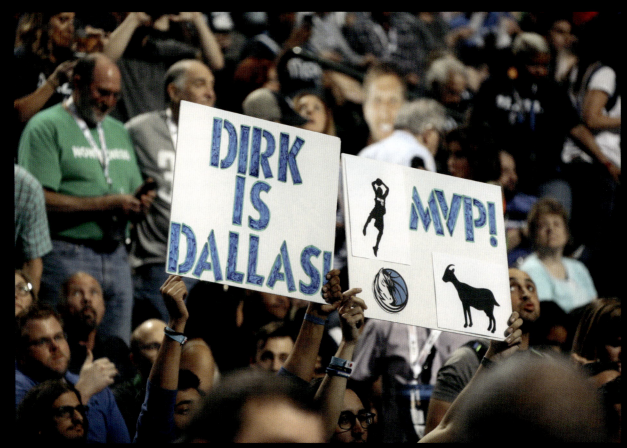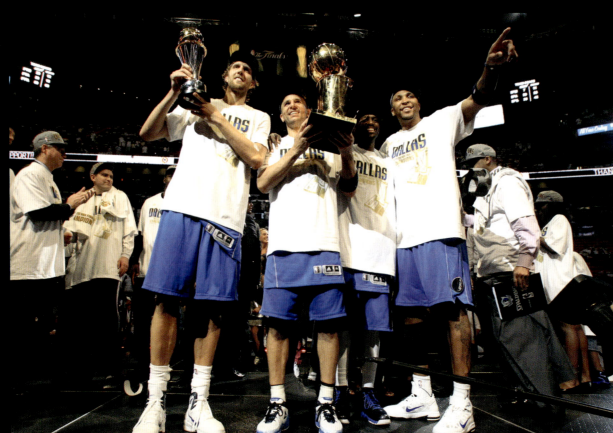

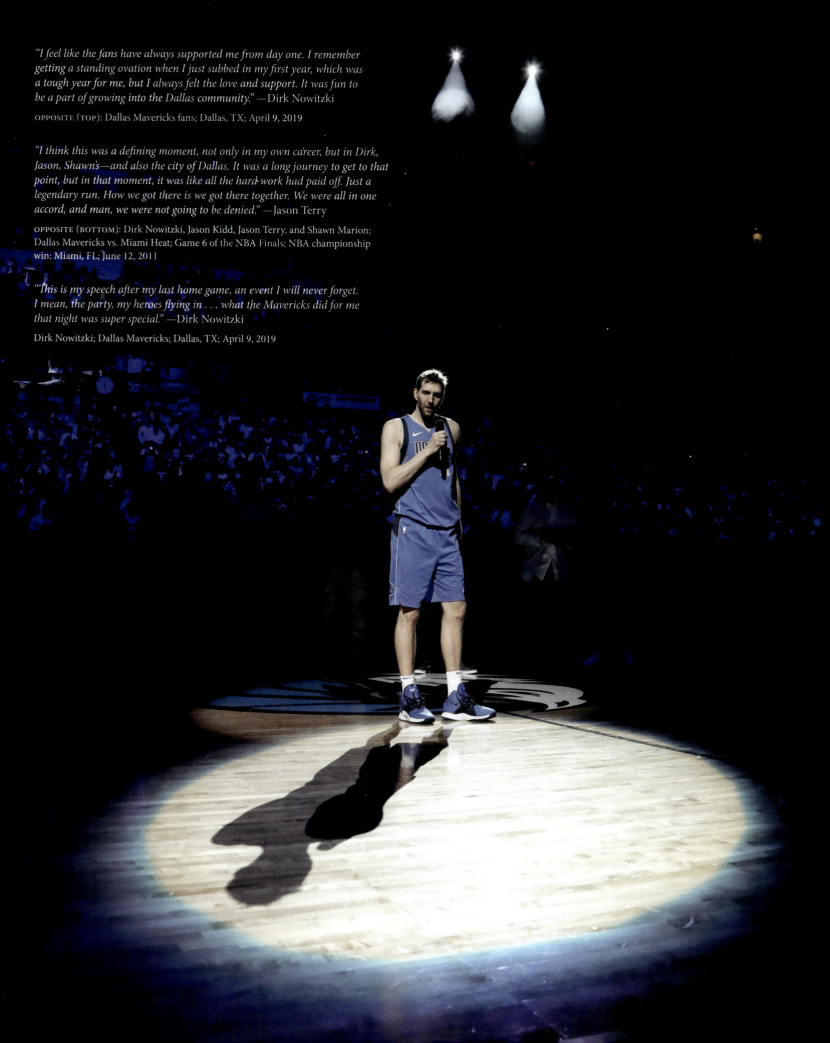

"I feel like the fans have always supported me from day one. I remember getting a standing ovation when I just subbed in my first year, which was a tough year for me, but I always felt the love and support. It was fun to be a part of growing into the Dallas community." —Dirk Nowitzki

OPPOSITE (TOP): Dallas Mavericks fans; Dallas, TX; April 9, 2019

"I think this was a defining moment, not only in my own career, but in Dirk, Jason, Shawn's—and also the city of Dallas. It was a long journey to get to that point, but in that moment, it was like all the hard work had paid off. Just a legendary run. How we got there is we got there together. We were all in one accord, and man, we were not going to be denied." —Jason Terry

OPPOSITE (BOTTOM): Dirk Nowitzki, Jason Kidd, Jason Terry, and Shawn Marion; Dallas Mavericks vs. Miami Heat; Game 6 of the NBA Finals; NBA championship win; Miami, FL; June 12, 2011

"This is my speech after my last home game, an event I will never forget. I mean, the party, my heroes flying in . . . what the Mavericks did for me that night was super special." —Dirk Nowitzki

Dirk Nowitzki; Dallas Mavericks; Dallas, TX; April 9, 2019

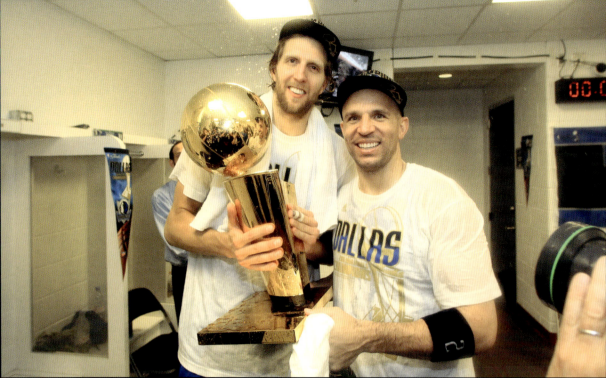

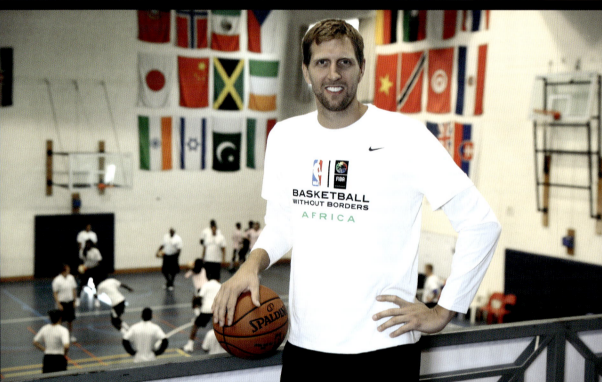

"J-Kidd, that's my guy. What I appreciate about him the most is his almost stubborn competitiveness. And all the things that he did for the team. All the little things that don't show up on a stat sheet. He was a warrior and a big part of us winning the championship. We will always have a bond and a friendship." —Dirk Nowitzki

"This is me in Johannesburg for Basketball Without Borders. I'm from Germany; I grew up playing international ball, and the NBA has done a fantastic job over the last twenty years of growing the sport outside of the US. And now it's a truly global sport." —Dirk Nowitzki

TOP: Dirk Nowitzki and Jason Kidd; Dallas Mavericks vs. Miami Heat; Game 6 of the NBA Finals; NBA championship win; Miami, FL; June 12, 2011

ABOVE: Dirk Nowitzki; Dallas Mavericks; Basketball Without Borders; Johannesburg, South Africa; August 3, 2017

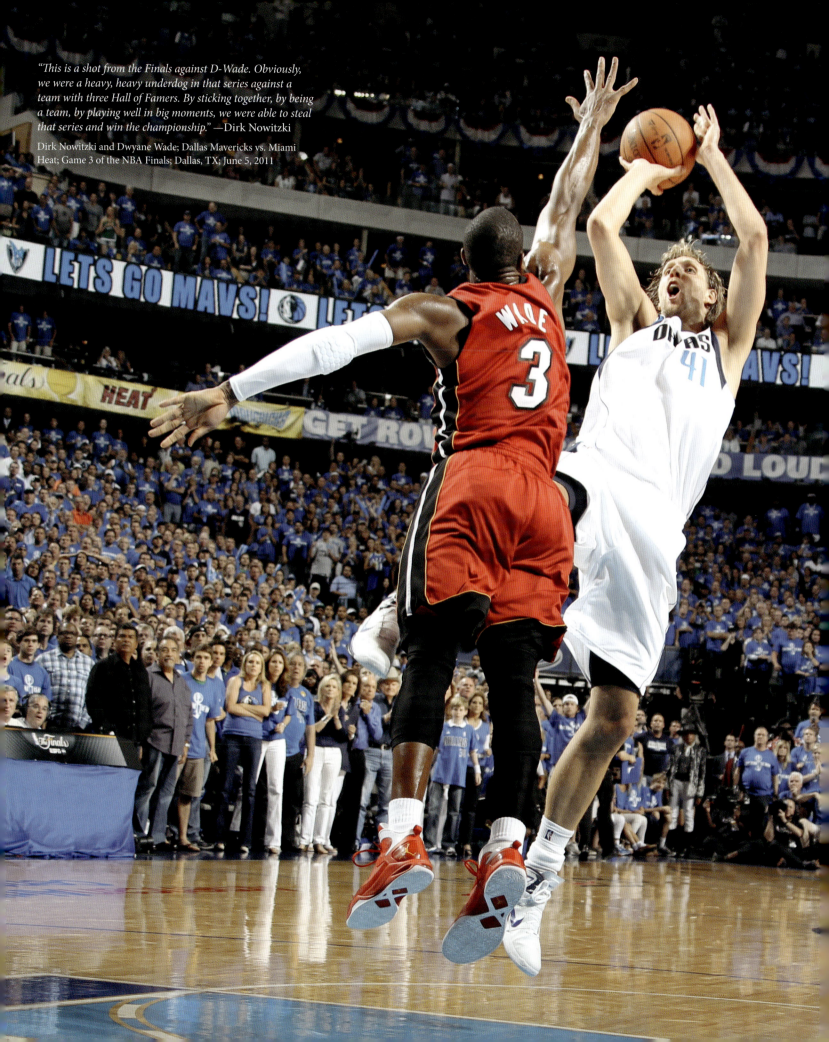

"This is a shot from the Finals against D-Wade. Obviously, we were a heavy, heavy underdog in that series against a team with three Hall of Famers. By sticking together, by being a team, by playing well in big moments, we were able to steal that series and win the championship." —Dirk Nowitzki

Dirk Nowitzki and Dwyane Wade; Dallas Mavericks vs. Miami Heat; Game 3 of the NBA Finals; Dallas, TX; June 5, 2011

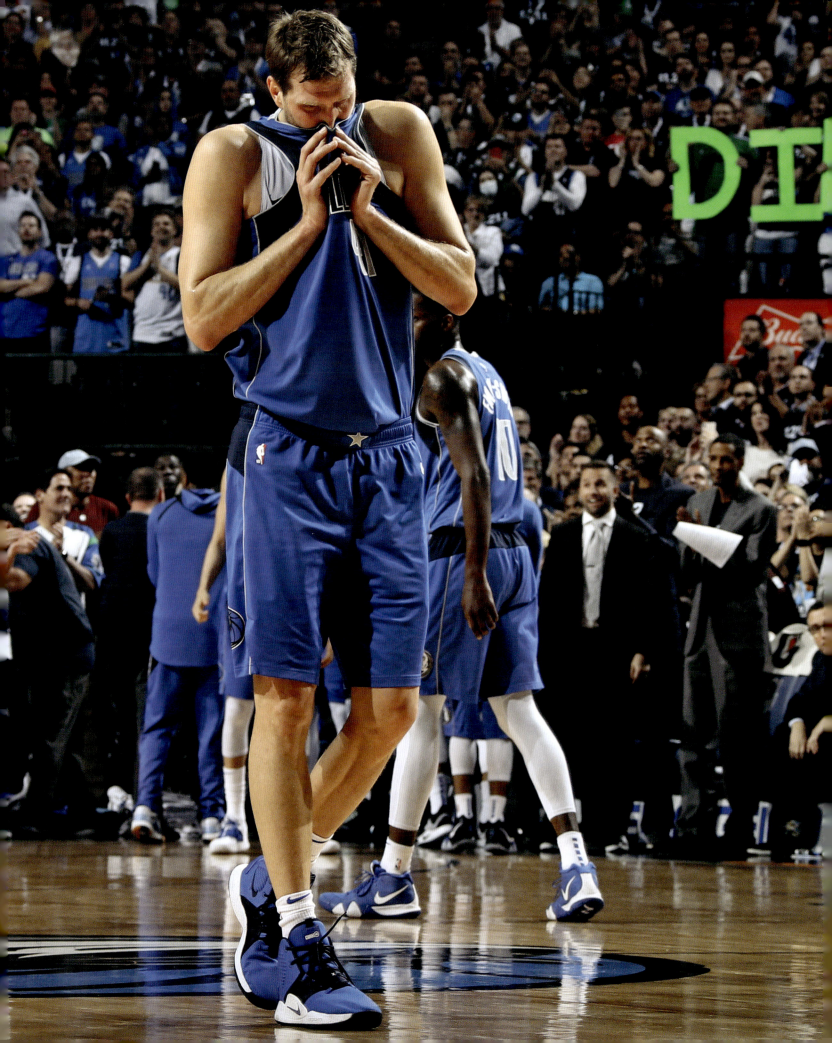

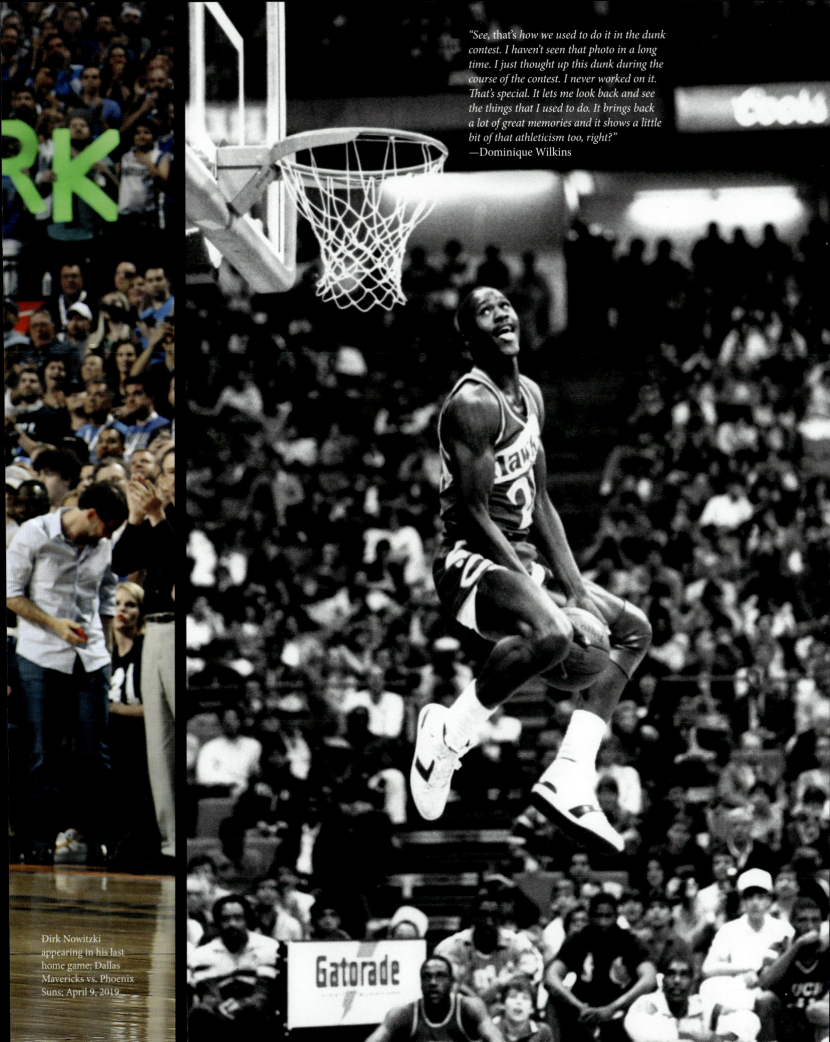

"See, that's *how we used to do it in the dunk contest. I haven't seen that photo in a long time. I just thought up this dunk during the course of the contest. I never worked on it. That's special. It lets me look back and see the things that I used to do. It brings back a lot of great memories and it shows a little bit of that athleticism too, right?"*
—Dominique Wilkins

Dirk Nowitzki appearing in his last home game; Dallas Mavericks vs. Phoenix Suns; April 9, 2019

PREVIOUS PAGE: Dominique Wilkins; Atlanta Hawks; NBA Slam Dunk Contest; Dallas, TX; February 8, 1986

"I think that dunk kind of put me on the map as 'Spida.' I wasn't even supposed to be in the dunk contest. To go from that to winning it kind of put my nickname out there. That's huge. My guy Nat—he's taken different photos of me, and he continues to take a bunch. I appreciate him. That one in particular was the start of the nickname 'Spida.' I'll never forget that weekend in LA. It was my first All-Star weekend, and to come out with the trophy is huge. I'm forever grateful for that, for Nat to be able to capture that. And the photo itself looks dope, so I appreciate it."
—Donovan Mitchell

RIGHT: Donovan Mitchell; Utah Jazz; NBA Slam Dunk Contest; Los Angeles, CA; February 17, 2018

THIS SPREAD & OVERLEAF: Dražen Petrović; New Jersey Nets; East Rutherford, NJ; 1991

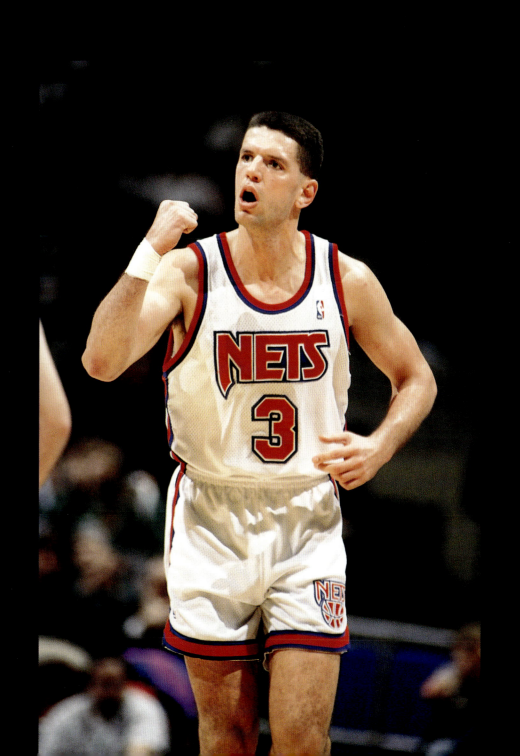

"I loved photographing Dražen. This was when he had been on the Nets for two years. I went to his apartment, and he literally had a couch, a TV, and a mattress on the floor in his bedroom. He spent all of his time at the practice facility."
—Nathaniel S. Butler

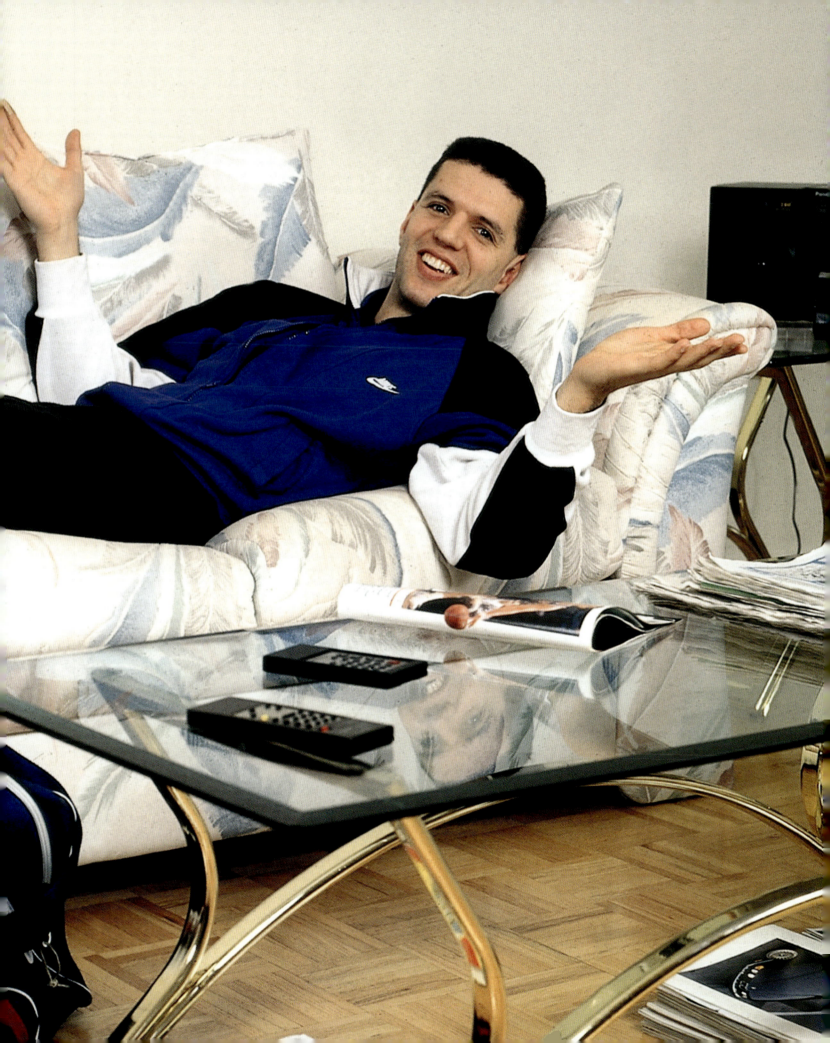

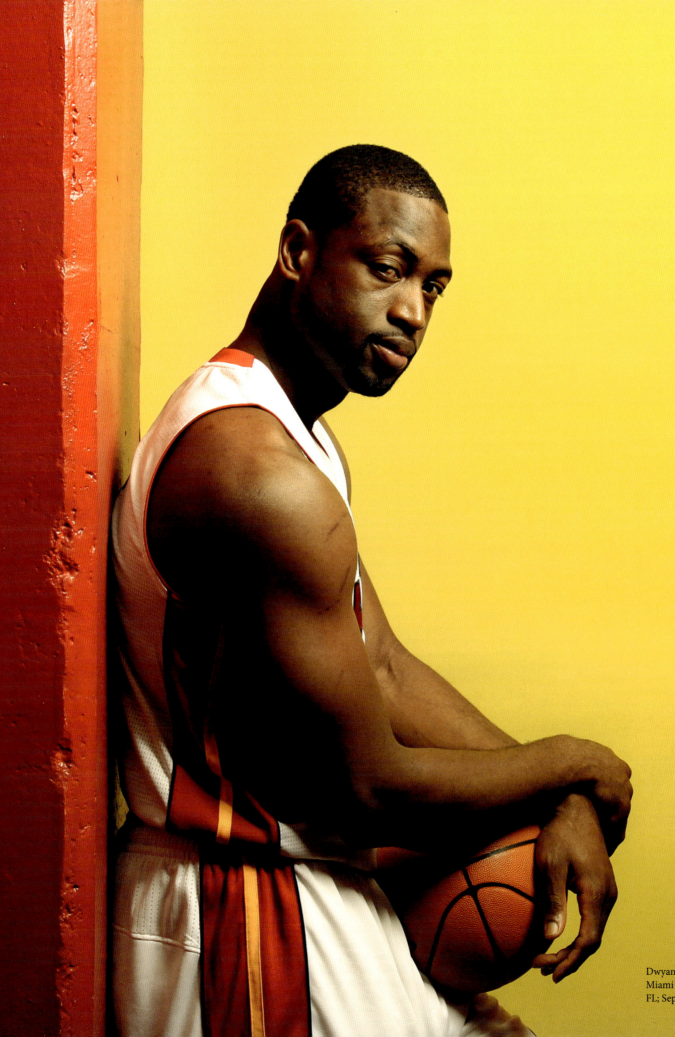

Dwyane Wade; Miami Heat; Miami Heat Media Day; Miami, FL; September 28, 2012

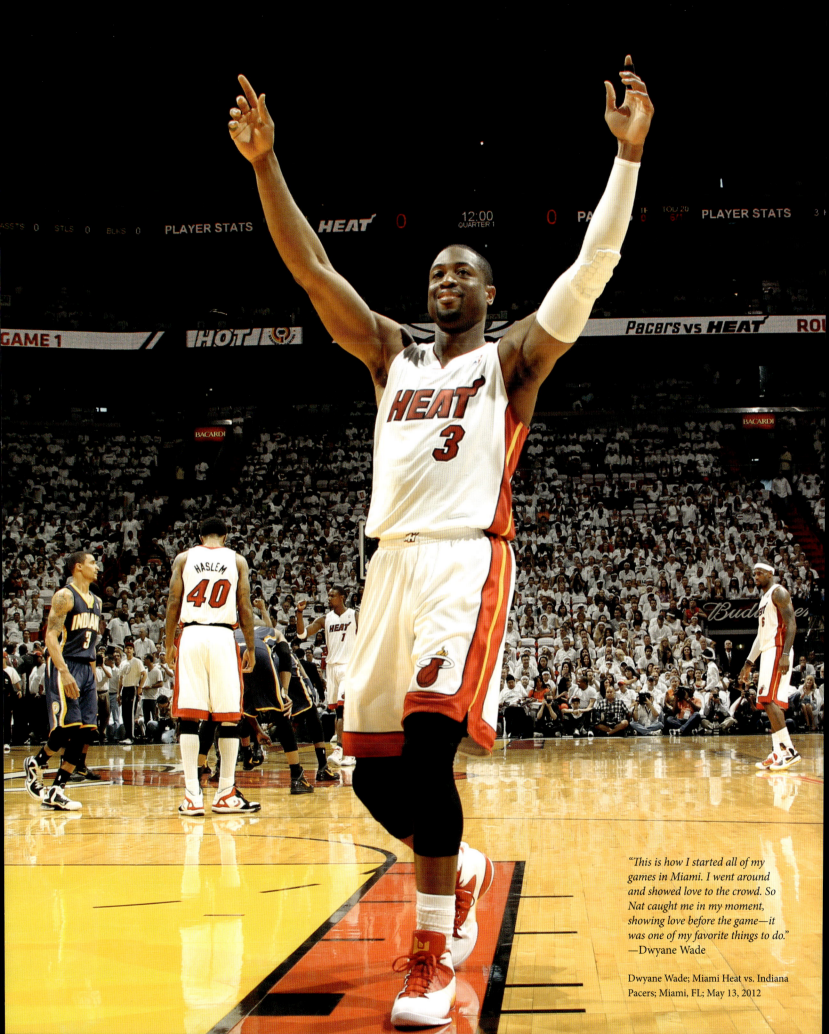

"This is how I started all of my games in Miami. I went around and showed love to the crowd. So Nat caught me in my moment, showing love before the game—it was one of my favorite things to do."
—Dwyane Wade

Dwyane Wade; Miami Heat vs. Indiana Pacers; Miami, FL; May 13, 2012

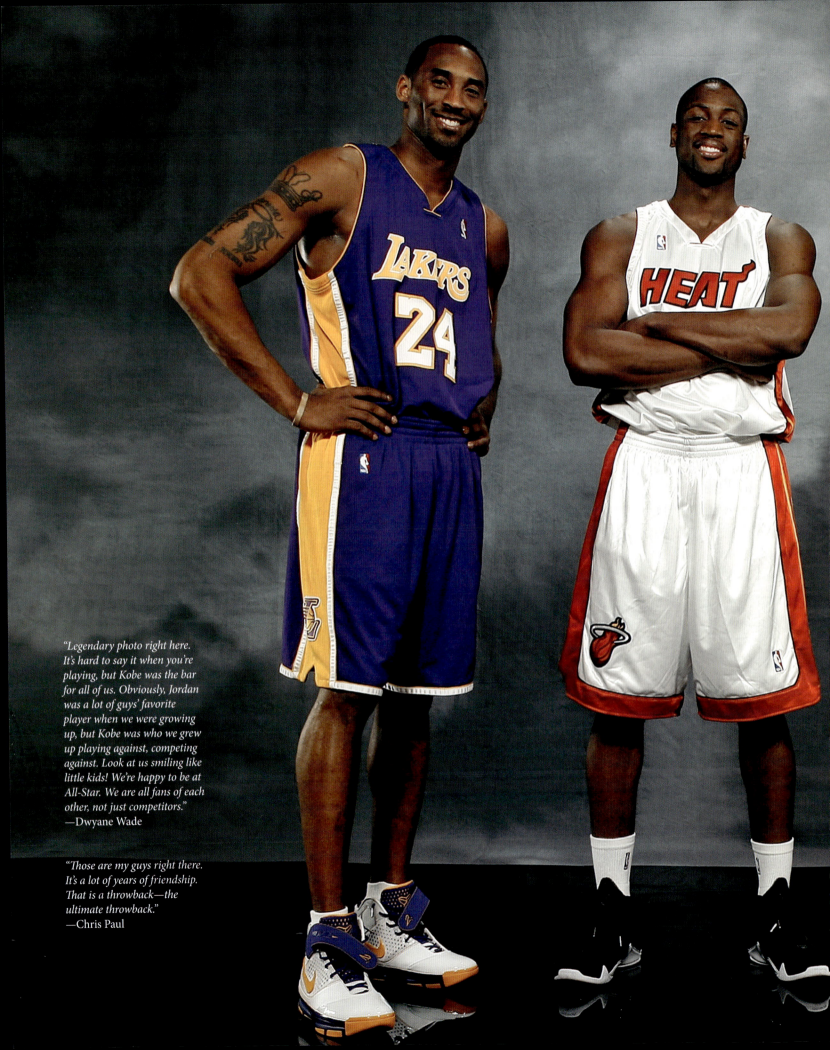

"Legendary photo right here. It's hard to say it when you're playing, but Kobe was the bar for all of us. Obviously, Jordan was a lot of guys' favorite player when we were growing up, but Kobe was who we grew up playing against, competing against. Look at us smiling like little kids! We're happy to be at All-Star. We are all fans of each other, not just competitors."
—Dwyane Wade

"Those are my guys right there. It's a lot of years of friendship. That is a throwback—the ultimate throwback."
—Chris Paul

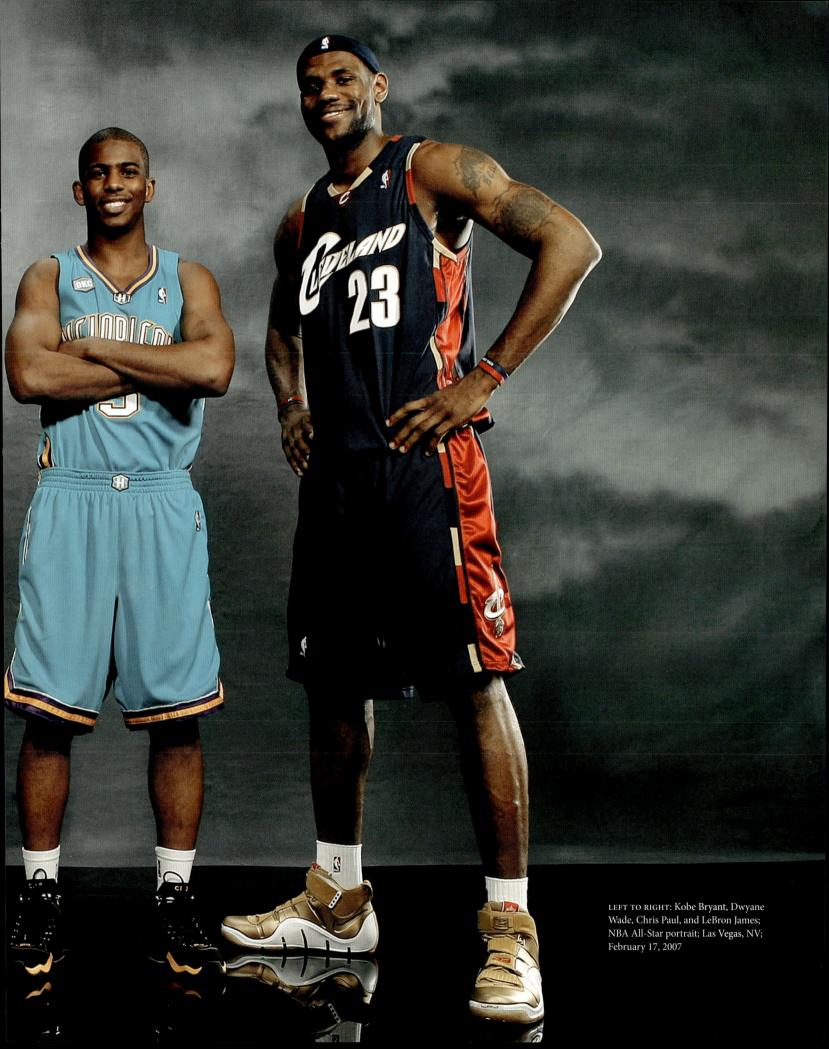

LEFT TO RIGHT: Kobe Bryant, Dwyane Wade, Chris Paul, and LeBron James; NBA All-Star portrait; Las Vegas, NV; February 17, 2007

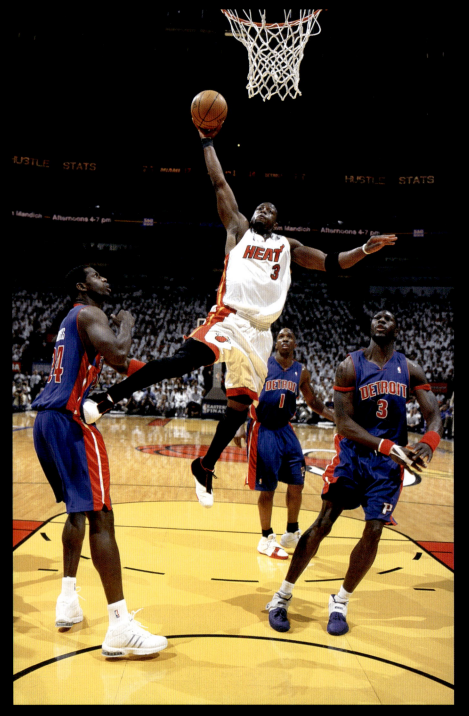

Dwyane Wade; Miami Heat vs. Detroit Pistons; Miami, FL; May 27, 2006

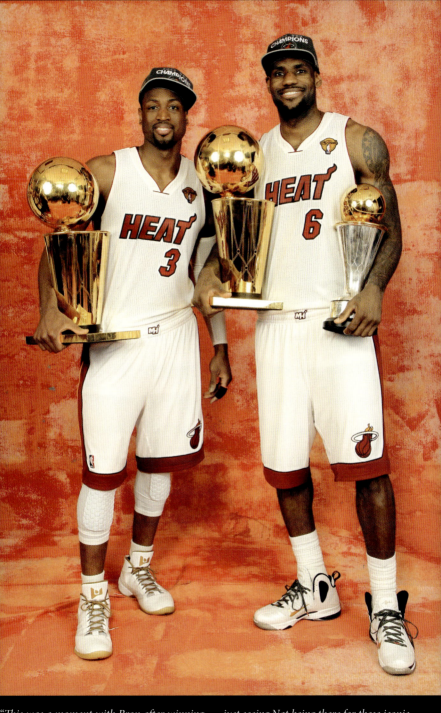

"This was a moment with Bron after winning . . . just seeing Nat being there for these iconic moments, you appreciate it. Especially as an old guy."
—Dwyane Wade

Dwyane Wade and LeBron James; Miami Heat; Game 5 of the NBA Finals; NBA championship win; Miami, FL; June 21, 2012

This game winner was in The Garden, my favorite place to play.
—Dwyane Wade

Dwyane Wade; Miami Heat vs. New York Knicks; New York, NY; March 15, 2005

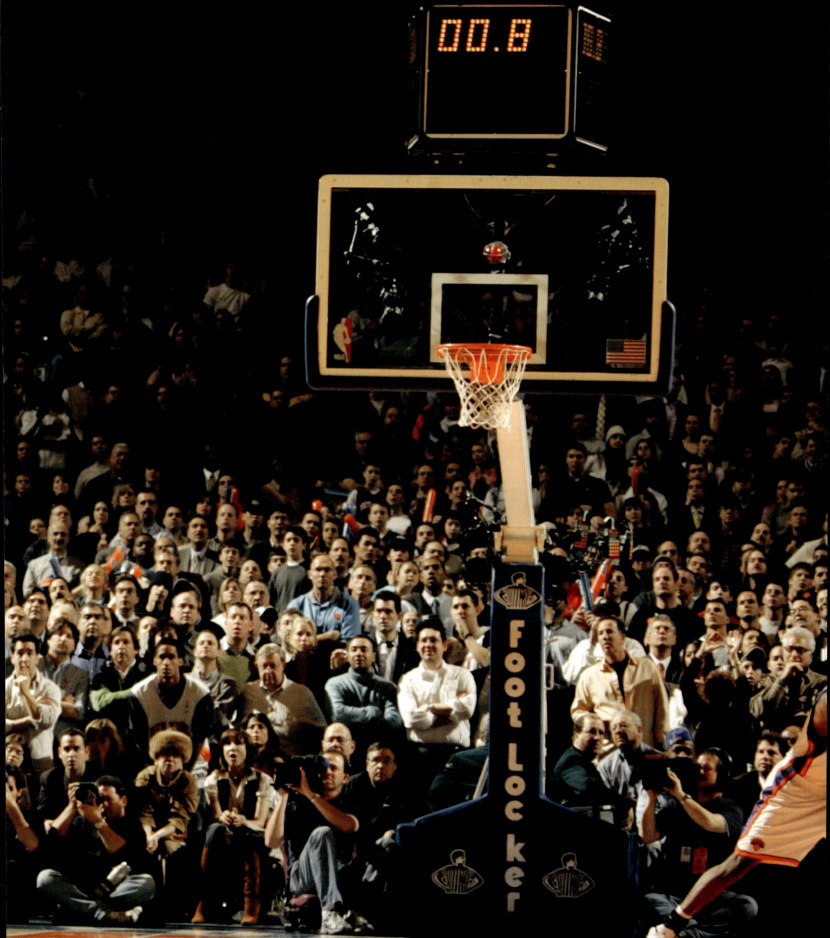

"The 1992 All-Star Game is a core memory of mine! I owe so much to Commissioner David Stern for allowing me to play in the game and helping me change the world after my diagnosis. Loved the last couple minutes of the game, competing against my two good friends and NBA greats Michael Jordan and Isiah Thomas."
—Earvin "Magic" Johnson

"I remember this like it was yesterday. After Magic's diagnosis, he had not played the entire season, and so basketball fans worldwide were elated to see him back on the court. I vividly remember holding up my camera to cover my face as I teared up, watching Chris Mullin and others welcome Magic back with open arms. Not only was Magic back on the court, he also kicked ass and won the All-Star MVP award. This helped set the stage for Magic to go on and play later that summer on the heralded 'Dream Team' at the 1992 Olympics in Barcelona."
—Nathaniel S. Butler

Earvin "Magic" Johnson; NBA All-Star MVP; Orlando, FL; February 9, 1992

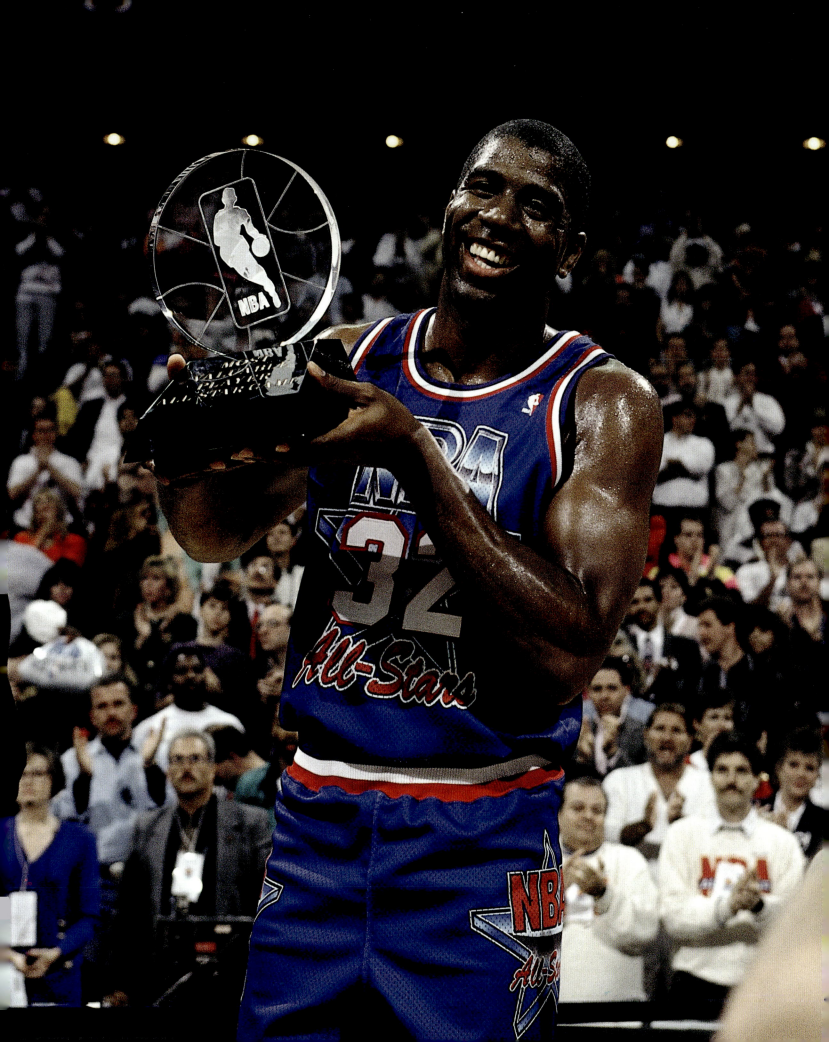

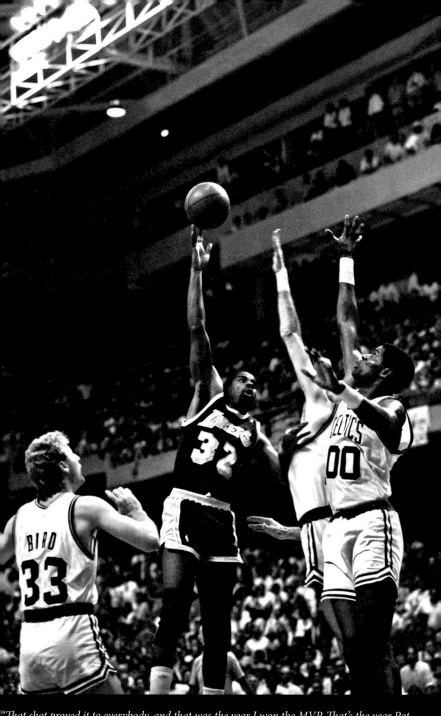

"That shot proved it to everybody, and that was the year I won the MVP. That's the year Pat [Riley] said, 'OK, Earvin, I want you to take over.' And that's what happened. After that, people said, 'It is Larry [Bird] and Magic,' instead of, 'Larry can do this, and Magic can't do that.'"
—Earvin "Magic" Johnson

Earvin "Magic" Johnson scores his "junior, junior skyhook" over three Celtics Hall of Famers; Los Angeles

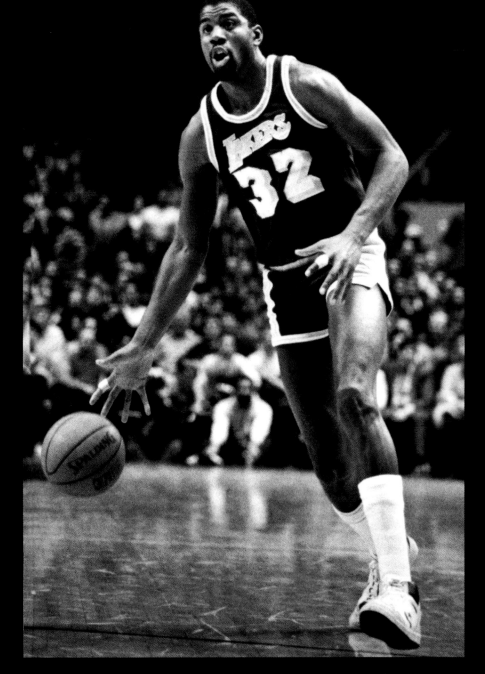
Earvin "Magic" Johnson; Los Angeles Lakers vs. New York Knicks; New York, NY; March 9, 1988

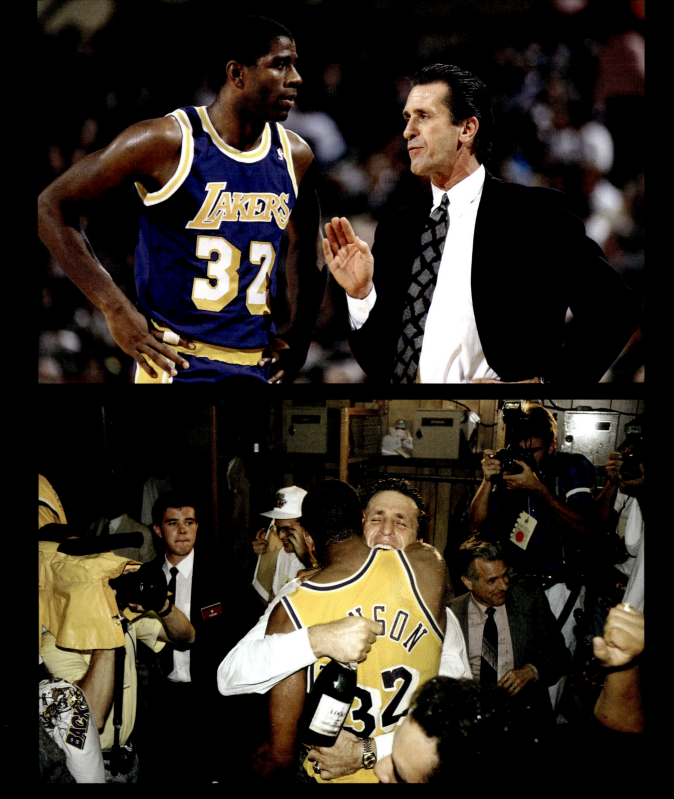

TOP: Earvin "Magic" Johnson and Coach Pat Riley; Los Angeles Lakers vs. New York Knicks; New York, NY; December 18, 1990

ABOVE: Earvin "Magic" Johnson celebrates his fifth NBA championship win with Coach Pat Riley; Los Angeles Lakers vs. Detroit Pistons; Inglewood, CA; June 21, 1988

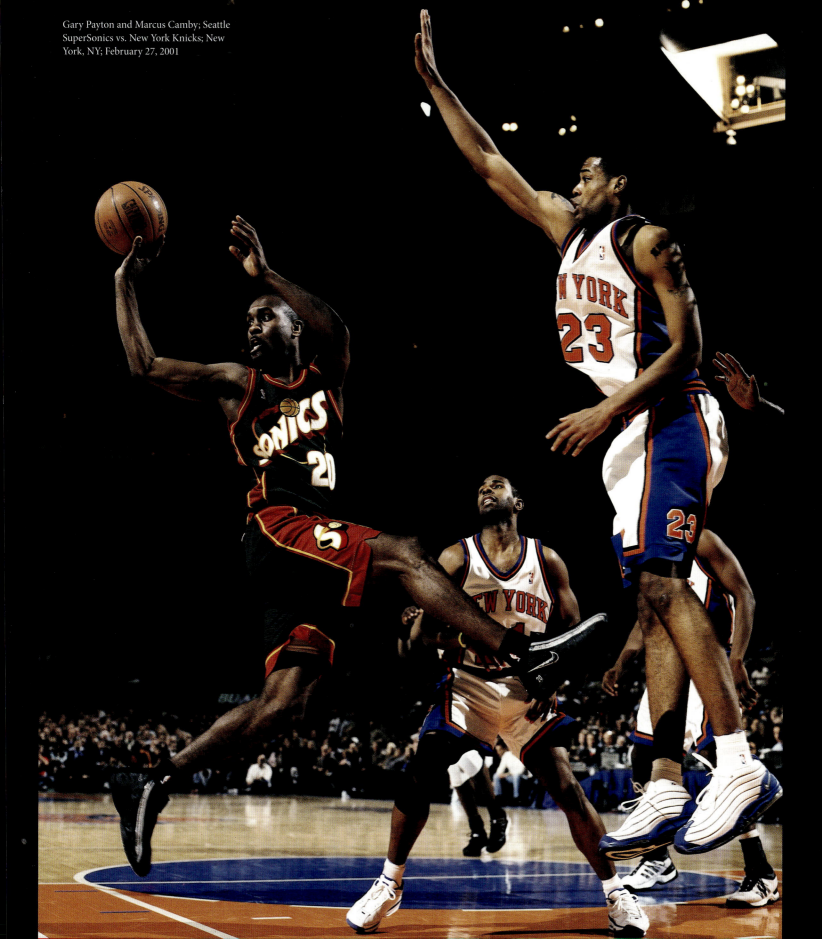

Gary Payton and Marcus Camby; Seattle SuperSonics vs. New York Knicks; New York, NY; February 27, 2001

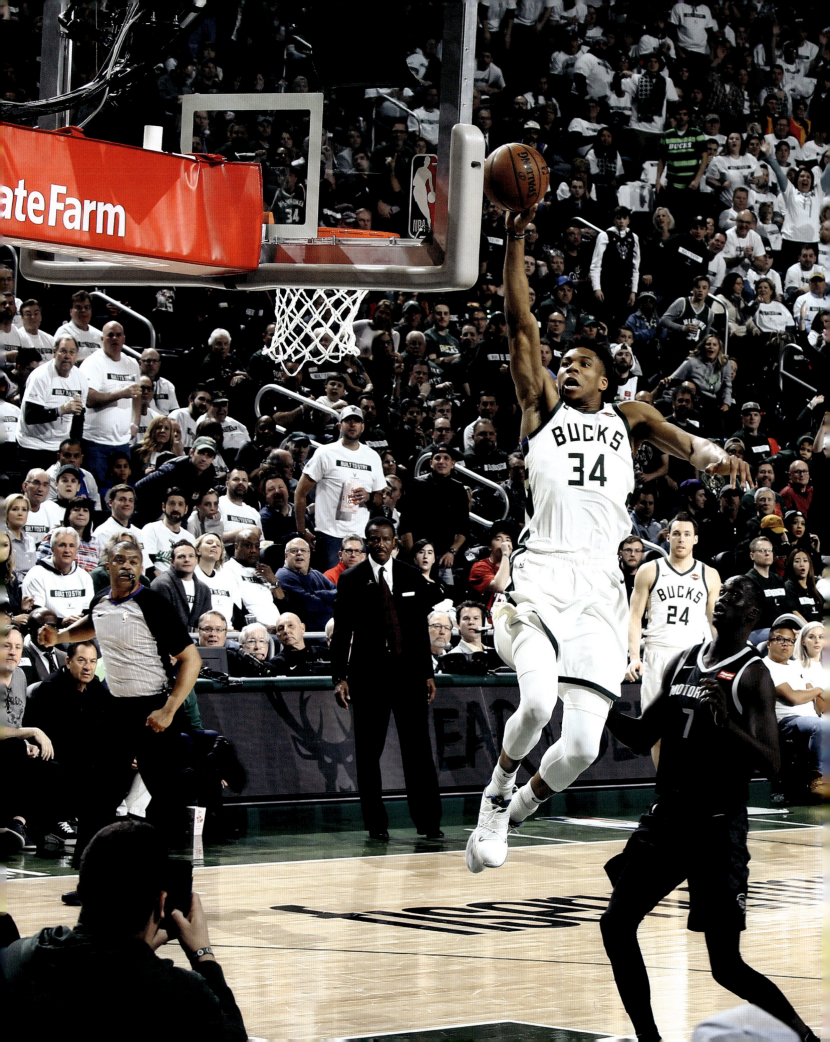

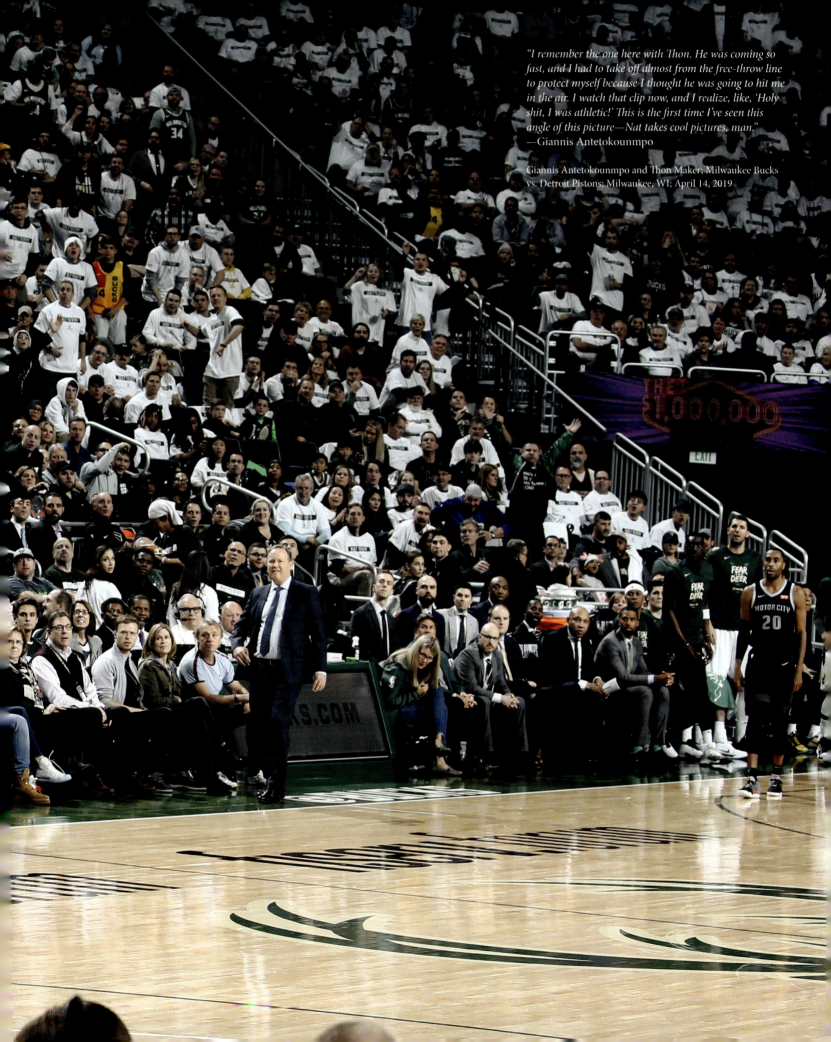

"I remember the one here with Thon. He was coming so fast, and I had to take off almost from the free-throw line to protect myself because I thought he was going to hit me in the air. I watch that clip now, and I realize, like, 'Holy shit, I was athletic!' This is the first time I've seen this angle of this picture—Nat takes cool pictures, man."
—Giannis Antetokounmpo

Giannis Antetokounmpo and Thon Maker; Milwaukee Bucks vs. Detroit Pistons; Milwaukee, WI; April 14, 2019

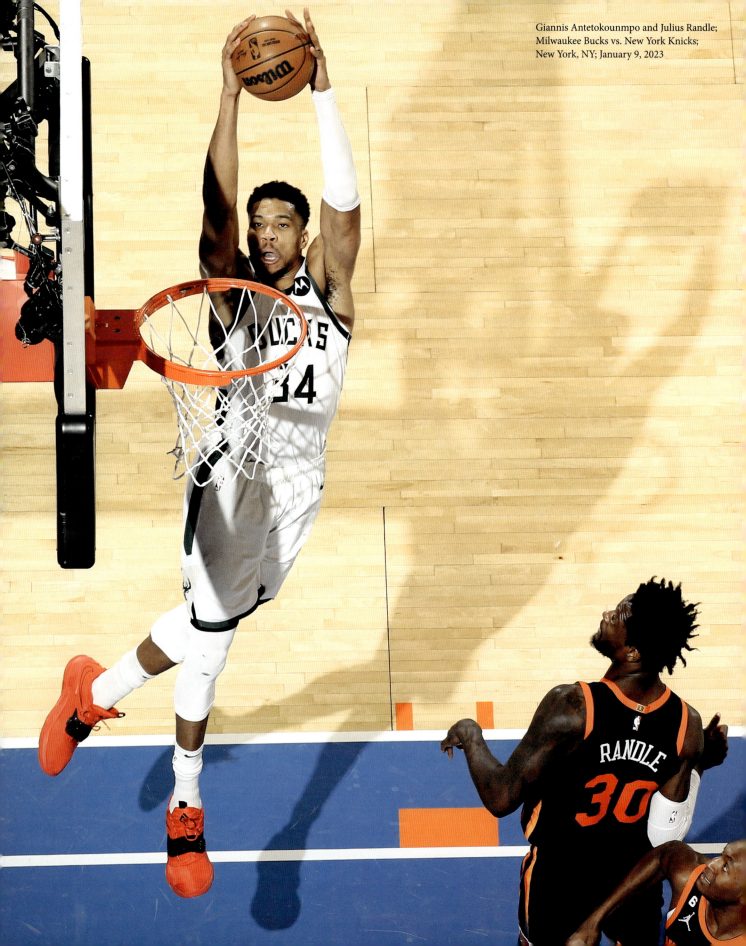

Giannis Antetokounmpo and Julius Randle; Milwaukee Bucks vs. New York Knicks; New York, NY; January 9, 2023

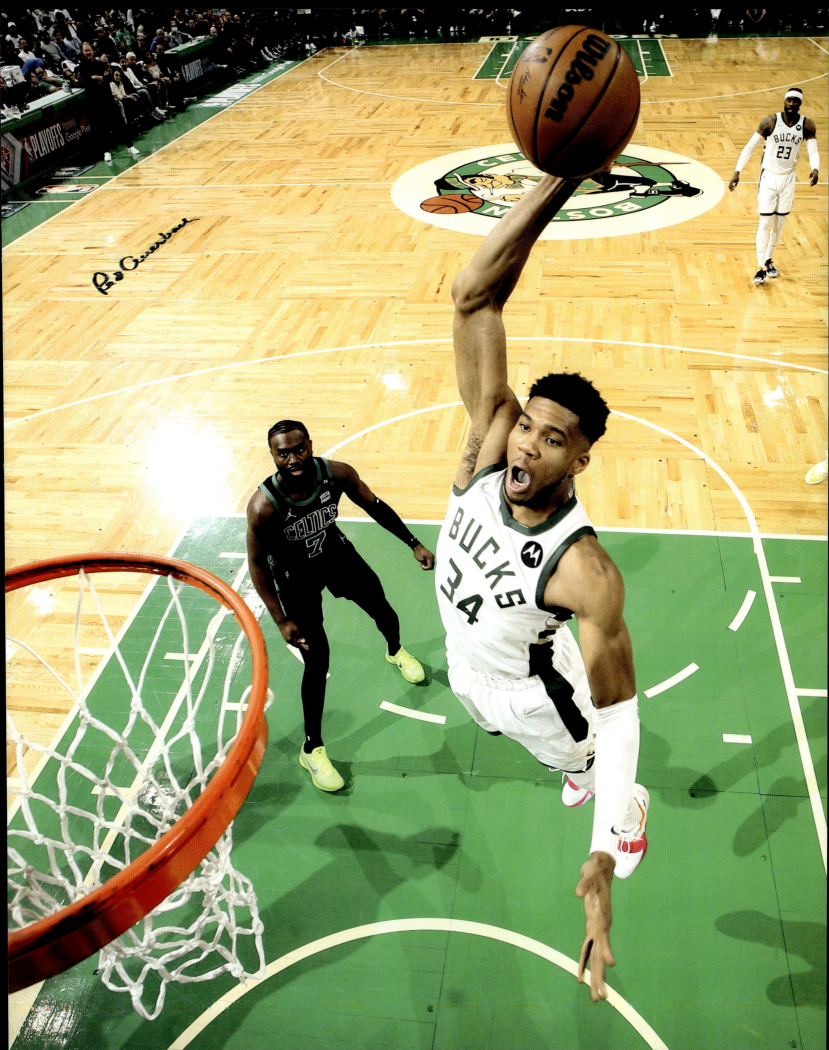

"I enjoy competing in the playoffs a lot. You work extremely hard all year long to be in that position—to be able to play the best basketball that you can for your team, but at the same time, to enjoy it. Whenever I'm able to make the playoffs or have my team make the playoffs, I'm always happy."
—Giannis Antetokounmpo

PREVIOUS PAGE: Giannis Antetokounmpo and Jaylen Brown; Milwaukee Bucks vs. Boston Celtics; Boston, MA; May 1, 2022

"I just go to a place where I'm locked in just by myself, getting ready to basically go to battle. I understand that I do something that I enjoy, but I'm just trying to perfect my craft to the best of my ability and get ready to compete." —Giannis Antetokounmpo

OPPOSITE: Giannis Antetokounmpo; Milwaukee Bucks; Brooklyn, NY; November 6, 2023

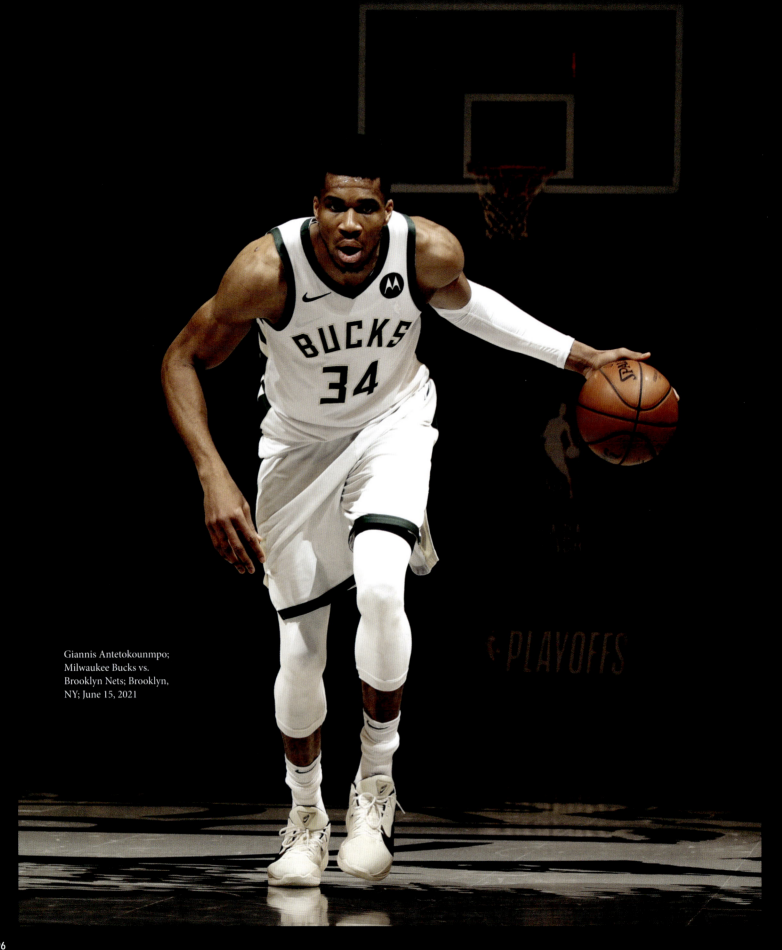

Giannis Antetokounmpo;
Milwaukee Bucks vs.
Brooklyn Nets; Brooklyn,
NY; June 15, 2021

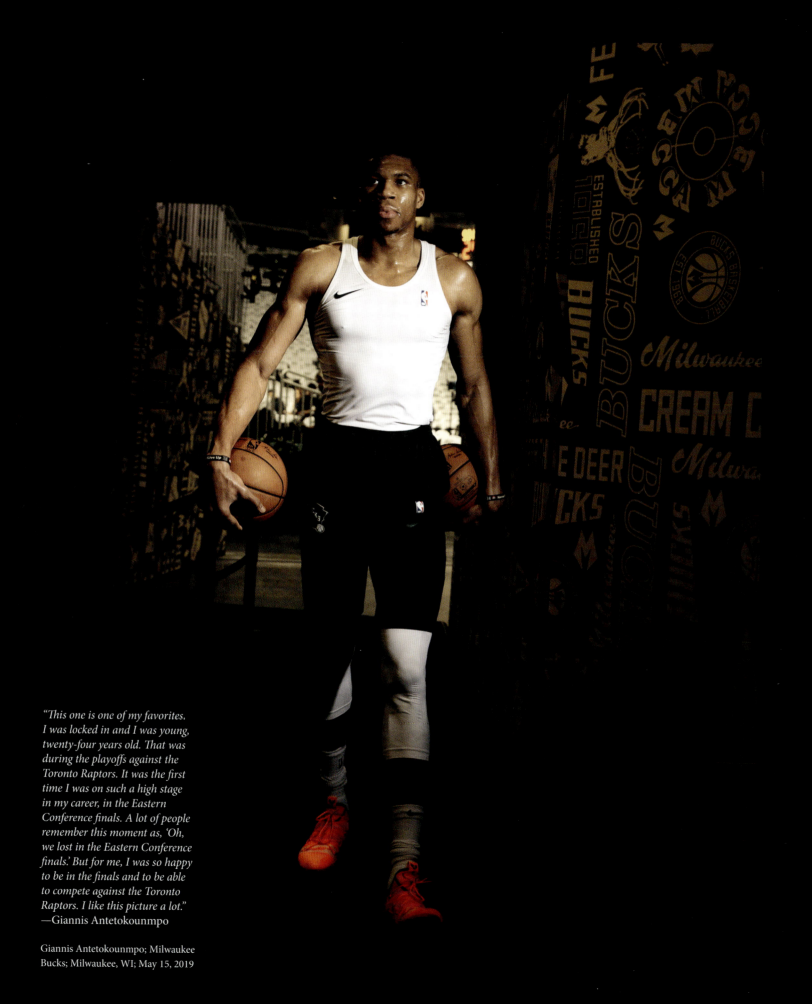

"This one is one of my favorites. I was locked in and I was young, twenty-four years old. That was during the playoffs against the Toronto Raptors. It was the first time I was on such a high stage in my career, in the Eastern Conference finals. A lot of people remember this moment as, 'Oh, we lost in the Eastern Conference finals.' But for me, I was so happy to be in the finals and to be able to compete against the Toronto Raptors. I like this picture a lot."
—Giannis Antetokounmpo

Giannis Antetokounmpo; Milwaukee Bucks; Milwaukee, WI; May 15, 2019

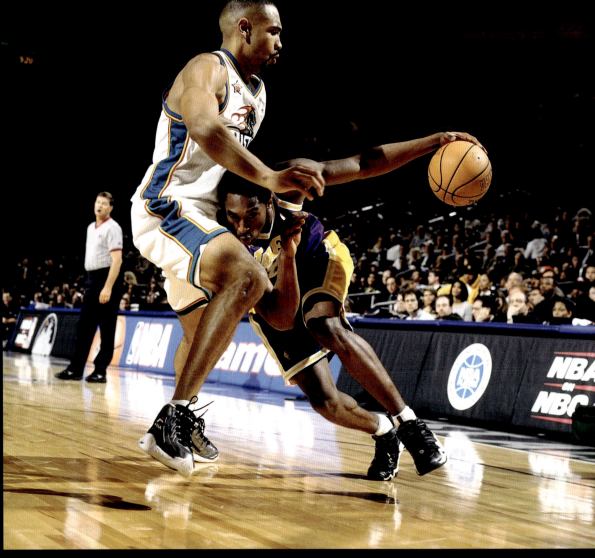

"This was the 1998 NBA All-Star Game in New York City. It was my fourth All-Star game and Kobe's first. There was a big lead-up to that game for Kobe Bryant against Michael Jordan. I don't remember this actual moment, but I remember the excitement and the energy in Madison Square Garden. What was fascinating was maybe six weeks before this game, I flew to Los Angeles to film a Sprite commercial with Kobe. I flew out there and arrived in my trailer having already read and agreed to the script for the spot. The director comes into my trailer and says, 'Kobe would like to rewrite the commercial.' I said, 'Wait, we agreed in advance on the script.' Anyway, I let Kobe go ahead and rewrite it, which featured him saying all the good lines and giving me none whatsoever. The director decided that wasn't fair, and we went back to the original script. We both went on to film a series of Sprite commercials." —Grant Hill

ABOVE: Grant Hill, Detroit Pistons; Kobe Bryant, Los Angeles Lakers; NBA All-Star Game; New York, NY; February 8, 1998

"'The Next MJ' was a label that I did not embrace and did not enjoy at all. I had so much respect for Michael Jordan, his legacy and his accomplishments. I felt my game was actually different than Michael Jordan's, maybe actually more Magic Johnson, as I enjoyed passing the ball and the joy that comes with my teammates scoring. Michael was a scorer and an absolute killer out there on the court. But Michael was always good to me and always looked out for me, took care of me. After this game, I went to dinner with him at his restaurant, Michael Jordan's Steak House, in Chicago. He has always shown me the utmost respect and was always a fan of my father, Calvin Hill."
—Grant Hill

OPPOSITE: Grant Hill and Michael Jordan; Detroit Pistons vs. Chicago Bulls; March 22, 1997

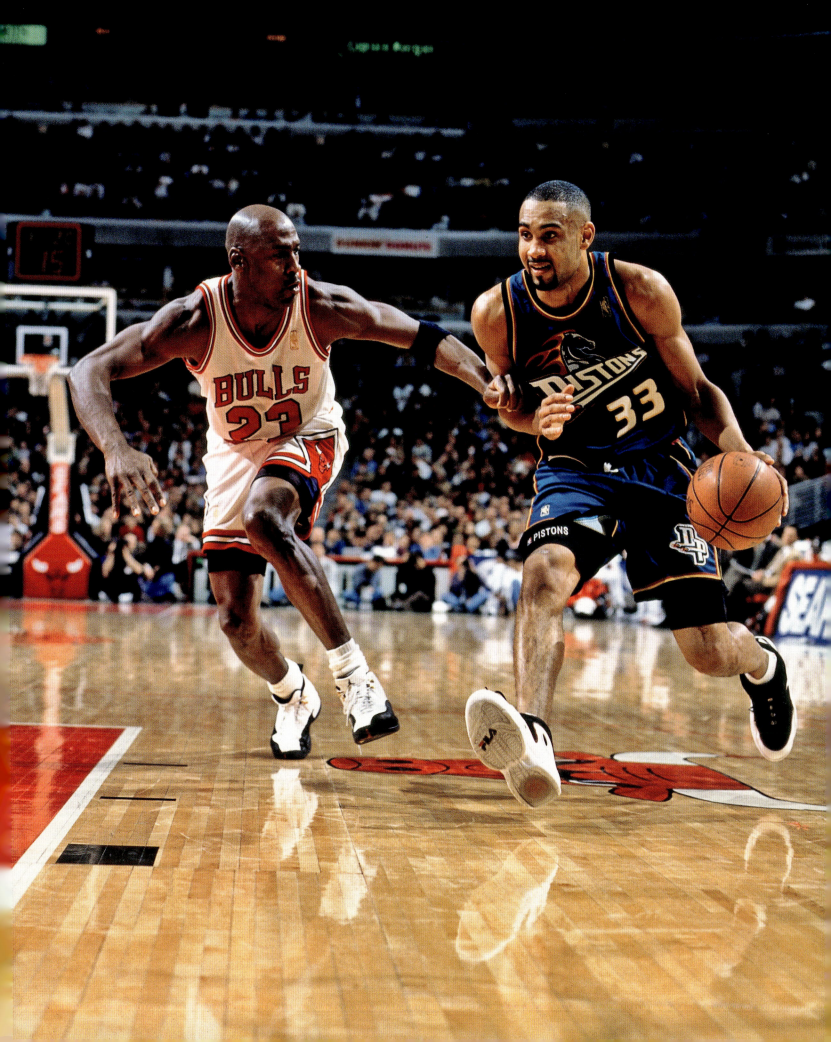

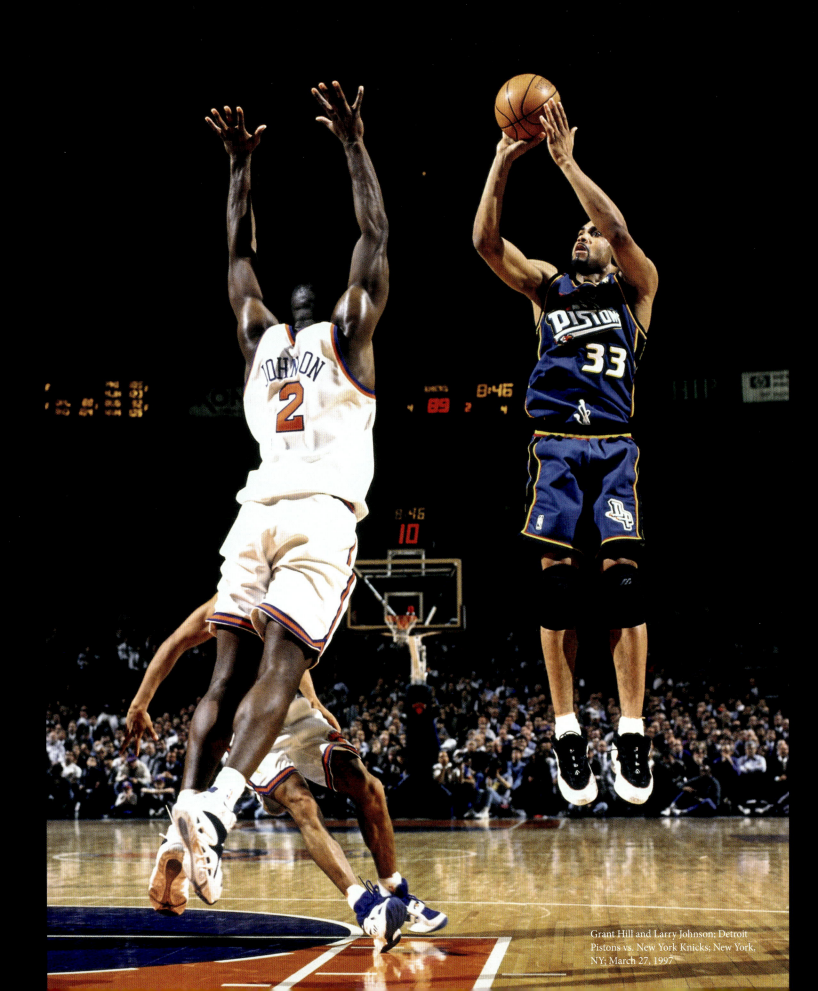

Grant Hill and Larry Johnson; Detroit Pistons vs. New York Knicks; New York, NY; March 27, 1997

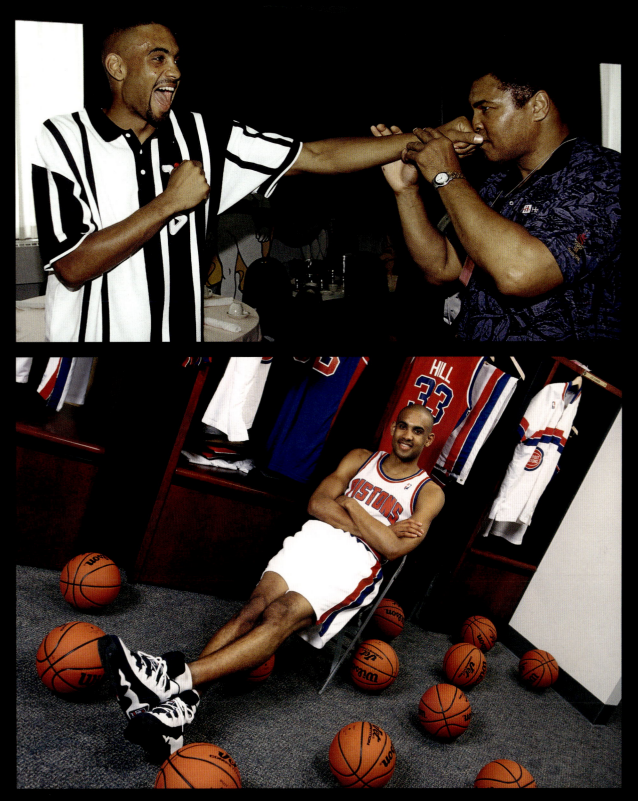

"We were at the 1996 Atlanta Olympics, staying at the Omni Hotel, and in the meal room when one day, lo and behold, Muhammad Ali came to visit us. He lit the torch at the opening ceremonies and a few days later came by to see us. It was truly an honor and a privilege. It was exciting to see all these great NBA players giddy over meeting this legend, this icon. I don't remember this picture being taken, but I remember the moment and the fact that he helped orchestrate it by putting my fist up to his face as if I was jabbing him or punching him, makes it just perfect. It was really just the highlight for me at the '96 Olympics." —Grant Hill

TOP: Grant Hill, Team USA, and Muhammad Ali; 1996 Olympics; Atlanta, GA; August 1996

ABOVE: Grant Hill; Detroit Pistons; Auburn Hills, MI; 1995

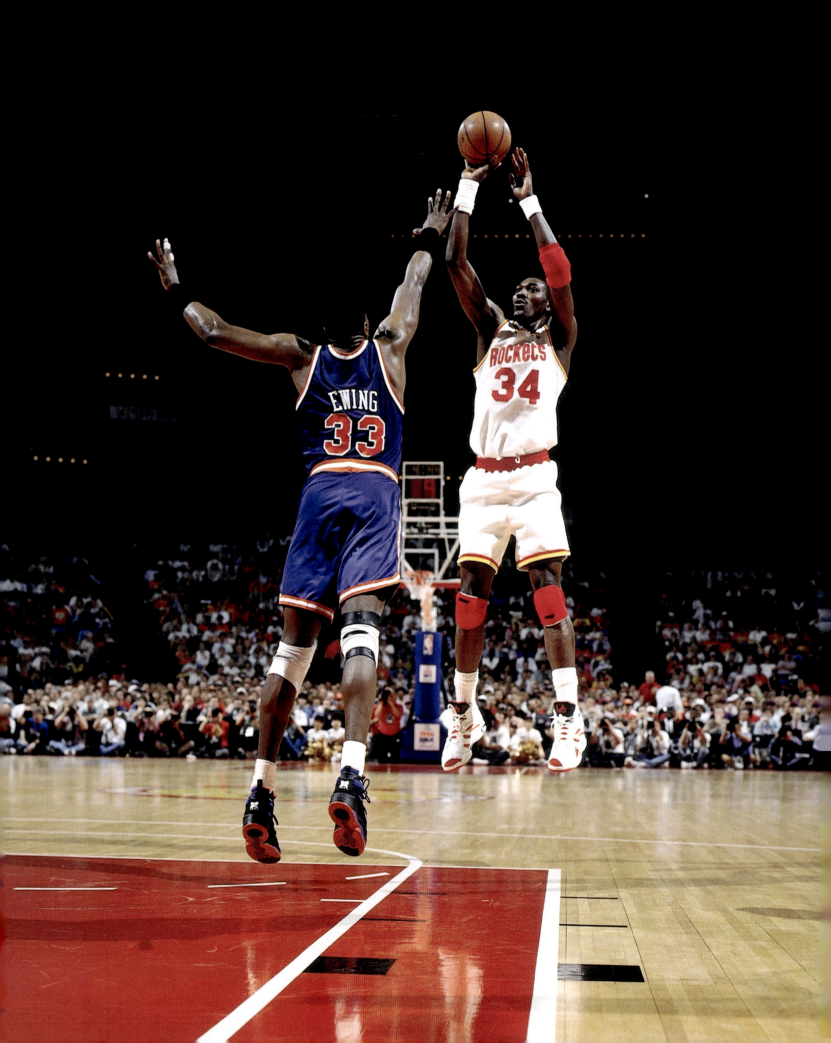

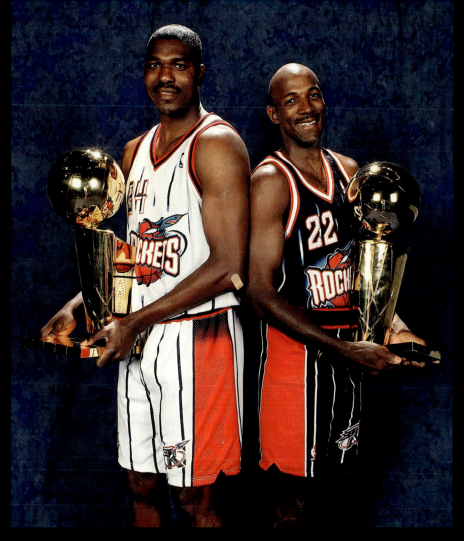

ABOVE: Hakeem Olajuwon and Clyde Drexler; Houston Rockets; New York, NY; 1995

OPPOSITE: Hakeem Olajuwon and Patrick Ewing; Houston Rockets vs. New York Knicks; Game 1 of the

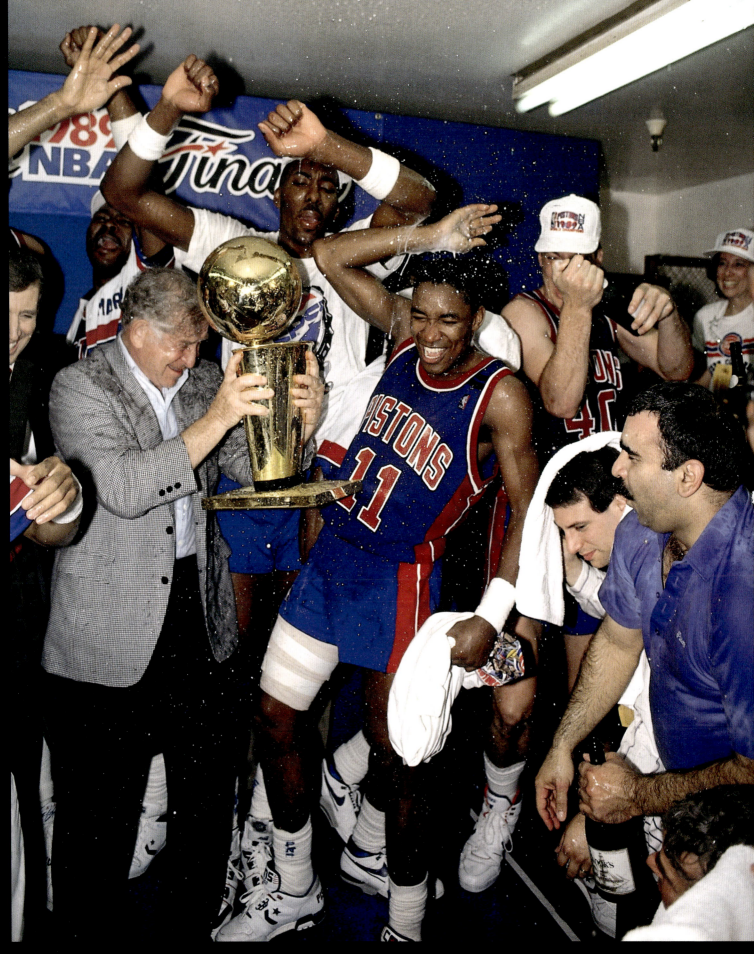

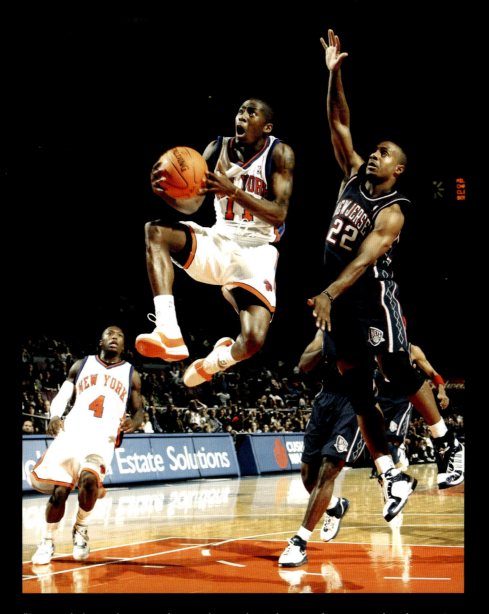

"Being with the Knicks was my favorite place to play. I always tried to put on a show, because I never knew who was going to be in the crowd. One particular game, I remember playing against the New Jersey Nets and Jay Williams, and I had a layup wearing my S. Carters, and I didn't look when the ball went in. I'll never forget that play." —Jamal Crawford

ABOVE: Jamal Crawford and Jay Williams; New York Knicks vs. New Jersey Nets; New York, NY; October 13, 2006

"A championship moment. Celebration. That was our first championship beating the Lakers. That was awesome. You never realize how important those memories are going to be as you get older. But when you get a chance to look back and experience that moment and capture it through this picture, it's good." —Isiah Thomas

OPPOSITE: Isiah Thomas; Detroit Pistons; Game 4 of the NBA Finals; NBA championship win; Inglewood, CA; June 13, 1989

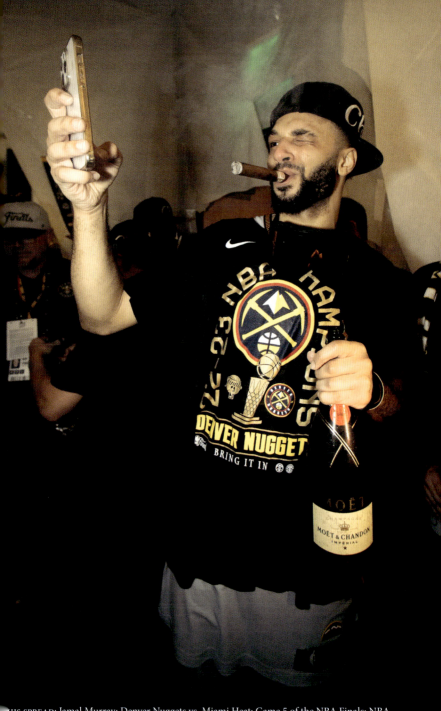

this spread: Jamal Murray; Denver Nuggets vs. Miami Heat; Game 5 of the NBA Finals; NBA ampionship win; Denver, CO: June 12, 2023

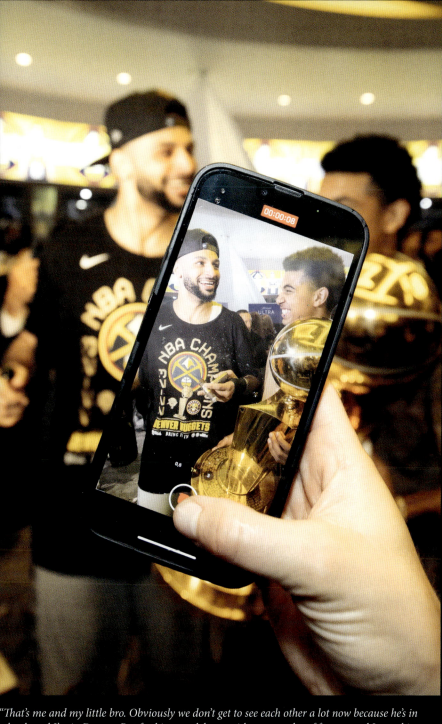

"That's me and my little bro. Obviously we don't get to see each other a lot now because he's in school, and I'm in Denver. But for him to celebrate with us was a lot of fun . . . and I gave him a couple sips of the champagne." —Jamal Murray

"This photo represents everything I've been through—whether it's growing up or my career, all the adversity that I've been through to get to this point. It's a blessing. So, just praising the man above."
—James Harden

James Harden; Houston Rockets vs. New York Knicks; New York, NY; January 23, 2019

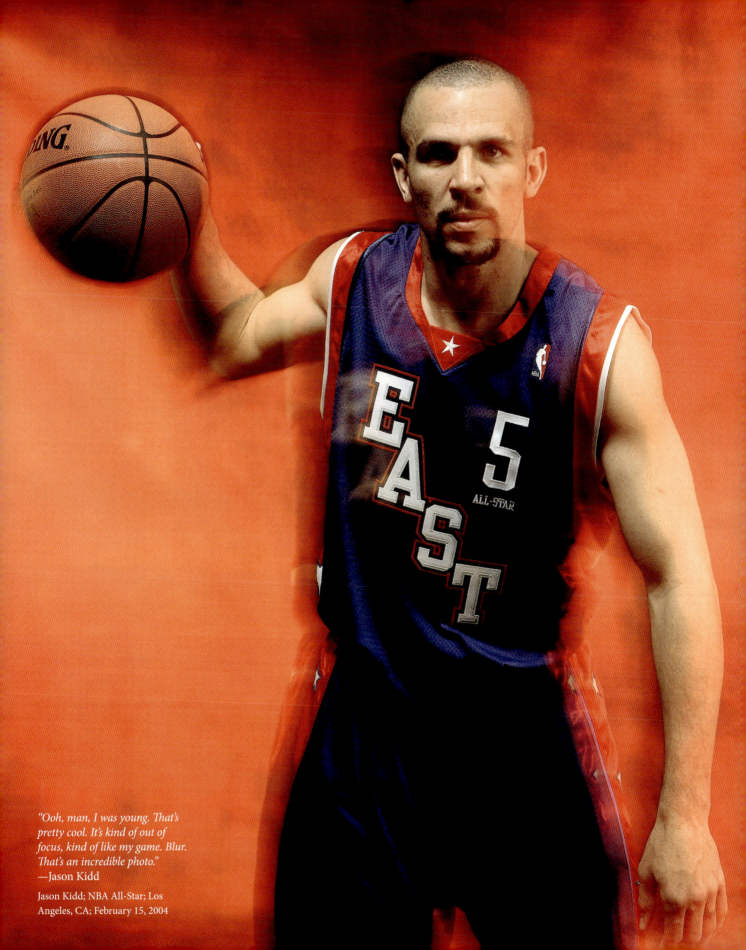

"Ooh, man, I was young. That's pretty cool. It's kind of out of focus, kind of like my game. Blur. That's an incredible photo."
—Jason Kidd

Jason Kidd; NBA All-Star; Los Angeles, CA; February 15, 2004

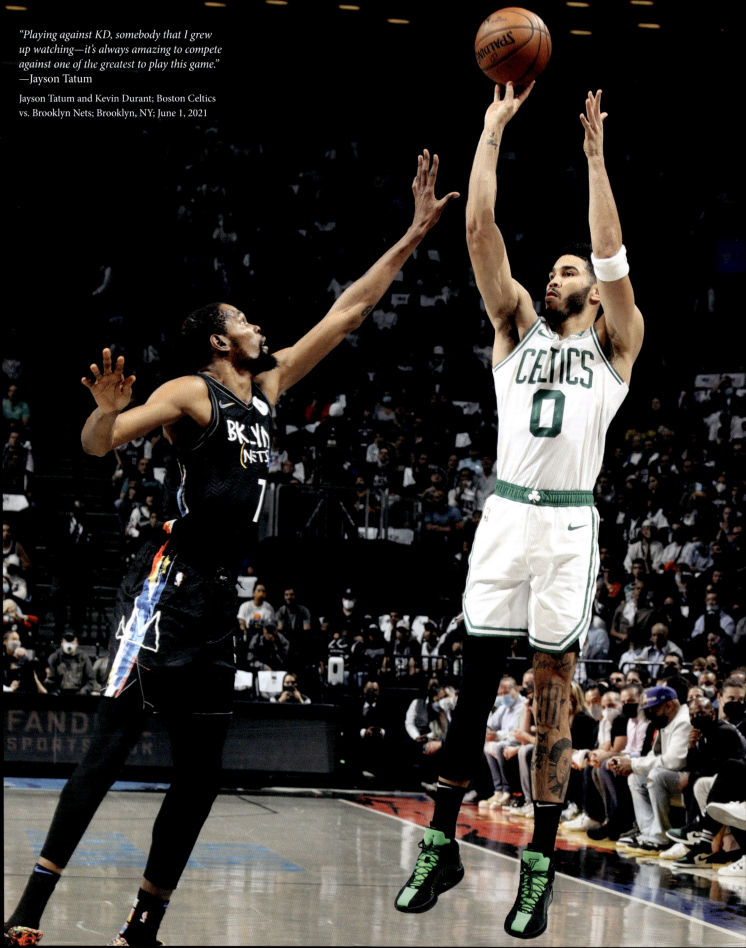

"Playing against KD, somebody that I grew up watching—it's always amazing to compete against one of the greatest to play this game."
—Jayson Tatum

Jayson Tatum and Kevin Durant; Boston Celtics vs. Brooklyn Nets; Brooklyn, NY; June 1, 2021

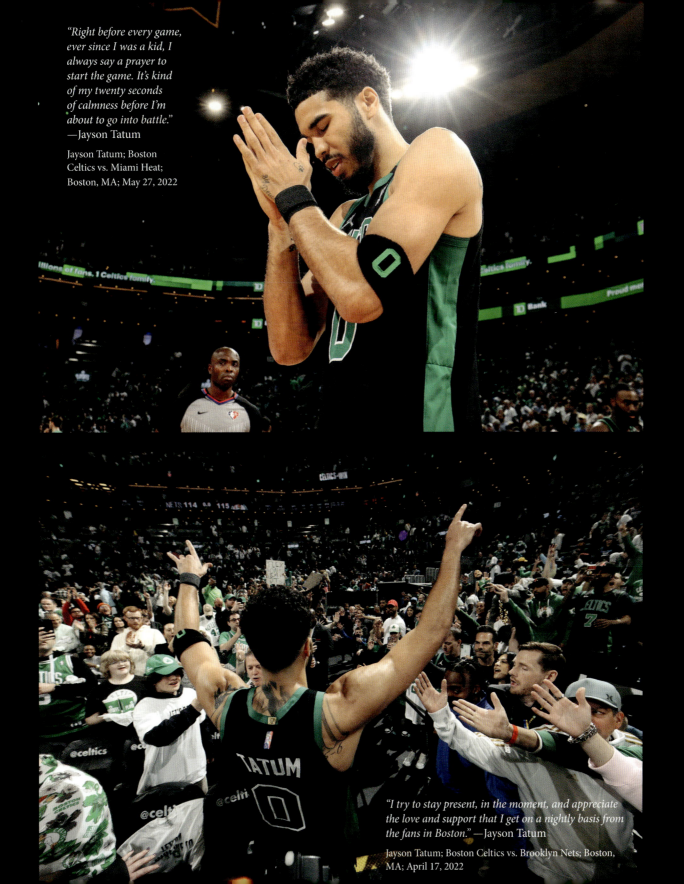

"Right before every game, ever since I was a kid, I always say a prayer to start the game. It's kind of my twenty seconds of calmness before I'm about to go into battle."
—Jayson Tatum

Jayson Tatum; Boston Celtics vs. Miami Heat; Boston, MA; May 27, 2022

"I try to stay present, in the moment, and appreciate the love and support that I get on a nightly basis from the fans in Boston." —Jayson Tatum

Jayson Tatum; Boston Celtics vs. Brooklyn Nets; Boston, MA; April 17, 2022

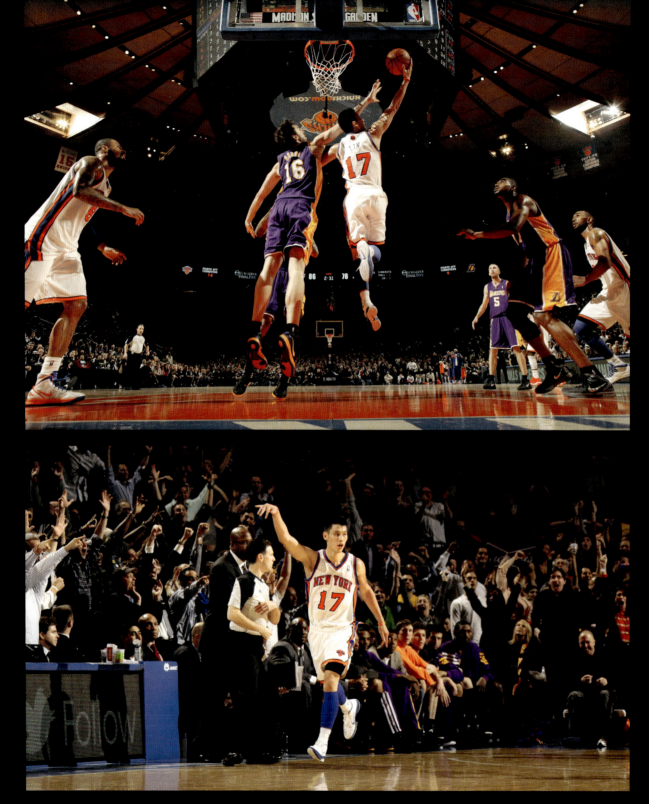

TOP: Jeremy Lin and Pau Gasol; New York Knicks vs. Los Angeles Lakers; New York, NY; February 10, 2012

ABOVE: Jeremy Lin; New York Knicks vs. Los Angeles Lakers; New York, NY; February 10, 2012

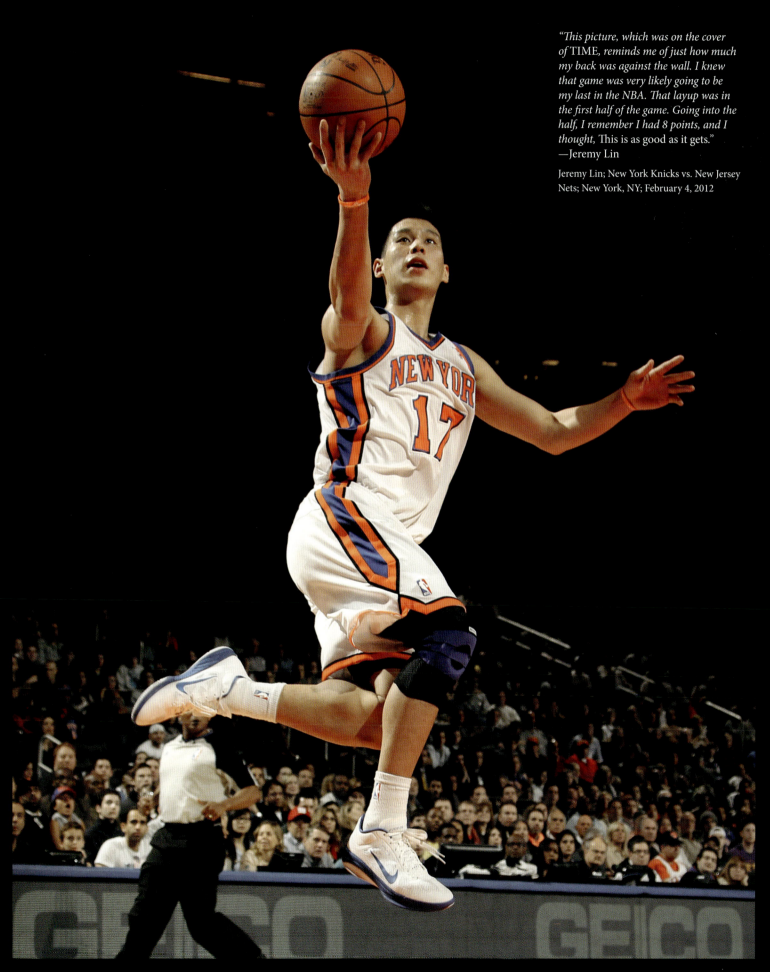

"This picture, which was on the cover of TIME, reminds me of just how much my back was against the wall. I knew that game was very likely going to be my last in the NBA. That layup was in the first half of the game. Going into the half, I remember I had 8 points, and I thought, This is as good as it gets."
—Jeremy Lin

Jeremy Lin; New York Knicks vs. New Jersey Nets; New York, NY; February 4, 2012

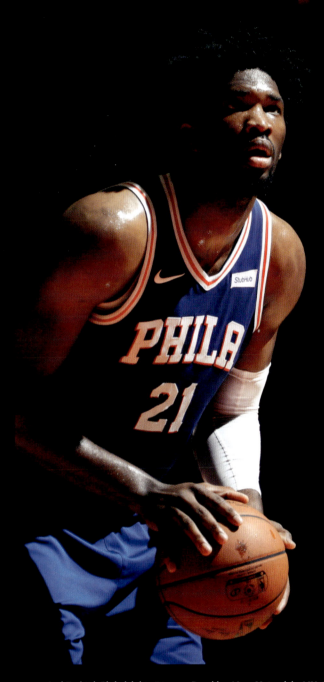

ABOVE: Joel Embiid; Philadelphia 76ers vs. Brooklyn Nets; Uniondale, NY; October 11, 2017

"The DUNK—not the only highlight of my career, but certainly one of the most memorable! Everything fell into place, and I just elevated and threw it down. I remember the roar of The Garden crowd. If you are a Knicks fan, that poster taken by Nat was on your wall." —John Starks

OPPOSITE: John Starks; New York Knicks vs. Chicago Bulls; New York, NY; May 25, 1993

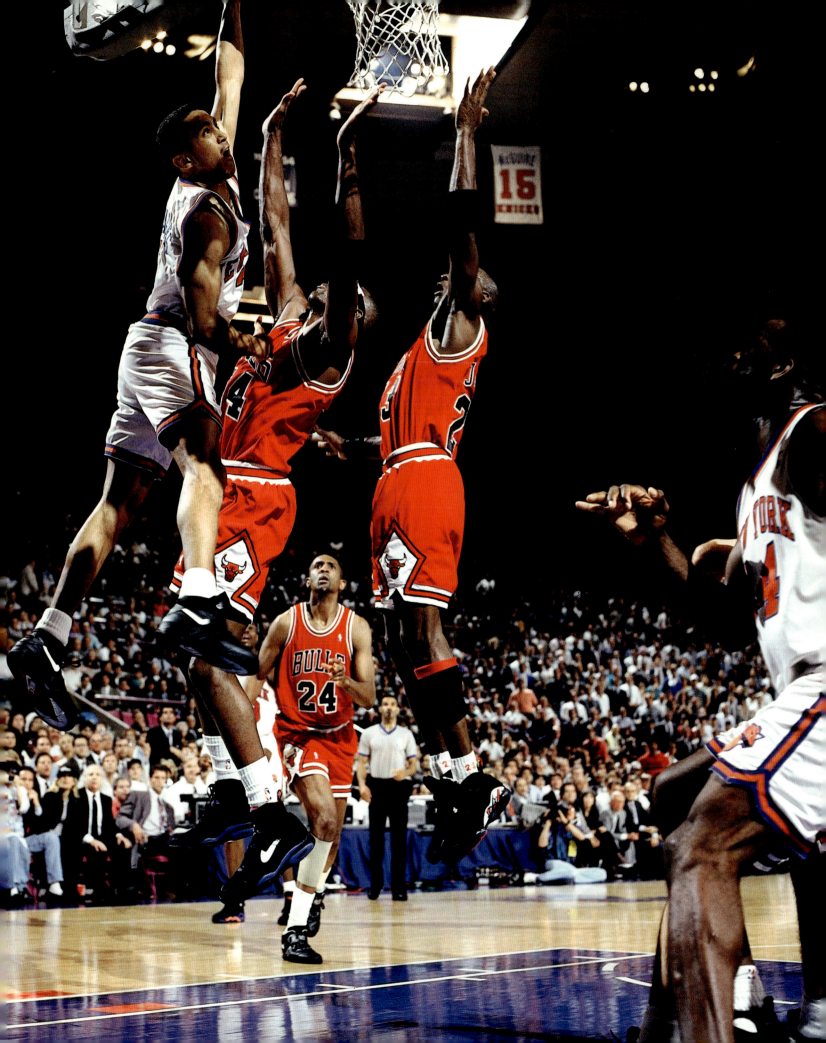

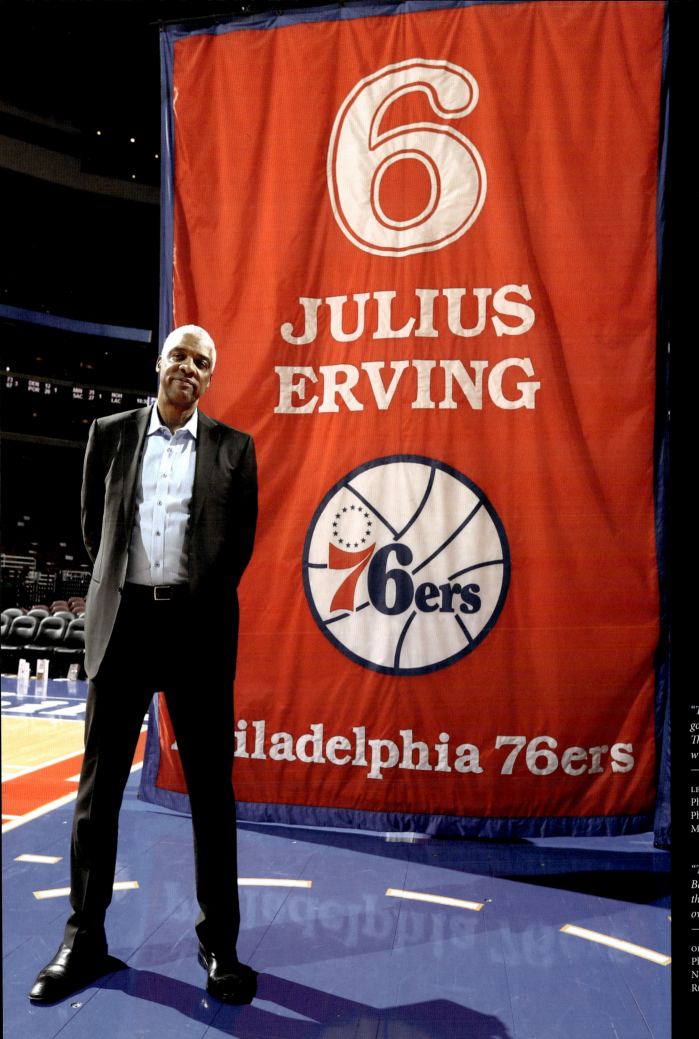

"This was a good day—going into the rafters. The same happened with the Nets."
—Julius Erving

LEFT: Julius Erving; Philadelphia 76ers; Philadelphia, PA; March 1, 2014

"This is me and Barkley, one of the three years we overlapped."
—Julius Erving

OPPOSITE: Julius Erving; Philadelphia 76ers vs. New Jersey Nets; East Rutherford, NJ, 1986

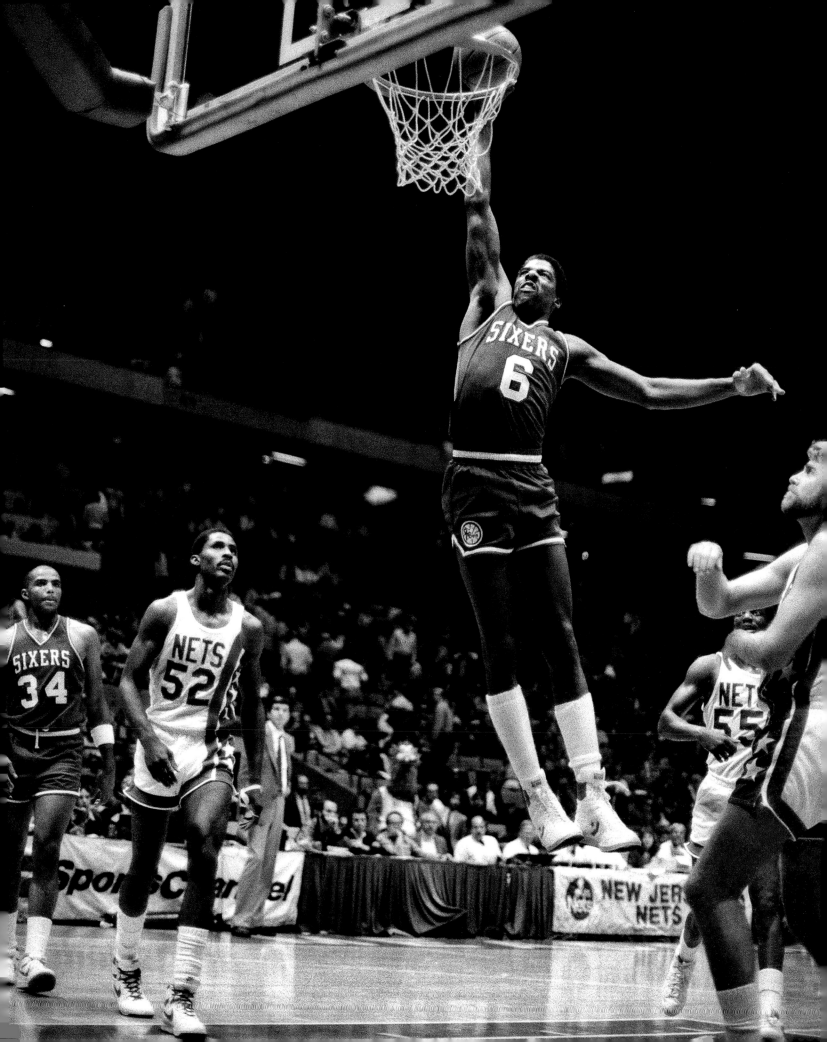

ABOVE: Grant Hill, Bill Russell, and Kareem Abdul-Jabbar; Los Angeles, CA; February 17, 2018

OPPOSITE: Kareem Abdul-Jabbar, Bill Laimbeer, and Isiah Thomas; Los Angeles Lakers vs. Detroit Pistons; NBA Finals; Pontiac, MI; 1988

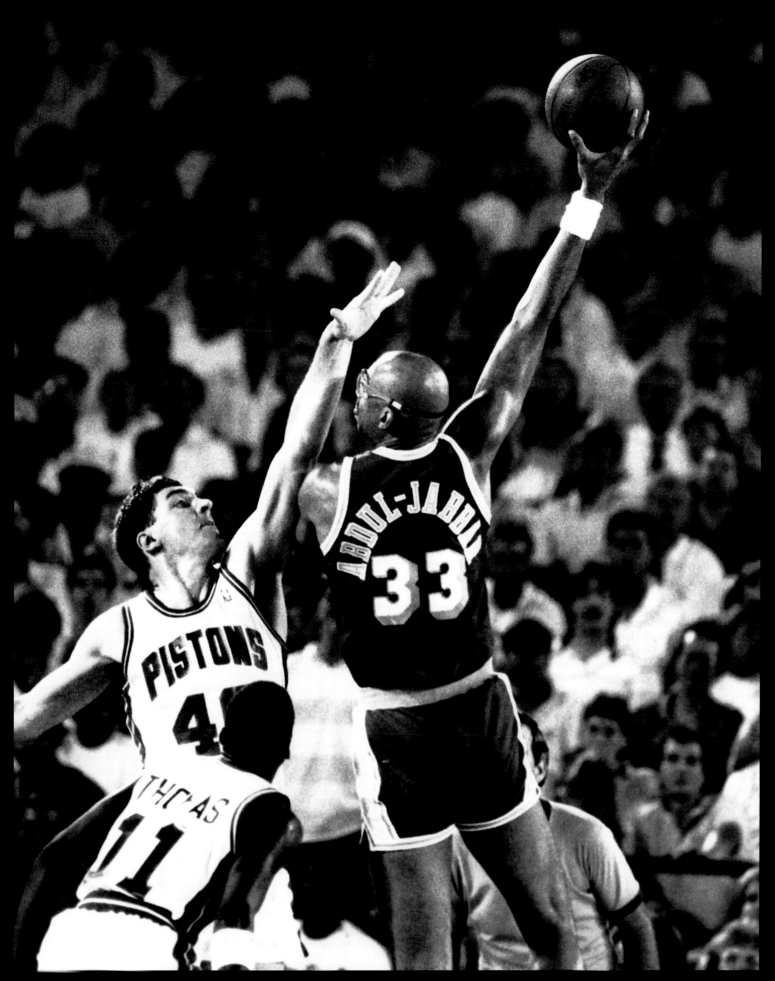

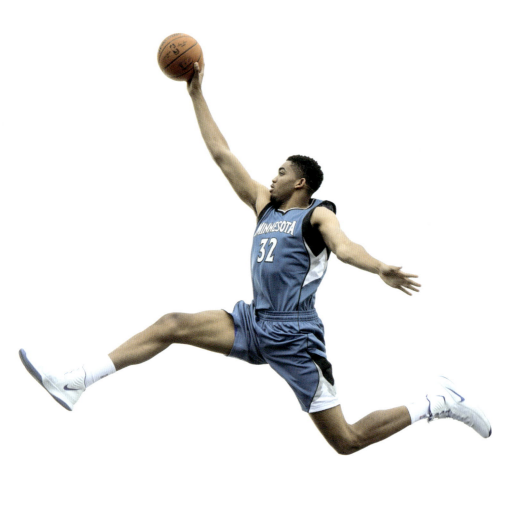

"When I look at these photos, I see joy. I was nineteen years old, fresh out of Kentucky, and had just had the greatest day of my life. I got the dream job that I worked so hard for. This was the culmination of all of my hard work coming together, and this photo shoot has become iconic for all of the rookies coming in. I was just so excited to show my personality. The photos were so good, and the photographer was amazing . . . it was really cool."
—Karl-Anthony Towns

THIS SPREAD: Karl-Anthony Towns; Minnesota Timberwolves; NBA Rookie photo shoot; Tarrytown, NY; August 8, 2015

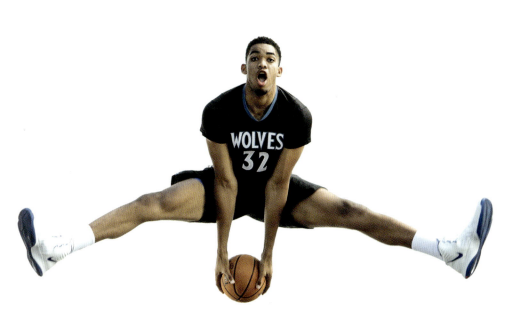

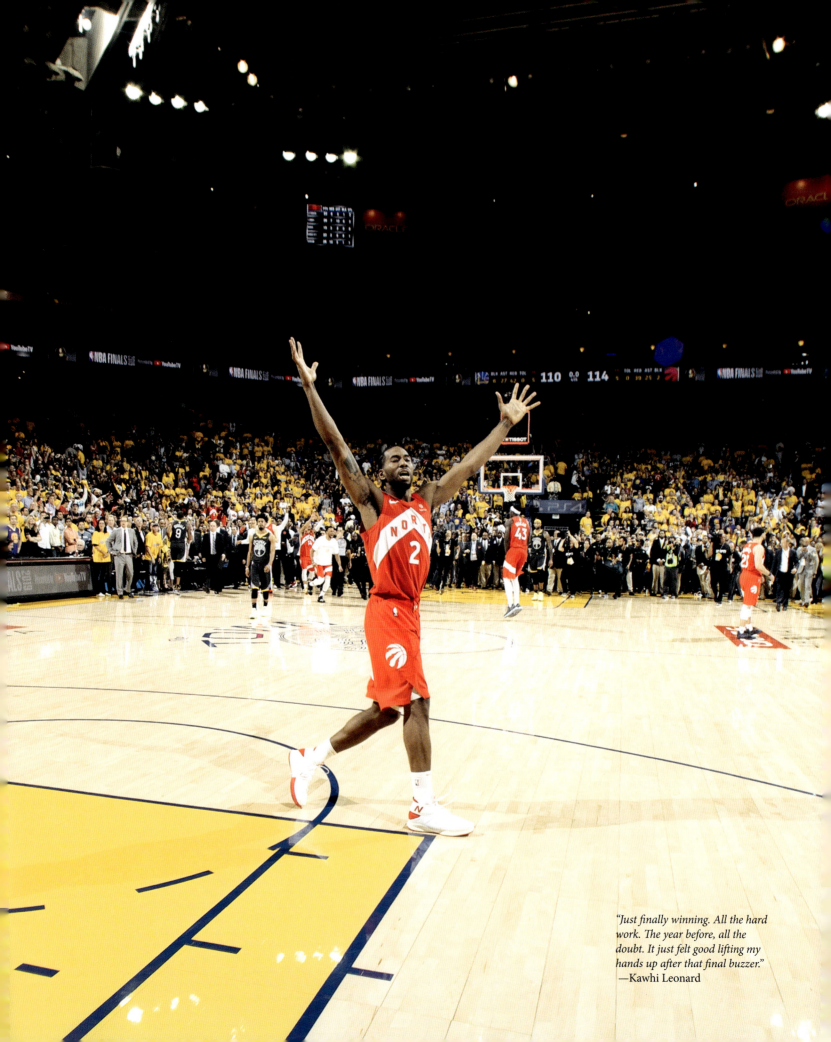

"Just finally winning. All the hard work. The year before, all the doubt. It just felt good lifting my hands up after that final buzzer."
—Kawhi Leonard

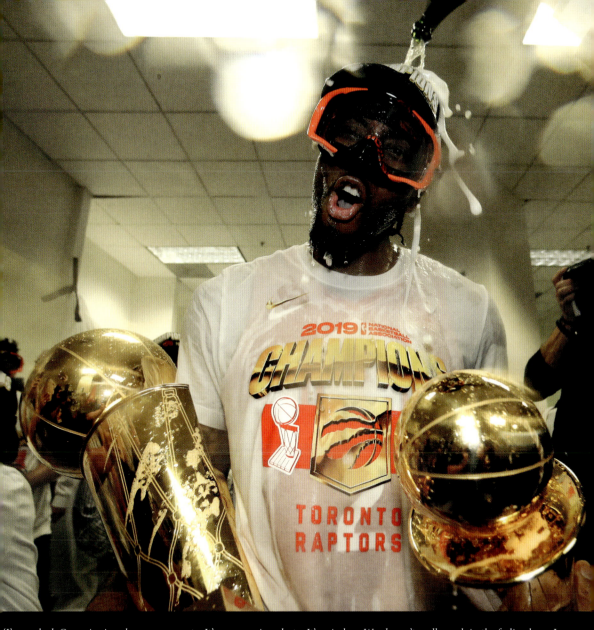

'I'm soaked. Our winning champagne party. It's an amazing photo. It's priceless. Words can't really explain the feeling here. I was so tired, though. I remember just being so tired and wanting to just fall to the floor and sleep. It was amazing."
—Kawhi Leonard

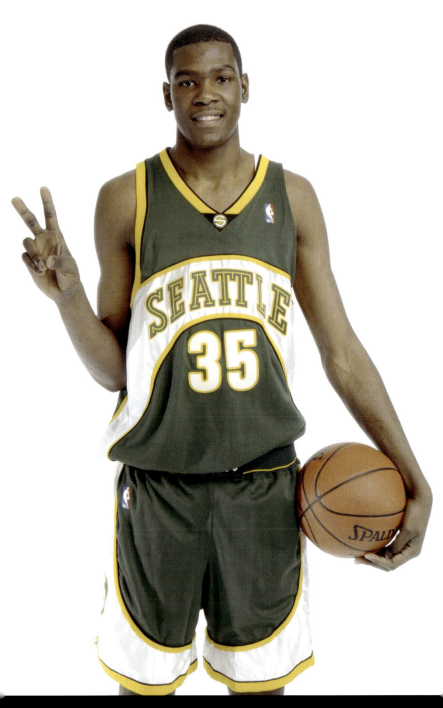

"That's the journey. That's the start of it all. I remember that day like it was yesterday. Being able to put that jersey on and represent the NBA and my family, it meant a lot to me." —Kevin Durant

ABOVE: Kevin Durant; Seattle SuperSonics; NBA Rookie photo shoot; New York, NY; June 27, 2007

"I think I remember this play. That was my last year in OKC. It's just the excitement, man. The enthusiasm. My love for the game is showing on that one. That's a playoff game—that crowd during the playoffs was unmatched." —Kevin Durant

OPPOSITE: Kevin Durant; Oklahoma City Thunder vs. San Antonio Spurs; Oklahoma City, OK; May 12, 2016

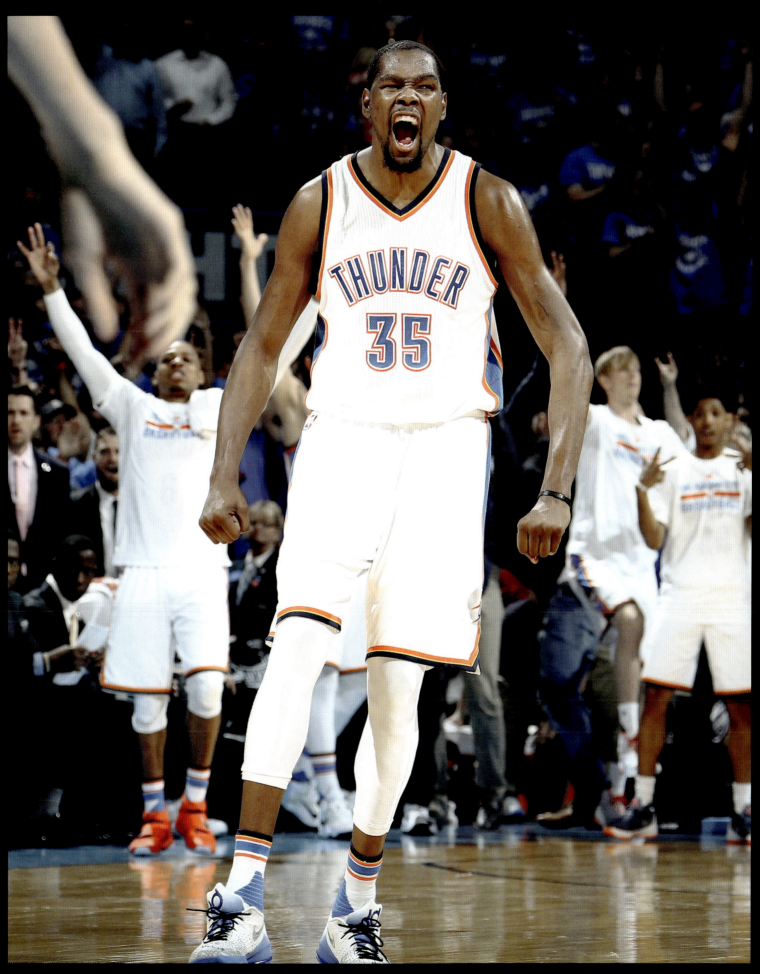

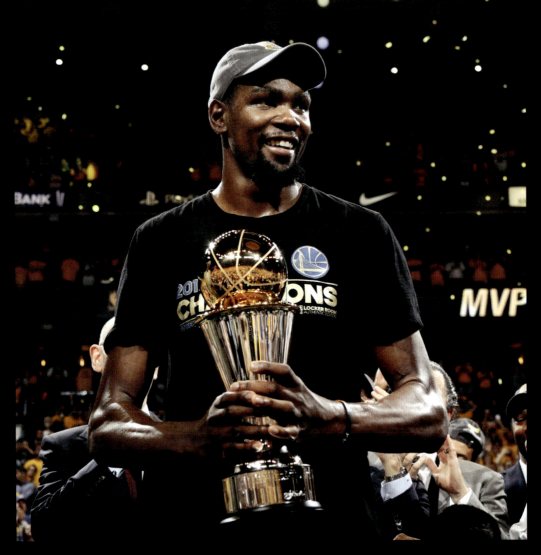

"Being on that stage for the first time and knowing that my talent was good enough to have that in my hands— to actually go out there and produce and do it in the way and in the fashion that I did it, I was super proud of myself." —Kevin Durant

THIS SPREAD: Kevin Durant; Golden State Warriors; Game 5 of the NBA Finals; NBA championship win; Oakland, CA; June 12, 2017

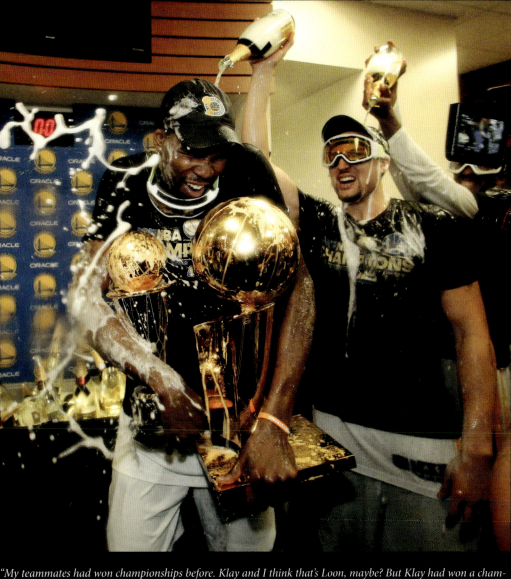

"My teammates had won championships before. Klay and I think that's Loon, maybe? But Klay had won a championship before, and that was my first one, so he was super excited for me. That was the culture at Golden State. Everybody was excited about everyone else's success. Holding those trophies—that spoke about the year that we had as a group. We were able to go 15-1 in the playoffs. The smiles. The excitement. That was one of the greatest teams to ever be assembled." —Kevin Durant

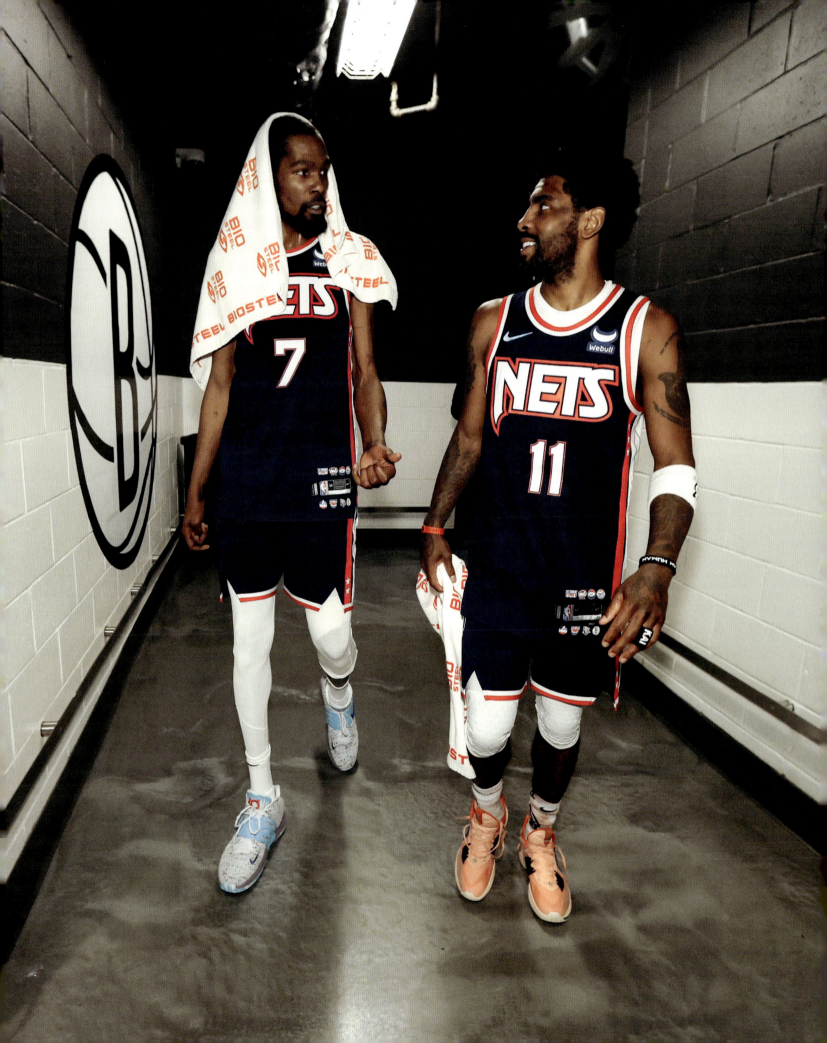

"In Brooklyn, trying to start something new with the little brother of the city, it was a fun journey. I enjoyed my time. That chapter, there was a lot on my mind going into that next season, right after the pandemic. I didn't know how I would play or what type of player I would be. I didn't have any confidence in myself, in my body. And I appreciate Brooklyn just throwing me in the fire and not putting any minute restrictions on me. Allowing me to guard the best players, go out there and shoot whenever I wanted, play forty minutes. They just threw me in the fire right after the Achilles, and I don't know if any other team would have did that. I appreciate them, and those years in Brooklyn were huge for my development after the Achilles." —Kevin Durant

ABOVE: Kevin Durant; Brooklyn Nets vs. Boston Celtics; Brooklyn, NY; April 23, 2022

"My brother for life. He was somebody I enjoyed playing with. I know it didn't end the way we wanted to, but I enjoyed every moment that I had with Kai. He taught me a lot about the game. He can do everything—pass, dribble, shoot, rebound, play defense. But he didn't try to force any action, and I learned a lot from that." —Kevin Durant

Above: Kevin Garnett; Minnesota Timberwolves; 1996

"Obviously I'm older here. This is the joint for my book cover right here. This is dope."
—Kevin Garnett

Opposite: Kevin Garnett; Boston Celtics; Los Angeles, CA; February 18, 2011

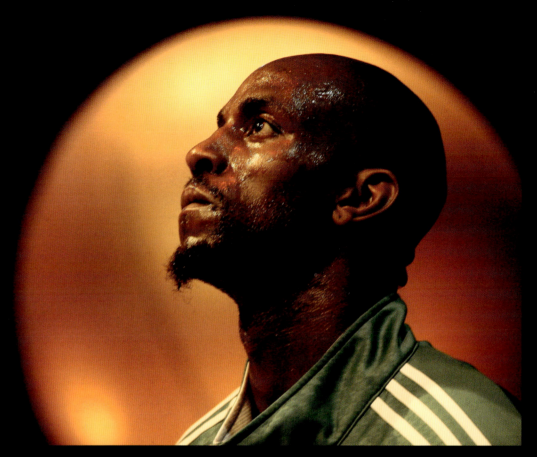

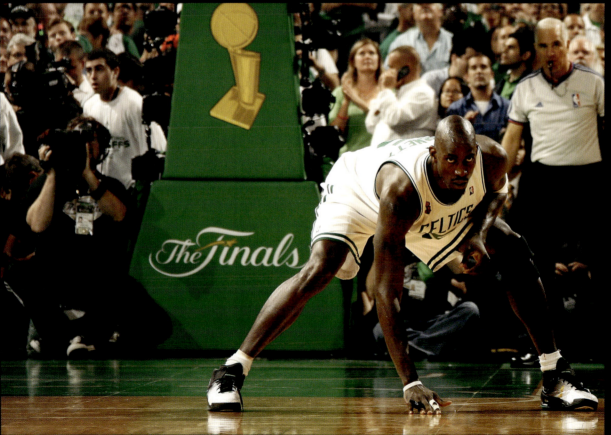

TOP: Kevin Garnett; Boston Celtics vs. Los Angeles Lakers; Game 3 of the NBA Finals; Los Angeles, CA; June 10, 2008
ABOVE: Kevin Garnett; Boston Celtics vs. Los Angeles Lakers; Game 6 of the NBA Finals; Boston, MA; June 17, 2008

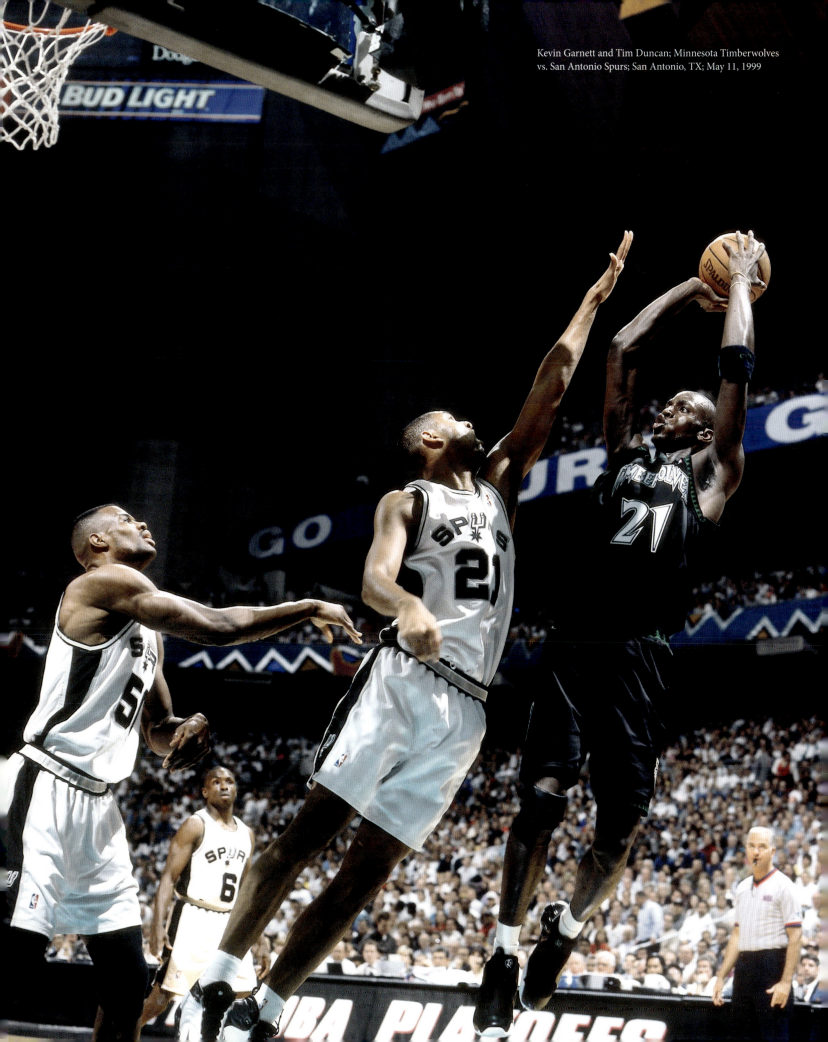

Kevin Garnett and Tim Duncan; Minnesota Timberwolves vs. San Antonio Spurs; San Antonio, TX; May 11, 1999

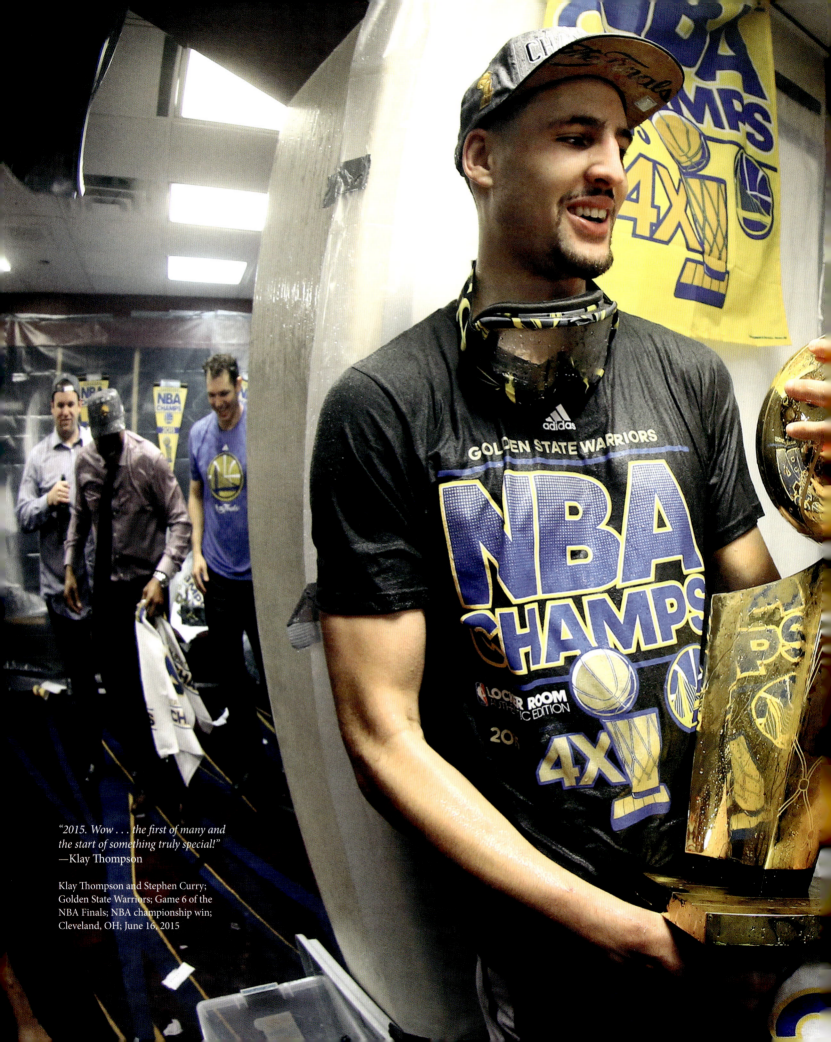

"2015. Wow... the first of many and the start of something truly special!"
—Klay Thompson

Klay Thompson and Stephen Curry; Golden State Warriors; Game 6 of the NBA Finals; NBA championship win; Cleveland, OH; June 16, 2015

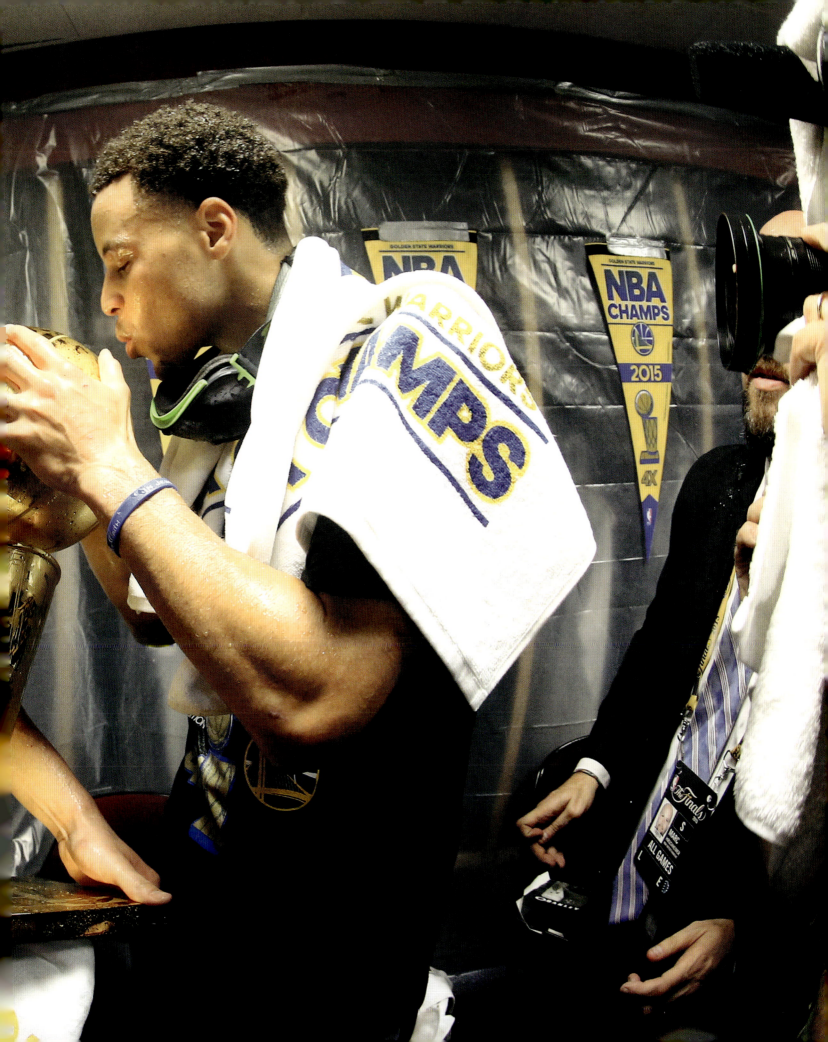

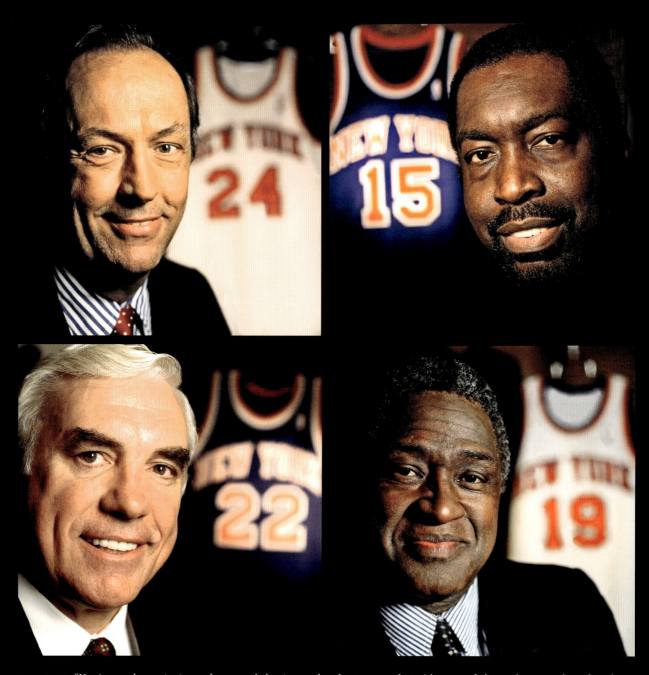

TOP RIGHT: "Yes, it was about winning and teamwork, but it was also about camaraderie. It's a great feeling to know you have friends, not just teammates but friends for so long, and it continues on. I was somewhat of an outsider because I played against these guys when I was with the Baltimore Bullets. I was traded to the New York Knicks, who were our mortal enemies at the time. Coming into the locker room that first day and being embraced by them meant a lot to me in terms of where I felt my career was going." —Earl Monroe

CLOCKWISE FROM TOP LEFT: Bill Bradley, Earl Monroe, Willis Reed, and Dave DeBusschere; New York Knicks; NBA at 50 portraits; Secaucus, NJ; 1996

"When I look at these photos, I think of family . . . always sharing, caring, that special bond, we still have it after fifty years! That's what made us champions—that type of togetherness, oneness, always communicating. Willis was the catalyst for it; he was the backbone of the team. I had so many positive role models on that team. We all loved Red Holzman; he was hard but fair and always got the best out of his players. He never saw color, and we always gave 110 percent."
—Walt "Clyde" Frazier

Walt "Clyde" Frazier; New York Knicks; NBA at 50 portraits; New York, NY; 1996

"Playing against Kobe was like no other! He was so talented, so fierce, so fearless. He made you want to be better! Even as a competitor, you had to respect him. He overachieved; he maxed out everything in life he put his mind to. He pushed you to work to be the best in whatever field you were in. And that to me is 'Mamba Mentality.'"
—Jamal Crawford

"My relationship with Kobe is everlasting; it's eternal. We're connected forever. What I remember most is his spirit and his soul and how he brought a lot of people together. I miss him every day. Shout-out to Black Mamba."
—Kyrie Irving

"Kobe's a brother to me. From the time I was in high school, watching him from afar to getting in this league at eighteen, watching him up close. All the battles we had throughout my career. The one thing that we always shared was that determination of just always wanting to win and just wanting to be great."
—LeBron James

"Kobe Bryant meant a lot to me. Especially his work ethic, seeing him show up in the gym at 5:30 a.m., leaving at 8 a.m. while everybody was just getting to the gym in the summertime. And I asked him what makes him so great, and he said, 'Preparation is what makes greatness.'"
—Metta World Peace

"Kobe is always somebody that I looked up to from afar. I followed his career closely, just because I had a tremendous amount of respect for him. I thought he was the complete package—from athleticism, killer instinct, skill. He had the will to win, and I always loved competing against him. In his prime, he was the one that I think was the greatest player that ever played. I always remember when he scored 62 points against us in three quarters, and we scored, what, 61 as a team? He was an absolute machine. We still miss him every day. May he rest in peace." —Dirk Nowitzki

Kobe Bryant; Los Angeles Lakers; All-Star portrait; Houston, TX; February 19, 2006

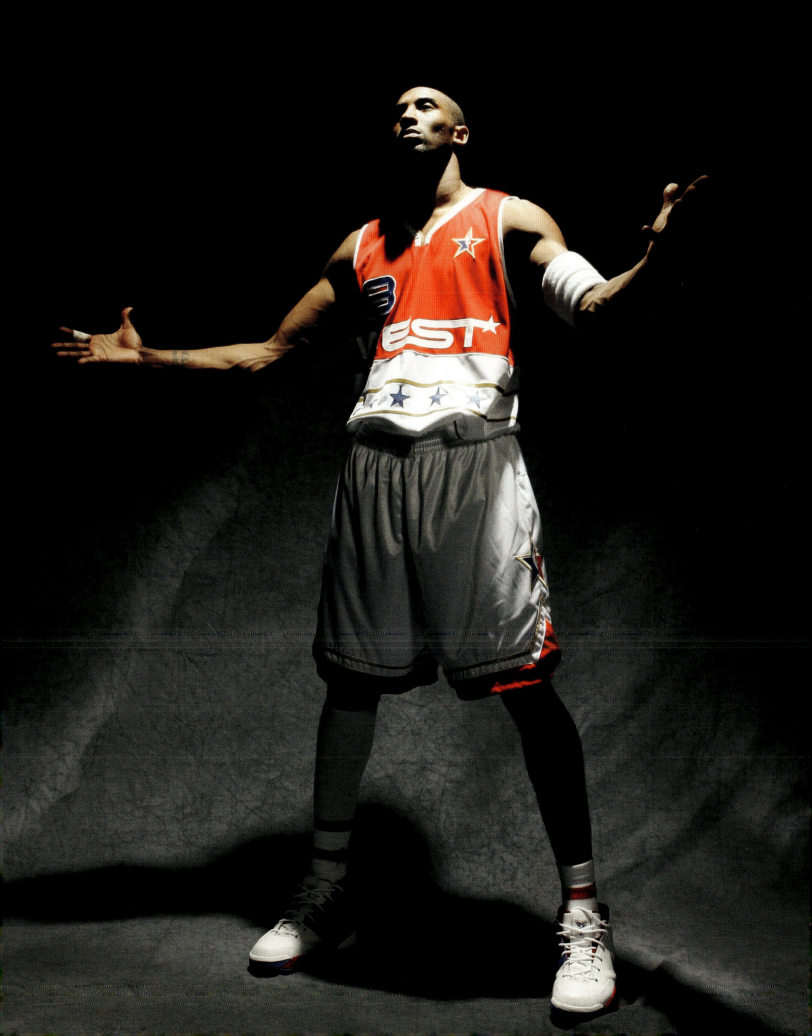

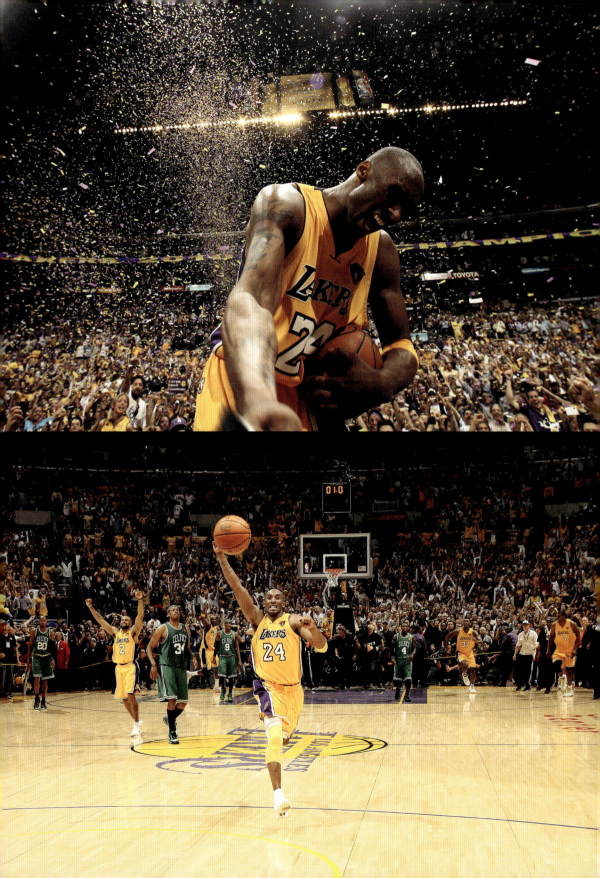

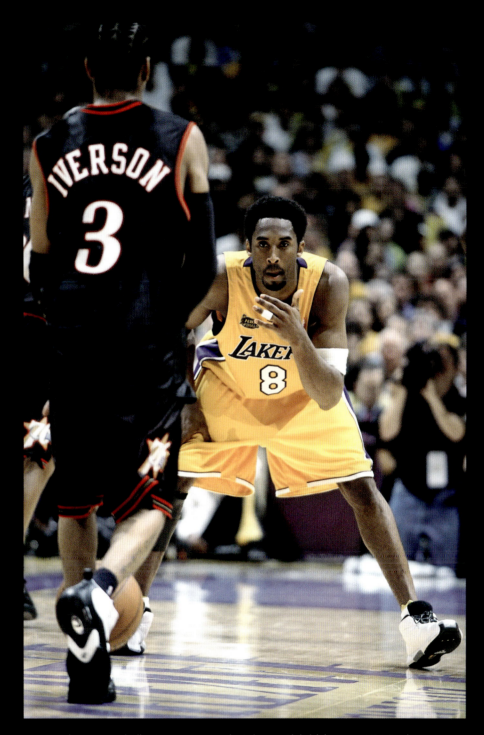

ABOVE: Kobe Bryant and Allen Iverson; Los Angeles Lakers vs. Philadelphia 76ers; NBA Finals; Los Angeles, CA; 2001

"When I see that photo, I just was relieved that finally I got my ring. I wanted to embrace Kobe first, because without him, I don't have a ring. And then it was off to partying after that."
—Metta World Peace

OPPOSITE (TOP & BOTTOM): Kobe Bryant; Los Angeles Lakers vs. Boston Celtics; Game 7 of the NBA Finals; NBA championship win; Los Angeles, CA; June 17, 2010

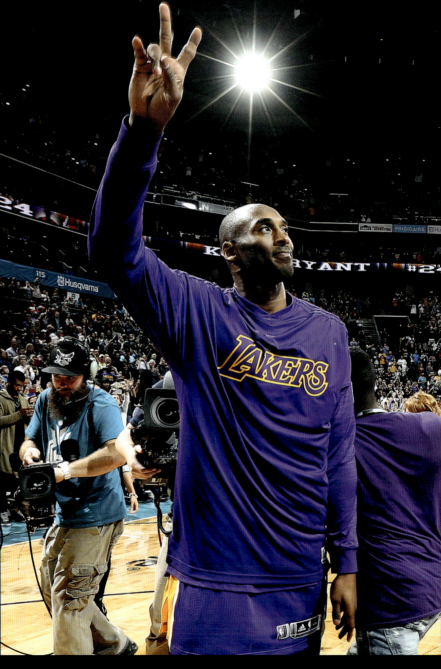

Kobe Bryant; Los Angeles Lakers vs. Charlotte Hornets; Charlotte, NC; December 28, 2015

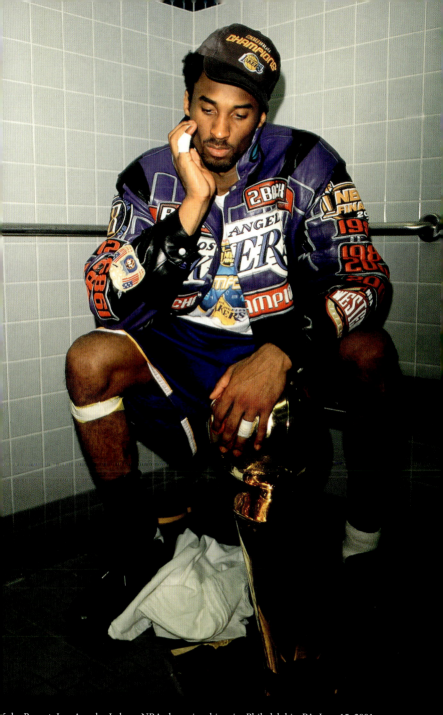

Kobe Bryant; Los Angeles Lakers; NBA championship win; Philadelphia, PA; June 15, 2001

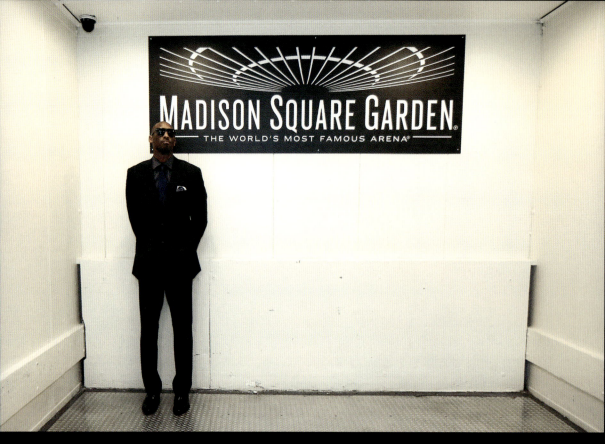

TOP: Kobe Bryant; Los Angeles Lakers; New York, NY; November 8, 2015
ABOVE: Kobe Bryant; Team USA; Las Vegas, NV; August 23, 2007

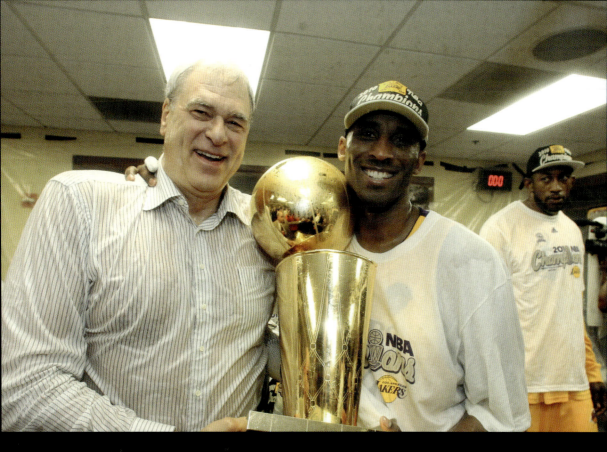

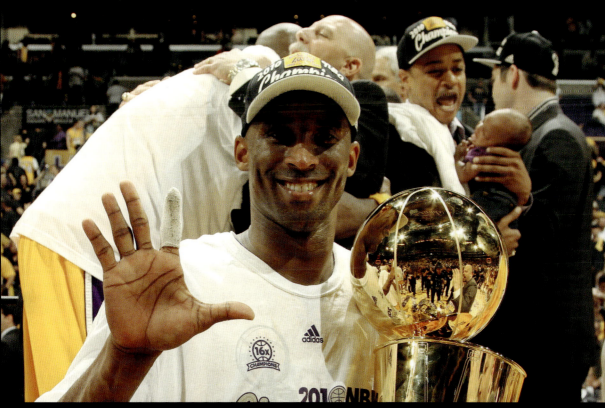

TOP: Phil Jackson and Kobe Bryant; Los Angeles Lakers; NBA championship win; Los Angeles, CA; June 17, 2010

ABOVE: Kobe Bryant; Los Angeles Lakers; NBA championship win; Los Angeles, CA; June 17, 2010—Kobe wins his fifth NBA championship.

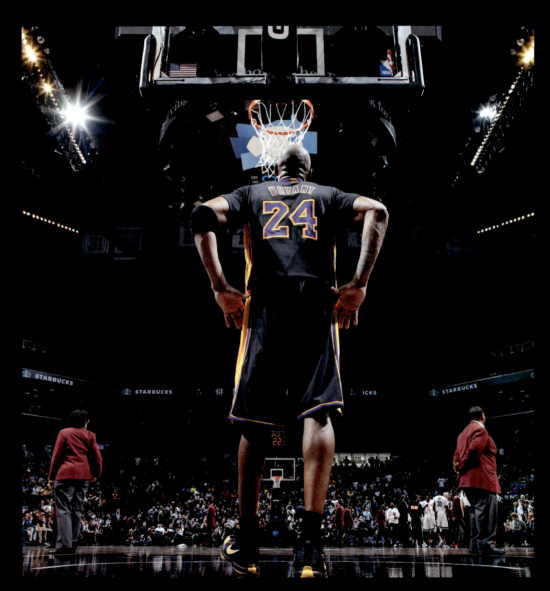

Kobe Bryant; Los Angeles Lakers vs. Brooklyn Nets; Brooklyn, NY; November 6, 2015

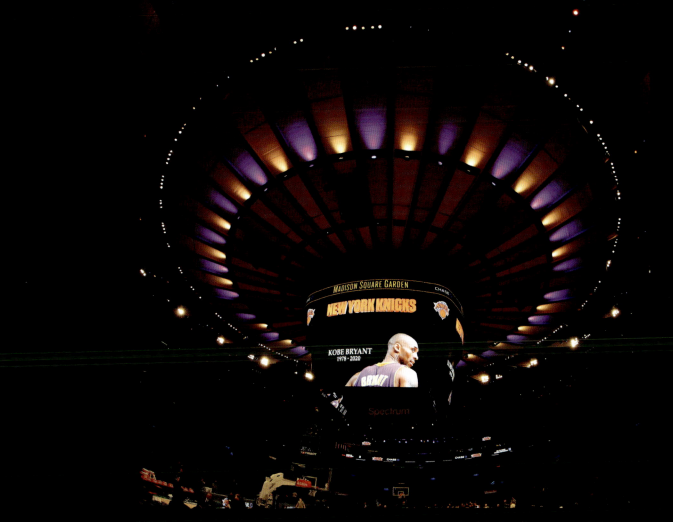

Kobe Bryant; Los Angeles Lakers; New York, NY; January 26, 2020—memorialized the day of his passing on the Madison Square Garden scoreboard

Cleveland, Ohio; January 28, 2020—NBA pays tribute to legendary Kobe Bryant after his sudden and tragic passing.

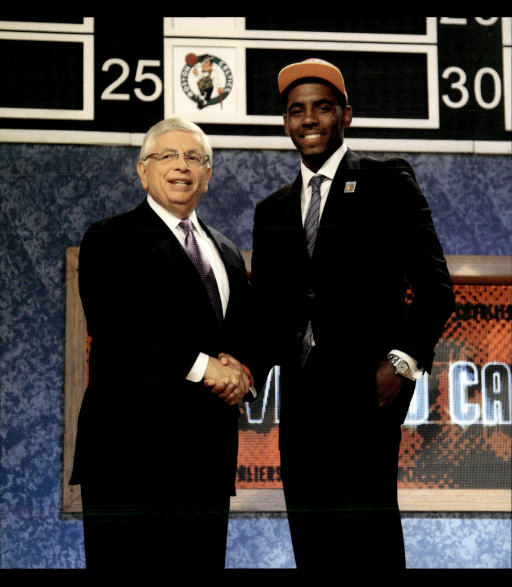

"*Rest in paradise, David Stern. To be able to shake his hand, on this stage, I was thinking,* Don't be nervous, make sure you look at the right cameras and bask in this moment because you are home. *This is one of those dreams-come-true moments that I will have forever and it will be part of my legacy that I can celebrate forever, because this is what jump-started my dream.*" —Kyrie Irving

ABOVE: Commissioner David Stern and Kyrie Irving; Prudential Center; Newark, NJ; June 23, 2011—Kyrie was selected number 1 overall by the Cleveland Cavaliers during the 2011 NBA Draft.

"*What's great about this is that right after winning the championship, I put 'Mood' and your picture of Kobe with the trophy on my Instagram. So when someone made this piece for me, the only thing I was thinking about was commemorating Kobe, and I knew that this was going to be a remembrance game because, on January 26, 2020, we were here at MSG when I got the call pregame that Kobe, GiGi, and the rest had transitioned. I wanted this to be not only about Kobe, but all of the families that were lost that day. It gave me more motivation to continue on.*" —Kyrie Irving

OPPOSITE: Kyrie Irving; Brooklyn Nets; New York, NY; April 6, 2022

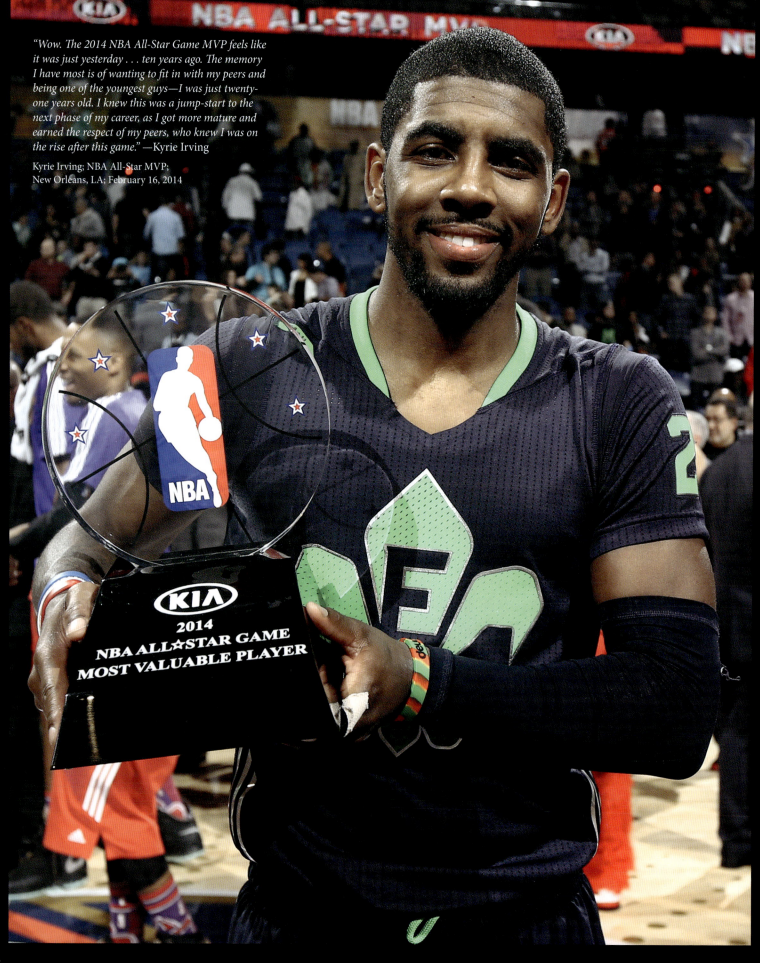

"Wow. The 2014 NBA All-Star Game MVP feels like it was just yesterday . . . ten years ago. The memory I have most is of wanting to fit in with my peers and being one of the youngest guys—I was just twenty-one years old. I knew this was a jump-start to the next phase of my career, as I got more mature and earned the respect of my peers, who knew I was on the rise after this game." —Kyrie Irving

Kyrie Irving; NBA All-Star MVP;
New Orleans, LA; February 16, 2014

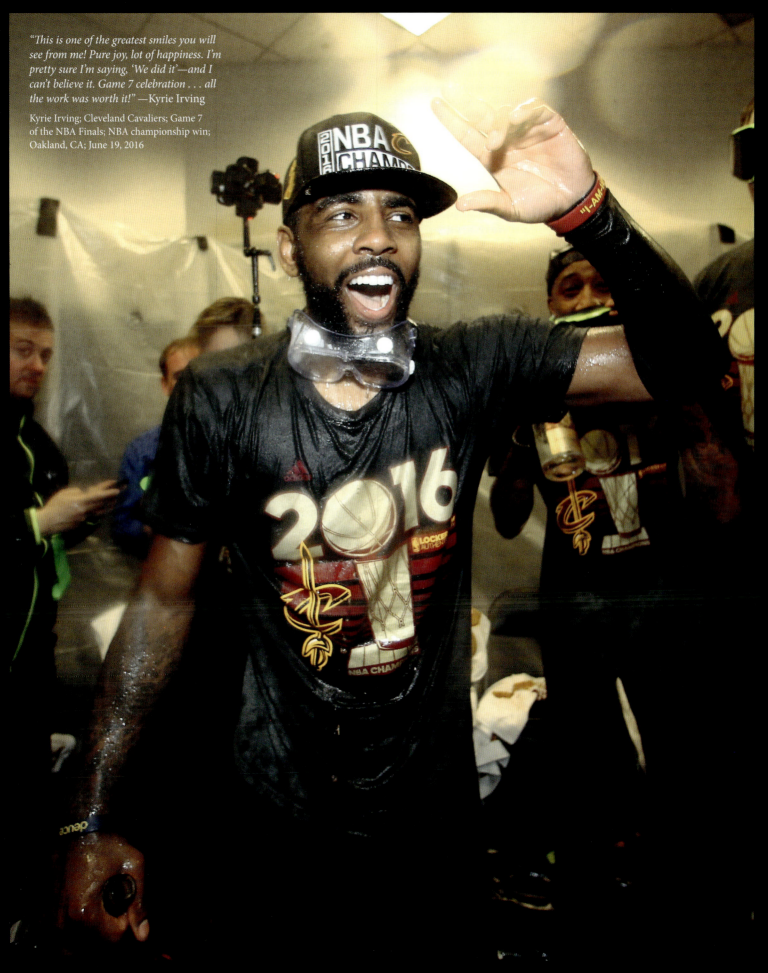

"This is one of the greatest smiles you will see from me! Pure joy, lot of happiness. I'm pretty sure I'm saying, 'We did it'—and I can't believe it. Game 7 celebration . . . all the work was worth it!" —Kyrie Irving

Kyrie Irving; Cleveland Cavaliers; Game 7 of the NBA Finals; NBA championship win; Oakland, CA; June 19, 2016

"This is the epitome of the 10,000-hours rule. Working in the shadows, in the dark, before you actually get to showcase who you are in front of millions, sometimes billions of people—this is the work that doesn't get seen or appreciated. But when you're trying to be one of the greatest of all time, these are the hours that you put in . . . and that no one sees." —Kyrie Irving

Kyrie Irving; Brooklyn Nets; Brooklyn, NY; April 7, 2021—warming up pregame

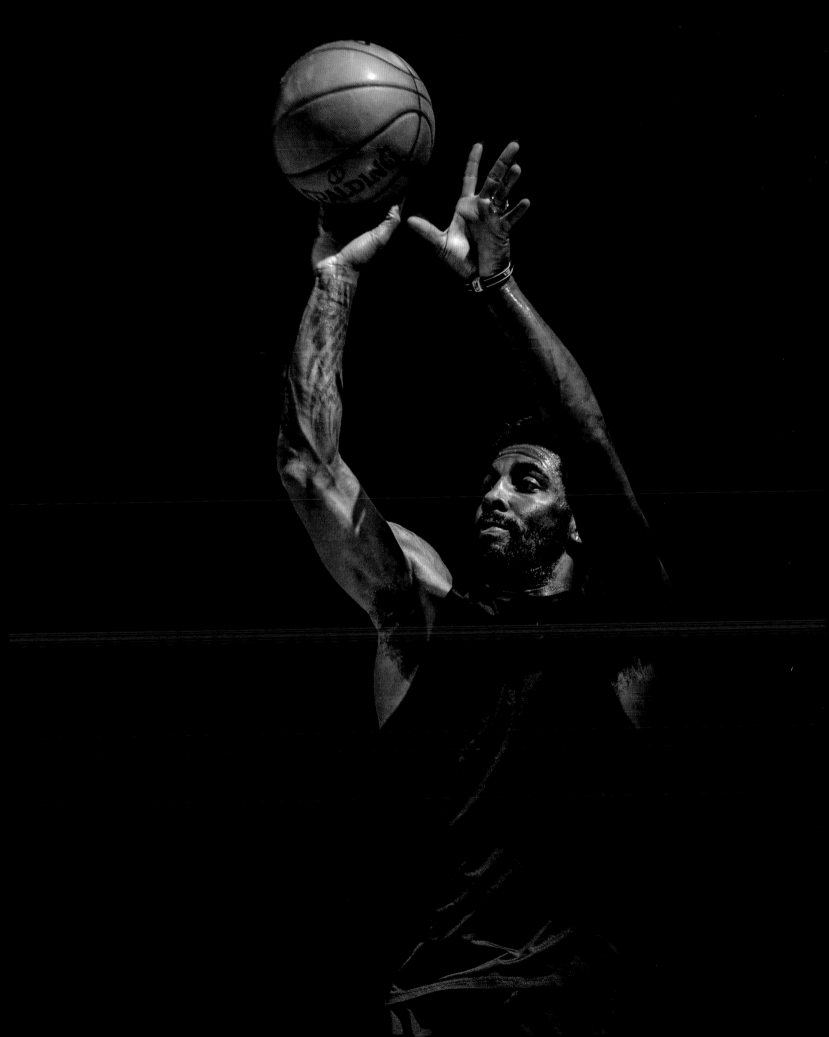

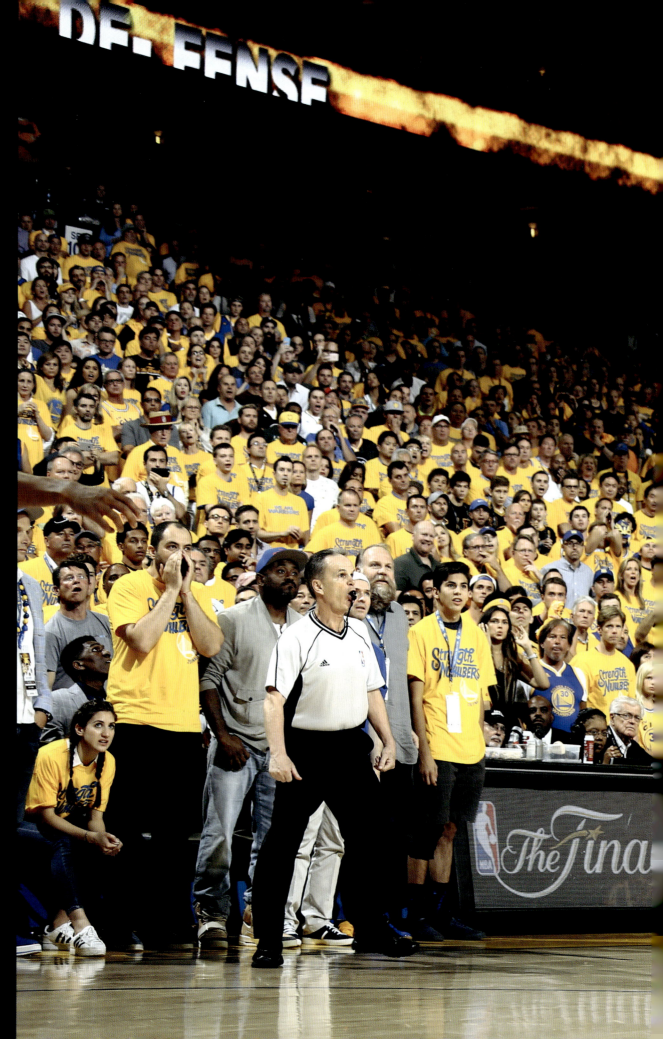

"Every time I look at this shot, it reminds me of how much hard work went into it . . . how many things had to go the right way. We had to be lucky to get to this moment, to be honest; they were playing so well. For me, I just wanted to get my right elbow tucked and follow through . . . this was one of those moments that helped define a big part of my career."
—Kyrie Irving

"This takes me back to Cleveland. It takes me back to a championship. I didn't know Kyrie was going to take that step-back 3. We wanted to get the switch with Steph and let him attack, but once he got into his rhythm and his step back, I was like, 'Oh, shit!' And then he made one of the biggest shots in NBA history. That shot right there changed people's careers. It changed the city of Cleveland, the state of Ohio. It changed a lot of careers—every different aspect of mine, from LeBron's to Kyrie's, to K-Love, RJ, Channing Frye, Griff, the whole organization. It was arguably the biggest Game 7 shot in NBA history!"
—Tyronn Lue

Kyrie Irving and Stephen Curry; Cleveland Cavaliers vs. Golden State Warriors; Game 7 of the NBA Finals; Oakland, CA; June 19, 2016

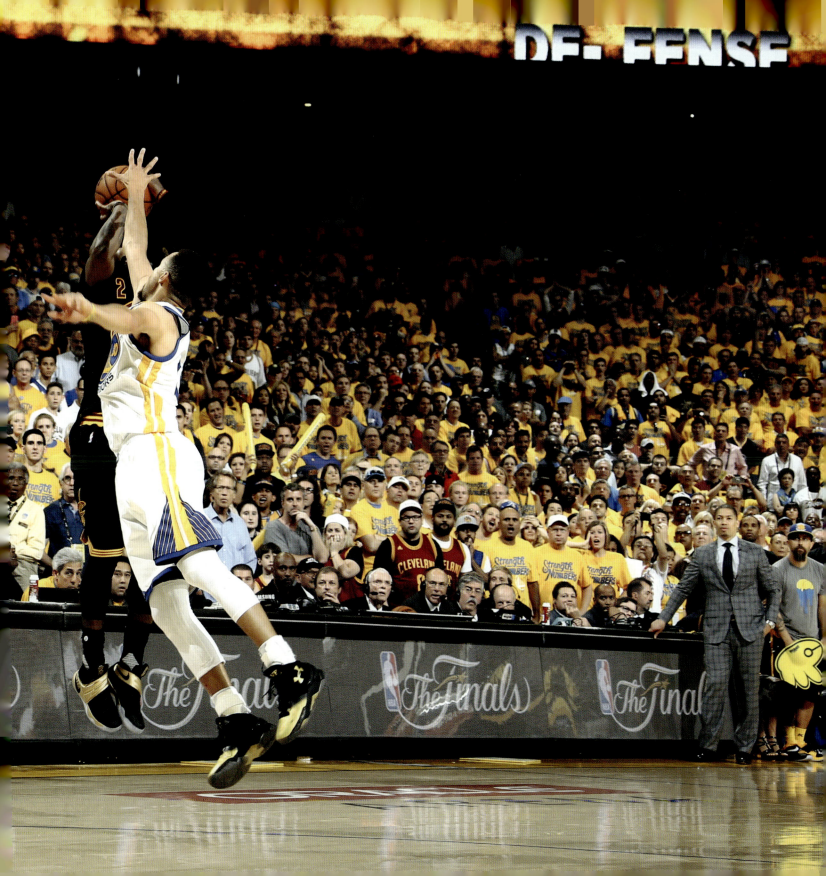

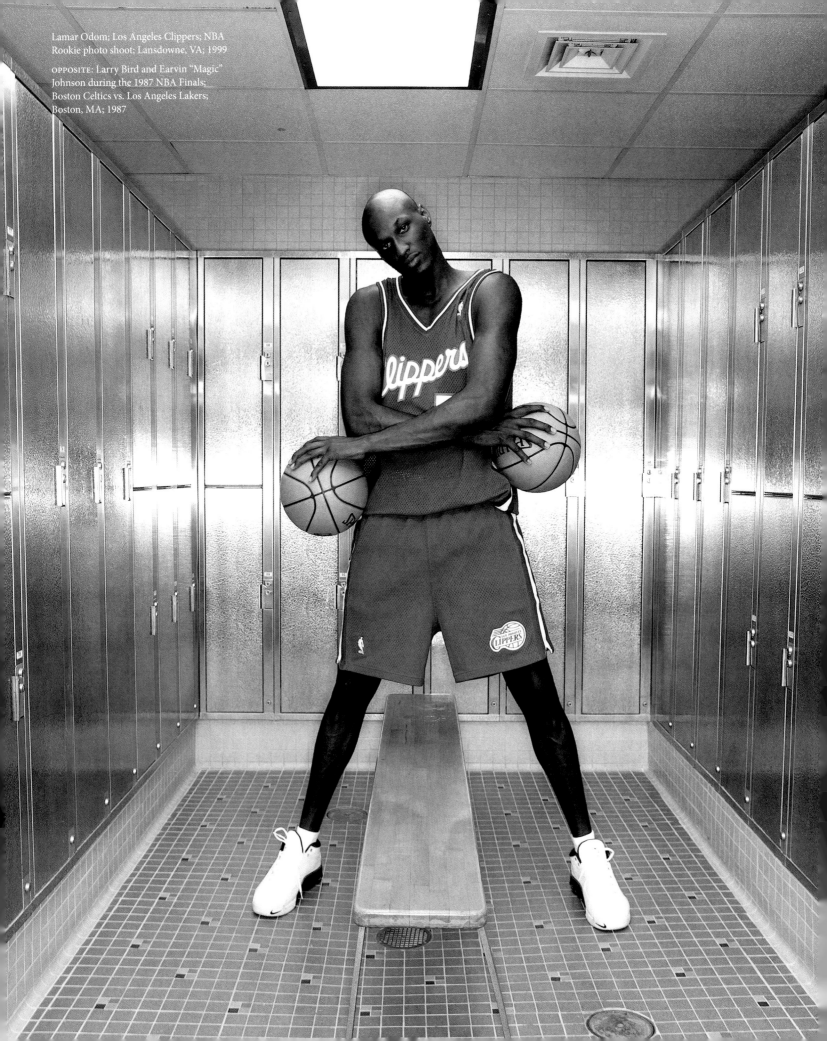

Lamar Odom; Los Angeles Clippers; NBA Rookie photo shoot; Lansdowne, VA; 1999

OPPOSITE: Larry Bird and Earvin "Magic" Johnson during the 1987 NBA Finals; Boston Celtics vs. Los Angeles Lakers; Boston, MA; 1987

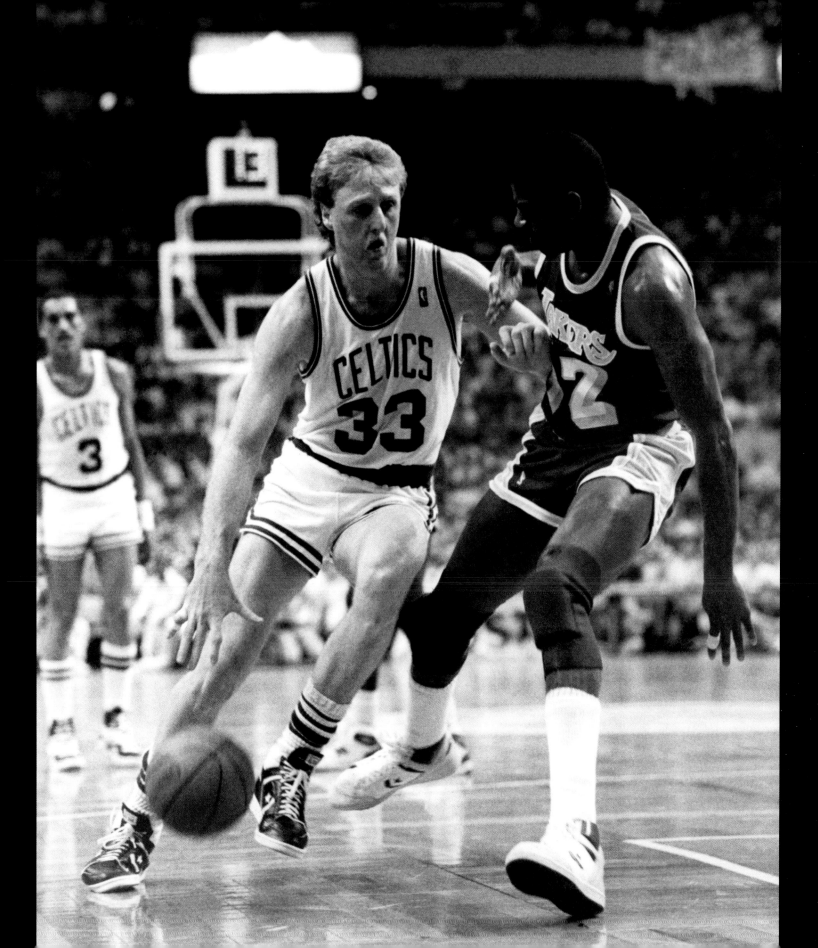

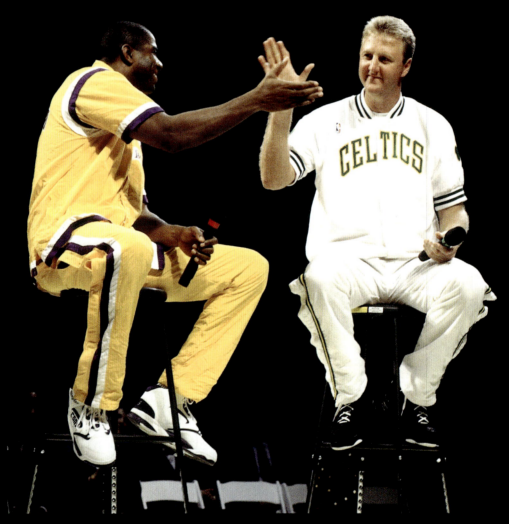

ABOVE: Earvin "Magic" Johnson (Los Angeles Lakers) and Larry Bird (Boston Celtics); Larry Bird Night; Boston, MA; February 4, 1993

"My life in college was playing pickup basketball, writing columns, eating unhealthy food, trying not to screw things up with girls, doing regrettable things with my friends . . . and then every so often, I went to The Garden and watched the Living Legend jog by me." —Bill Simmons

OPPOSITE: Larry Bird, stepping onto the Boston Garden floor for the final time; Boston Celtics vs. Cleveland Cavaliers; Boston, MA; May 15, 1992

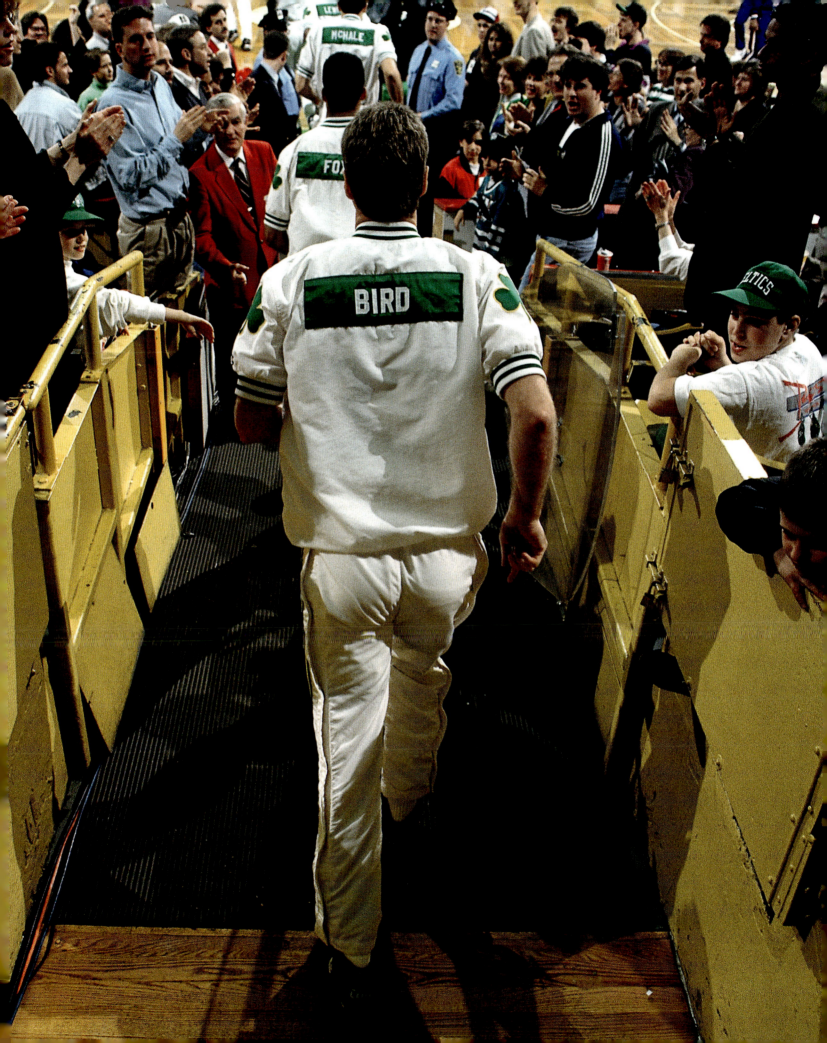

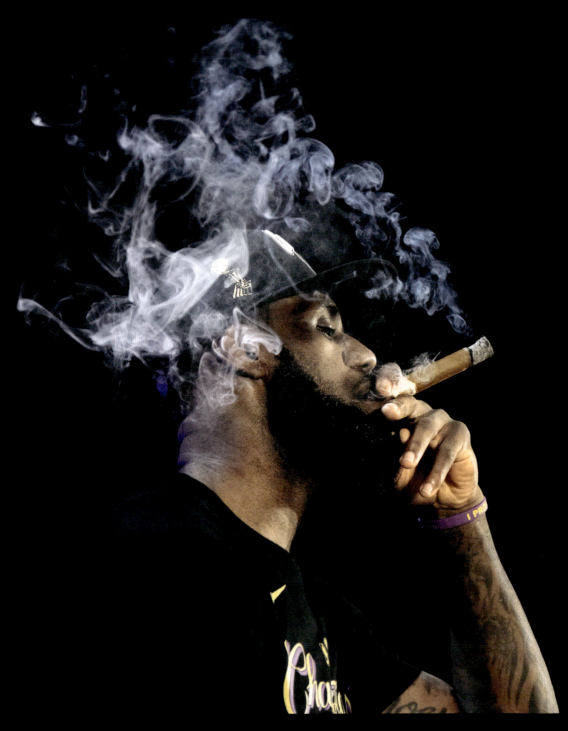

"Gratification. Satisfaction. And the job is done. Obviously, when you win it all, you're just enjoying that moment, man. Because it doesn't happen all the time. I've been a part of this thing for two decades, and I've had four of those moments. So, just taking it all in." —LeBron James

LeBron James celebrates with a victory cigar after winning his fourth NBA championship; Los Angeles Lakers; NBA championship win; Orlando, FL; October 11, 2020

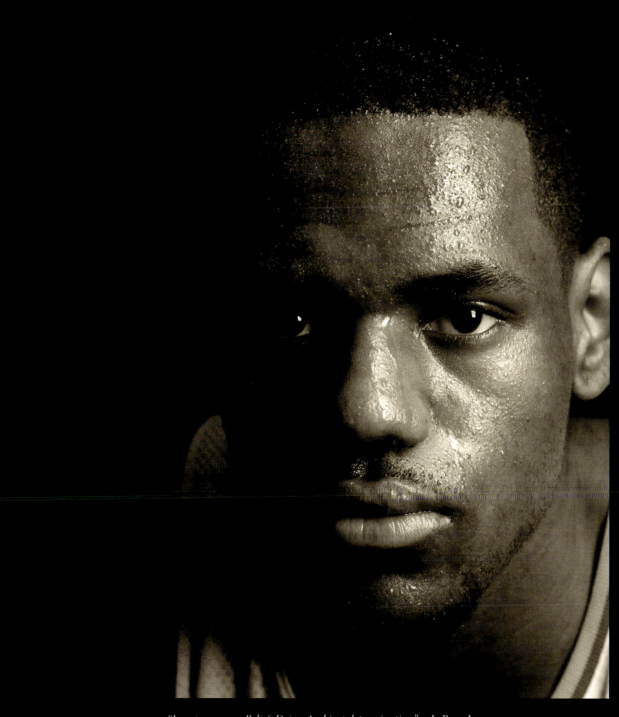

"I see innocence. Belief. Drive. And just determination." —LeBron James

LeBron James; Cleveland Cavaliers; Cleveland Cavaliers Media Day; Cleveland, OH; October 3, 2003

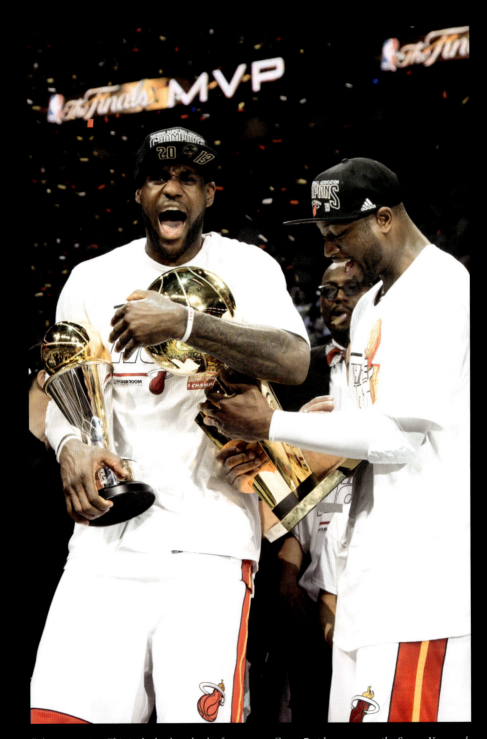

"This is pure joy. This is the back-to-back after we won Game 7 at home versus the Spurs. You work hard all year to be able to have this moment, and this is just pure happiness." —LeBron James

LeBron James and Dwyane Wade; Miami Heat; Game 7 of the NBA Finals; NBA championship win; Miami, FL; June 20, 2013

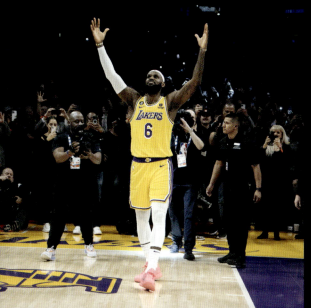
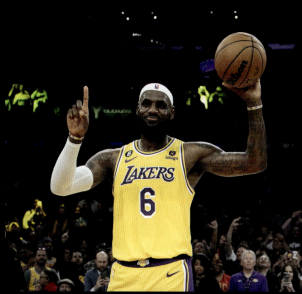
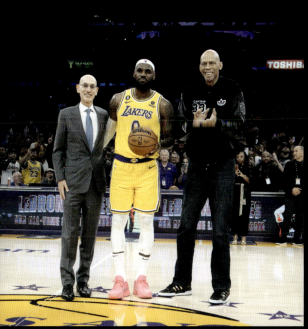
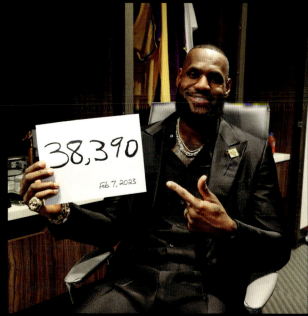

"This is like . . . I don't even understand it. I'm not the all-time leading scorer in Ohio high school history. I never thought about being the leading scorer of anything. So to be the all-time leading scorer in NBA history, it's like, what the heck? It doesn't sink in. But to be here with the Captain, and to be here with the Commish, and having this moment with my whole family and friends here, it was pretty unique." —LeBron James

LeBron James; Los Angeles Lakers; Los Angeles, CA; February 7, 2023—breaks the All-Time NBA Scoring Record; (BOTTOM LEFT) LeBron James, Commissioner Adam Silver, and Kareem Abdul-Jabbar

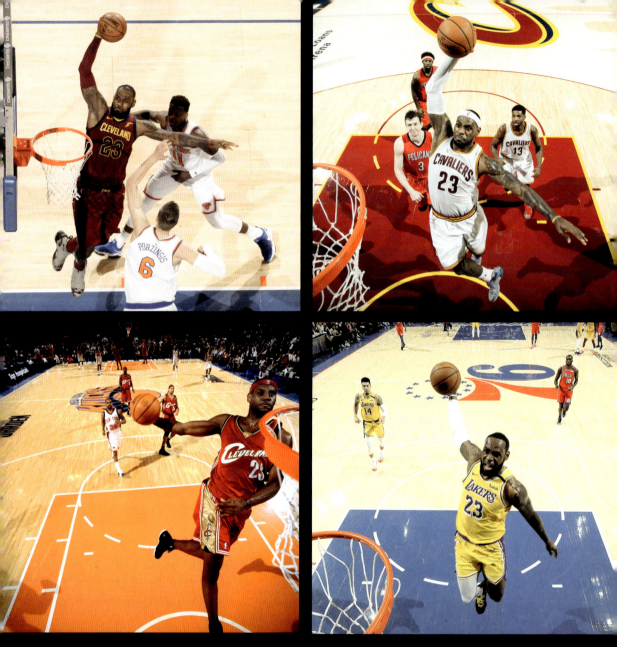

CLOCKWISE FROM TOP LEFT: LeBron James and Kristaps Porzingis; Cleveland Cavaliers vs. New York Knicks; New York, NY; November 13, 2017 • LeBron James; Cleveland Cavaliers vs. New Orleans Pelicans; Cleveland, OH; November 10, 2014 • LeBron James; Los Angeles Lakers vs. Philadelphia 76ers; Philadelphia, PA; January 25, 2020 • LeBron James; Cleveland Cavaliers vs. New York Knicks; New York, NY; April 14, 2004

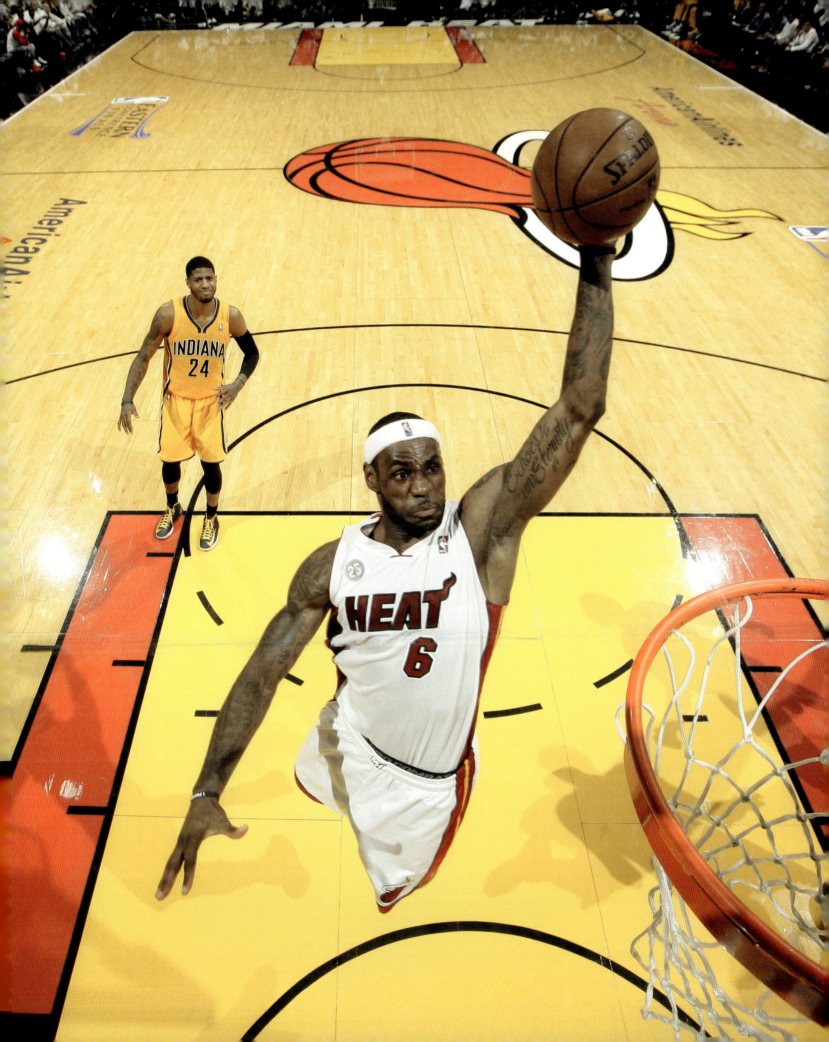

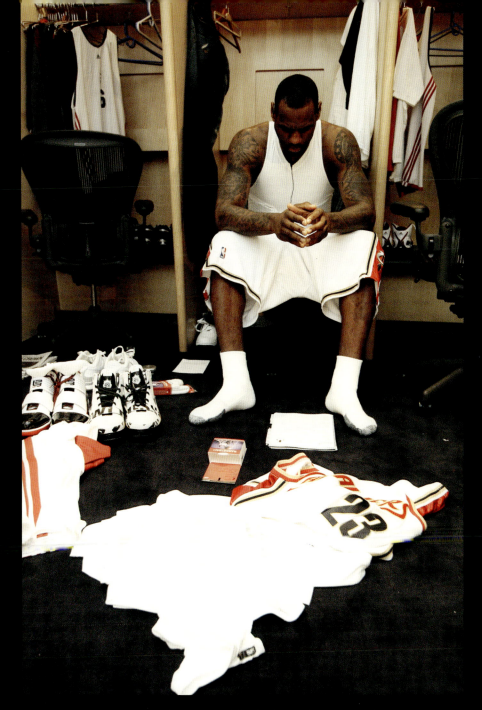

"People always think I'm lying when I say stuff like this, but, yeah, I set my uniform out from time to time because of Deion [Sanders]. I saw it one time when Deion was playing for the Niners before one of their Super Bowl games, and his whole uniform was laid out, and you saw him, had the VHS player in the background, had the film going, and you could see he was just super-duper locked in, and this is one of those moments for me. I just thought about Prime and getting ready for that moment." —LeBron James

ABOVE: LeBron James; Cleveland Cavaliers; Cleveland, OH; May 5, 2009

OPPOSITE: LeBron James; Los Angeles Lakers; Los Angeles, CA; February 7, 2023

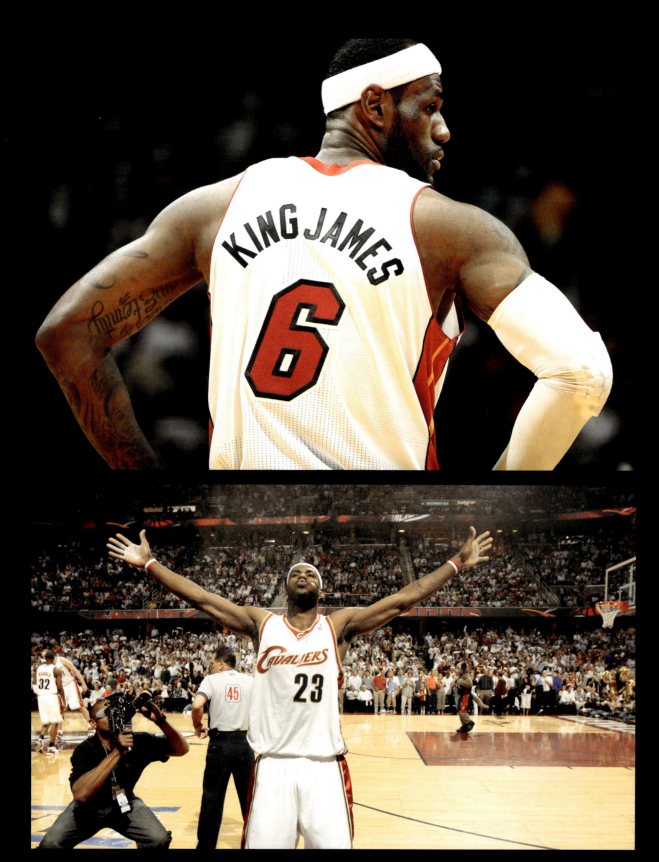

"I hope the league goes back to this at some point. Nickname jerseys were pretty cool. I thought it brought some creative juice to the league, and for us to have that moment when I got to represent my nickname in this sport, it was pretty cool." —LeBron James

TOP: LeBron James; Miami Heat vs. Brooklyn Nets; Miami, FL; April 8, 2014

ABOVE: LeBron James; Cleveland Cavaliers vs. Washington Wizards; Cleveland, OH; May 3, 2006

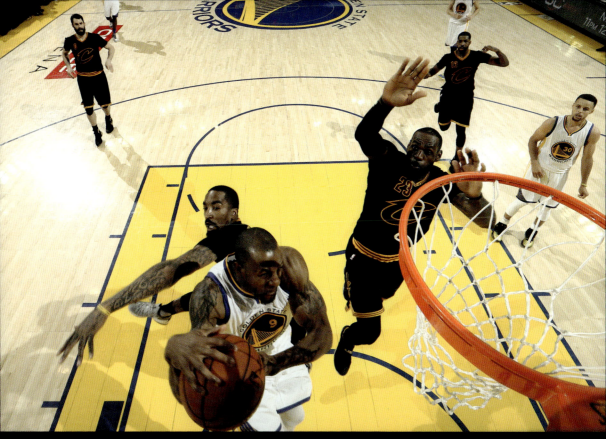

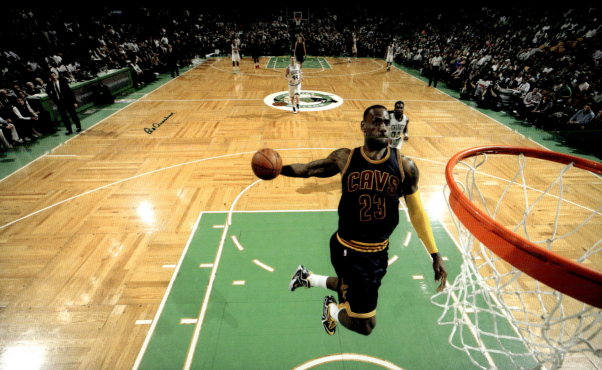

"This is one of the most iconic moments in NBA history. The chase-down block. One of my signature defensive plays, but it happened in one of the most pivotal moments in NBA history, in Finals history. To be able to get back in transition and not goaltend, not foul, and make that play—that was dope." —LeBron James

TOP: LeBron James and Andre Iguodala; Cleveland Cavaliers vs. Golden State Warriors; Game 7 of the NBA Finals; Oakland, CA; June 19, 2016— the memorable chase down block of Andre Iguodala to help seal the win

ABOVE: LeBron James; Cleveland Cavaliers vs. Boston Celtics; Boston, MA; April 23, 2015

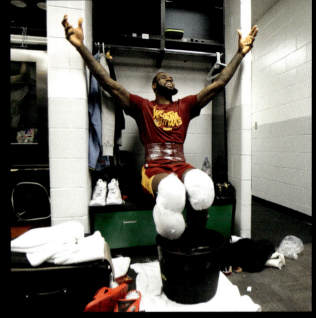
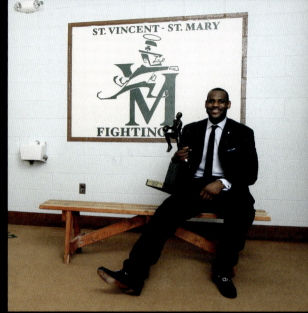

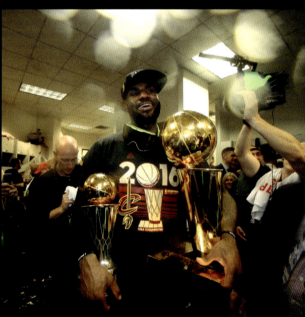

BOTTOM LEFT: "This is pretty cool. I've seen this photo a few times of me coming into New York. I've always had the aspiration of wanting to be the greatest of all time. That's just been one of my personal goals. You're always going to have barbershop talks and everyone is going to have their opinion on who they believe it is, but that's just my personal vice." —LeBron James

CLOCKWISE FROM TOP LEFT: LeBron James celebrates advancing to his eighth straight NBA Finals; Cleveland Cavaliers vs. Boston Celtics; Boston, MA; May 27, 2018 • LeBron James; Akron, OH; May 4, 2009—receives first NBA MVP at St. Vincent–St. Mary High School • LeBron James; Cleveland Cavaliers; Game 7 of the NBA Finals; NBA championship win; Oakland, CA; June 19, 2016 • LeBron James; Los Angeles Lakers; Brooklyn, NY; January 23, 2020

"Obviously there was a lot of stuff that happened in that summer and in that fall. It was very important that we, as the players, continue to have that message going if we were going to get back to playing. And the great thing about Adam Silver, he always listened to us, listened to me. For us to continue to highlight that during a very difficult time in America . . . for us Black athletes and Black people, we wanted to highlight that every single night we stepped onto the floor—understanding that basketball is important, but people's lives are even more important. To be a part of that movement was great." —LeBron James

OPPOSITE: LeBron James; Los Angeles Lakers; Orlando, FL; September 6, 2020

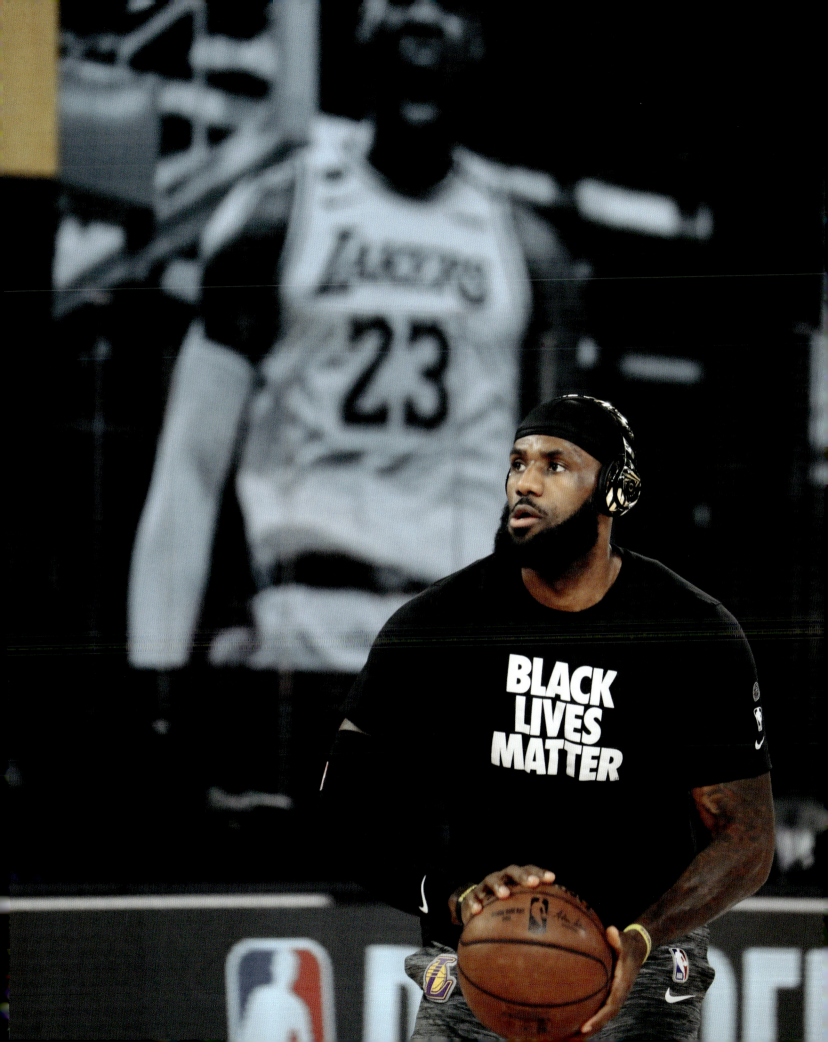

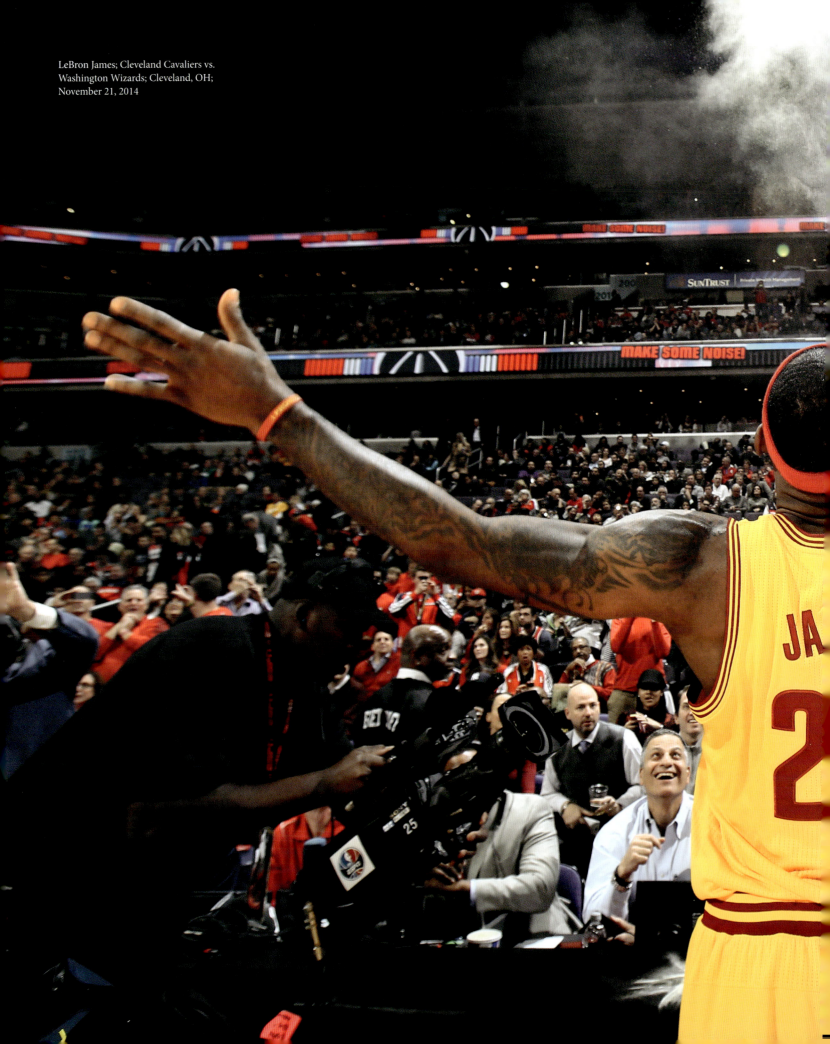

LeBron James; Cleveland Cavaliers vs. Washington Wizards; Cleveland, OH; November 21, 2014

"I enjoy every day playing basketball. It's always amazing being at The Garden—the most famous arena, so I'm happy to just be able to play there." —Luka Dončić

THIS SPREAD: Luka Dončić; Dallas Mavericks vs. New York Knicks; New York, NY; November 14, 2019

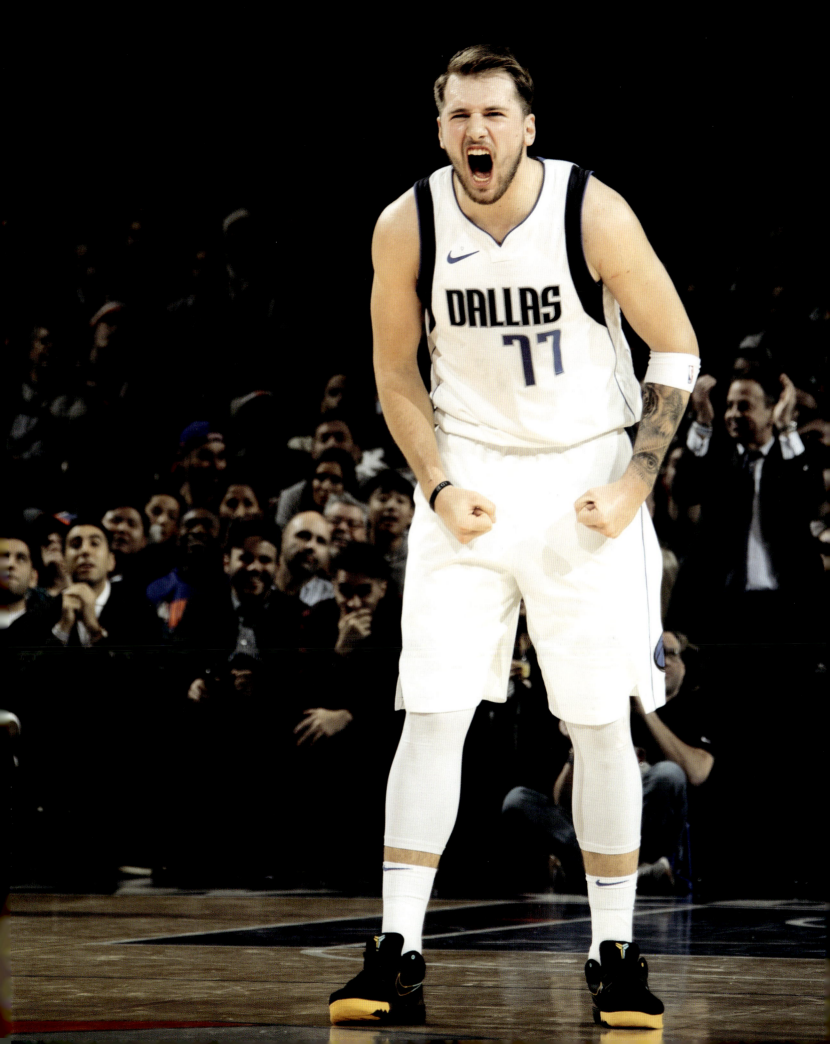

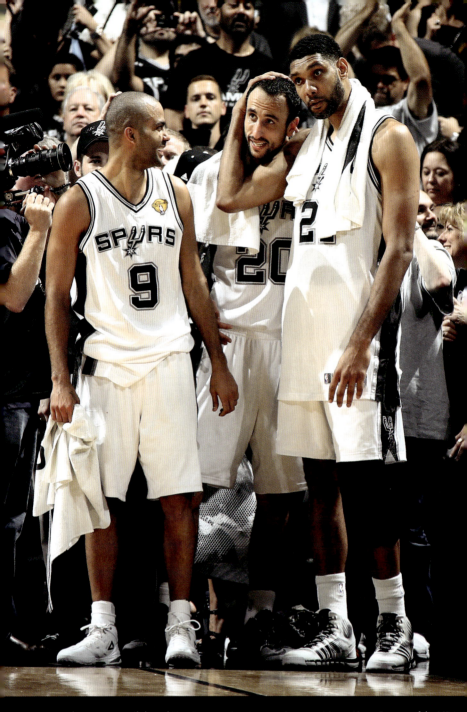

ABOVE: Tony Parker, Manu Ginóbili, and Tim Duncan; San Antonio Spurs vs. Miami Heat; Game 5 of the NBA Finals; San Antonio, TX; June 15, 2014

"Damn, makes me think of getting my shot blocked. Why do you think my arm is so far out? Playing against a guy like Manute Bol, people didn't realize he can really shoot the 3. So he was a very versatile guy just from being how tall he was. But he was very competitive. I mean, anytime somebody grows up fighting lions, I mean, come on. He's got all the dog in him." —Derrick Coleman

"Pretty cool picture. I'm sure he got the block on that play. [My dad is] where I get it from, as well."
—Bol Bol

OPPOSITE: Manute Bol and Derrick Coleman; Philadelphia 76ers vs. New Jersey Nets; East Rutherford, NJ; 1990

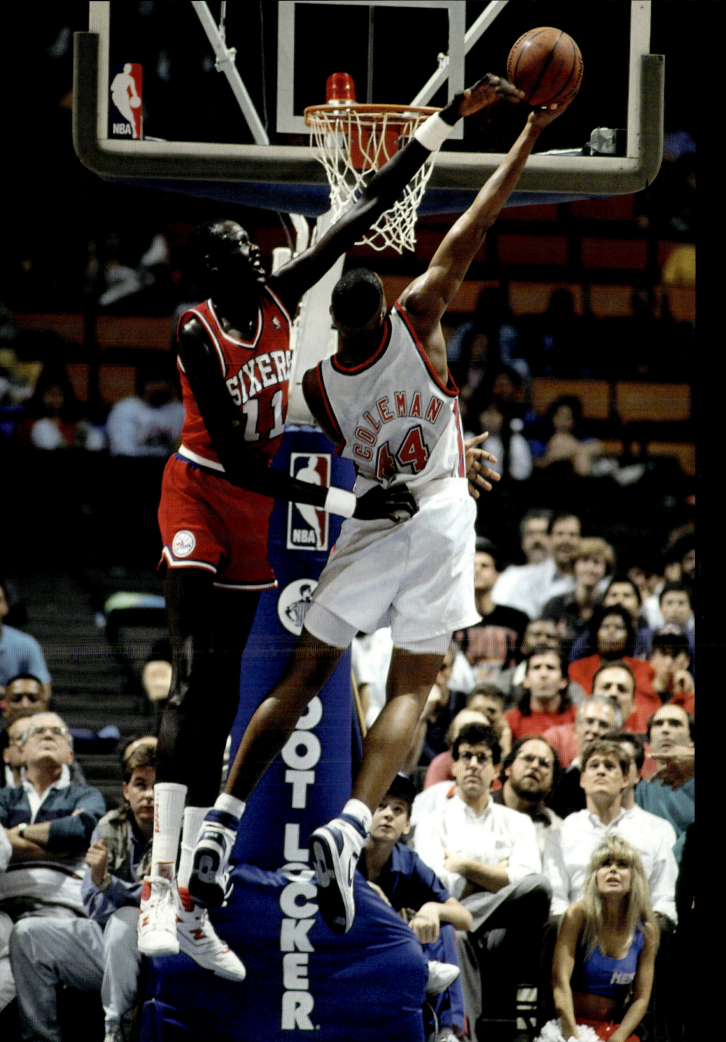

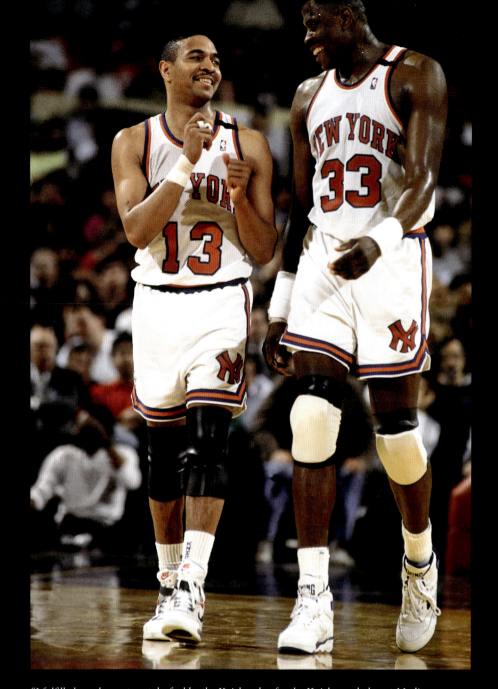

"I fulfilled my dream to get drafted by the Knicks, play for the Knicks, and play at Madison Square Garden alongside Patrick Ewing, who, in my opinion, was the greatest Knick of all time. Two players living out their dreams . . ." —Mark Jackson

ABOVE: Mark Jackson and Patrick Ewing; New York Knicks; New York, NY; 1990

"In my dream the night before, this was a dunk! I have mad respect for not only Michael and Scottie, but their entire supporting cast. The Bulls had sustained greatness, and without them in my path, I would have won two championships—one in New York, and one in Indy . . ." —Mark Jackson

OPPOSITE: Mark Jackson, Michael Jordan, and Scottie Pippen; Indiana Pacers vs. Chicago Bulls; Indianapolis, IN; May 25, 1998

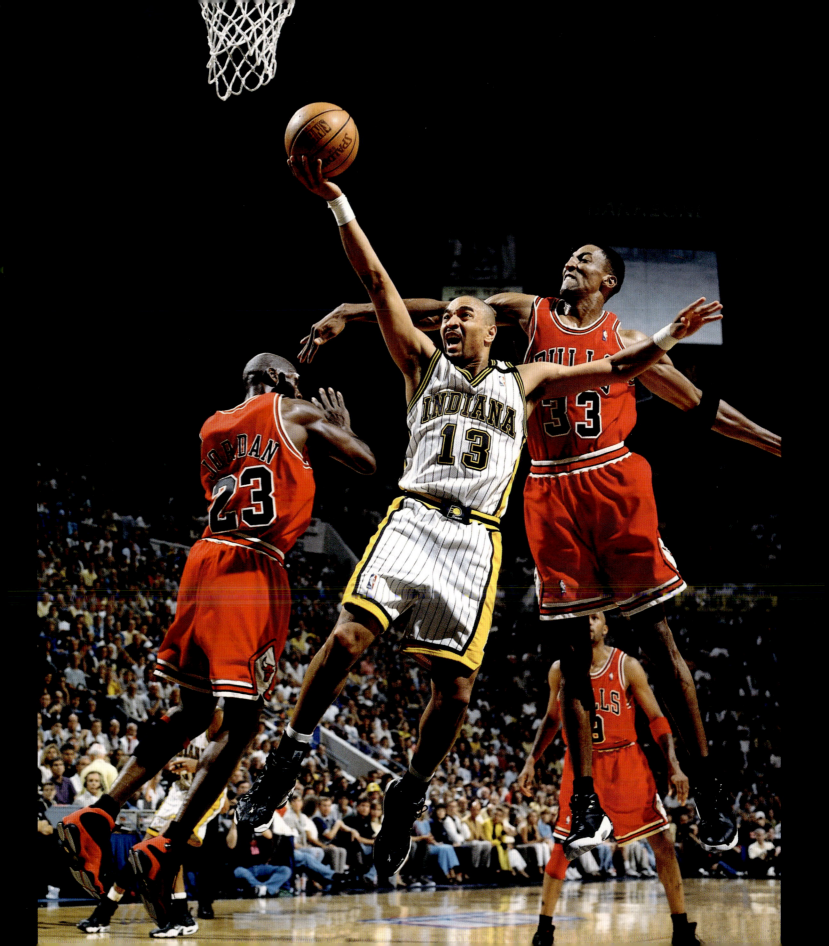

"I often like to joke and say that Michael and I were in the same rookie class, 1984. It's impossible to sum up the influence he has had on me in a few sentences or a selection of photographs. I am forever grateful and so fortunate to have been there through it all—there are so many wonderful memories from six championships and the 1992 Barcelona Olympics, in particular, which helped shape me both personally and professionally. For ALL of us basketball fans, I thank you." —Nathaniel S. Butler

ABOVE: Michael Jordan; Chicago Bulls vs. New York Knicks; New York, NY; March 10, 1996

OPPOSITE: Michael Jordan; Chicago Bulls vs. Utah Jazz; Game 6 of the NBA Finals; NBA championship win; Salt Lake City, UT; June 14, 1998—wins his sixth NBA championship

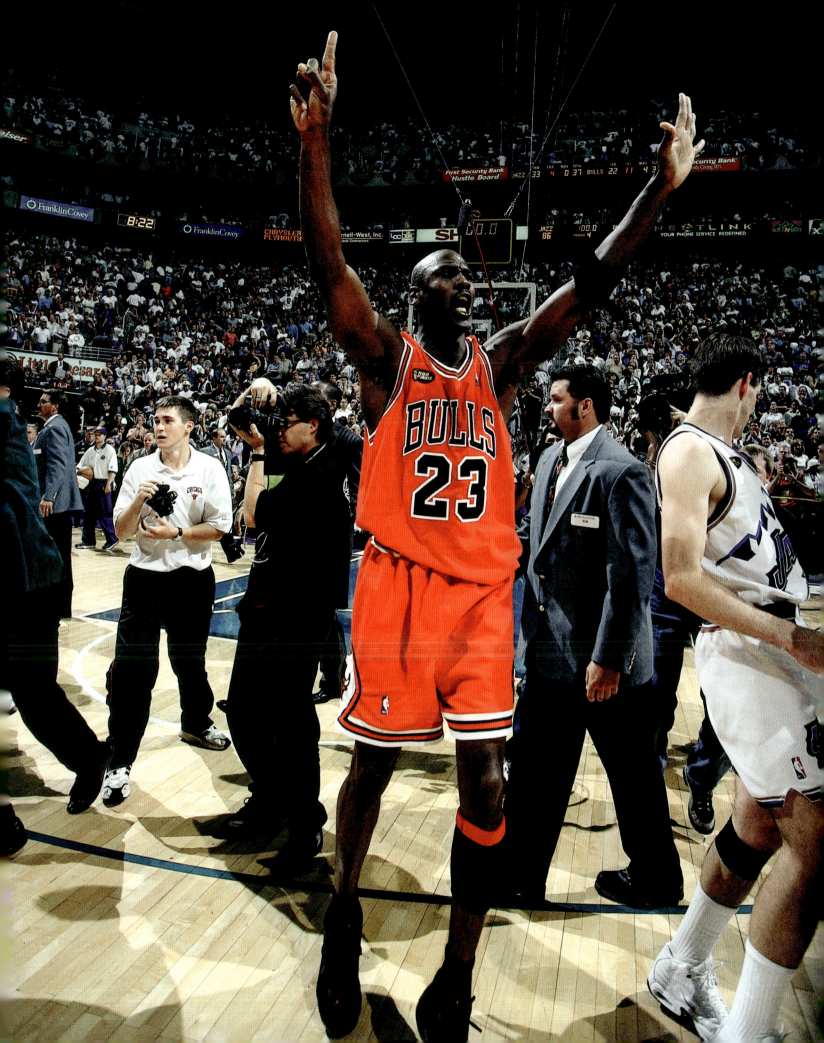

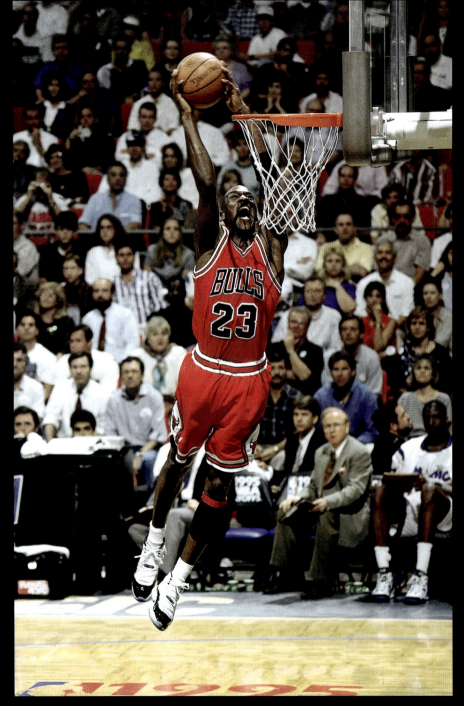

Michael Jordan; Chicago Bulls vs. Orlando Magic; Orlando, FL; May 10, 1995

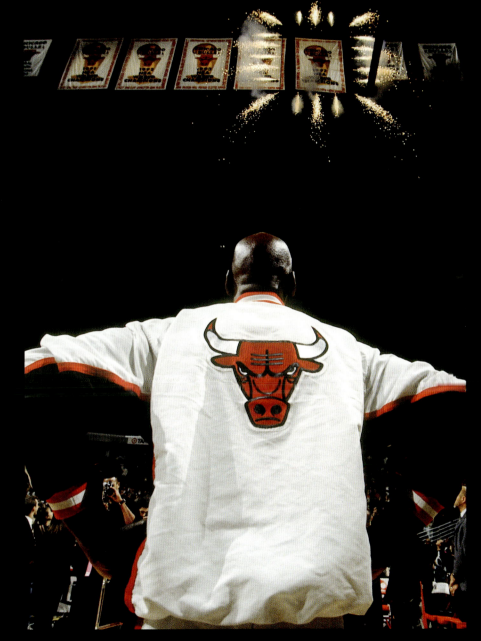

Michael Jordan watches as the fifth championship banner is raised; Chicago Bulls; Ring Night; Chicago, IL; November 1, 1997

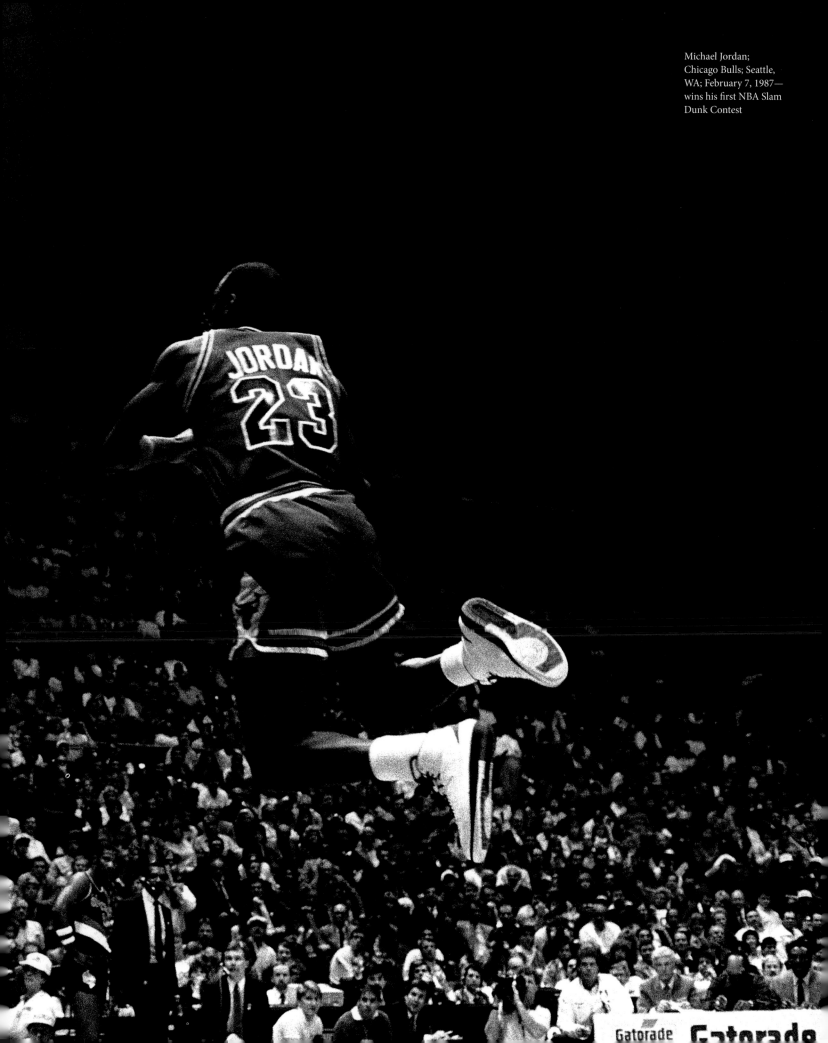

Michael Jordan; Chicago Bulls; Seattle, WA; February 7, 1987—wins his first NBA Slam Dunk Contest

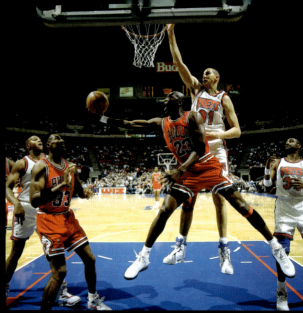
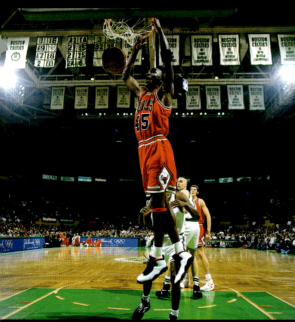
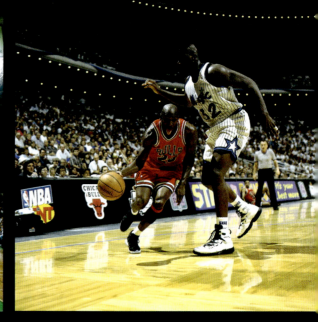

CLOCKWISE FROM TOP LEFT: Michael Jordan and John Starks; Chicago Bulls vs. New York Knicks; Chicago, IL; 1993 • Michael Jordan and Sam Bowie; Chicago Bulls vs. New Jersey Nets; East Rutherford, NJ; 1993 • Michael Jordan and Shaquille O'Neal; Chicago Bulls vs. Orlando Magic; Orlando, FL; May 16, 1995 • Michael Jordan; Chicago Bulls vs. Boston Celtics; Boston, MA; March 22, 1995

OPPOSITE: Michael Jordan and Otis Smith; Chicago Bulls vs. Orlando Magic; Orlando, FL; February 14, 1990—Michael Jordan wears the number 12

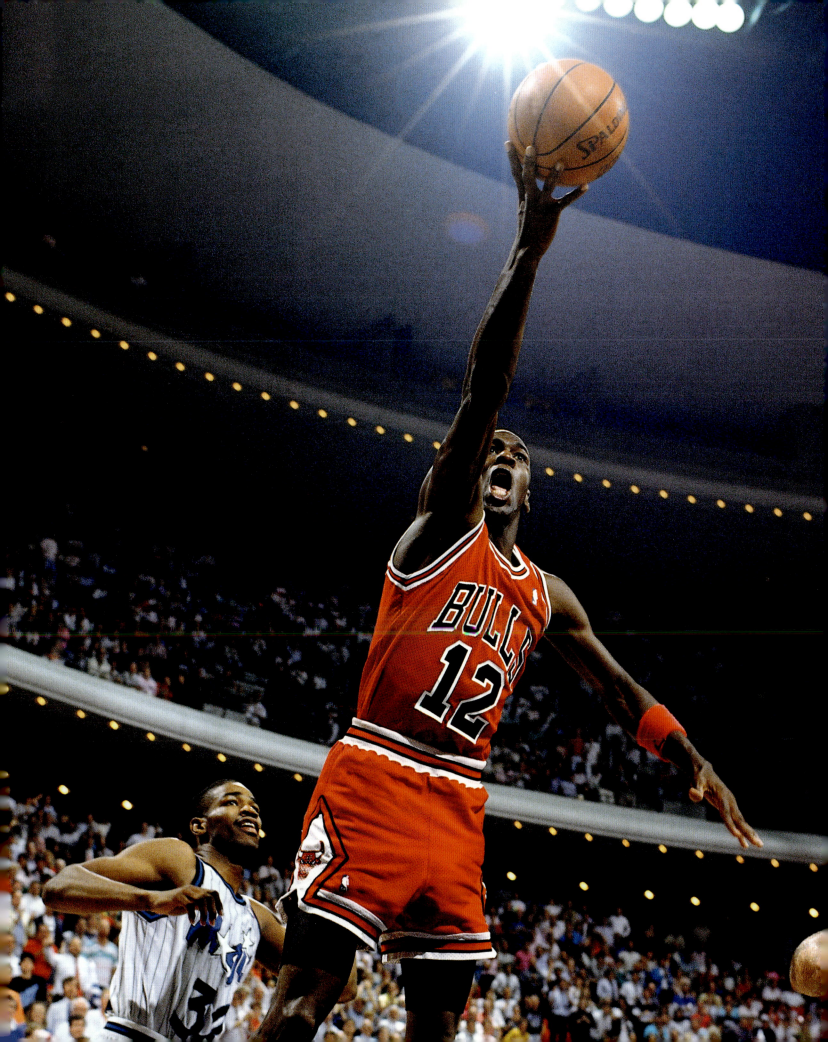

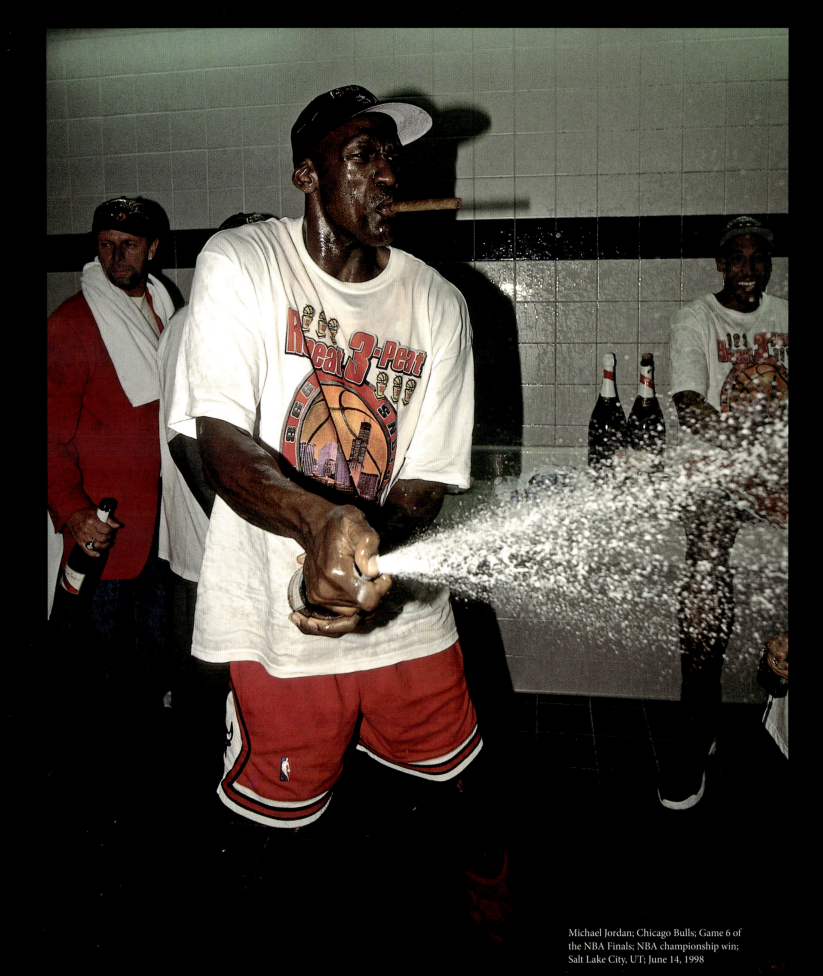

Michael Jordan; Chicago Bulls; Game 6 of the NBA Finals; NBA championship win; Salt Lake City, UT; June 14, 1998

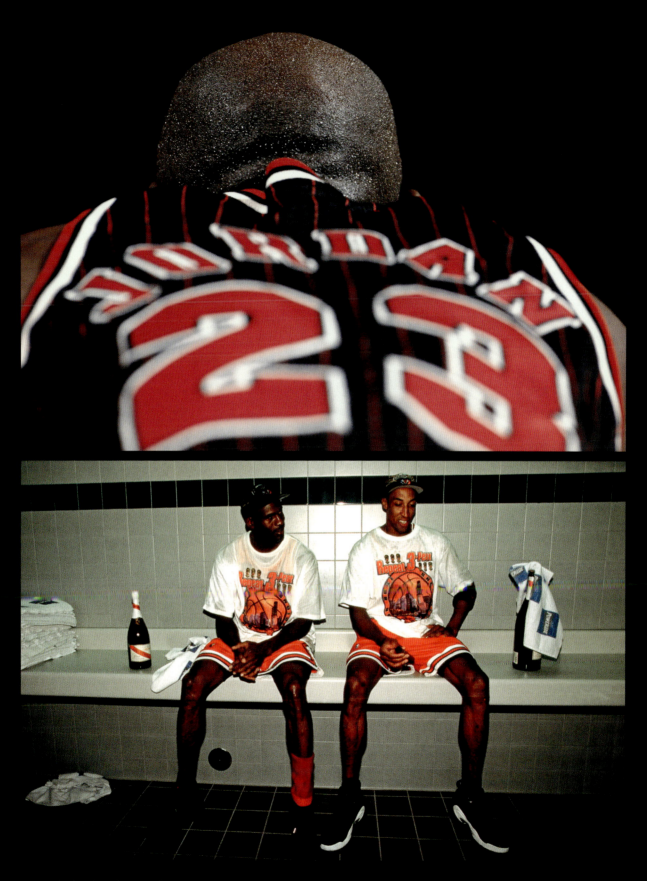

TOP: Michael Jordan; Chicago Bulls; 1995

ABOVE: Michael Jordan and Scottie Pippen; Chicago Bulls; Game 6 of the NBA Finals; NBA championship win; Chicago, IL; June 14, 1998

OVERLEAF: Michael Jordan; Chicago Bulls; NBA All-Star Game; Cleveland, OH; 1997

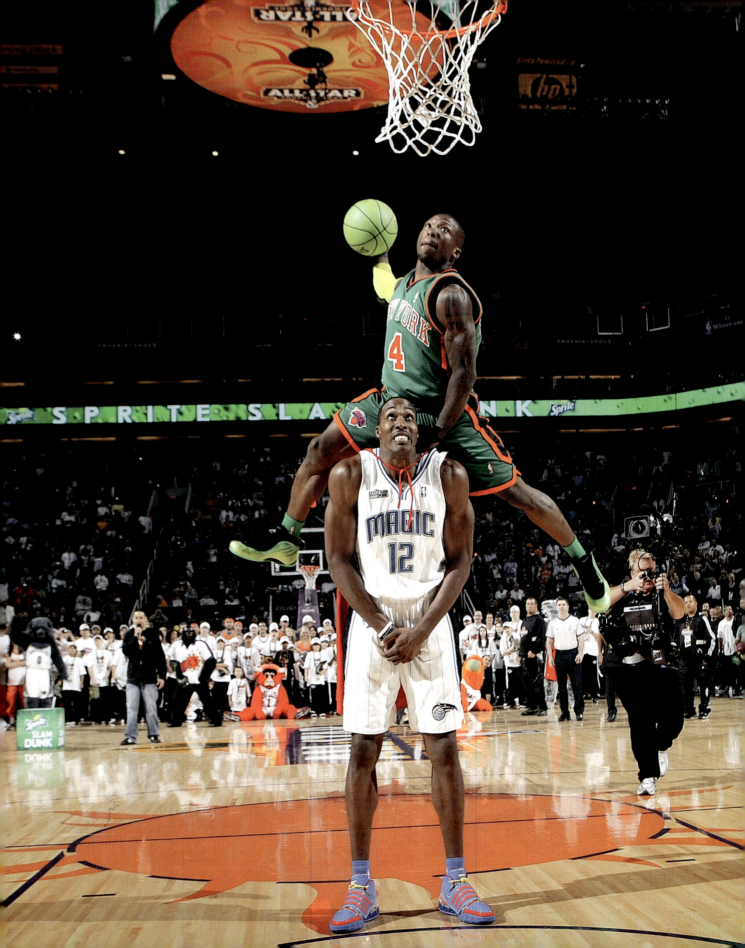

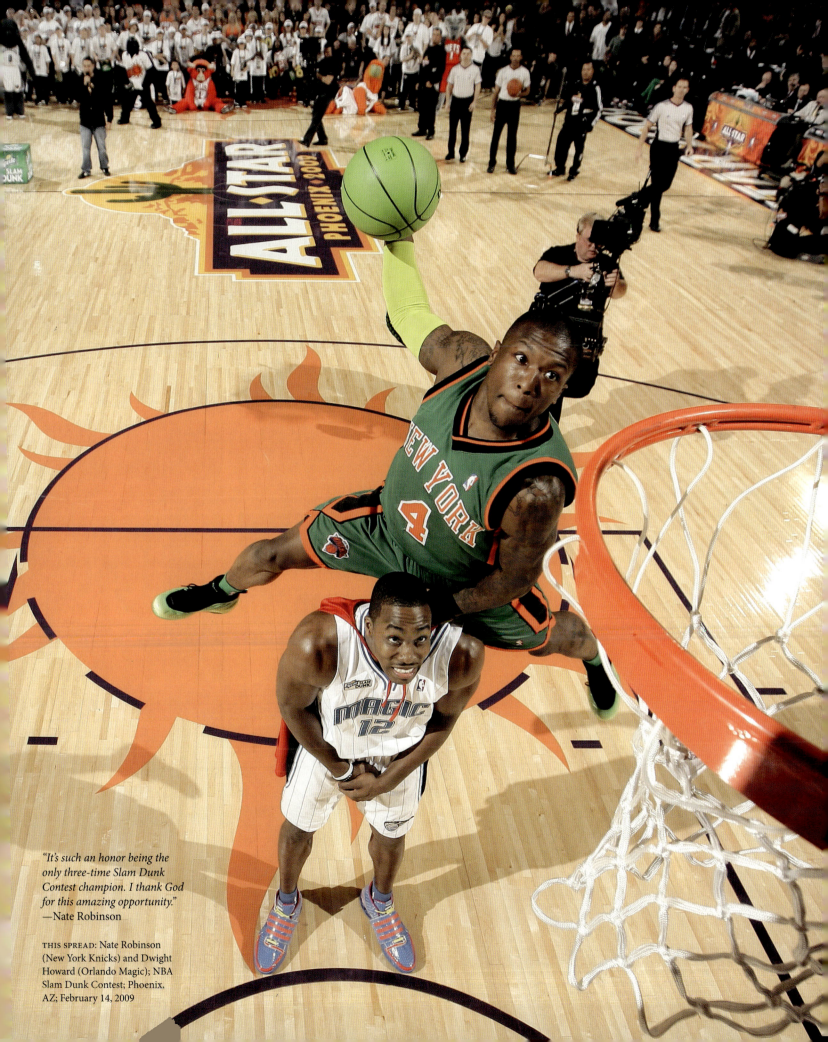

"It's such an honor being the only three-time Slam Dunk Contest champion. I thank God for this amazing opportunity."
—Nate Robinson

THIS SPREAD: Nate Robinson (New York Knicks) and Dwight Howard (Orlando Magic); NBA Slam Dunk Contest; Phoenix, AZ; February 14, 2009

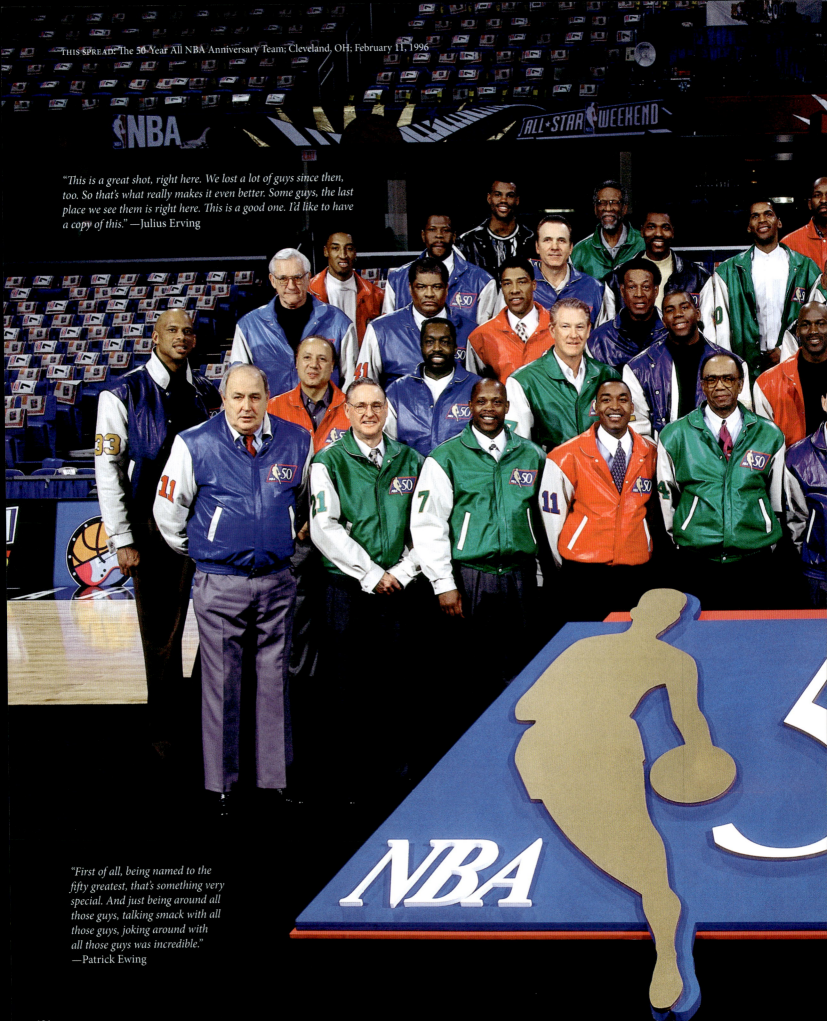

THIS SPREAD: The 50-Year All NBA Anniversary Team; Cleveland, OH; February 11, 1996

"This is a great shot, right here. We lost a lot of guys since then, too. So that's what really makes it even better. Some guys, the last place we see them is right here. This is a good one. I'd like to have a copy of this." —Julius Erving

"First of all, being named to the fifty greatest, that's something very special. And just being around all those guys, talking smack with all those guys, joking around with all those guys was incredible."
—Patrick Ewing

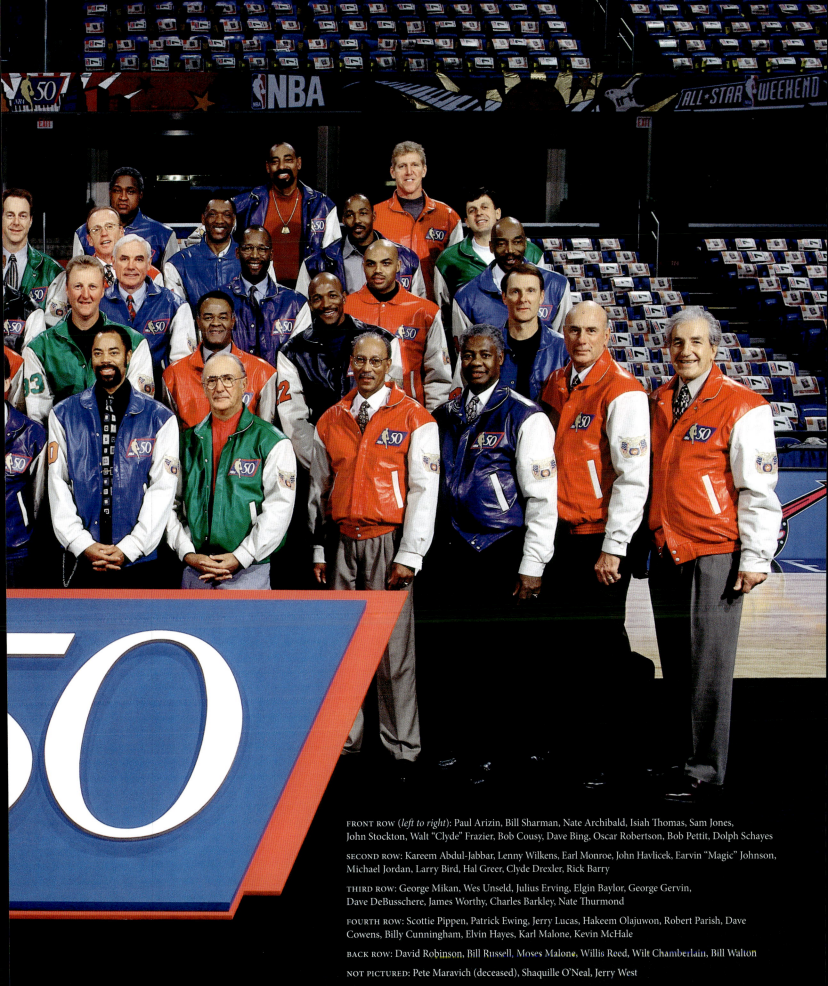

FRONT ROW (*left to right*): Paul Arizin, Bill Sharman, Nate Archibald, Isiah Thomas, Sam Jones, John Stockton, Walt "Clyde" Frazier, Bob Cousy, Dave Bing, Oscar Robertson, Bob Pettit, Dolph Schayes

SECOND ROW: Kareem Abdul-Jabbar, Lenny Wilkens, Earl Monroe, John Havlicek, Earvin "Magic" Johnson, Michael Jordan, Larry Bird, Hal Greer, Clyde Drexler, Rick Barry

THIRD ROW: George Mikan, Wes Unseld, Julius Erving, Elgin Baylor, George Gervin, Dave DeBusschere, James Worthy, Charles Barkley, Nate Thurmond

FOURTH ROW: Scottie Pippen, Patrick Ewing, Jerry Lucas, Hakeem Olajuwon, Robert Parish, Dave Cowens, Billy Cunningham, Elvin Hayes, Karl Malone, Kevin McHale

BACK ROW: David Robinson, Bill Russell, Moses Malone, Willis Reed, Wilt Chamberlain, Bill Walton

NOT PICTURED: Pete Maravich (deceased), Shaquille O'Neal, Jerry West

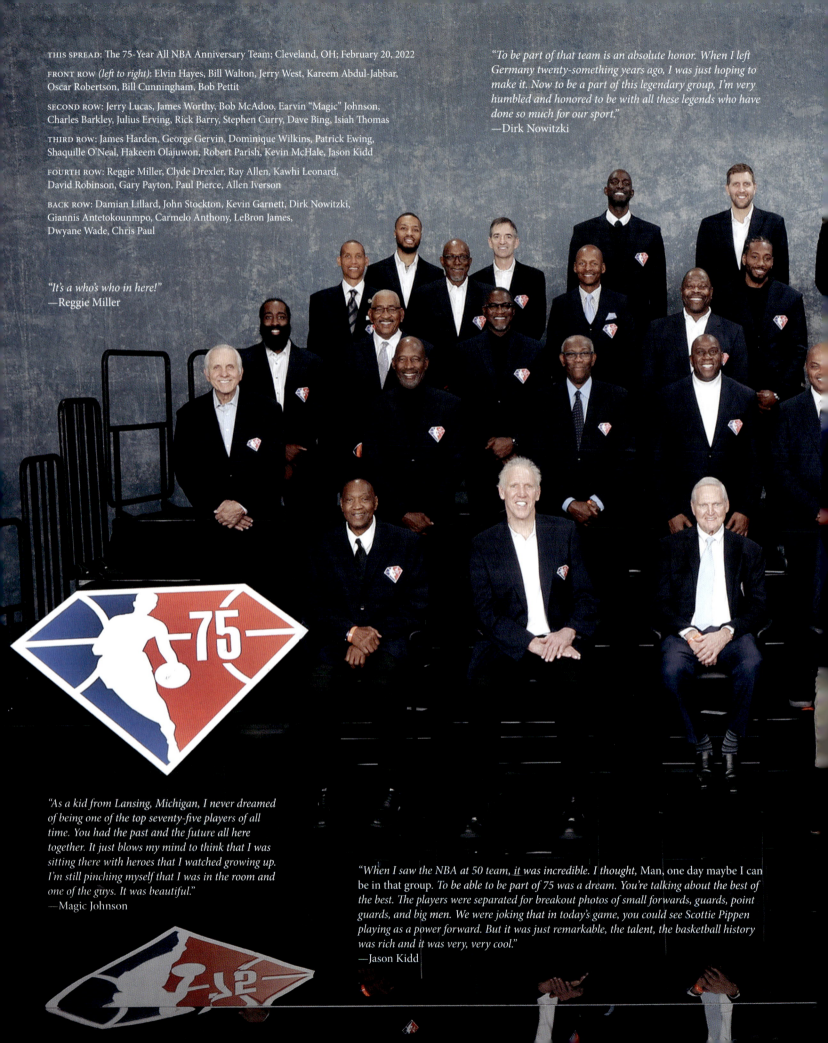

THIS SPREAD: The 75-Year All NBA Anniversary Team; Cleveland, OH; February 20, 2022

FRONT ROW (*left to right*): Elvin Hayes, Bill Walton, Jerry West, Kareem Abdul-Jabbar, Oscar Robertson, Bill Cunningham, Bob Pettit

SECOND ROW: Jerry Lucas, James Worthy, Bob McAdoo, Earvin "Magic" Johnson, Charles Barkley, Julius Erving, Rick Barry, Stephen Curry, Dave Bing, Isiah Thomas

THIRD ROW: James Harden, George Gervin, Dominique Wilkins, Patrick Ewing, Shaquille O'Neal, Hakeem Olajuwon, Robert Parish, Kevin McHale, Jason Kidd

FOURTH ROW: Reggie Miller, Clyde Drexler, Ray Allen, Kawhi Leonard, David Robinson, Gary Payton, Paul Pierce, Allen Iverson

BACK ROW: Damian Lillard, John Stockton, Kevin Garnett, Dirk Nowitzki, Giannis Antetokounmpo, Carmelo Anthony, LeBron James, Dwyane Wade, Chris Paul

"To be part of that team is an absolute honor. When I left Germany twenty-something years ago, I was just hoping to make it. Now to be a part of this legendary group, I'm very humbled and honored to be with all these legends who have done so much for our sport."
—Dirk Nowitzki

"It's a who's who in here!"
—Reggie Miller

"As a kid from Lansing, Michigan, I never dreamed of being one of the top seventy-five players of all time. You had the past and the future all here together. It just blows my mind to think that I was sitting there with heroes that I watched growing up. I'm still pinching myself that I was in the room and one of the guys. It was beautiful."
—Magic Johnson

"When I saw the NBA at 50 team, it was incredible. I thought, Man, one day maybe I can be in that group. To be able to be part of 75 was a dream. You're talking about the best of the best. The players were separated for breakout photos of small forwards, guards, point guards, and big men. We were joking that in today's game, you could see Scottie Pippen playing as a power forward. But it was just remarkable, the talent, the basketball history was rich and it was very, very cool."
—Jason Kidd

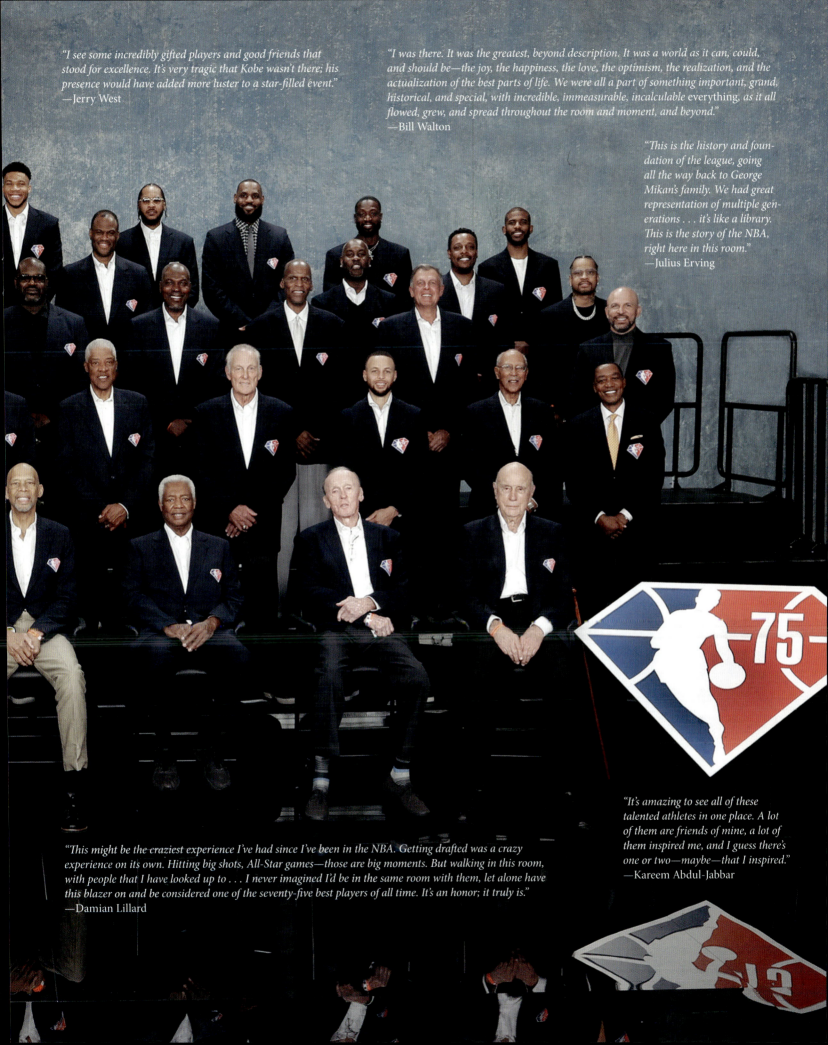

"I see some incredibly gifted players and good friends that stood for excellence. It's very tragic that Kobe wasn't there; his presence would have added more luster to a star-filled event."
—Jerry West

"I was there. It was the greatest, beyond description. It was a world as it can, could, and should be—the joy, the happiness, the love, the optimism, the realization, and the actualization of the best parts of life. We were all a part of something important, grand, historical, and special, with incredible, immeasurable, incalculable everything, as it all flowed, grew, and spread throughout the room and moment, and beyond."
—Bill Walton

"This is the history and foundation of the league, going all the way back to George Mikan's family. We had great representation of multiple generations . . . it's like a library. This is the story of the NBA, right here in this room."
—Julius Erving

"This might be the craziest experience I've had since I've been in the NBA. Getting drafted was a crazy experience on its own. Hitting big shots, All-Star games—those are big moments. But walking in this room, with people that I have looked up to . . . I never imagined I'd be in the same room with them, let alone have this blazer on and be considered one of the seventy-five best players of all time. It's an honor; it truly is."
—Damian Lillard

"It's amazing to see all of these talented athletes in one place. A lot of them are friends of mine, a lot of them inspired me, and I guess there's one or two—maybe—that I inspired."
—Kareem Abdul-Jabbar

ABOVE: Nikola Jokić; Denver Nuggets; Denver, CO; May 31, 2023

"That's a foul. But it's always a pleasure to play against him. I think he's a unique player. A fighter, a warrior who never quits—he developed his game, and he's one of the best in the league at what he does. He can guard multiple positions; he's definitely a fun matchup to play against."
—Nikola Jokić

OPPOSITE: Nikola Jokić and Bam Adebayo; Denver Nuggets vs. Miami Heat; Denver, CO; June 1, 2023

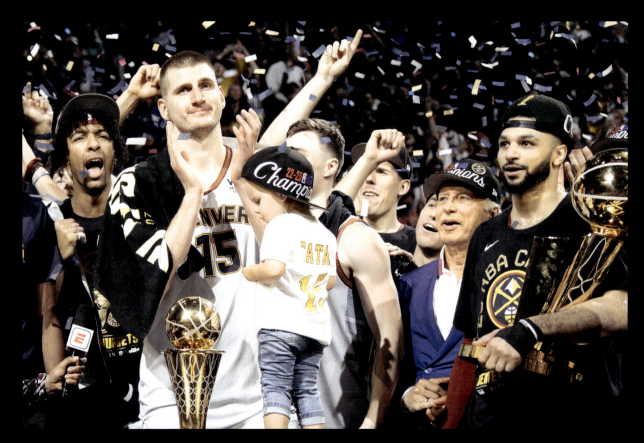

"I told him, 'If we win it, I'm going to push you in [the pool].' And a few seconds after this, Vlatko [Čančar] jumped in with a cannonball. It was a great memory." —Nikola Jokić

"This is one of my favorites. I actually thought he was going to throw me in the cold tub, so that's why I resisted so much. But I think when we win [another one], we're going to jump in the pool again, for sure." —Jamal Murray

THIS PAGE: Nikola Jokić and Jamal Murray; Denver Nuggets; NBA championship win; Denver, CO; June 12, 2023

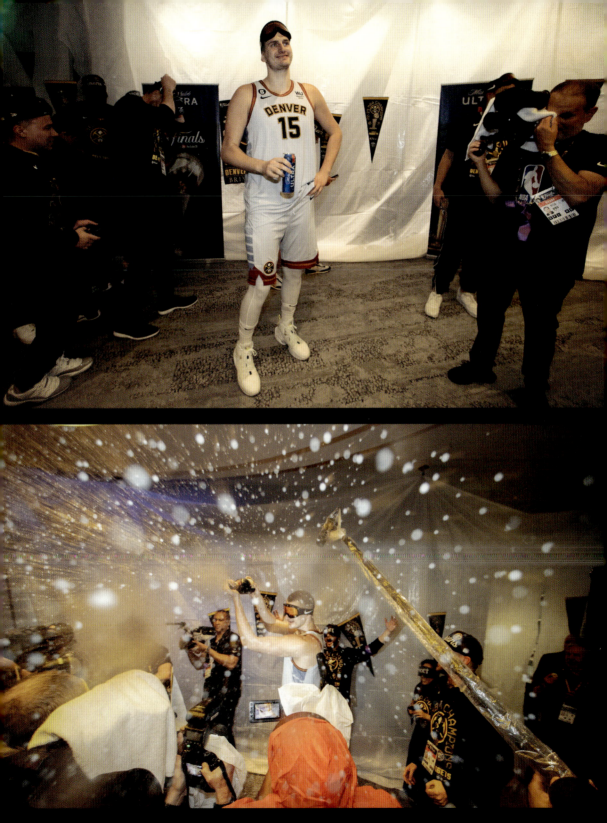

"I think in that moment I was just taking the time to recap what happened, with a beer. I love beer, that's my favorite drink—enjoying a cold one and thinking about what we did. Then I did this after the beer." —Nikola Jokić

THIS PAGE: Nikola Jokić; Denver Nuggets; NBA championship win; Denver, CO; June 12, 2023

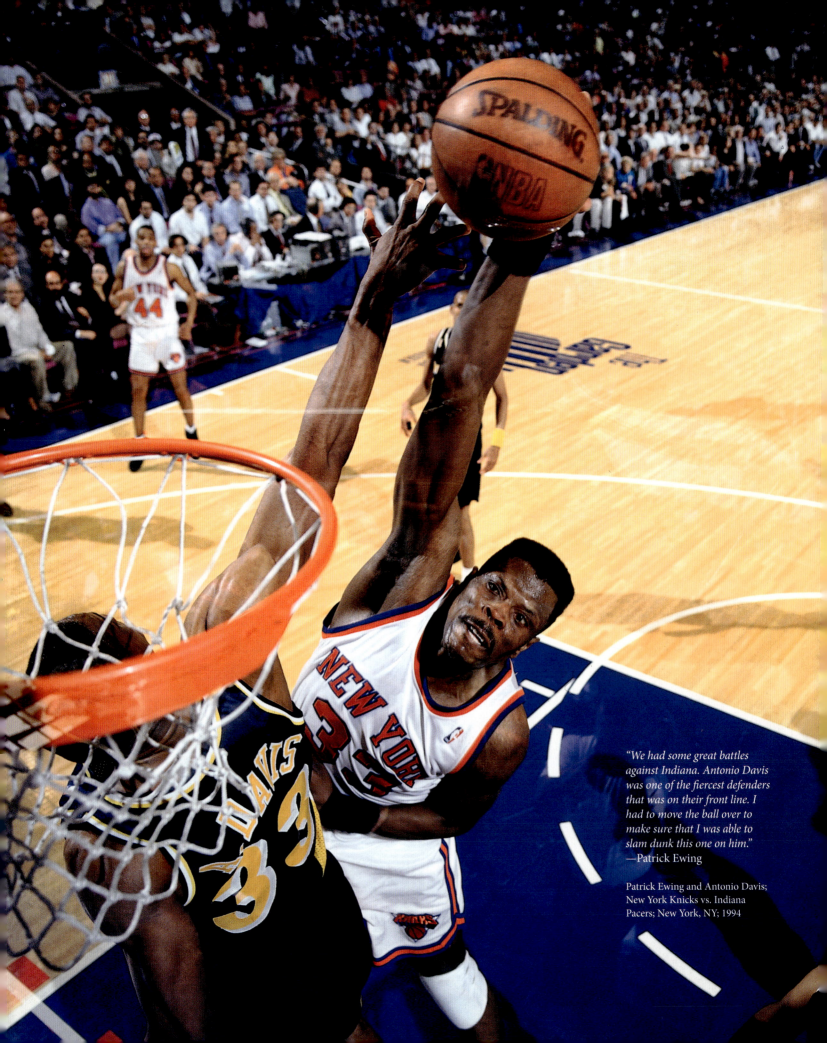

"We had some great battles against Indiana. Antonio Davis was one of the fiercest defenders that was on their front line. I had to move the ball over to make sure that I was able to slam dunk this one on him."
—Patrick Ewing

Patrick Ewing and Antonio Davis; New York Knicks vs. Indiana Pacers; New York, NY; 1994

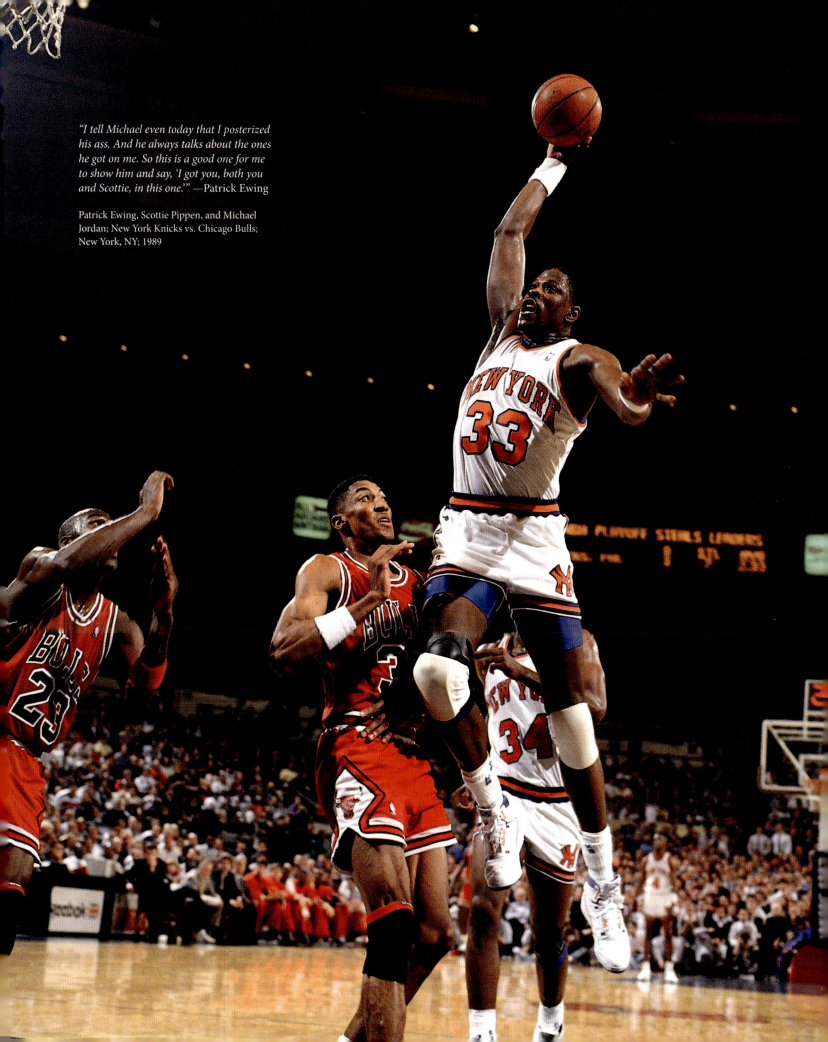

"I tell Michael even today that I posterized his ass. And he always talks about the ones he got on me. So this is a good one for me to show him and say, 'I got you, both you and Scottie, in this one.'" —Patrick Ewing

Patrick Ewing, Scottie Pippen, and Michael Jordan; New York Knicks vs. Chicago Bulls; New York, NY; 1989

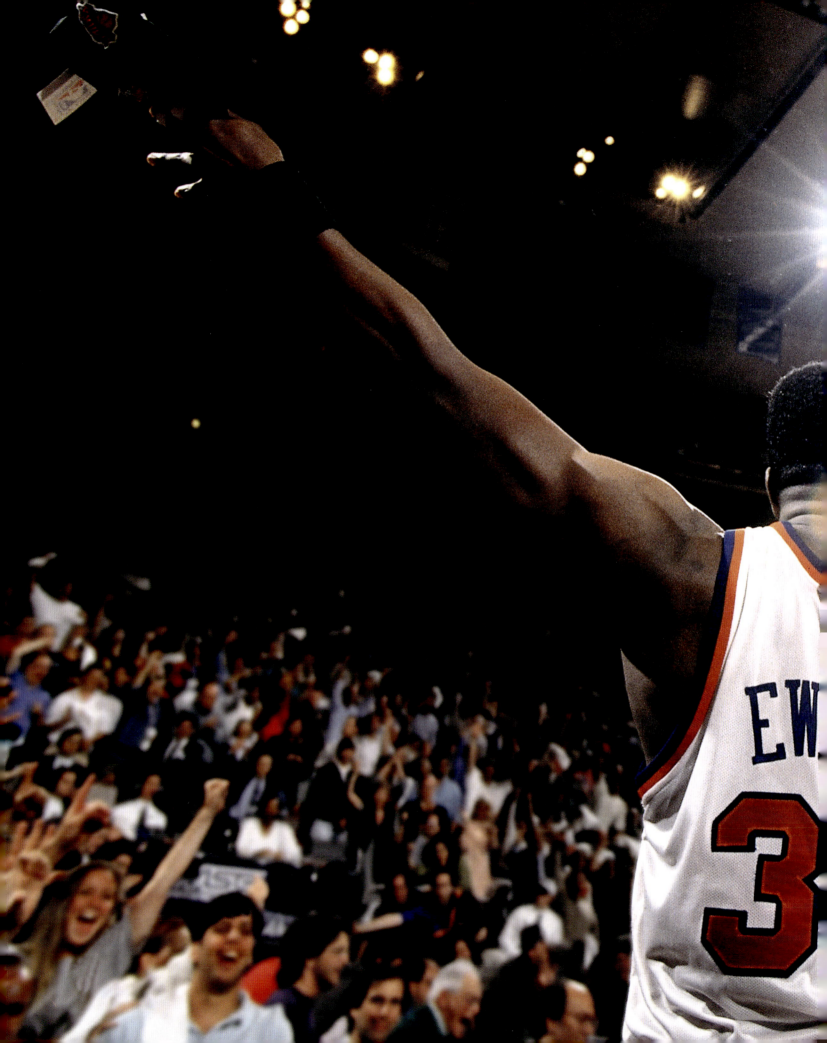

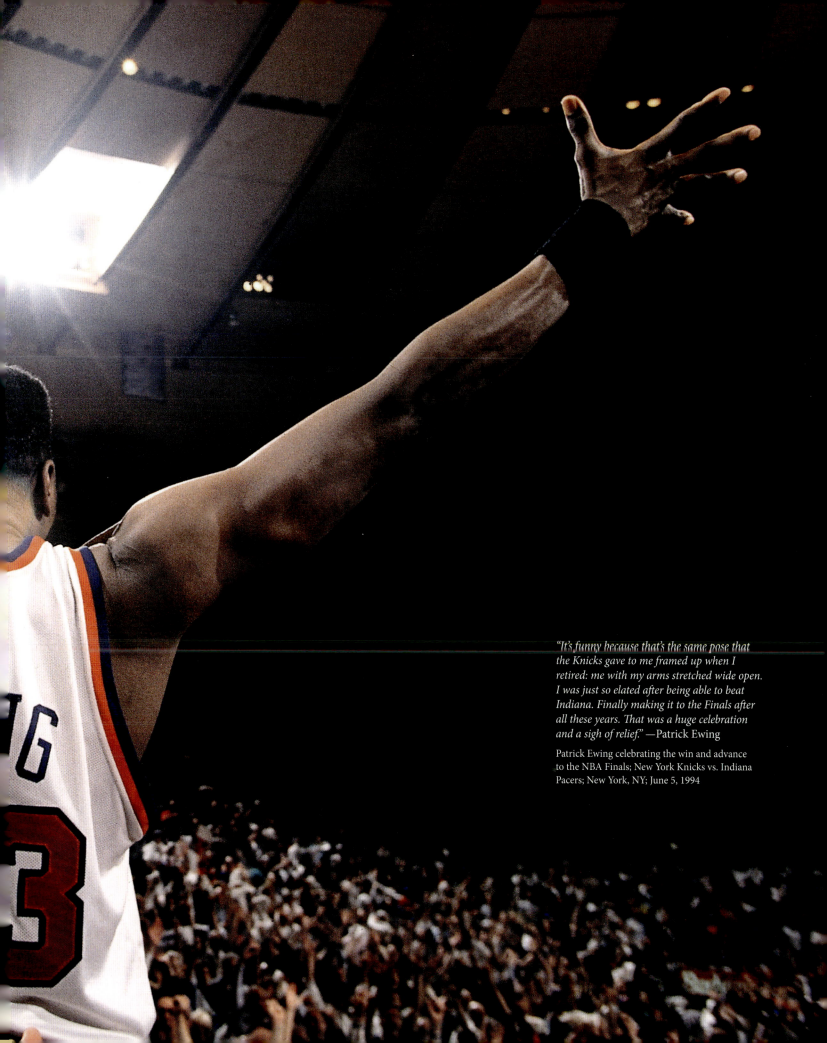

"It's funny because that's the same pose that the Knicks gave to me framed up when I retired: me with my arms stretched wide open. I was just so elated after being able to beat Indiana. Finally making it to the Finals after all these years. That was a huge celebration and a sigh of relief." —Patrick Ewing

Patrick Ewing celebrating the win and advance to the NBA Finals; New York Knicks vs. Indiana Pacers; New York, NY; June 5, 1994

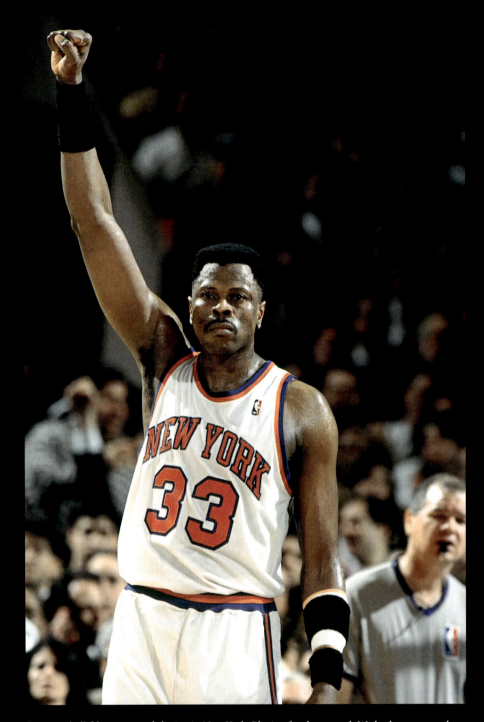

"I enjoyed all fifteen years of playing in New York. Playing for that crowd. We had our ups and we had our downs, but I think for the most part, they showed their appreciation for me."
—Patrick Ewing

ABOVE: Patrick Ewing; New York Knicks vs. Cleveland Cavaliers; New York, NY; April 27, 1995

"Just me battling against the great Patrick Ewing. I am who I am because of Patrick Ewing, David Robinson, and guys like that. So those were always fierce battles against the master, Patrick Ewing." —Shaquille O'Neal

OPPOSITE: Patrick Ewing and Shaquille O'Neal; New York Knicks vs. Los Angeles Lakers; New York, NY; March 19, 2000

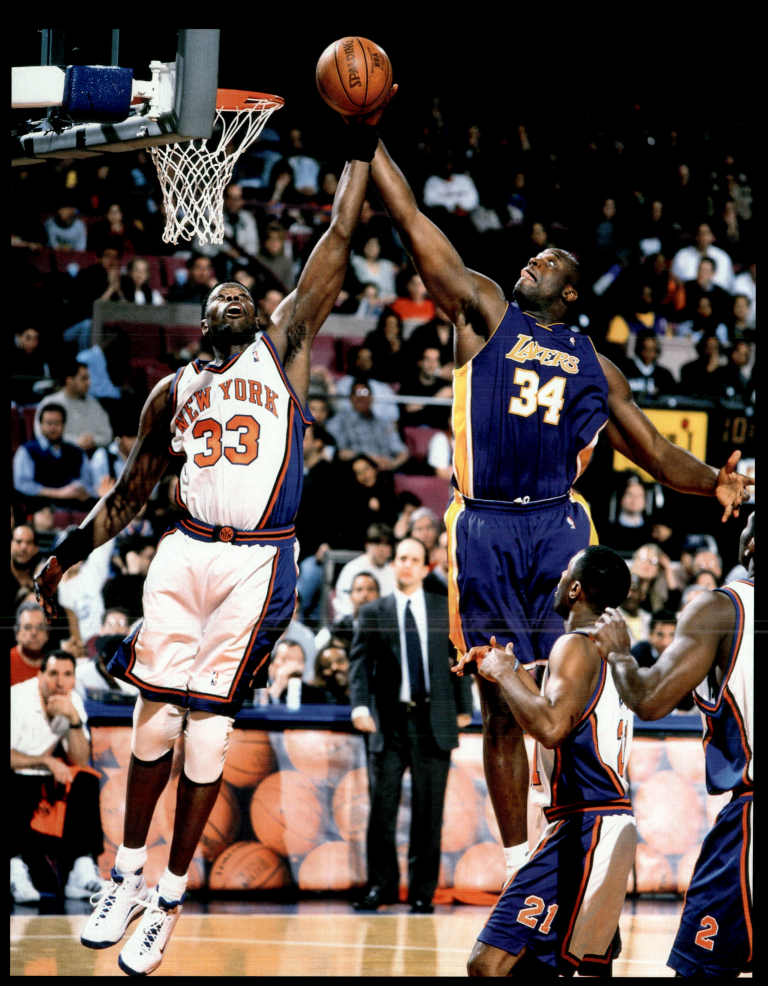

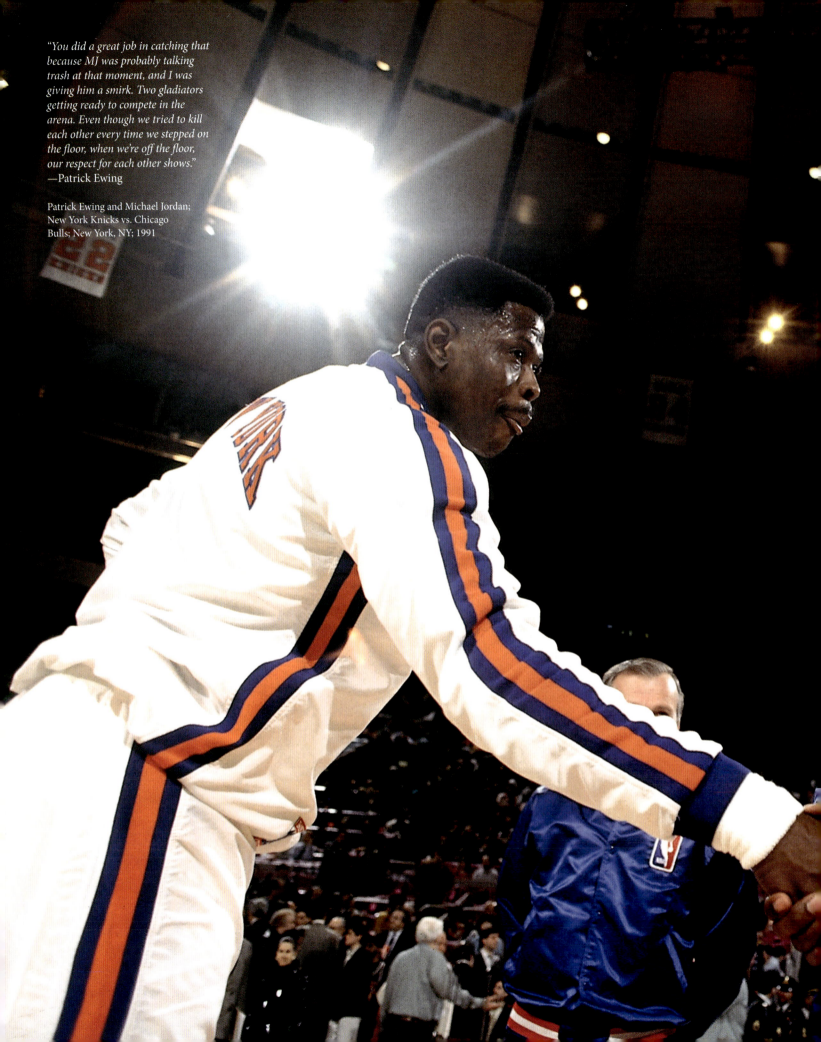

"You did a great job in catching that because MJ was probably talking trash at that moment, and I was giving him a smirk. Two gladiators getting ready to compete in the arena. Even though we tried to kill each other every time we stepped on the floor, when we're off the floor, our respect for each other shows."
—Patrick Ewing

Patrick Ewing and Michael Jordan; New York Knicks vs. Chicago Bulls; New York, NY; 1991

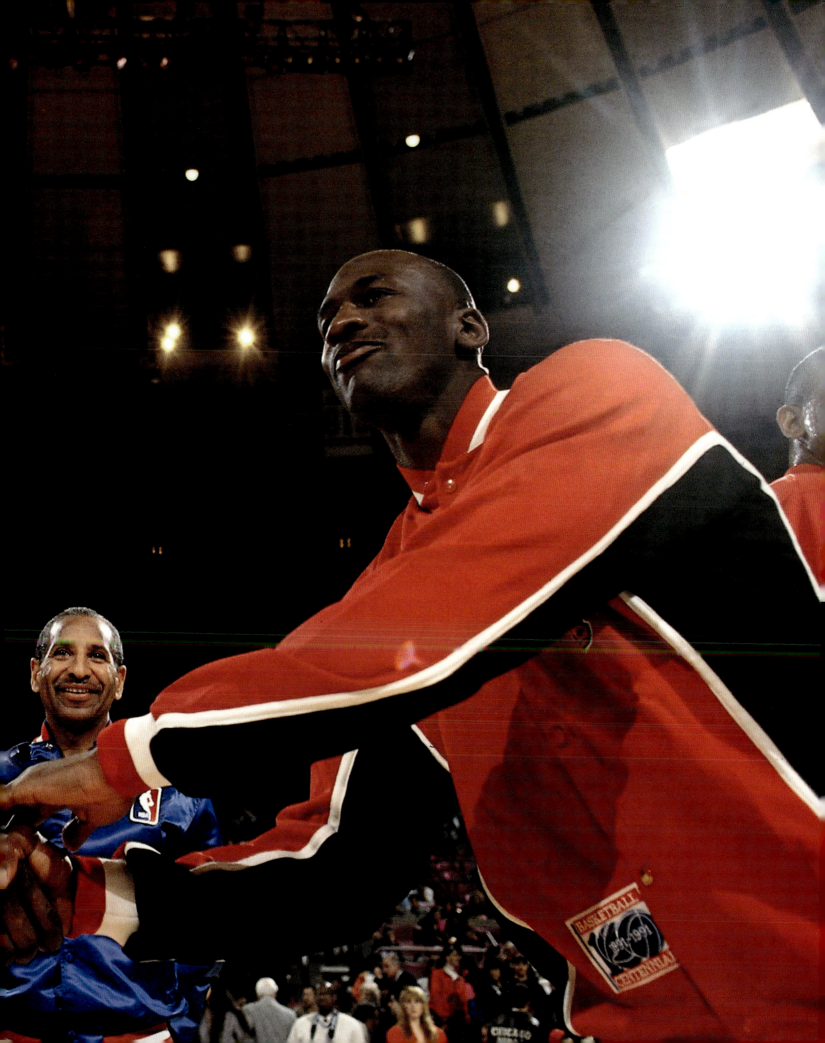

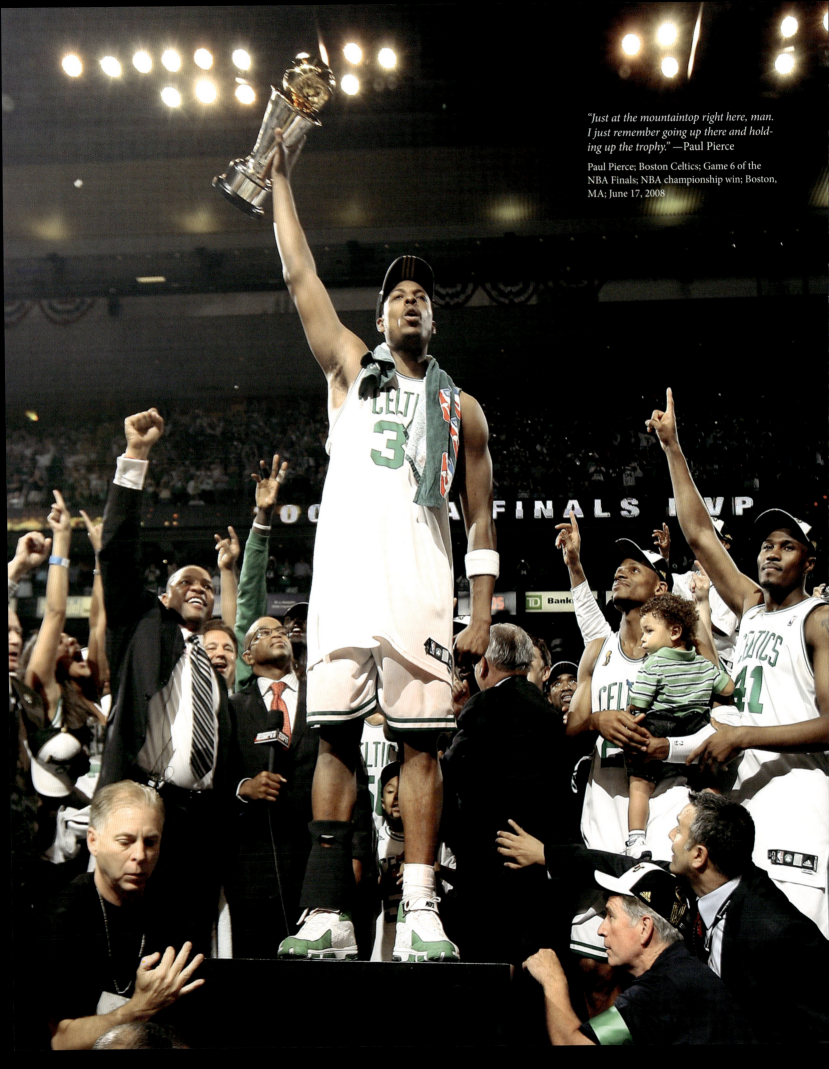

"Just at the mountaintop right here, man. I just remember going up there and holding up the trophy." —Paul Pierce

Paul Pierce; Boston Celtics; Game 6 of the NBA Finals; NBA championship win; Boston, MA; June 17, 2008

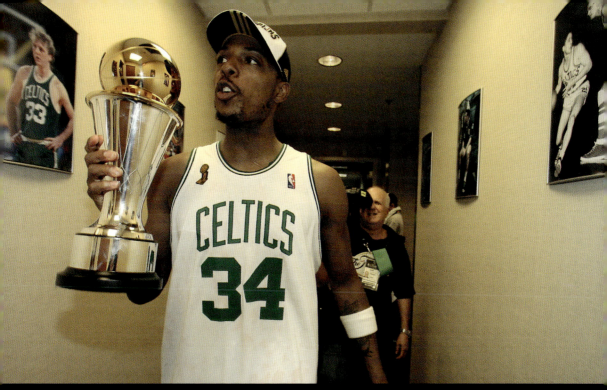

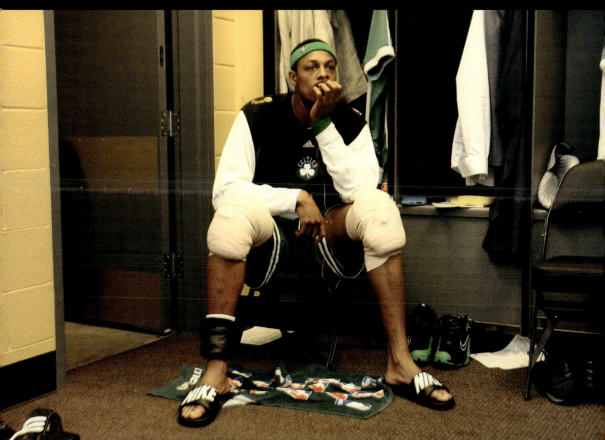

"I'm looking at a picture of Larry Bird in the Finals versus the Lakers. Larry Bird's always been an inspiration and huge in the Lakers-Celtics rivalry. I remember I looked at that and thought, *Damn, we're a part of that history now. It hit me.*" —Paul Pierce

TOP: Paul Pierce; Boston Celtics; NBA championship win; Boston, MA; June 17, 2008
ABOVE: Paul Pierce; Boston Celtics; NBA Finals; Boston, MA; June 10, 2008

"*I think about the rebounds we could have gotten . . . we could have pretty much finished that game.*"
—Kawhi Leonard

Ray Allen; Miami Heat vs. San Antonio Spurs; Miami, FL;
June 19, 2013

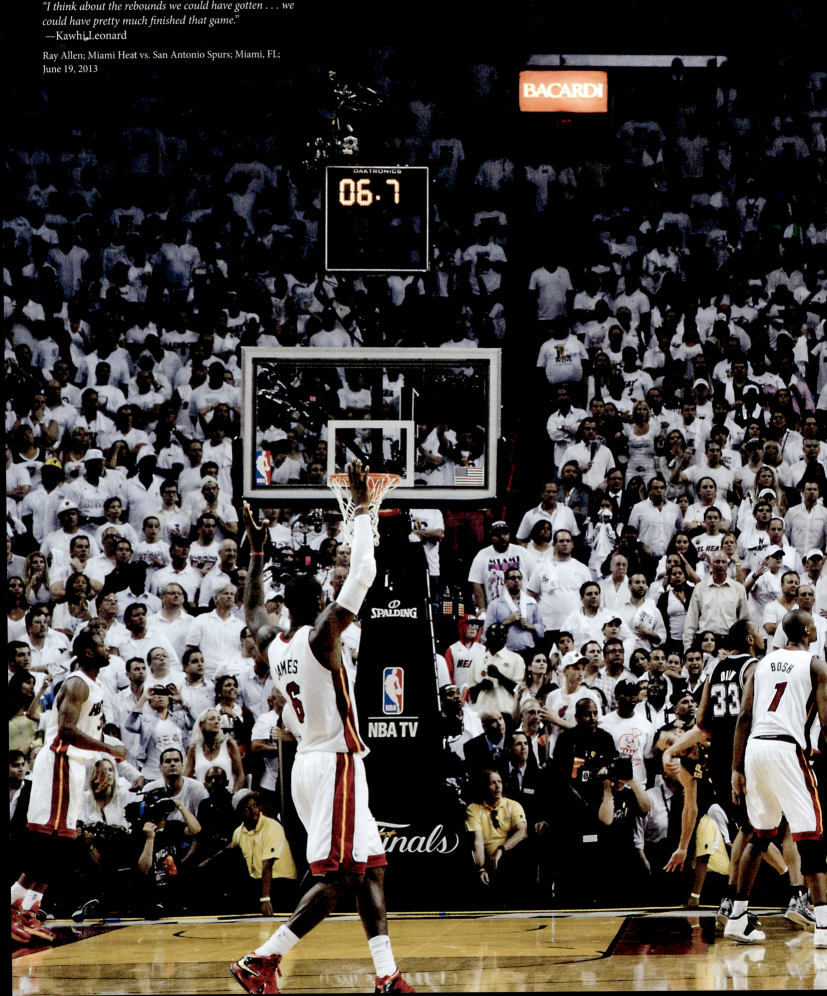

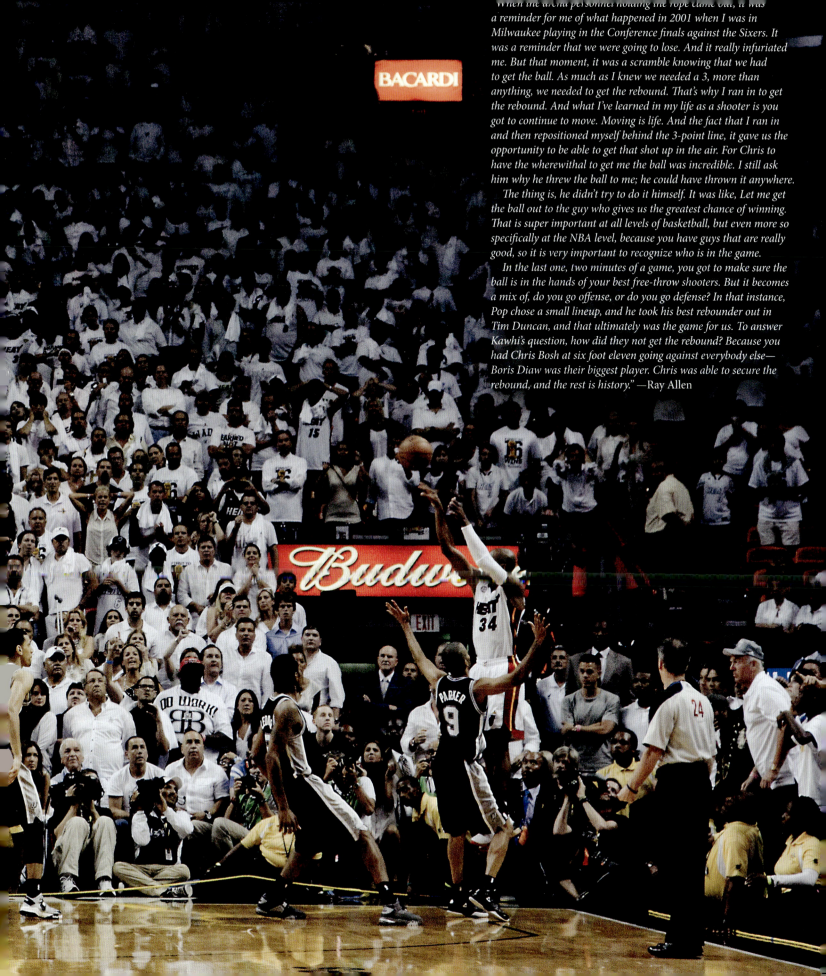

When the arena personnel holding the rope came out, it was a reminder for me of what happened in 2001 when I was in Milwaukee playing in the Conference finals against the Sixers. It was a reminder that we were going to lose. And it really infuriated me. But that moment, it was a scramble knowing that we had to get the ball. As much as I knew we needed a 3, more than anything, we needed to get the rebound. That's why I ran in to get the rebound. And what I've learned in my life as a shooter is you got to continue to move. Moving is life. And the fact that I ran in and then repositioned myself behind the 3-point line, it gave us the opportunity to be able to get that shot up in the air. For Chris to have the wherewithal to get me the ball was incredible. I still ask him why he threw the ball to me; he could have thrown it anywhere.

The thing is, he didn't try to do it himself. It was like, Let me get the ball out to the guy who gives us the greatest chance of winning. That is super important at all levels of basketball, but even more so specifically at the NBA level, because you have guys that are really good, so it is very important to recognize who is in the game.

In the last one, two minutes of a game, you got to make sure the ball is in the hands of your best free-throw shooters. But it becomes a mix of, do you go offense, or do you go defense? In that instance, Pop chose a small lineup, and he took his best rebounder out in Tim Duncan, and that ultimately was the game for us. To answer Kawhi's question, how did they not get the rebound? Because you had Chris Bosh at six foot eleven going against everybody else—Boris Diaw was their biggest player. Chris was able to secure the rebound, and the rest is history." —Ray Allen

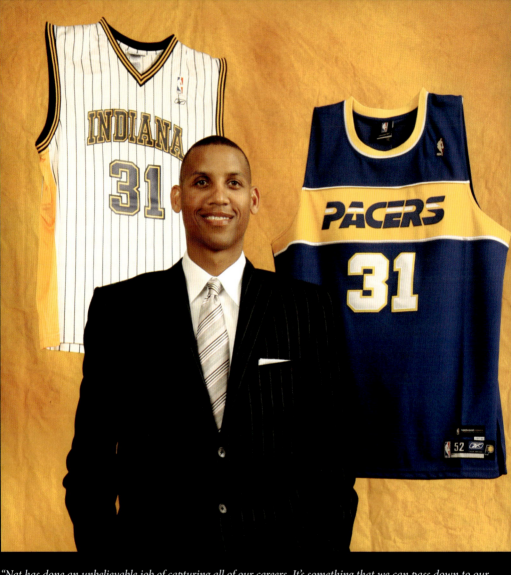

"Nat has done an unbelievable job of capturing all of our careers. It's something that we can pass down to our kids and show them, which makes it cool. To have the opportunity to play in the NBA has always been a lifelong dream, and when you're retired and you're away from the game, you cherish those moments." —Reggie Miller

Reggie Miller; Indiana Pacers; Jersey Retirement Ceremony; Indianapolis, IN; March 31, 2006

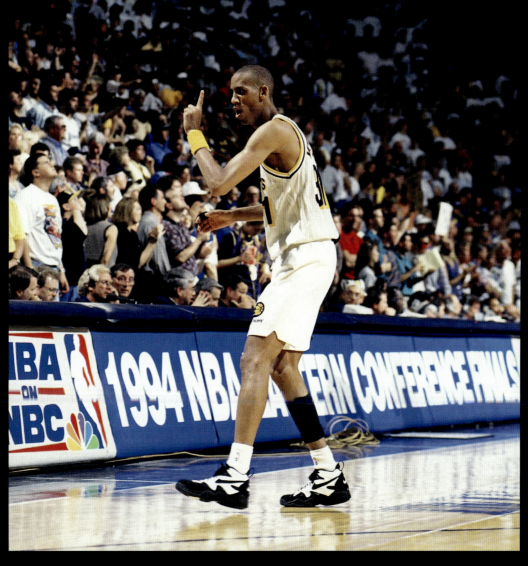

Reggie Miller; Indiana Pacers; Indianapolis, IN; May 30, 1994

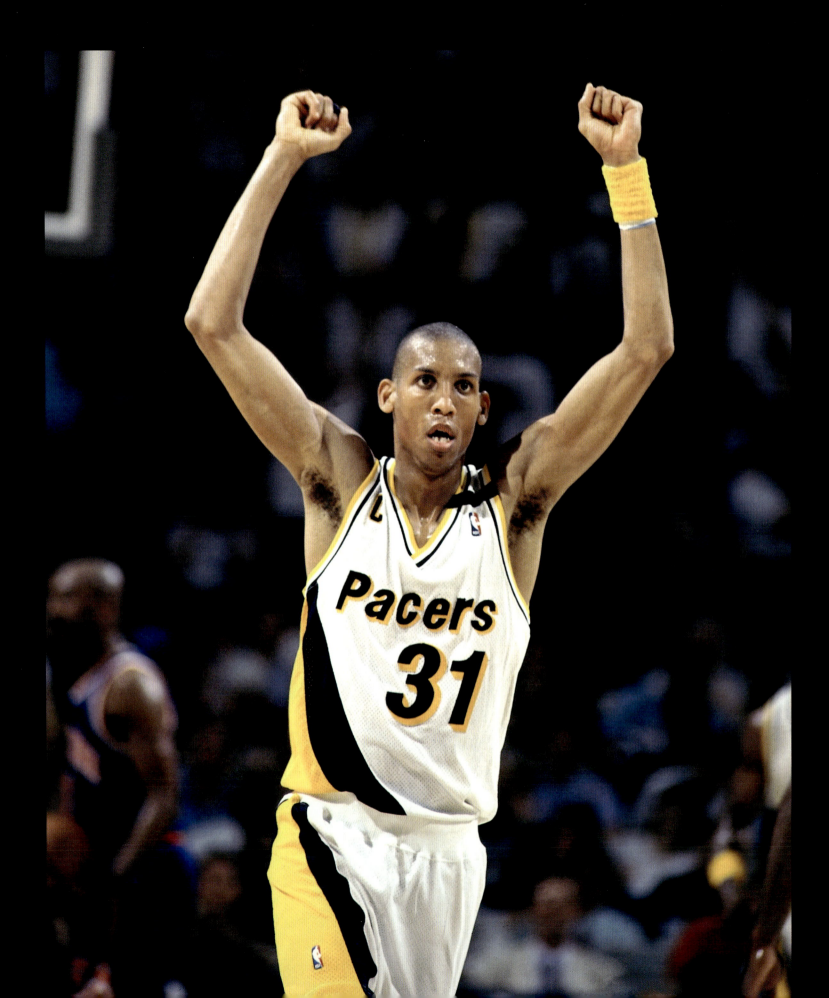

"Who doesn't like raising their hands? That means the shot went in or your team is winning. The adulation of victory."
—Reggie Miller

OPPOSITE: Reggie Miller; Indiana Pacers vs. New York Knicks; Indianapolis, IN; May 30, 1994

"This was a tough shot because John Starks is a heck of a defender, and I knew I had to get it off quick. But I'm sure it went in. I absolutely loved playing in The Garden. There's no better feeling. It's the Mecca of basketball. It's like being on Broadway. You get to showcase your talent on the biggest stage." —Reggie Miller

Reggie Miller and John Starks; Indiana Pacers vs. New York Knicks; New York, NY; June 1, 1994

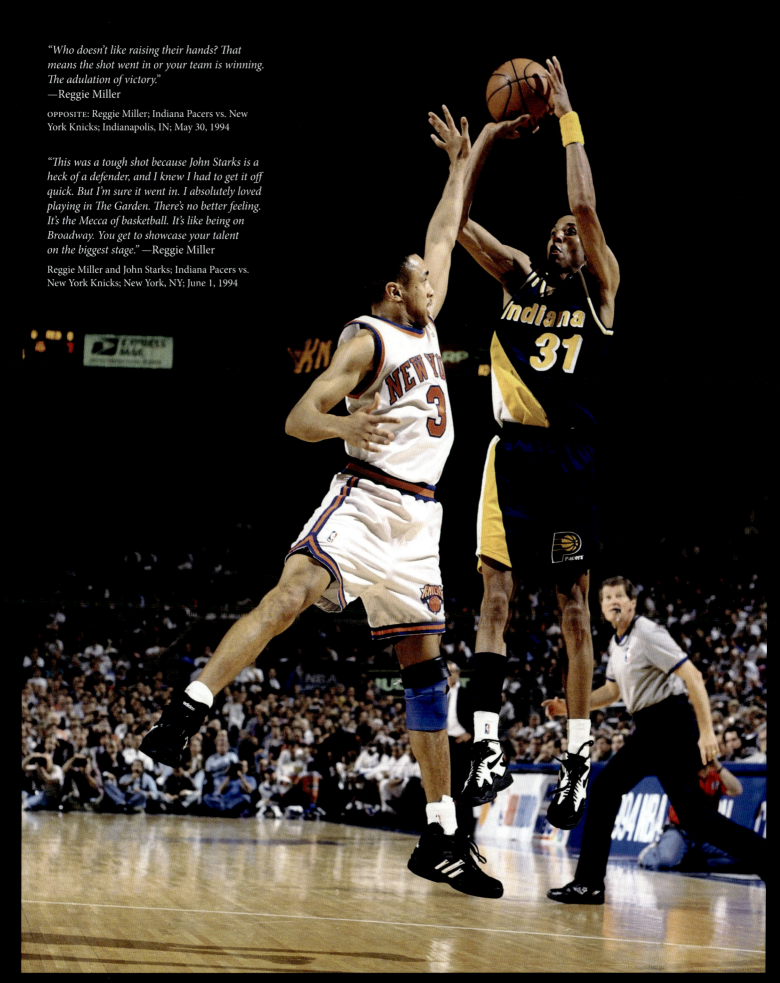

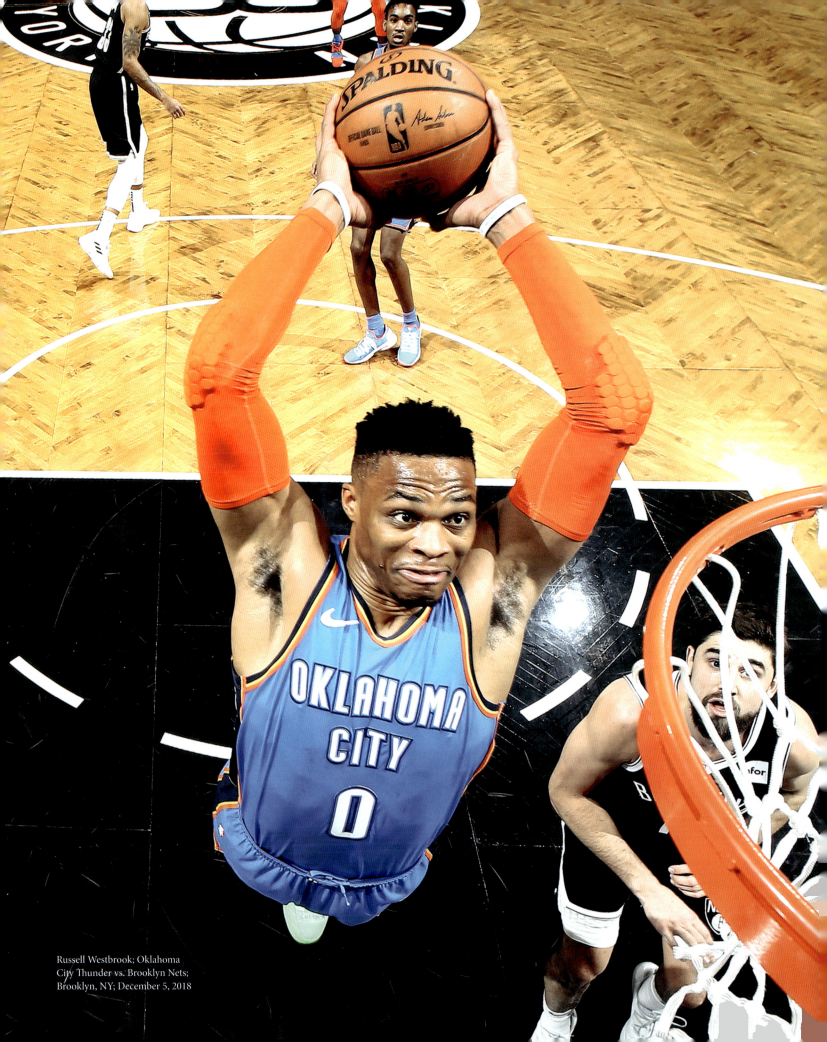

Russell Westbrook; Oklahoma City Thunder vs. Brooklyn Nets; Brooklyn, NY; December 5, 2018

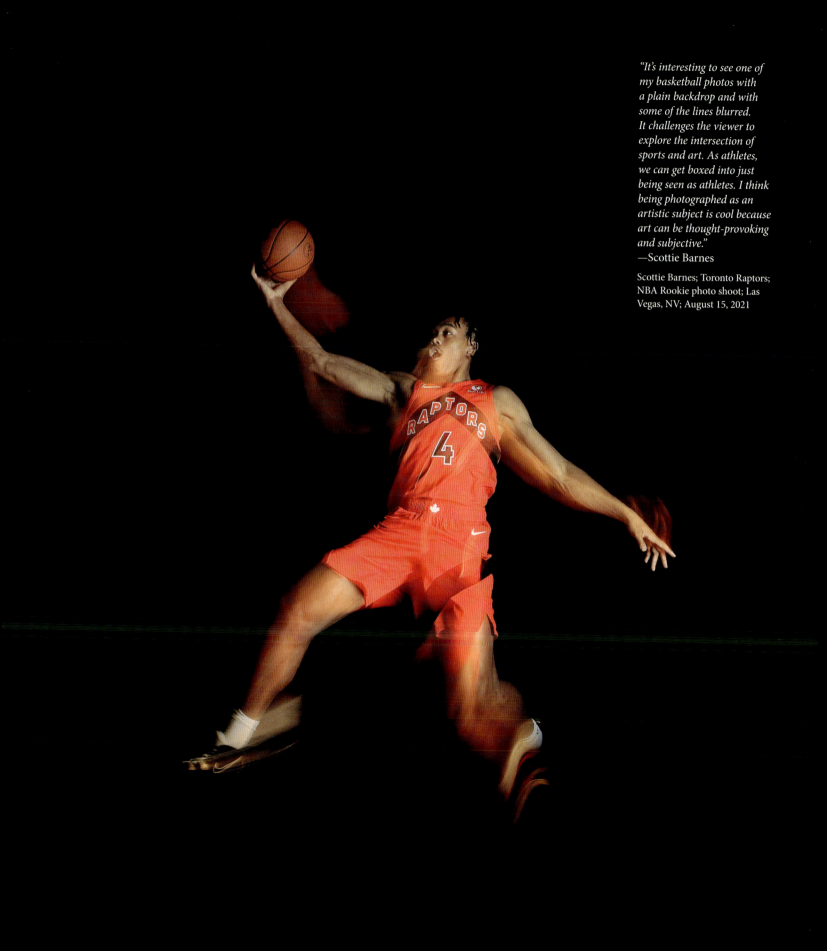

"It's interesting to see one of my basketball photos with a plain backdrop and with some of the lines blurred. It challenges the viewer to explore the intersection of sports and art. As athletes, we can get boxed into just being seen as athletes. I think being photographed as an artistic subject is cool because art can be thought-provoking and subjective."
—Scottie Barnes

Scottie Barnes; Toronto Raptors; NBA Rookie photo shoot; Las Vegas, NV; August 15, 2021

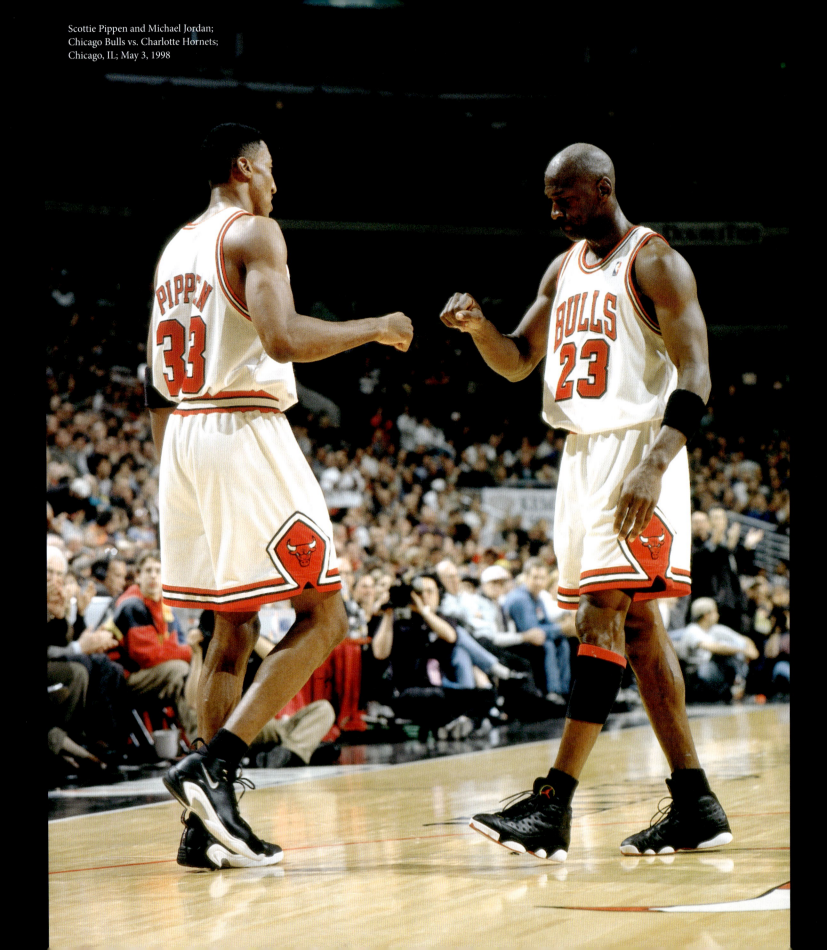

Scottie Pippen and Michael Jordan;
Chicago Bulls vs. Charlotte Hornets;
Chicago, IL; May 3, 1998

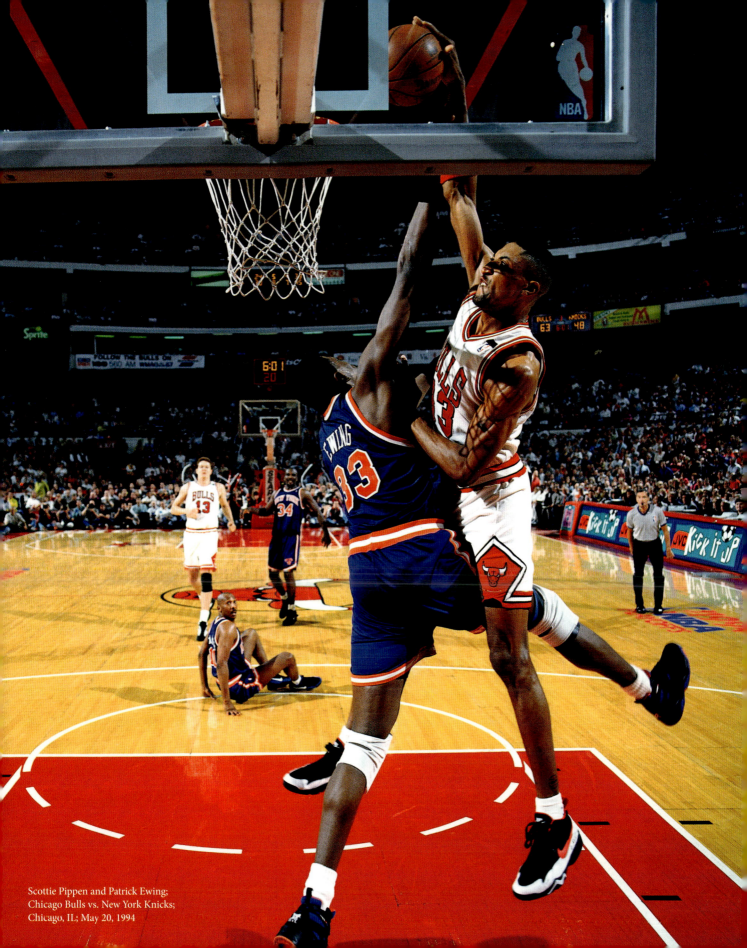

Scottie Pippen and Patrick Ewing;
Chicago Bulls vs. New York Knicks;
Chicago, IL; May 20, 1994

"I remember this iconic photo because it captures the essence of my hard work. You can see the sweat dripping and, of course, you see the beautiful face."
—Shaquille O'Neal

Shaquille O'Neal; Orlando Magic; East Rutherford, NJ; 1994

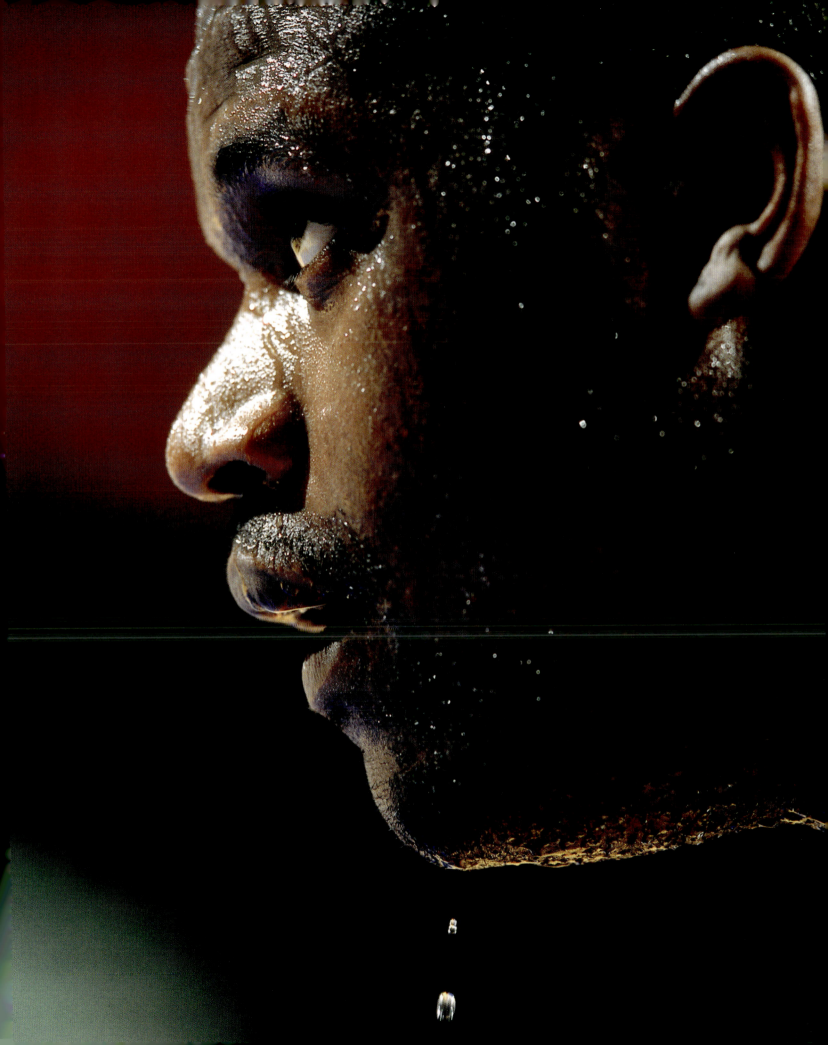

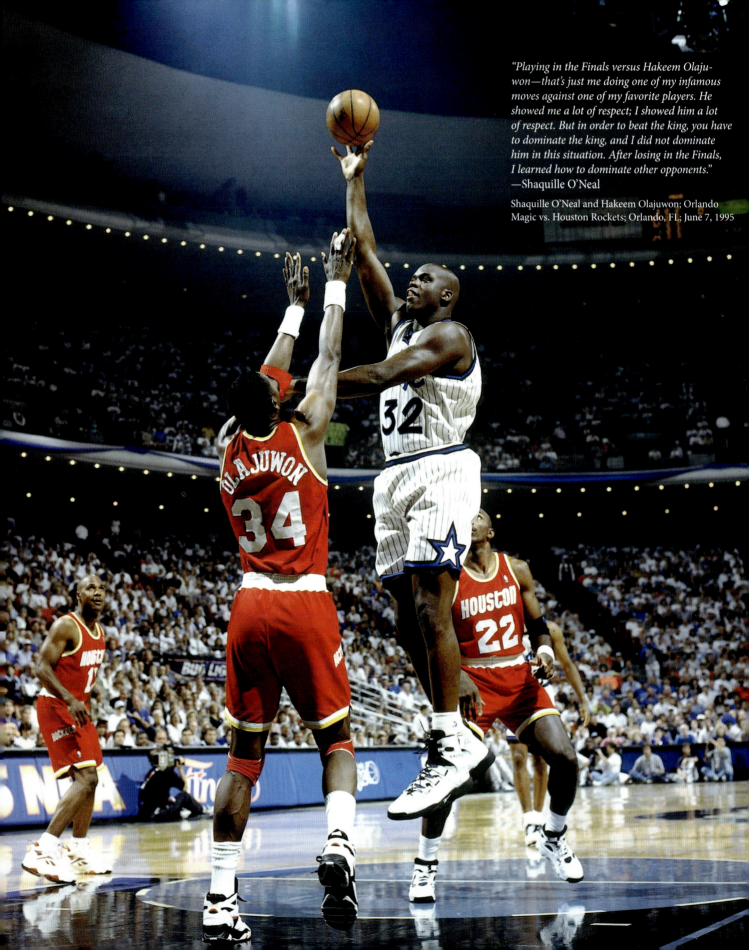

"Playing in the Finals versus Hakeem Olajuwon—that's just me doing one of my infamous moves against one of my favorite players. He showed me a lot of respect; I showed him a lot of respect. But in order to beat the king, you have to dominate the king, and I did not dominate him in this situation. After losing in the Finals, I learned how to dominate other opponents."
—Shaquille O'Neal

Shaquille O'Neal and Hakeem Olajuwon; Orlando Magic vs. Houston Rockets; Orlando, FL; June 7, 1995

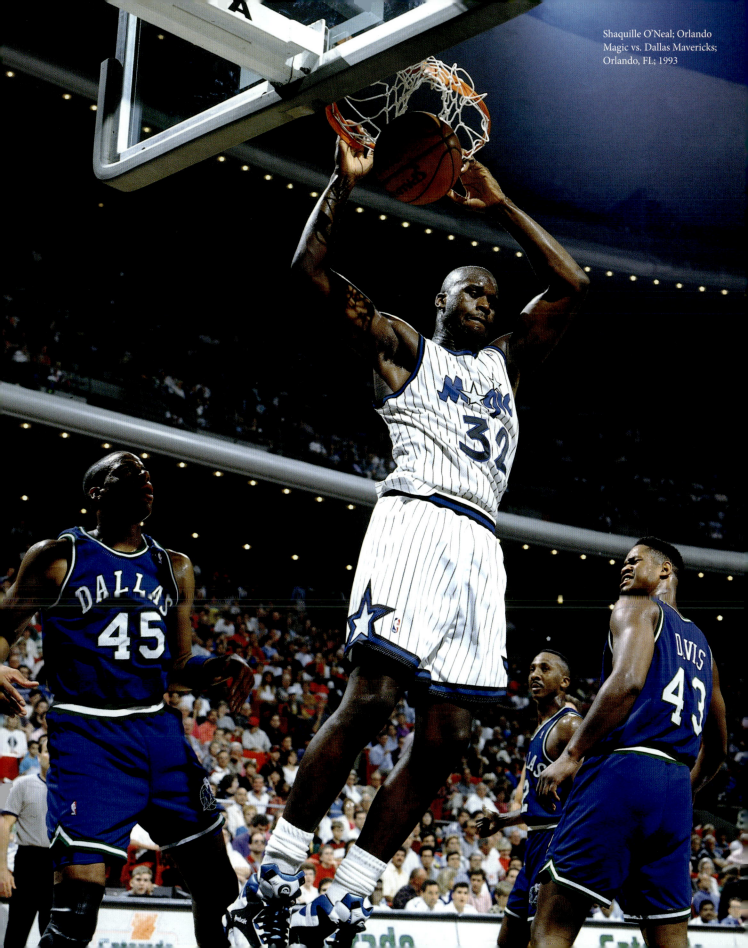

Shaquille O'Neal; Orlando Magic vs. Dallas Mavericks; Orlando, FL; 1993

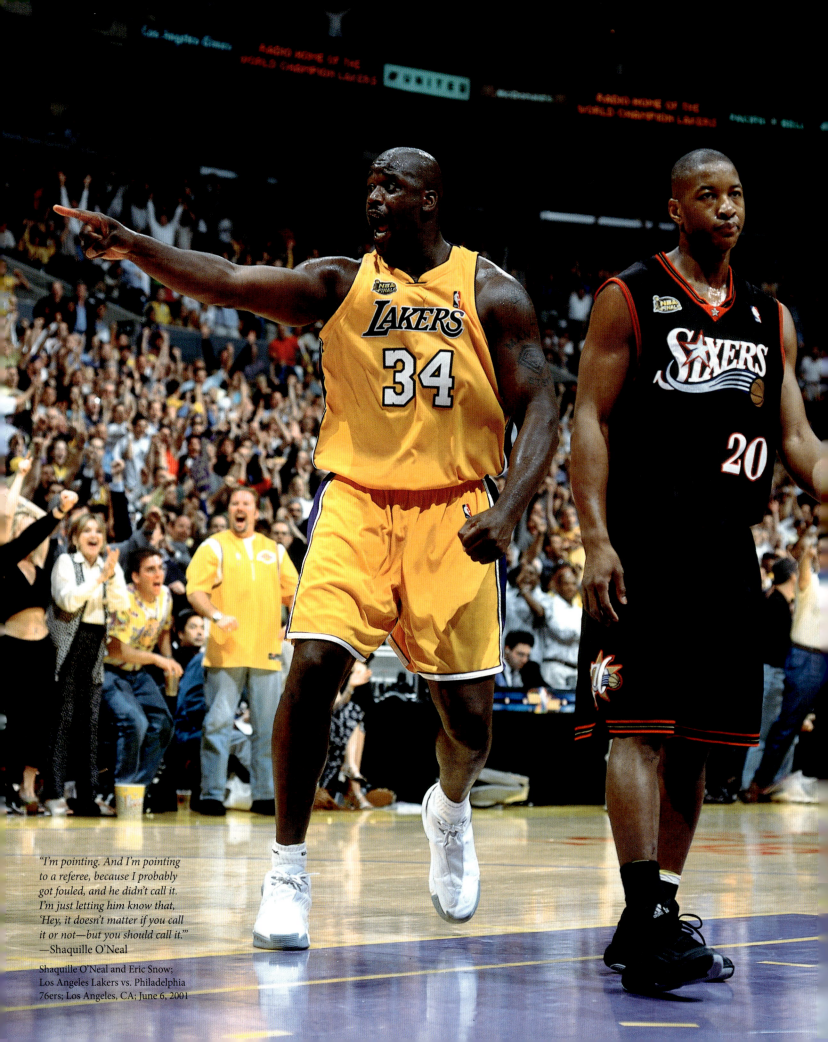

"I'm pointing. And I'm pointing to a referee, because I probably got fouled, and he didn't call it. I'm just letting him know that, 'Hey, it doesn't matter if you call it or not—but you should call it.'"
—Shaquille O'Neal

Shaquille O'Neal and Eric Snow; Los Angeles Lakers vs. Philadelphia 76ers; Los Angeles, CA; June 6, 2001

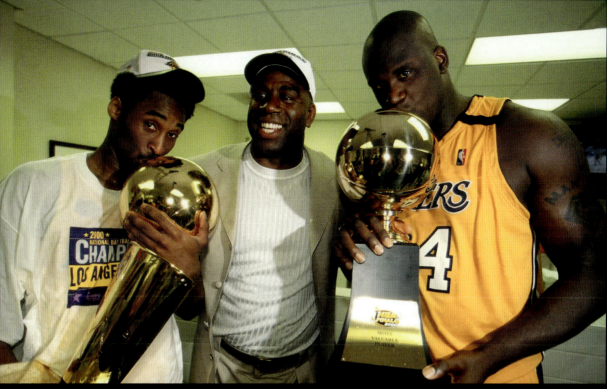

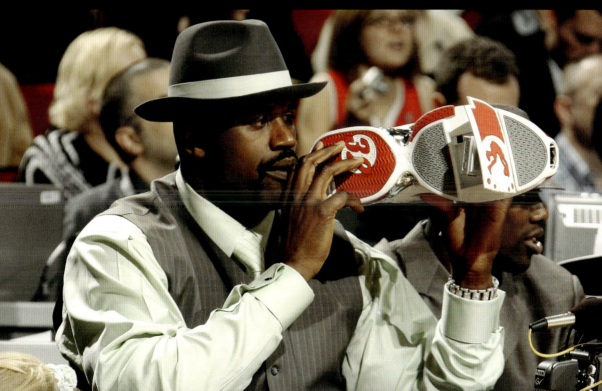

"This is me and Kobe's moment, and Magic had to bring himself in there with the smile—and this is the picture that went viral. When we were losing, you couldn't find nobody, but as soon as we started winning, everybody came around." —Shaquille O'Neal

TOP: Kobe Bryant, Earvin "Magic" Johnson, and Shaquille O'Neal; Los Angeles Lakers; NBA championship win; Los Angeles, CA; June 19, 2000

"This is my camcorder shoe at one of the All-Star Games. This was one of my Shaq shoes that I designed myself. My nickname used to be 'Shagyver.' I cut it apart and put a camera in it as a part of LA Gear with Steve Jackson." —Shaquille O'Neal

ABOVE: Shaquille O'Neal; Los Angeles Lakers; NBA All-Star Saturday Night; Houston, TX; February 18, 2006

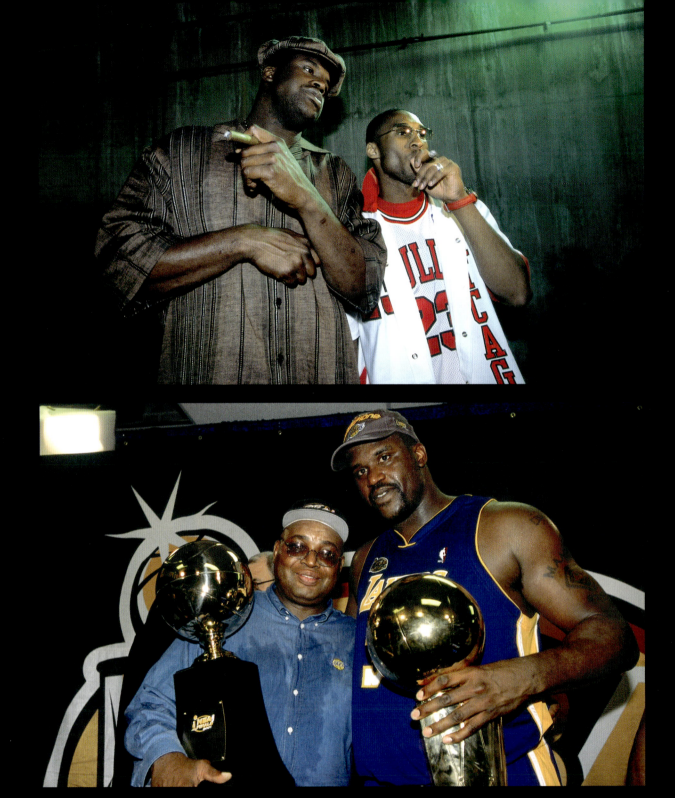

"I remember this. This is when I told Kobe Bryant to take off Michael's jersey and start putting on his own jersey."
—Shaquille O'Neal

TOP: Shaquille O'Neal and Kobe Bryant; Los Angeles Lakers; NBA championship win; East Rutherford, NJ; June 12, 2002

"This is my favorite guy in the world. Sgt. Phillip Arthur Harrison, my father, who told me I was going to be one of the most dominant players ever. And I wish he was still around."
—Shaquille O'Neal

ABOVE: Phillip Arthur Harrison and Shaquille O'Neal; Los Angeles

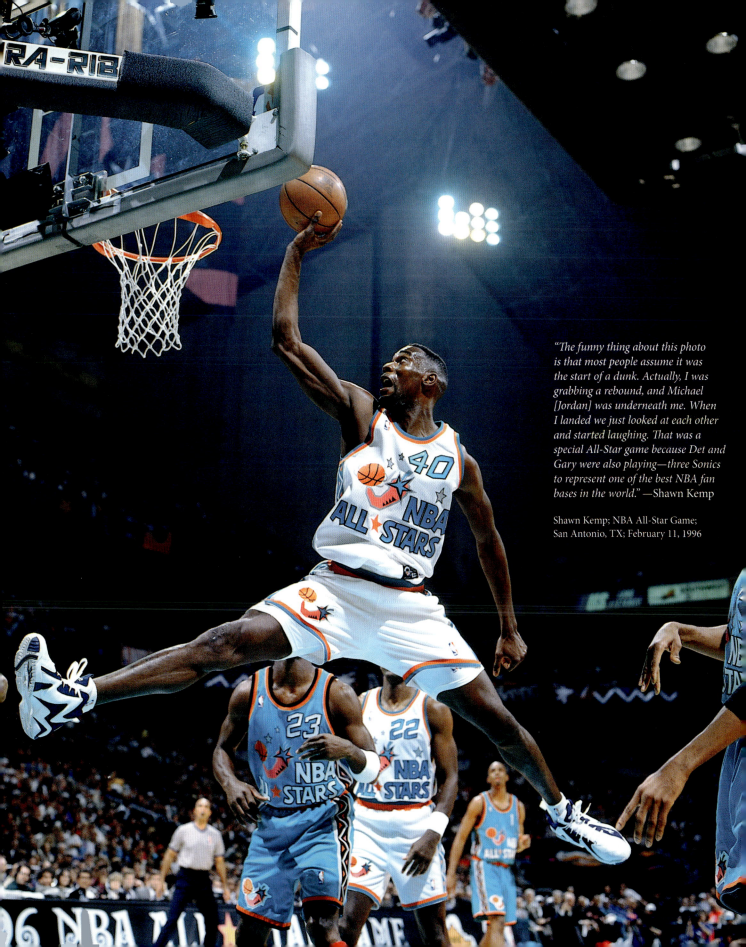

"The funny thing about this photo is that most people assume it was the start of a dunk. Actually, I was grabbing a rebound, and Michael [Jordan] was underneath me. When I landed we just looked at each other and started laughing. That was a special All-Star game because Det and Gary were also playing—three Sonics to represent one of the best NBA fan bases in the world." —Shawn Kemp

Shawn Kemp; NBA All-Star Game; San Antonio, TX; February 11, 1996

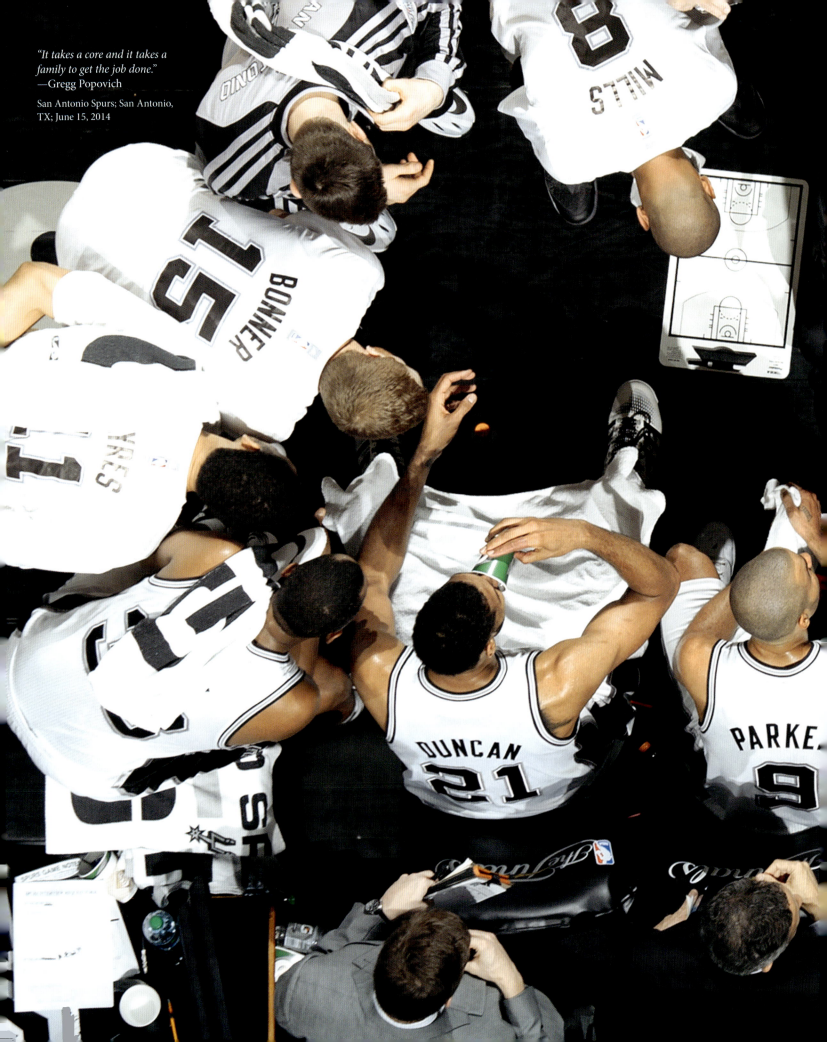

"It takes a core and it takes a family to get the job done."
—Gregg Popovich

San Antonio Spurs; San Antonio, TX; June 15, 2014

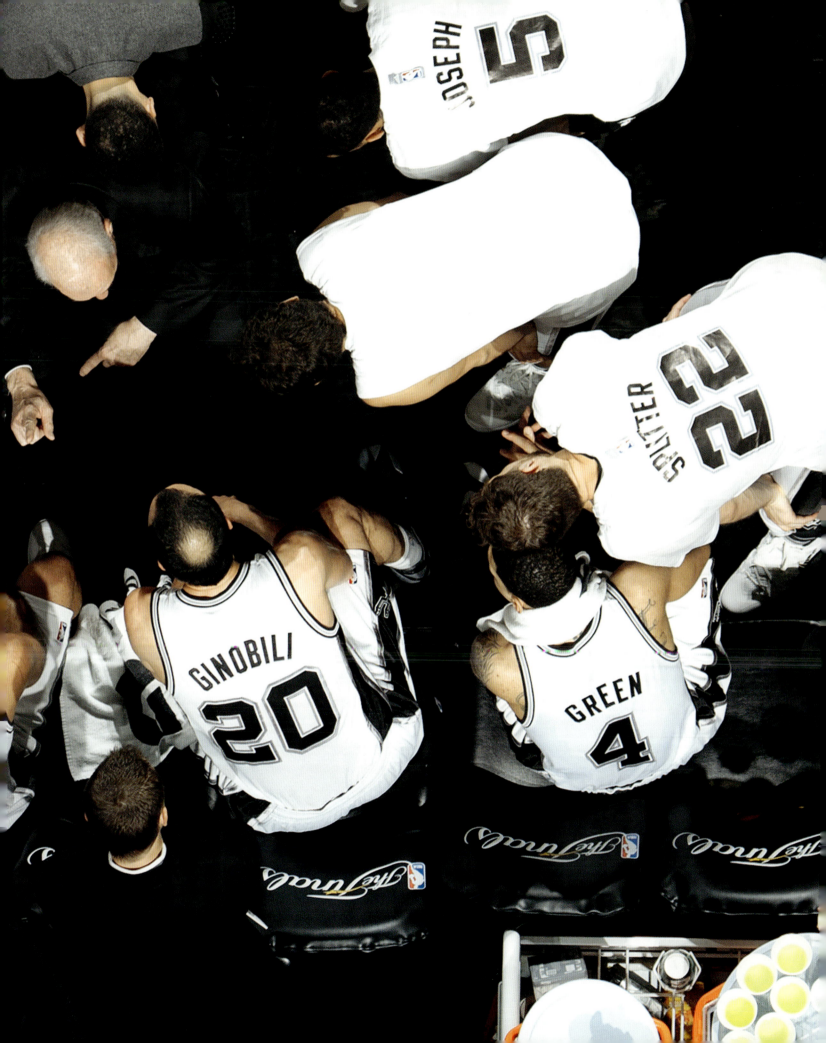

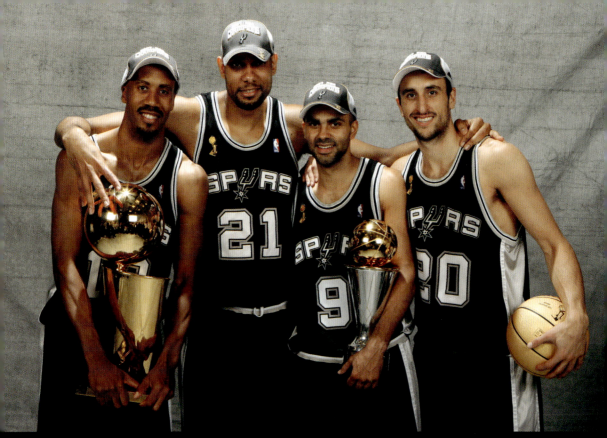

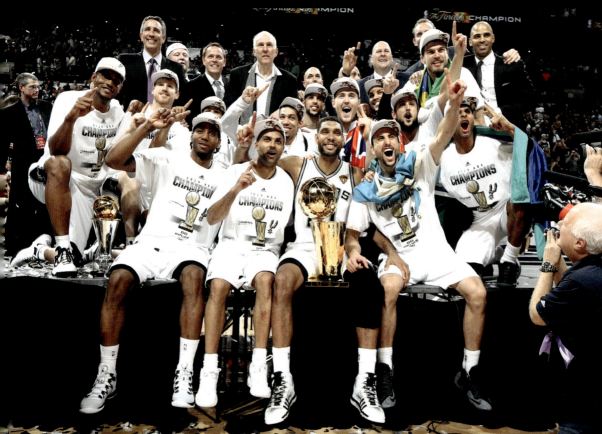

TOP: Bruce Bowen, Tim Duncan, Tony Parker, and Manu Ginóbili; San Antonio Spurs; NBA championship win; Cleveland, OH; June 14, 2007

"That was a long road because we were just there the last year, and were five seconds away, and then to come back the next year and play the same team and beat them, it was amazing. It was dope." —Kawhi Leonard

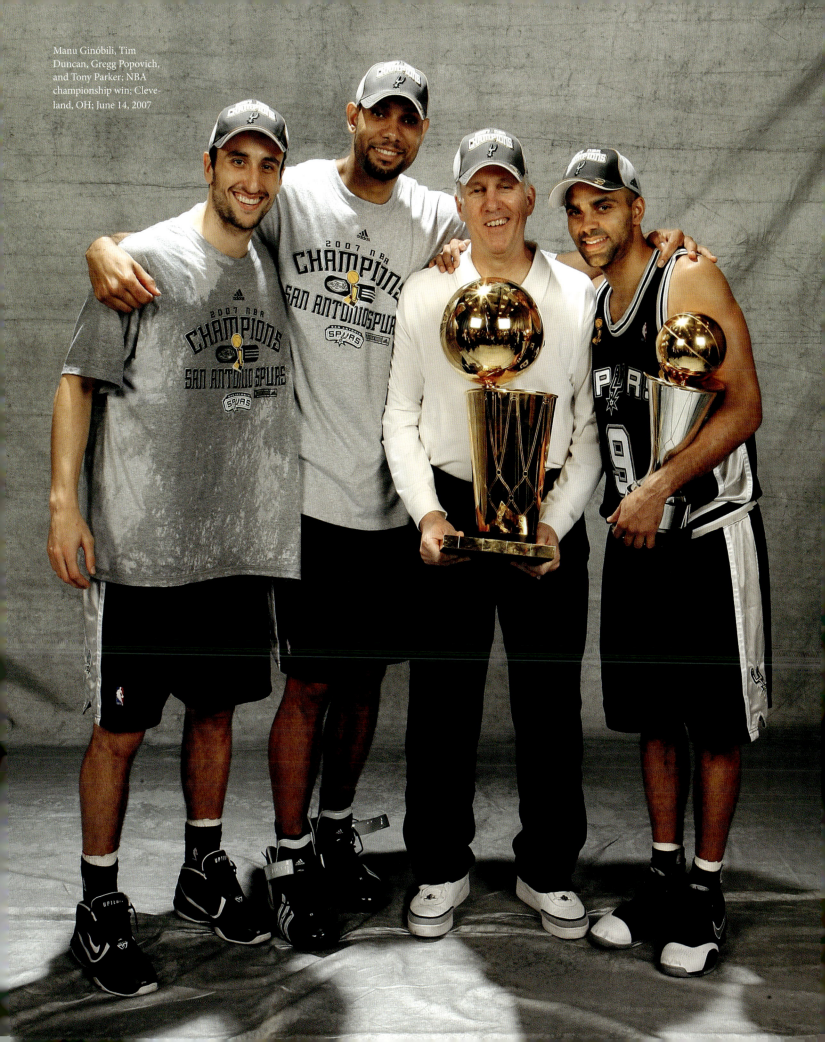

Manu Ginóbili, Tim Duncan, Gregg Popovich, and Tony Parker; NBA championship win; Cleveland, OH; June 14, 2007

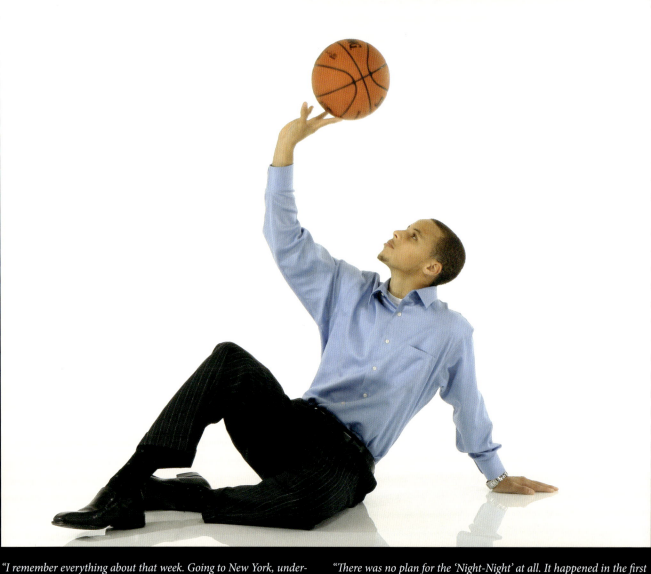

"I remember everything about that week. Going to New York, understanding the glitz and glam of the draft process . . . and that's such a 2009 'fit, with a nice tucked-in button-down with the crewneck T showing underneath. That's the game day 'fit I wore in college for three years. That was the start of thinking I was going to be drafted by New York when I was there for the draft. And my dad's birthday was the next day. A lot of change in my life, obviously, being drafted by the Warriors." —Stephen Curry

ABOVE: Stephen Curry; NBA Pre-Draft portrait; New York, NY; June 24, 2009

"This is one of my favorite pictures because I looked up to those two guys my whole career. And to do it in The Garden—that is something I looked forward to since I started playing basketball. And with those two guys? I appreciate New York for giving me so much love for that moment." —Stephen Curry

OPPOSITE (TOP): Ray Allen, Stephen Curry, and Reggie Miller; New York, NY; December 14, 2021—Stephen Curry breaks the all-time 3-point scoring record

"There was no plan for the 'Night-Night' at all. It happened in the first round in Denver, Game 3, in 2022. I was talking to Andre [Iguodala], and I was coming down the court on a possession with less than a minute left, and I told him, 'It's time to put the kids to bed.' So I got a pick-and-roll, got past Jokić, and scored a layup, and that was the sign I did. And then I did it in Game 5 when we closed it out. And then every series that postseason, there was just one moment where it felt like the right time, and thankfully the story ended the right way with the 3 I hit in Boston in Game 6 of the Finals. And this moment, I think I was the last one in the locker room, exhausted from the year but unbelievably happy that we got it done. The Finals MVP trophy and the Larry O'Brien Trophy . . . the closing of that chapter of my career. Hopefully, it's not the last one, but it's pretty dope." —Stephen Curry

OPPOSITE (BOTTOM): Stephen Curry; Golden State Warriors; NBA championship win; famous "Night-Night" photo; Boston, MA; June 16, 2022

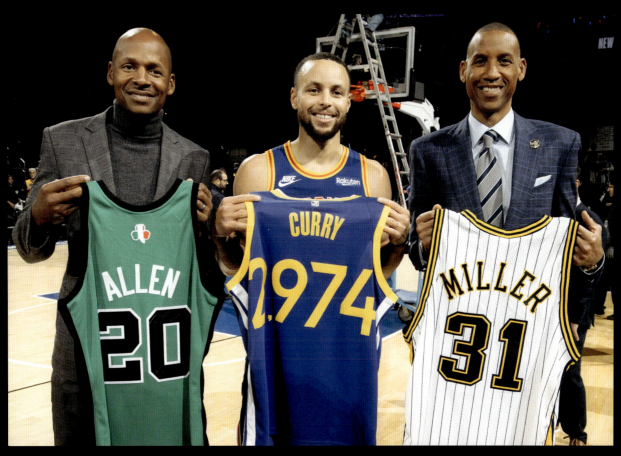
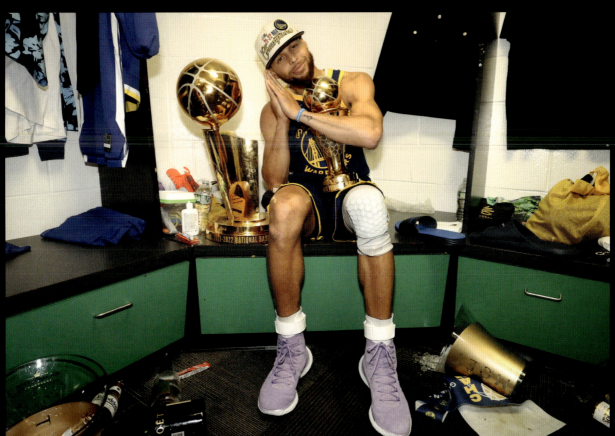

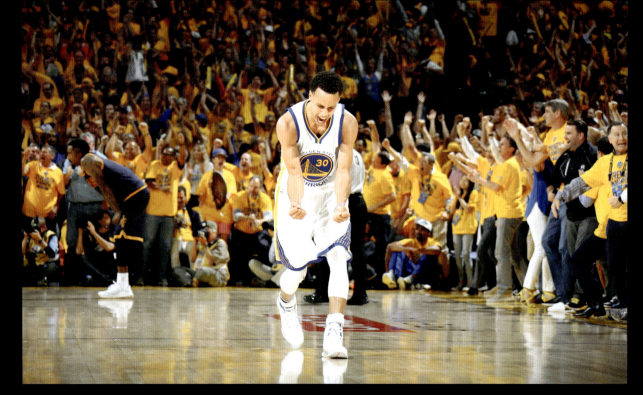

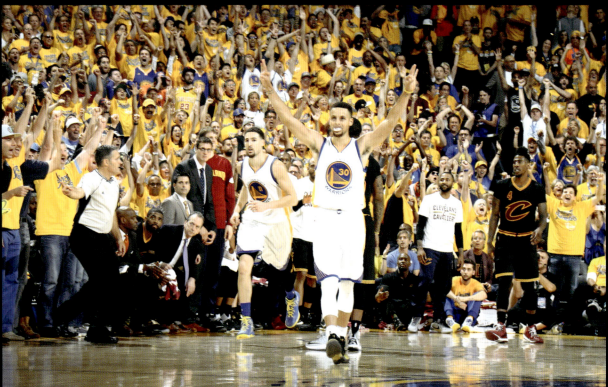

"I remember this. Andre [Iguodala] just hit an and-one. The first championship run in forty years at Oracle—there was no better environment, in terms of the noise and us getting over the hump of finally winning our first one. So that was special. There is a lot of energy in that picture, and that was the start of four amazing back-and-forth years." —Stephen Curry

TOP: Stephen Curry; Golden State Warriors vs. Cleveland Cavaliers; Game 5 of the NBA Finals; Oakland, CA; June 14, 2015

ABOVE: Stephen Curry; Golden State Warriors vs. Cleveland Cavaliers; Game 7 of the NBA Finals; Oakland, CA; June 19, 2016

OPPOSITE: Stephen Curry and LeBron James; Golden State Warriors vs. Cleveland Cavaliers; Game 2 of the NBA Finals; Oakland, CA; June 5, 2016

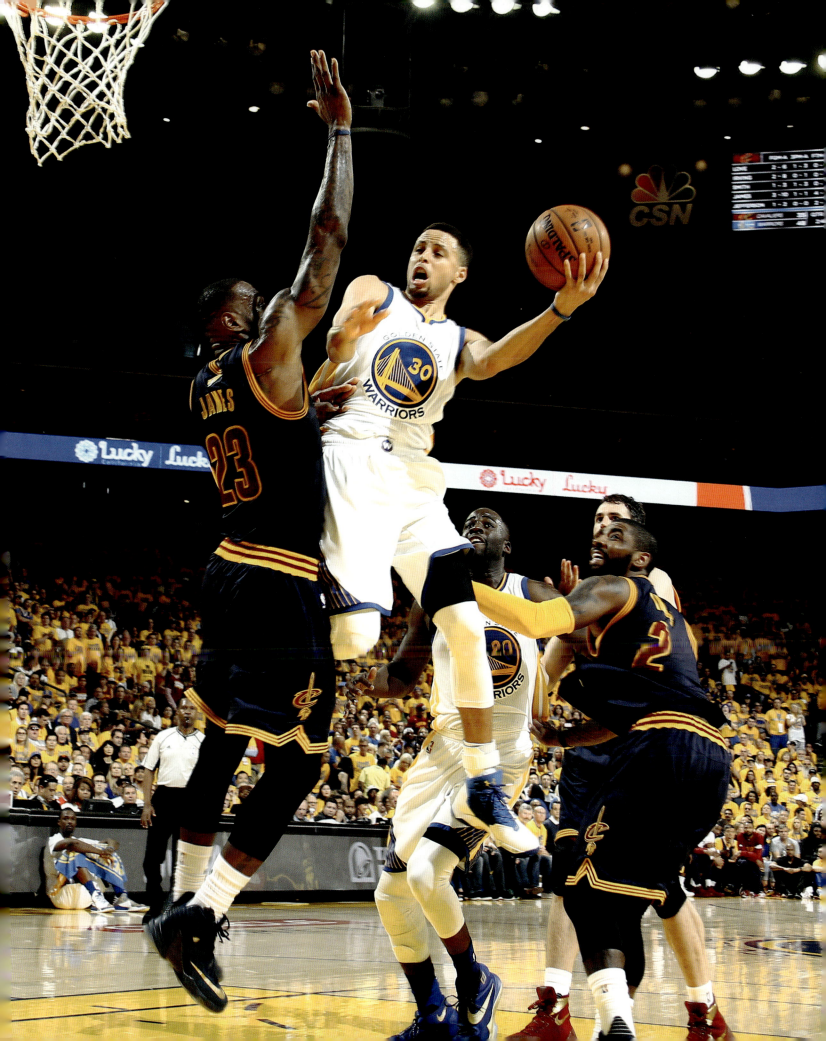

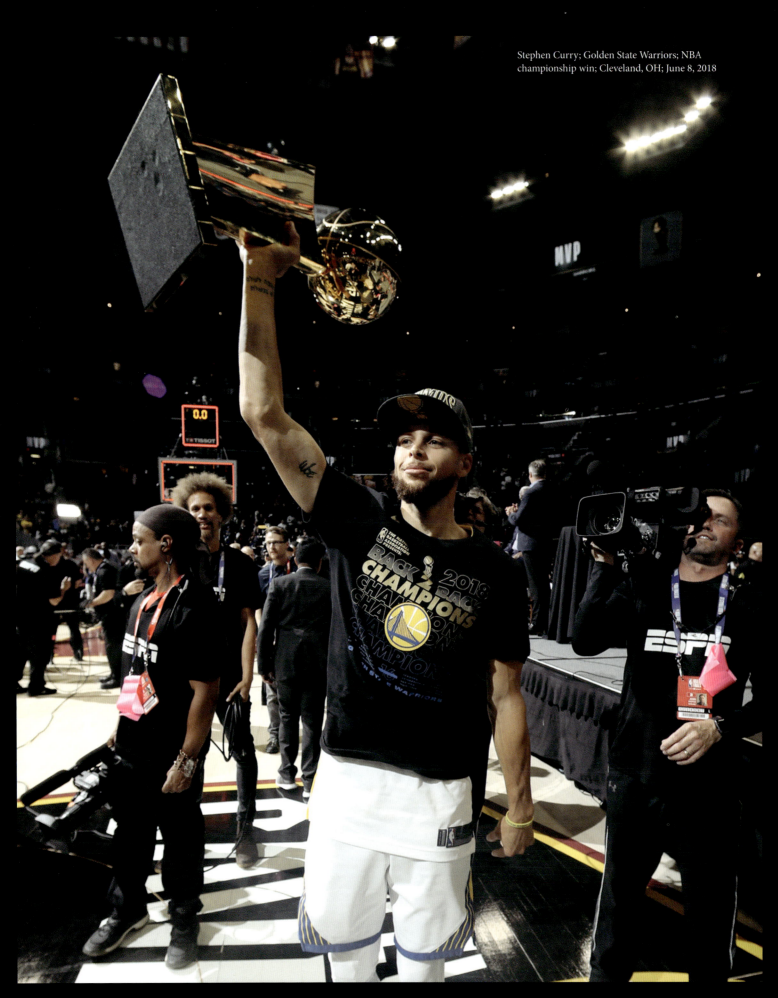

Stephen Curry; Golden State Warriors; NBA championship win; Cleveland, OH; June 8, 2018

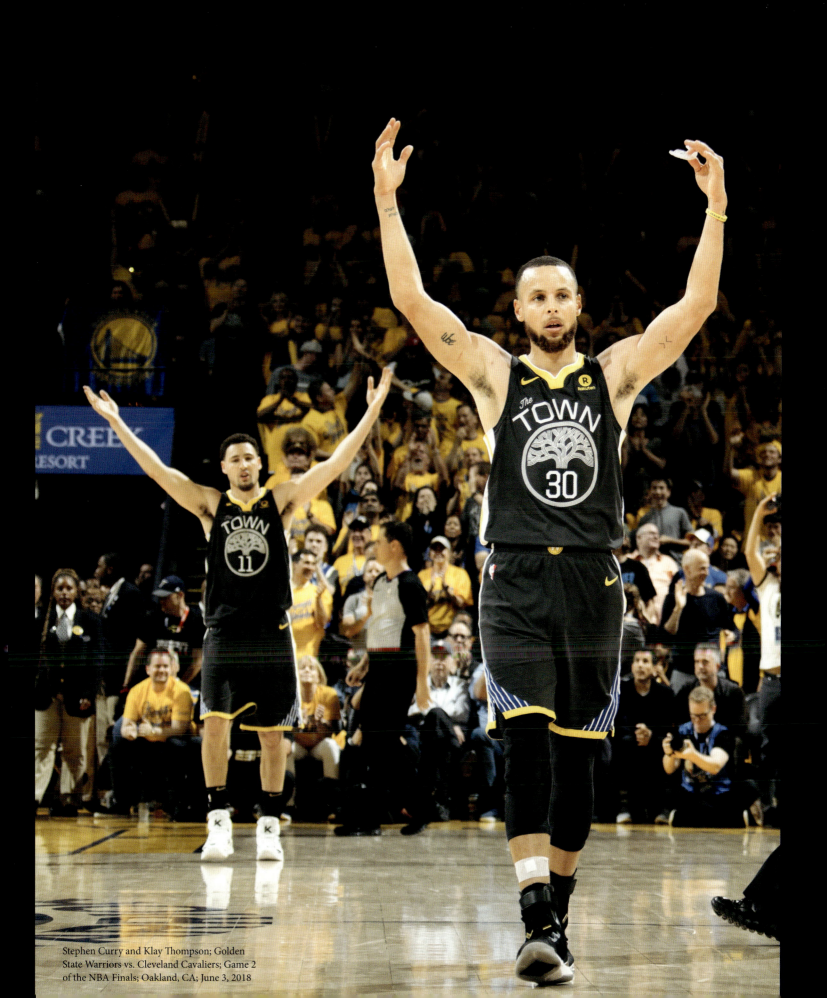

Stephen Curry and Klay Thompson; Golden State Warriors vs. Cleveland Cavaliers; Game 2 of the NBA Finals; Oakland, CA; June 3, 2018

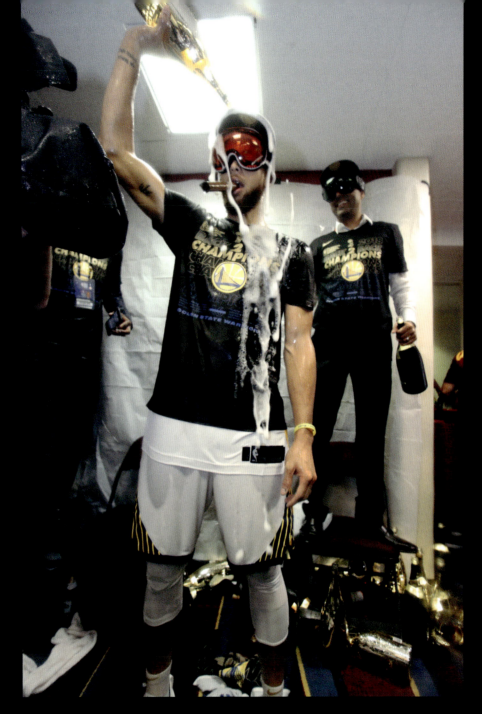

"That was a long time coming. That was right after I said, 'What they gonna say now?!' So that was a night for celebration. I wasted a really good cigar right there, actually."
—Stephen Curry

Stephen Curry; Golden State Warriors; NBA championship win; Cleveland, OH; June 8, 2018

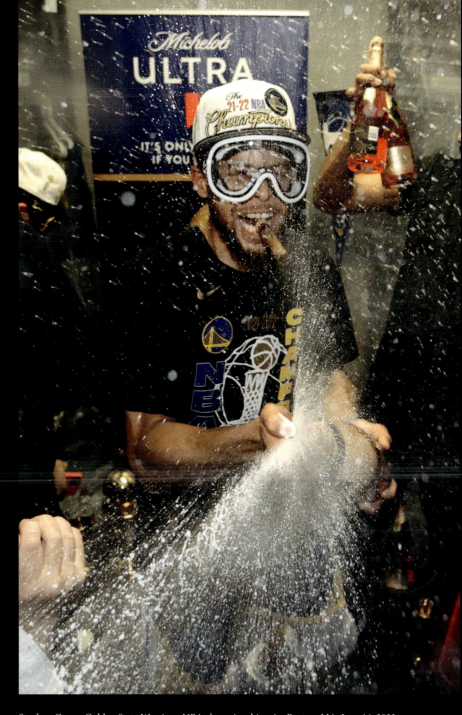

Stephen Curry; Golden State Warriors; NBA championship win; Boston, MA; June 16, 2022

"When I look at this image, I see the photographer, the man, the person who took this picture when he captured the moment—he actually got on the ground, and he was measuring the perfect angle to shoot at. He made it look like I was floating through the sky. This is the most classic, iconic shot, for a rookie having his portrait taken."
—Stephon Marbury

Stephon Marbury; NBA Rookie photo shoot; Orlando, FL; September 20, 1996

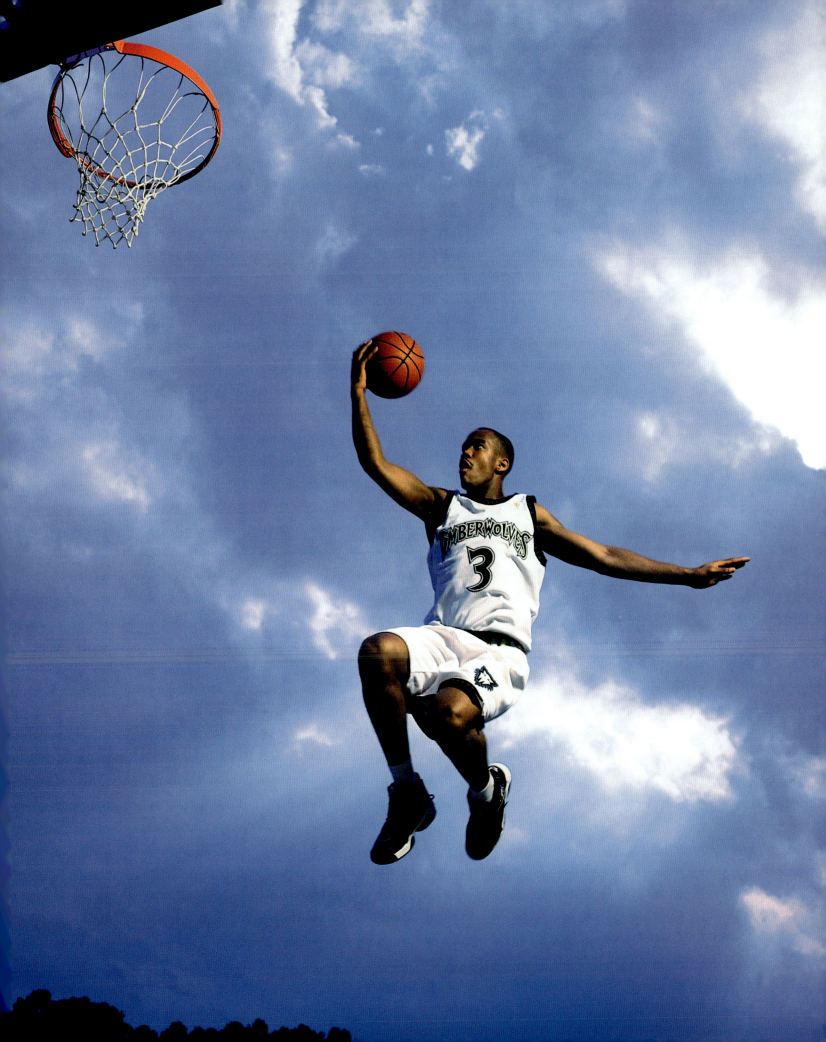

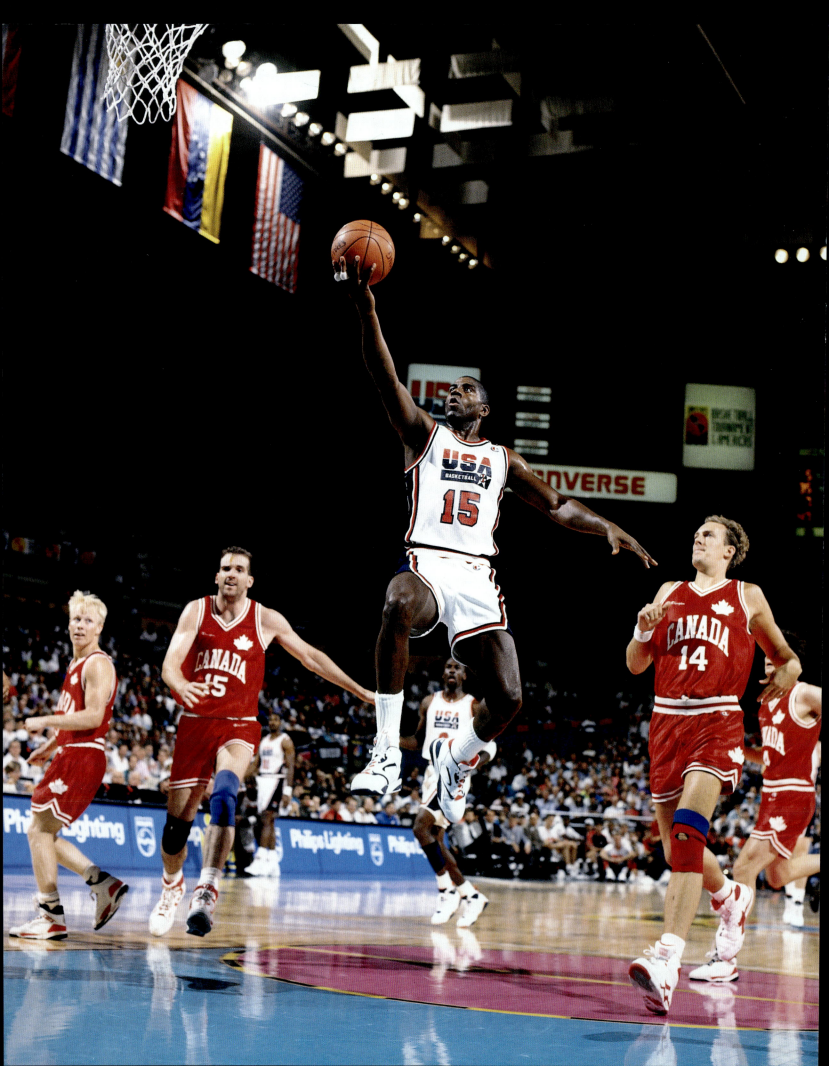

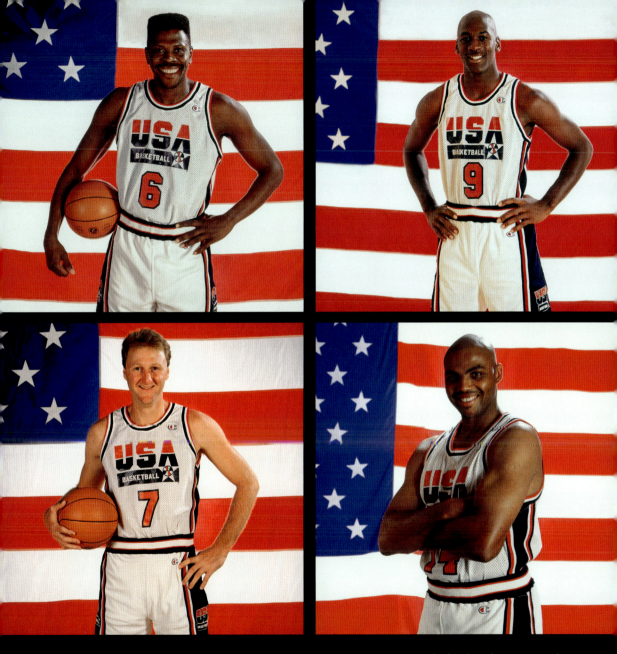

CLOCKWISE FROM TOP LEFT: Team USA portraits: Patrick Ewing; New York, NY; October 10, 1991 • Michael Jordan; Chicago, IL; October 7, 1991 • Charles Barkley; Lancaster, PA; October 3, 1991 • Larry Bird; Boston, MA; October 11, 1991

"Spending time covering them must have been what it was like to cover The Beatles. Everywhere we went, they were mobbed by fans. Going in and out of the hotel every day was an adventure with thousands of people out front. As far as I'm concerned, hands down, the best team ever assembled. Case closed." —Nathaniel S. Butler

OPPOSITE: Earvin "Magic" Johnson; Team USA; Tournament of the Americas; Portland, OR; June 29, 1992

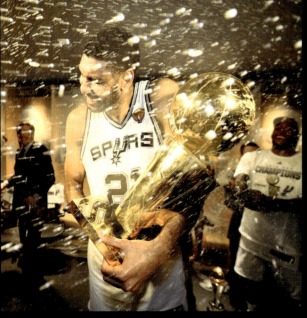
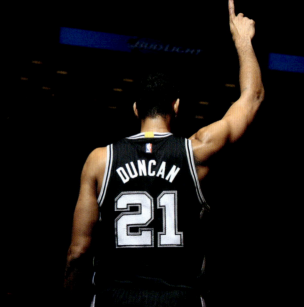
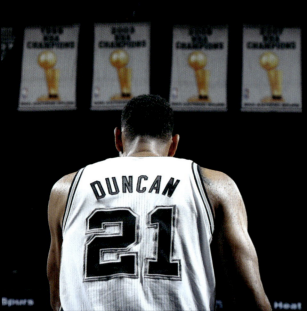
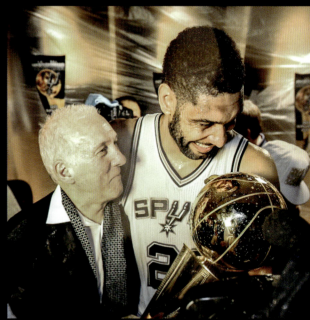

"Timmy Duncan. Mr. Fundamental. Mr. Humble. The Savant."
—Gregg Popovich

CLOCKWISE FROM TOP LEFT: Tim Duncan; San Antonio Spurs; NBA champion; San Antonio, TX; June 15, 2014 • Tim Duncan; San Antonio Spurs; Brooklyn, NY; December 3, 2014 • Gregg Popovich and Tim Duncan; San Antonio Spurs; NBA championship win; San Antonio,

OPPOSITE (TOP): Tim Duncan; San Antonio Spurs; "The Jungle" photo shoot in St. Croix at Tim's high school basketball court for NBA *Inside Stuff*; July 2, 2004

OPPOSITE (BOTTOM): Tim Duncan; San Antonio Spurs; during practice prior to Game 2 of NBA Finals; San Antonio, TX; June 11, 2005

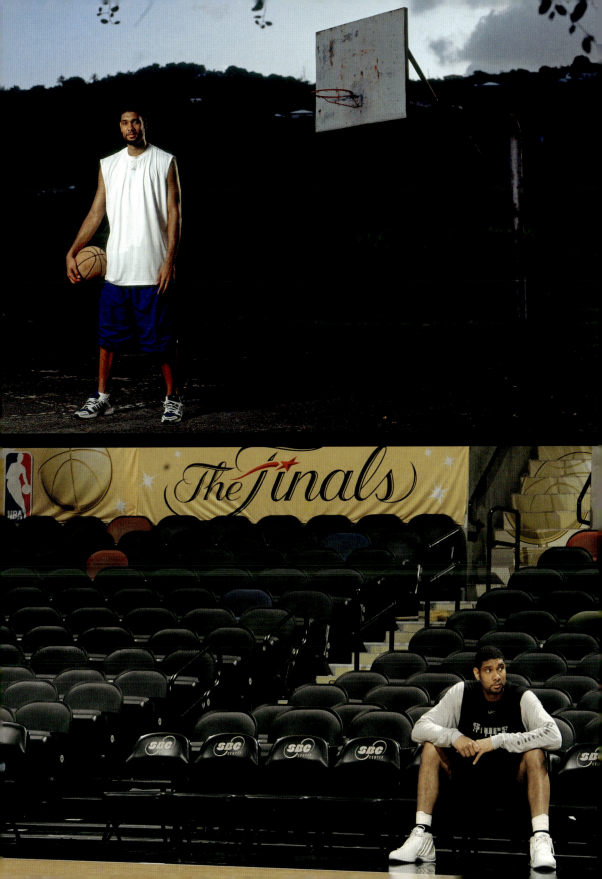

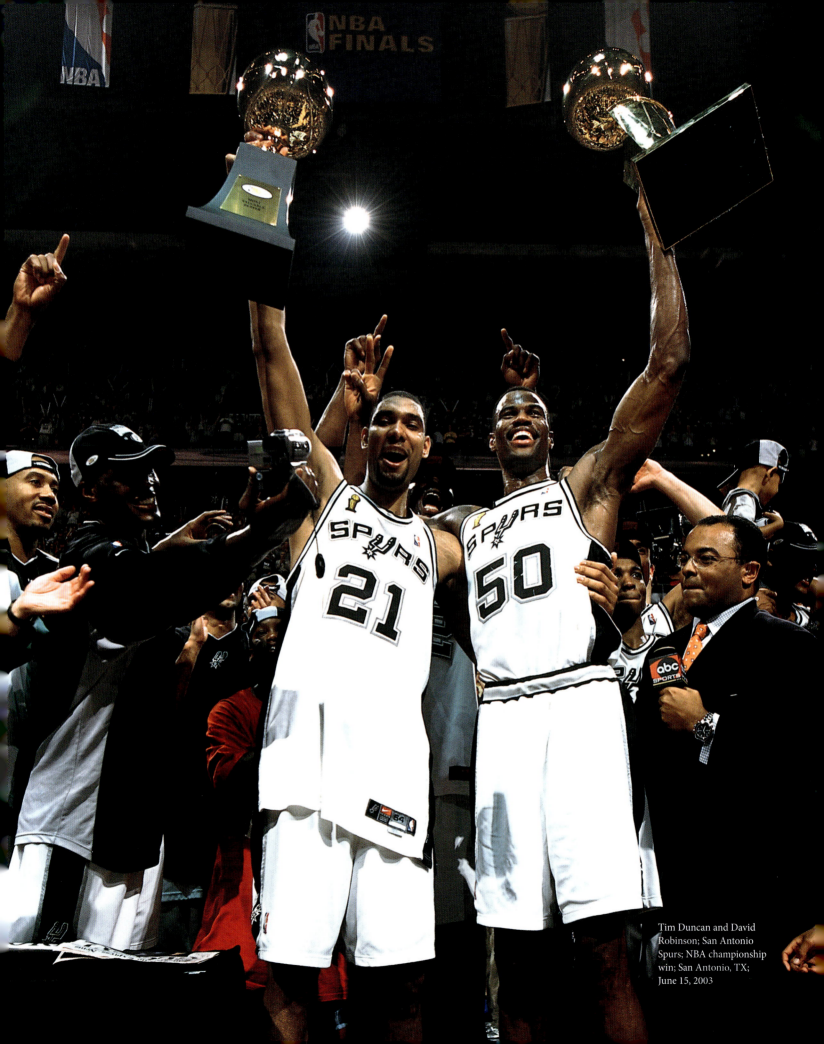

Tim Duncan and David Robinson; San Antonio Spurs; NBA championship win; San Antonio, TX; June 15, 2003

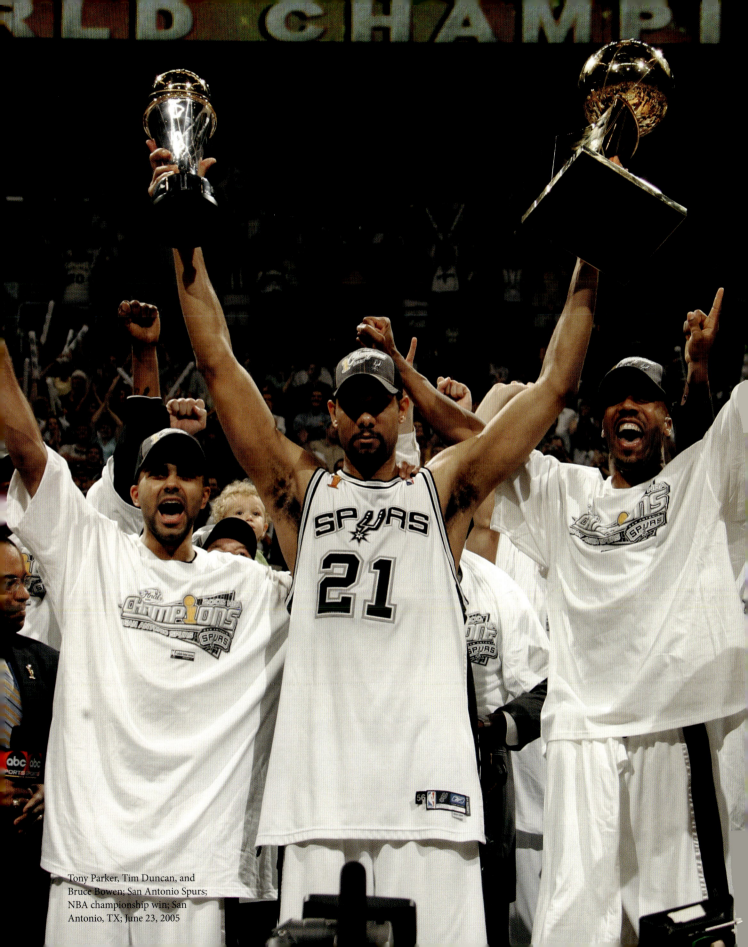

Tony Parker, Tim Duncan, and Bruce Bowen; San Antonio Spurs; NBA championship win; San Antonio, TX; June 23, 2005

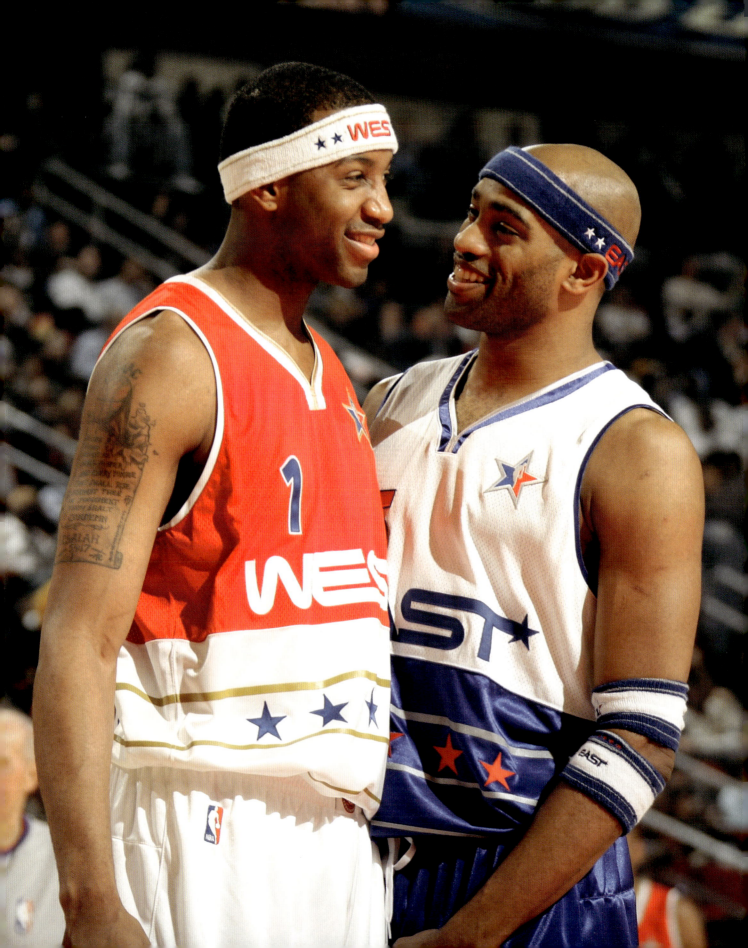

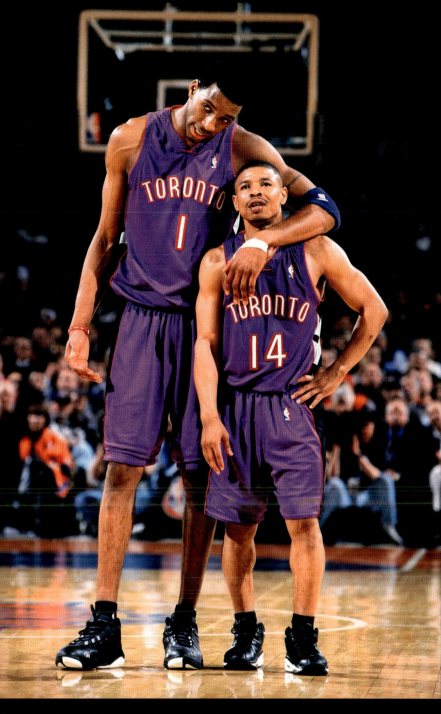

"I was hyped up, and the young fella T-Mac had to calm me down." —Tyrone "Muggsy" Bogues

ABOVE: Tracy McGrady and Tyrone "Muggsy" Bogues; Toronto Raptors vs. New York Knicks; New York, NY; April 26, 2000

OPPOSITE: Tracy McGrady and Vince Carter; NBA All-Star Game; Houston, TX; February 19, 2006

"This image is just the start of my journey. I'm still young, and I'm still trying to get it, but that was my first game of the playoffs—and I know players are made in the playoffs. These are the most important games, so for it to be my first game and to hit a game-winner, that's what takes me back to that moment." —Trae Young

ABOVE: Trae Young; Atlanta Hawks vs. New York Knicks; New York, NY; May 23, 2021

OPPOSITE: Trae Young; Atlanta Hawks; NBA Rookie photo shoot; Tarrytown, NY; August 12, 2018

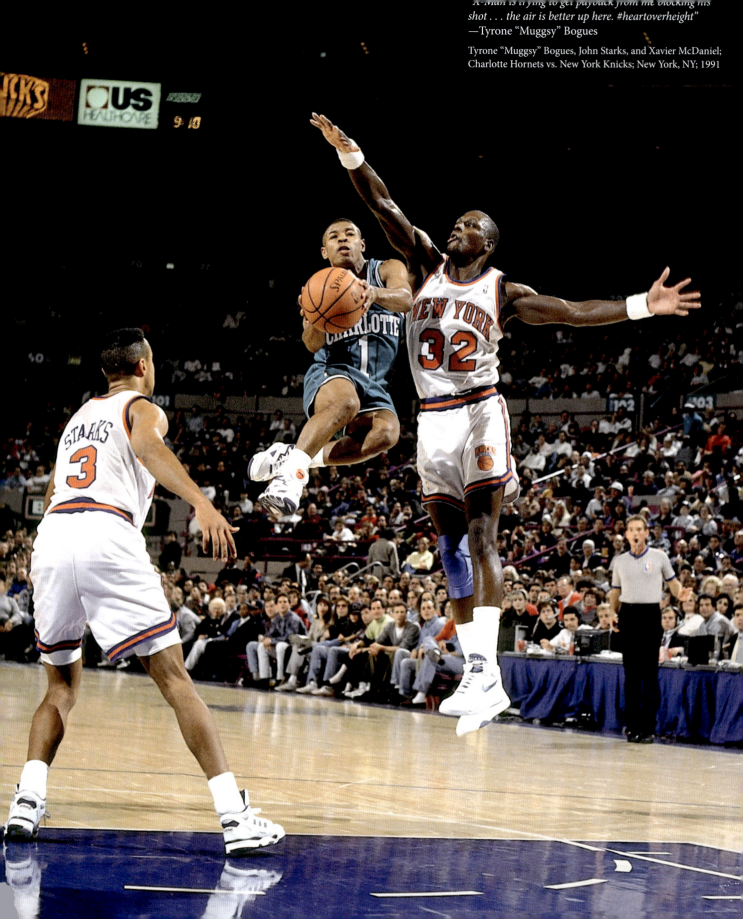

"X-Man is trying to get payback from me blocking his shot . . . the air is better up here. #heartoverheight"
—Tyrone "Muggsy" Bogues

Tyrone "Muggsy" Bogues, John Starks, and Xavier McDaniel; Charlotte Hornets vs. New York Knicks; New York, NY; 1991

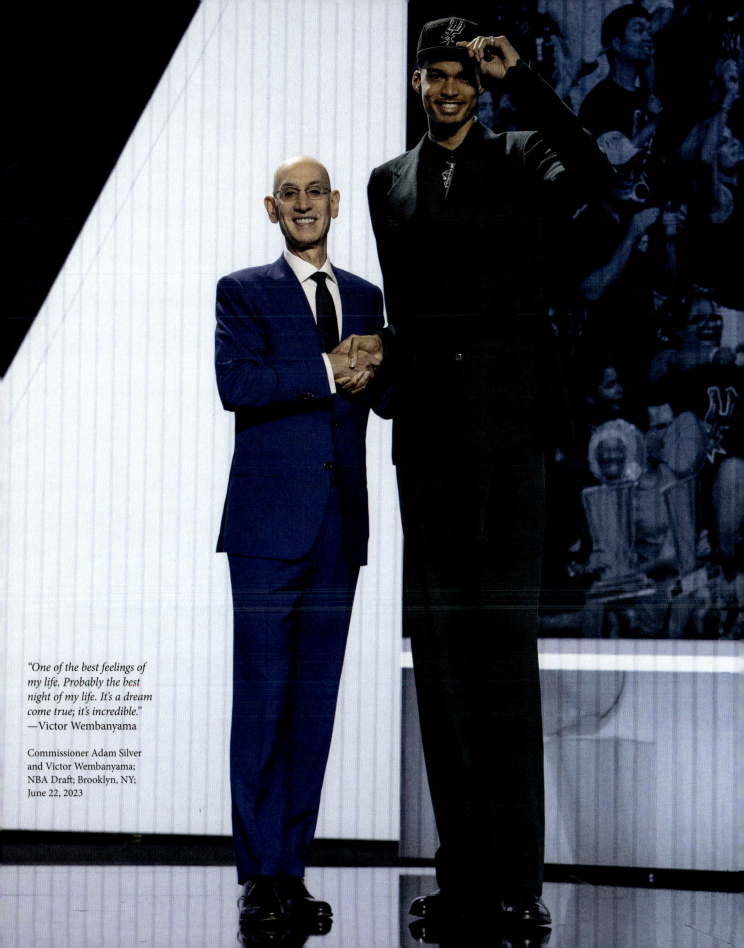

"One of the best feelings of my life. Probably the best night of my life. It's a dream come true; it's incredible."
—Victor Wembanyama

Commissioner Adam Silver and Victor Wembanyama; NBA Draft; Brooklyn, NY; June 22, 2023

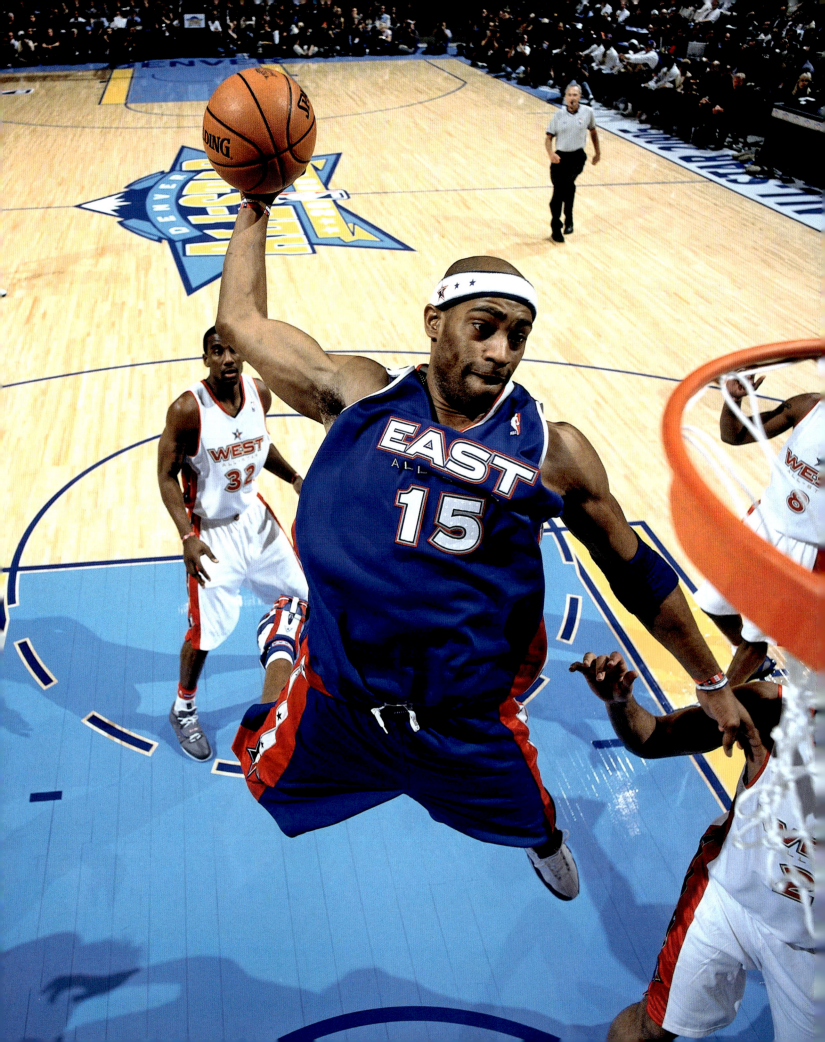

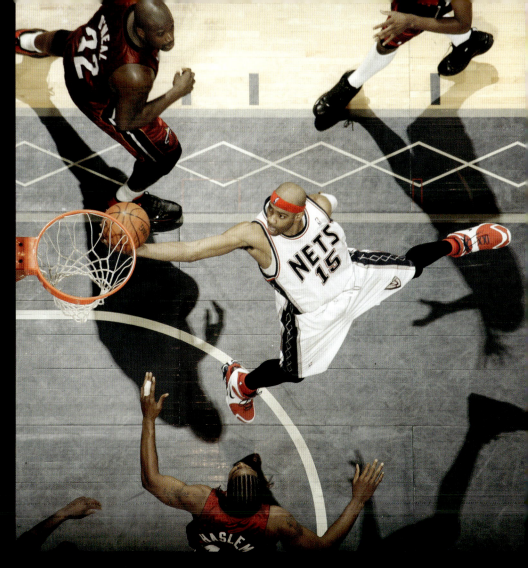

"I was traded to Jersey as a go-to guy, and here's a team that was very, very good defensively. I took advantage of any opportunity I could get into the paint against the 'Heat Culture's' defense. There you see Shaq who is standing behind me, I was trying to get the ball in the air, on the backboard before he tried to block, and it made for a pretty cool shot." Vince Carter

ABOVE: Vince Carter, Shaquille O'Neal, and Udonis Haslem; New Jersey Nets vs. Miami Heat; East Rutherford, NJ; May 12, 2006

"This was off the backboard during All-Star in Denver. It's a signature dunk that you've seen from others—from T-Mac—but it was an in-the-moment type of thing for me. I was in transition, on a fast break, the lane started to part a little bit, and if you watch the replay, once the ball kind of goes out of my hand and against the backboard, you can see everybody's faces looking at the hoop—and there I go. I was just putting on a show when I made my mind up that I was going to go dunk the ball, particularly in the All-Star Game." —Vince Carter

OPPOSITE: Vince Carter; NBA All-Star Game; Denver, CO; February 20, 2005

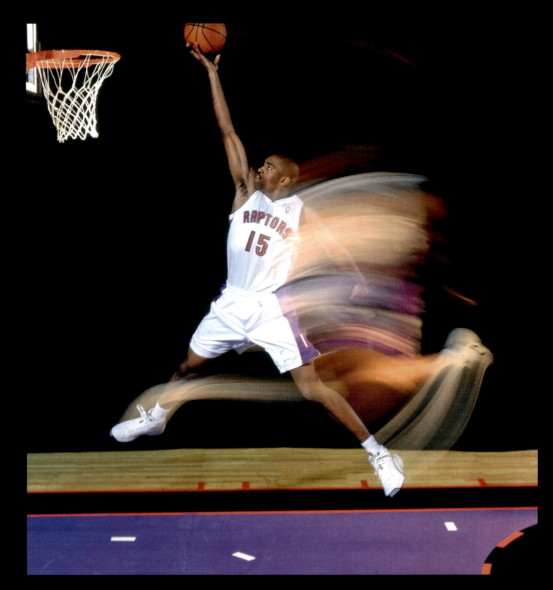

"It looks blurred—but that's young Vince at the time, and how I played. I played fast. Once I got up, it was like, 'He's already gone.' I think this captured that and me coming into the league, really getting the opportunity to play and show everybody what I can do." —Vince Carter

ABOVE: Vince Carter; Toronto Raptors; Toronto, Ontario; November 1, 1999

"This is the iconic first dunk of the All-Star dunk contest. I see so many things in this picture that bother me. Like, how I hold my hands, and when I'm focused in, I usually bite or cup my lip, and it just makes me laugh. That means I'm really focused and concentrating, and I was trying to hammer it down. When I look at it from this angle, I'm a big stickler when it comes to windmill dunks as far as full extension. And I think this photo captures what I like to see as far as eyes at the rim, full extension—and obviously, we know the outcome." —Vince Carter

OPPOSITE: Vince Carter; Toronto Raptors; NBA Slam Dunk Champion; Oakland, CA; February 12, 2000

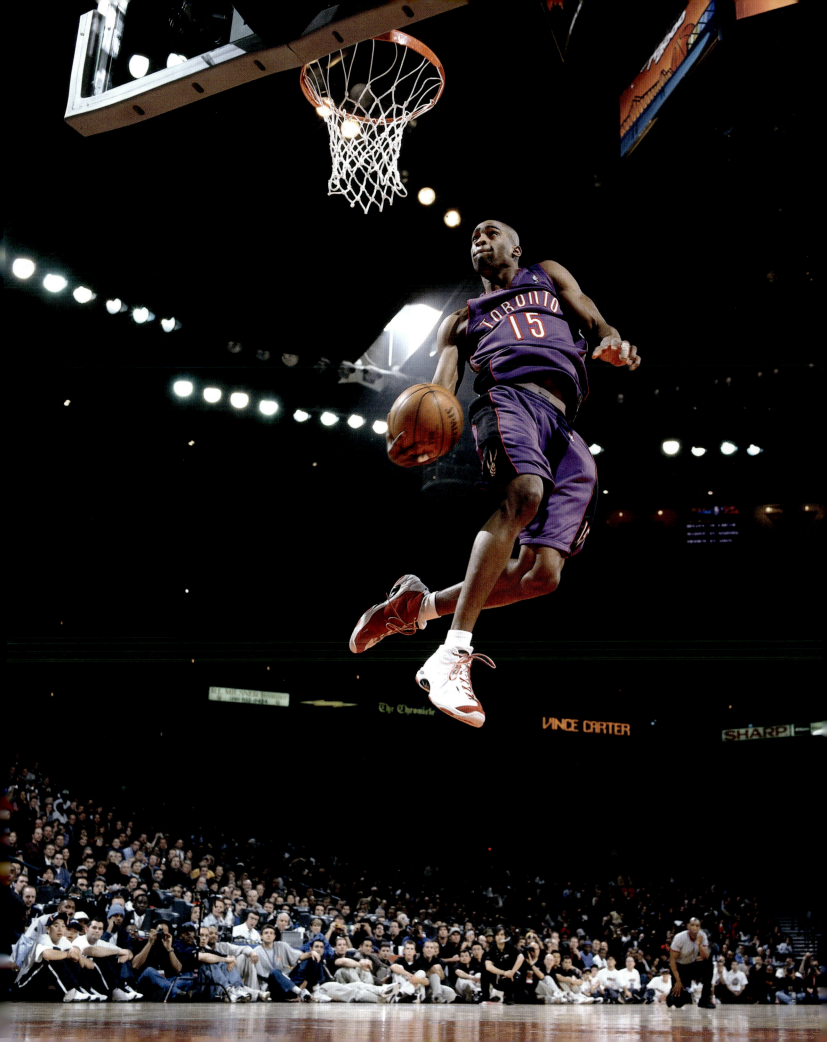

"Just kind of giving fans a sneak peek of what they're getting as an athlete. Obviously, they saw me do my thing for six years, but I think it's exciting, and you can see Vince as a vet. You can see the Carter 15, the signature Nets jersey at the time. And me flying through the air—that sets the tone for excitement. I was excited to be there for a new opportunity. Nat just asked me if I could do something in the air, and here I was visualizing a situation in a game to create a very cool picture. When you give your best with your pose, the picture portrays it. It's larger than life—higher than life—which is pretty cool."
—Vince Carter

Vince Carter; New Jersey Nets portrait; East Rutherford, NJ; December 23, 2004

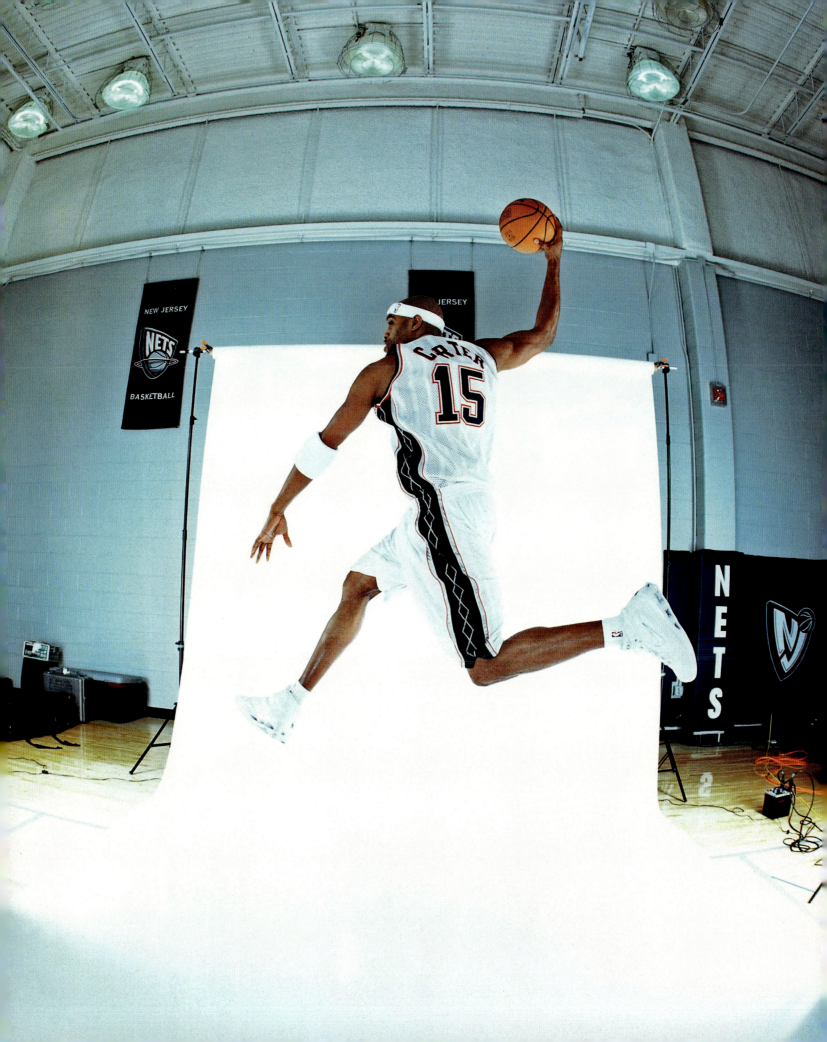

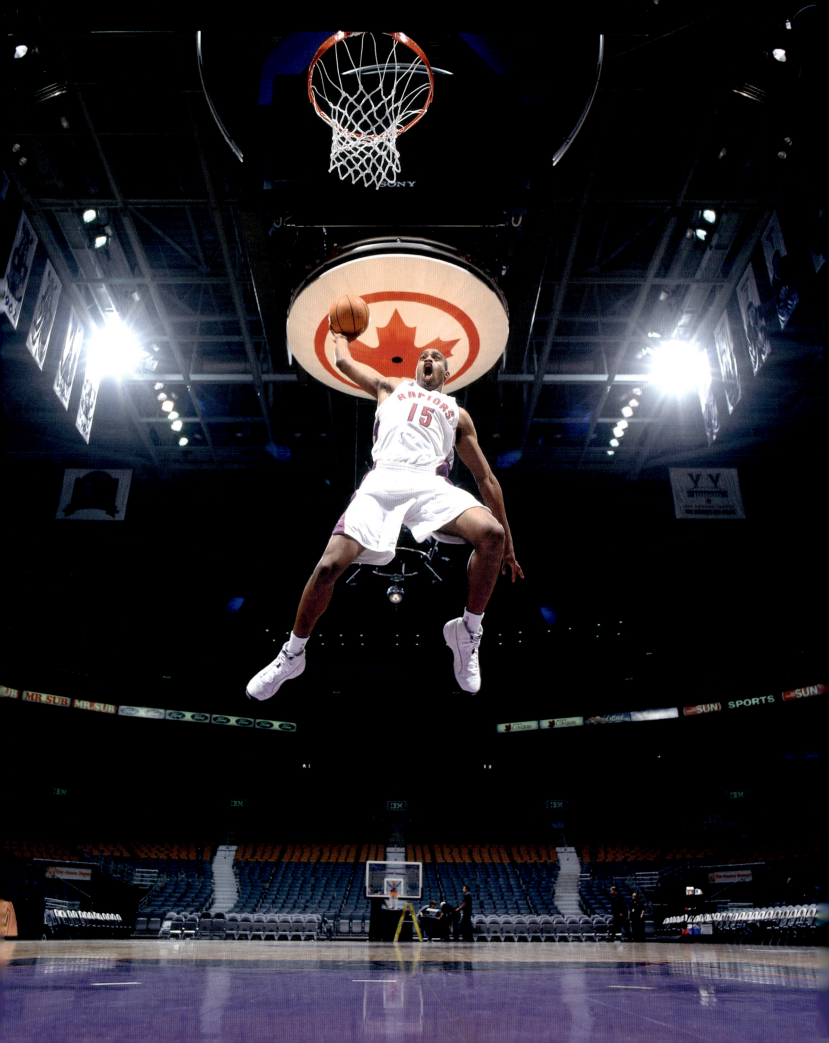

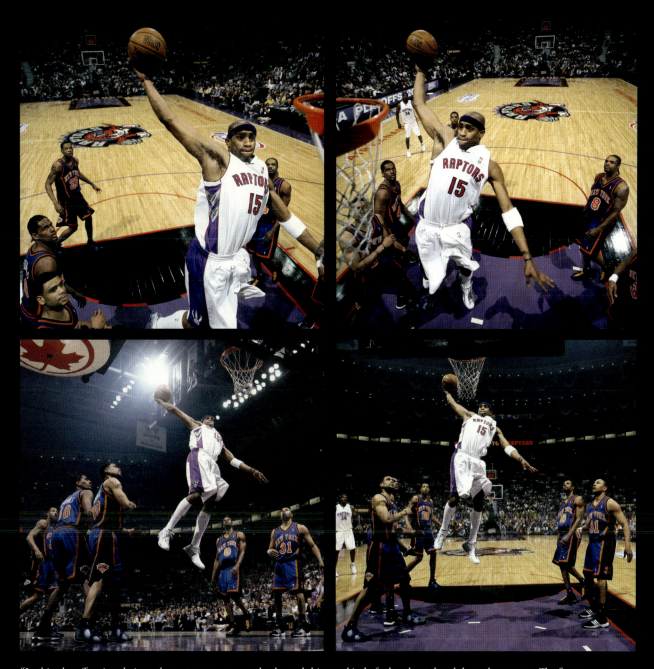

"In this playoff series, their goal was to stop me completely, and this was kind of a breakout, breakthrough moment. The first two games we played at The Garden, and to get in the paint was fine, but you were going to see those four guys emerge in front of you, where I had no shot to get close to the rim. So it was either a pass or you're forcing a shot. And here, it was one of the first plays of the game, and once I saw the lane parted, I just took off. And that took the tone for that game to really get us back into the series. All from one play. That was in the first quarter, in the first couple minutes of the game." —Vince Carter

ABOVE: Vince Carter; Toronto Raptors vs. New York Knicks; Toronto, Ontario; May 2, 2001

"That was the expression that I had then, just enjoying it. Flying through the air. I remember like it was yesterday—excitement and nerves and jitters and not knowing what the future holds." —Vince Carter

OPPOSITE: Vince Carter; Toronto Raptors; Toronto, Ontario; November 1, 1999

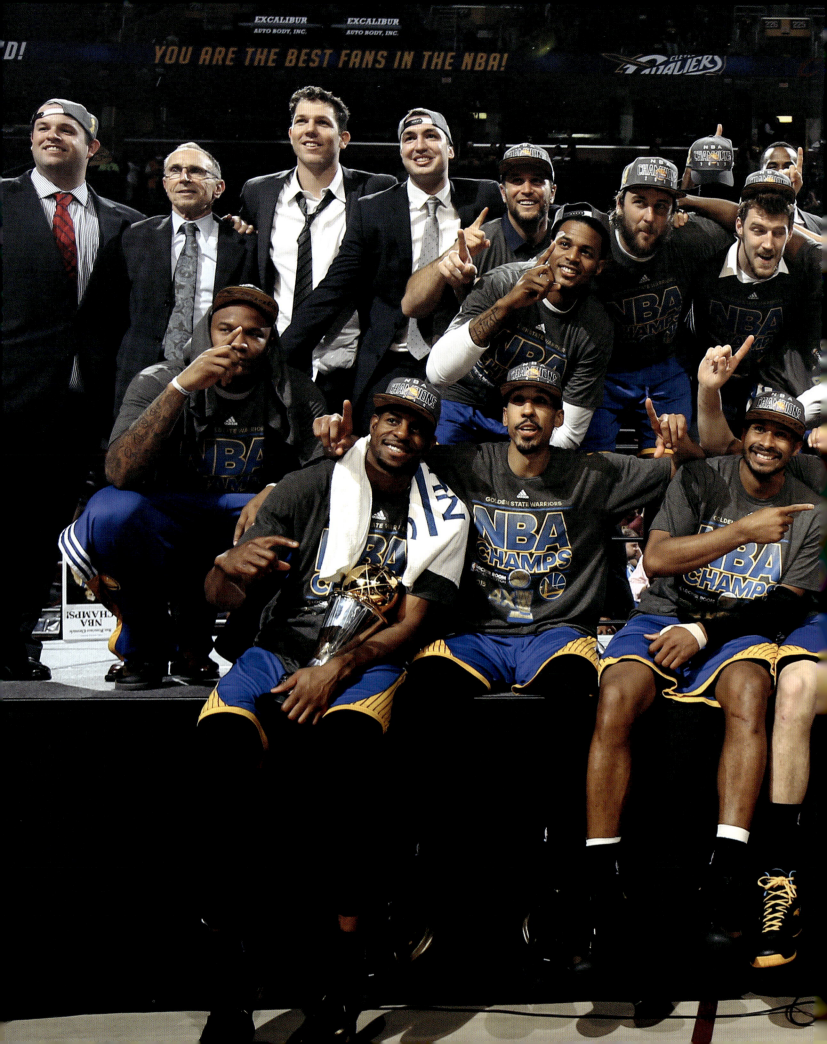

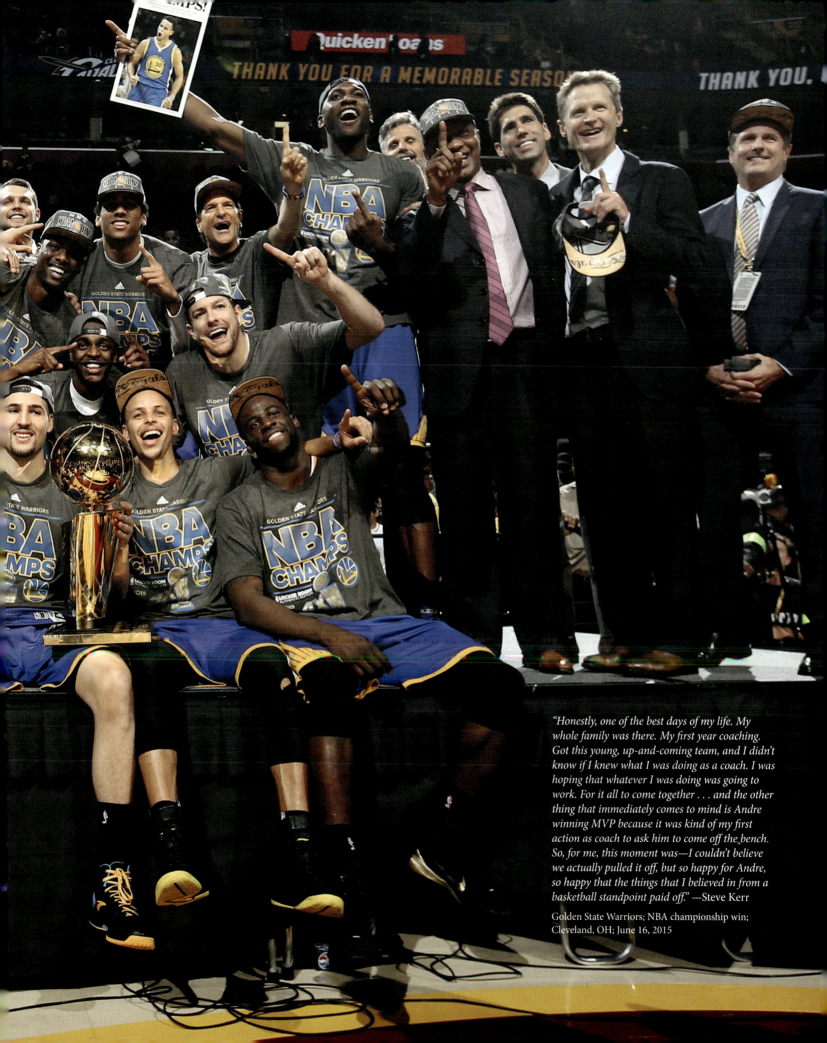

"Honestly, one of the best days of my life. My whole family was there. My first year coaching. Got this young, up-and-coming team, and I didn't know if I knew what I was doing as a coach. I was hoping that whatever I was doing was going to work. For it all to come together . . . and the other thing that immediately comes to mind is Andre winning MVP because it was kind of my first action as coach to ask him to come off the bench. So, for me, this moment was—I couldn't believe we actually pulled it off, but so happy for Andre, so happy that the things that I believed in from a basketball standpoint paid off." —Steve Kerr

Golden State Warriors; NBA championship win; Cleveland, OH; June 16, 2015

"This was a portrait that I took up at Kutsher's, an old resort in the Catskills. There is a very famous photo of Wilt as a kid there, working as a bellhop and passing luggage up through a second-story window. Back in the day, a lot of NYC and Philly kids worked at Kutsher's in the summers, resulting in legendary evening pickup games. Wilt had remained friendly with the owners throughout the years, and so he wanted to have his portrait taken there.

There had been rumors that the New Jersey Nets had reached out to Wilt about returning to play when he was fifty years old. And it was remarkable to me that he remained such a physical presence at our shoot, when he was nearly sixty. I so clearly remember having to pinch myself as I drove up to Kutsher's, thinking about how I was getting the opportunity to photograph Wilt Chamberlain. Still to this day, I am so grateful to have spent time with him in a place that was so meaningful." —Nathaniel S. Butler

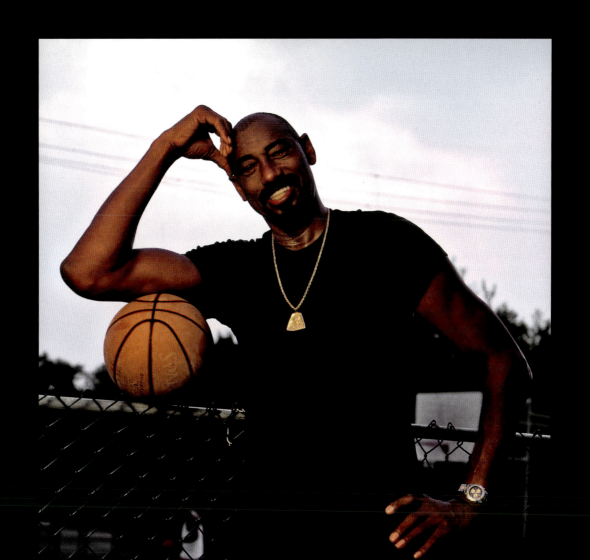

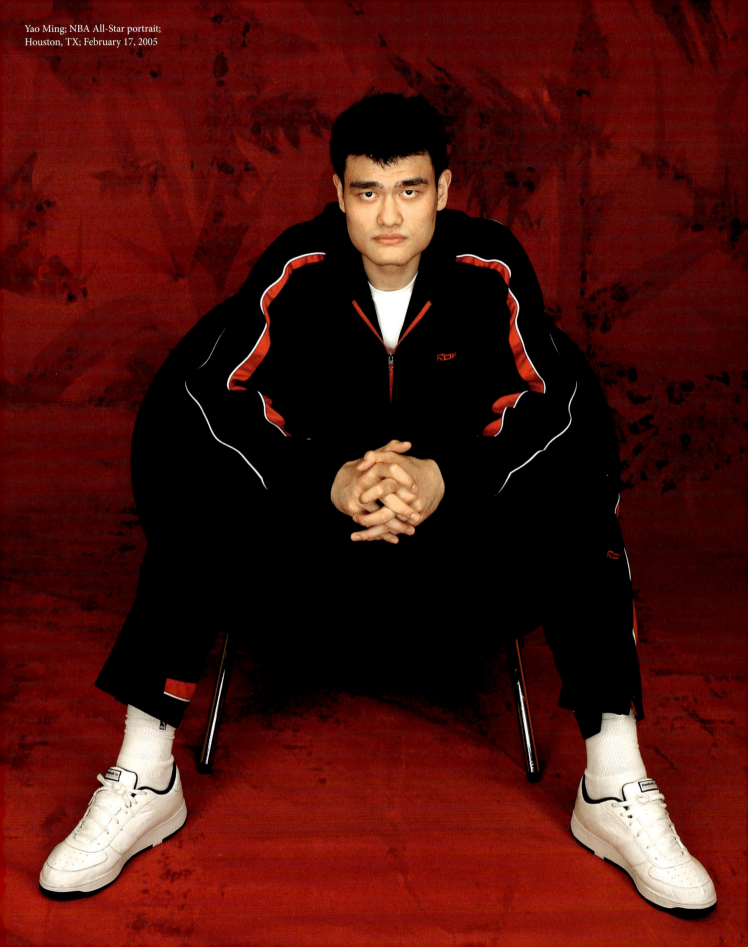

Yao Ming; NBA All-Star portrait;
Houston, TX; February 17, 2005

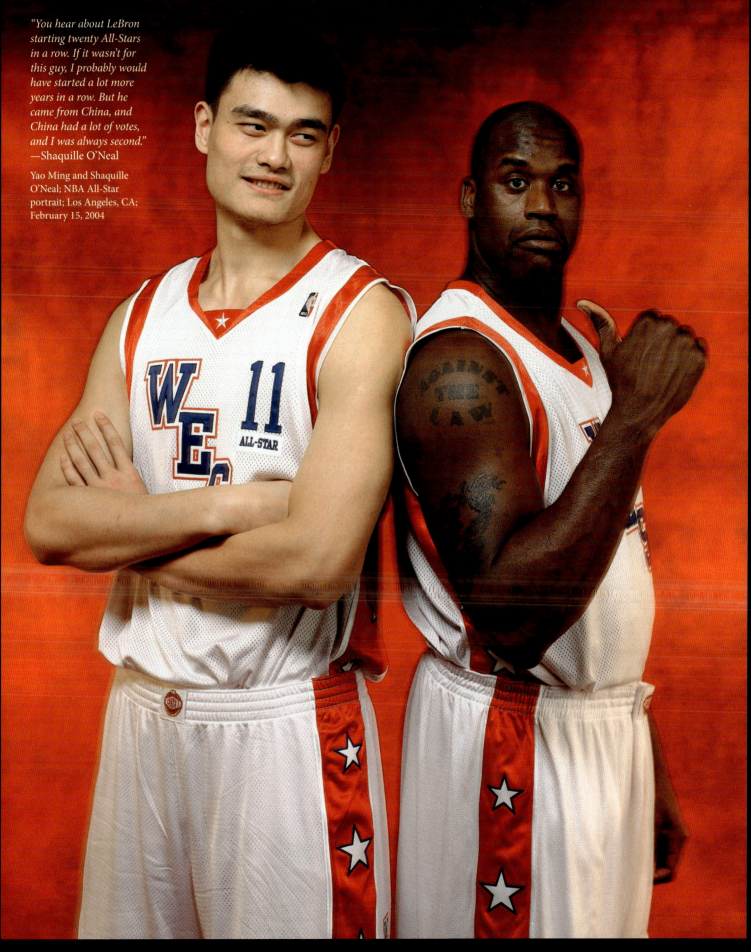

"You hear about LeBron starting twenty All-Stars in a row. If it wasn't for this guy, I probably would have started a lot more years in a row. But he came from China, and China had a lot of votes, and I was always second."
—Shaquille O'Neal

Yao Ming and Shaquille O'Neal; NBA All-Star portrait; Los Angeles, CA; February 15, 2004

Michael Jordan and Yao Ming; All-Star portrait;
Atlanta, GA; February 9, 2003

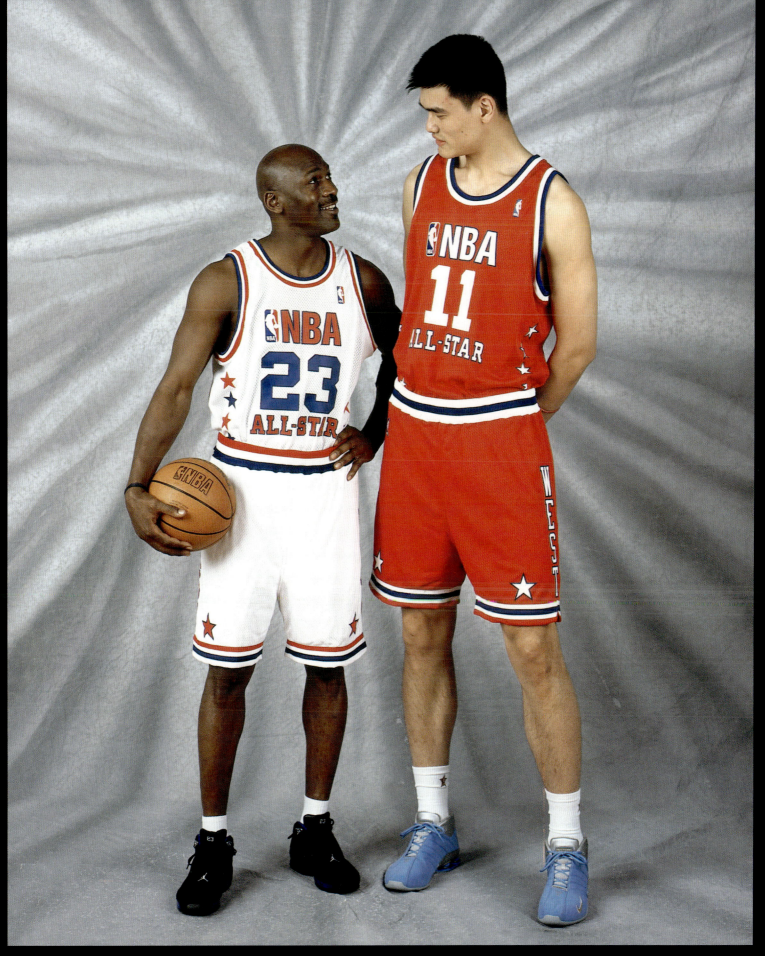

Zion Williamson; New Orleans Pelicans;
NBA Rookie photo shoot; Madison, NJ;
August 11, 2019

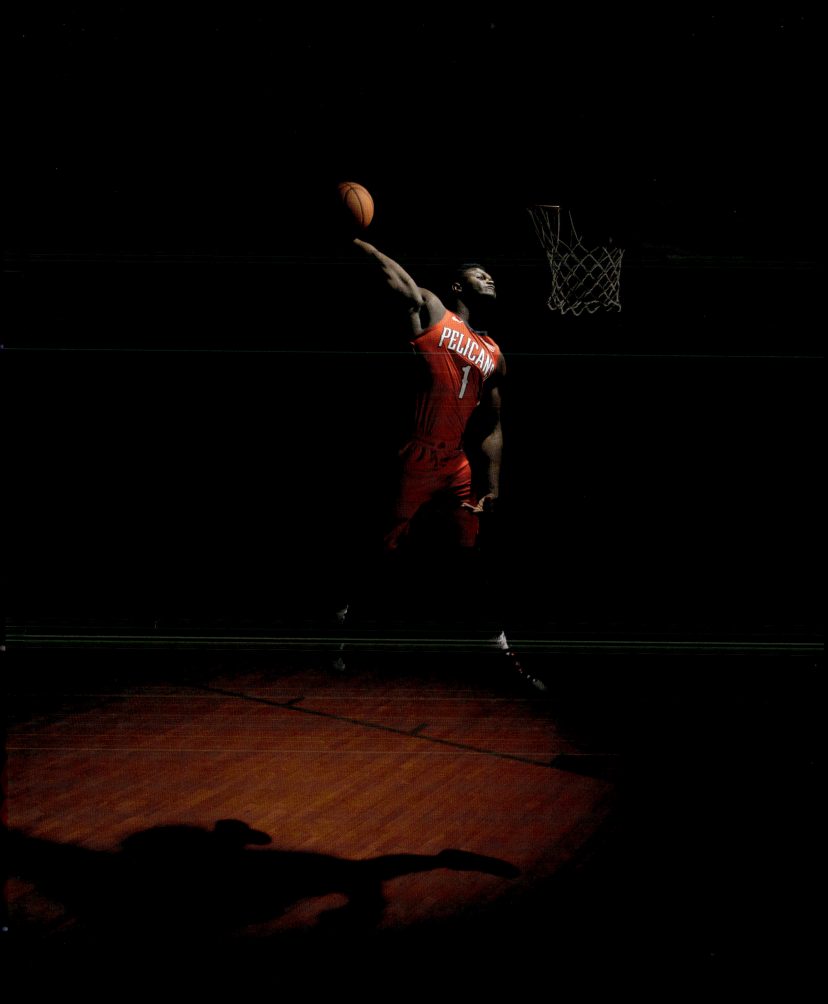

 by Spike Lee

Yo, Nat.

Looking through a camera lens for a living and enjoying basketball?

What do you think I've been doing all my life?

I was in the DA GARDEN, thirteen years old, when Willis Reed dragged his leg onto the court for Game 7 of the 1970 NBA Finals between my New York Knicks and the Los Angeles Lakers.

The game was over before it started. The entire Laker team froze when they heard the roar as we all recognized Willis out there during layup lines. They all froze!

And don't forget, we're talking about New York City. Basketball Mecca. If Willis was going to give us that, dragging his leg on the court with a torn muscle in his thigh, we were going to give him even more. The least we could do was scream and cheer until our throats were sore.

And don't even try to tell me Reed's performance was overrated because he had 4 points and 3 rebounds and Wilt Chamberlain had 21 points and 24 boards.

It's a team game. How about Walt "Clyde" Frazier's 36 points and 19 assists? How about my Man, Dave DeBusschere's 18 points and 17 rebounds?

And did you know – did you know, did you know, did you know – that when Willis got hurt in Game 5, Dave, Clyde, Bill Bradley, Dick Barnett, Cazzie Russell teamed up to outscore LA 32-18 in the fourth quarter and pull out the win? Those are my Guys. Those are my Heroes.

I'm in my sixties now, and I'm still chasing a feeling like that world championship.

I'm proud of my work, but I don't make Joints to win awards.

It's different in sports because the goal is to get to a championship.

We've been Starvin' like Marvin in New York.

But I still show up. While Nat's on the baseline with his cameras, I'm on the sidelines in my Knicks gear.

And while we're both waiting for another title, it sure beats being in the nosebleeds. Not bad for a couple of kids from Brooklyn and Long Island.

Nat will keep snapping his photos. I'll keep cheering on the Knickerbockers.

And don't worry, as a fellow Lensman, I'm not going tell you, "Money, it's got to be the ZOOM."

I know Ya Photos come from the heart, and Ya Heart's in Ya PHOTOS.

I look forward to the day Ya Camera, Ya Vision captures me smiling as wide as Broadway after another long-awaited Knicks championship. (Fifty-three years ... WTF.)

Orange and Blue Skies forever, Baby.

– From Da Blue Seats to Courtside Knicks Season Ticketholder since Patrick Ewing's Rookie Season
YA DIG? SHO'NUFF

OPPOSITE: Spike Lee; New York Knicks vs. Los Angeles Lakers; New York, NY; December 13, 2012
OVERLEAF: Chicago Stadium; Chicago, IL; 1994

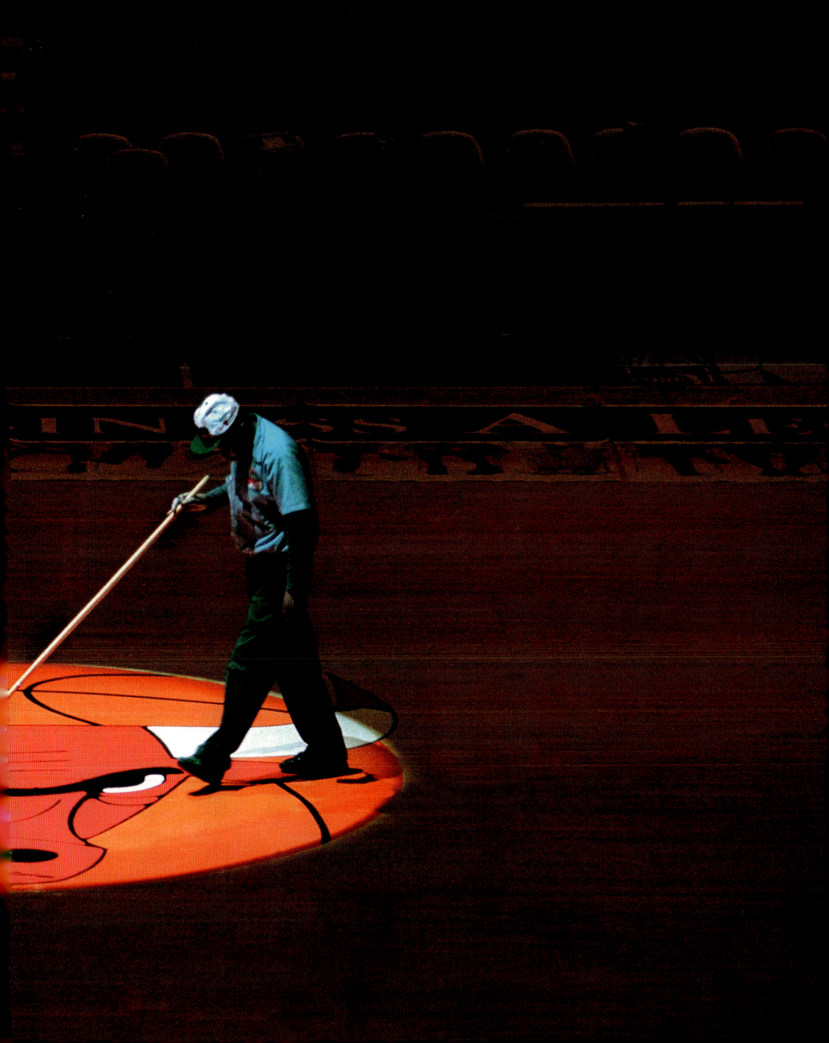

INDEX

A

Abdul-Jabbar, Kareem, 118, 119, 165, 196, 199
Abdur-Rahim, Shareef, 2
Adebayo, Bam, 200
Aguirre, Mark, 104
Ali, Muhammad, 101
Allen, Ray, 2, 46, 47, 140, 198, 214, 217, 239
Antetokounmpo, Giannis, front flap, 6, 20, 90, 92, 93, 95, 96, 97, 199
Anthony, Carmelo, 42, 43, 44, 45, 199
Archibald, Nate "Tiny," 196
Ariza, Trevor, 82
Arizin, Paul, 196
Asik, Ömer, 166
Ayres, Jeff, 234, 236

B

Barbosa, Leandro, 268
Barkley, Charles, 48, 49, 50, 117, 197, 199, 249
Barnes, Harrison, 269
Barnes, Scottie, 223
Barry, Rick, 197, 199
Baylor, Elgin, 196
Baynes, Aron, 236
Belinelli, Marco, 235, 236
Billups, Chauncey, 80
Bing, Dave, 197, 199
Bird, Larry, 86, 159, 160, 161, 197, 249
Blake, Steve, 112
Bogues, Tyrone "Muggsy," 255, 258
Bogut, Andrew, 268
Bol, Manute, 179
Bonner, Matt, 234, 236
Bosh, Chris, 77, 216
Bowen, Bruce, 236, 252, 253
Bowie, Sam, 188
Bradley, Bill, 136
Brandon, Terrell, 192, 193
Bridges, Mikal, 287
Bryant, Kobe, 2, 19, 78, 98, 139, 140, 141, 142, 143, 144, 145, 146, 147, 148, 149, 150, 231, 232
Brown, Dee, 54, 55
Brown, Jaylen, 93
Budenholzer, Mike, 91
Bynum, Andrew, 112, 140

C

Camby, Marcus, 2, 19, 89, 267
Carter, Vince, 254, 260, 261, 262, 263, 265, 266, 267
Cartwright, Bill, 115
Casey, Dwane, 90
Chamberlain, Wilt, 197, 270, 271, 286
Chandler, Tyson, 112
Christie, Doug, 25
Cole, J., 61
Coleman, Derrick, 179, 188
Connaughton, Pat, 90
Cousy, Bob, 197
Cowens, Dave, 196
Crawford, Jamal, 82, 105
Crowder, Jae, 171
Cunningham, Billy, 197, 199
Curry, Stephen, back cover, 20, 135, 157, 171, 199, 238, 239, 240, 241, 242, 243, 244, 245, 269

D

Davis, Antonio, 206
Davis, Baron, 38
Davis, Terry, 229
Daye, Austin, 236
DeBusschere, Dave, 136, 197
Diaw, Boris, 216, 234, 236
Doleac, Michael, 15
Dončić, Luka, 176, 177
Drexler, Clyde, 103, 197, 198, 228, 233
Duncan, Tim, 133, 178, 234, 236, 237, 248, 249, 250, 251, 252, 253
Durant, Kevin, 110, 124, 125, 126, 127, 128, 129

E

Elie, Mario, 31, 228
Elson, Francisco, 43
Embiid, Joel, 114
Erving, Julius, 116, 117, 196, 199
Ewing, Patrick, 13, 19, 29, 102, 180, 196, 198, 206, 207, 208, 209, 210, 211, 212, 225, 249
Ezeli, Festus, 269

F

Fisher, Derek, 140
Foye, Randy, 125
Frazier, Walt "Clyde," 137, 197

G

Gamble, Kevin, 56
Garnett, Kevin, 46, 47, 130, 131, 132, 133, 198
Gasol, Pau, 112
George, Paul, 167
Gervin, George, 196, 198
Ginóbili, Manu, 178, 235, 236, 237
Gminski, Mike, 117
Grant, Horace, 115
Green, Danny, 166, 217, 235, 236
Green, Draymond, 241, 269
Greer, Hal, 197
Griffin, Blake, 39

H

Hardaway, Anfernee "Penny," 31, 32
Harden, James, 108, 198
Harper, Derek, 225, 229
Harris, Joe, 222
Harrison, Phillip Arthur, 232
Haslem, Udonis, 15, 77, 261
Havlicek, John, 196
Hayes, Elvin, 197, 198
Hazzard, Rasheed, 145
Hill, George, 77
Hill, Grant, 98, 99, 100, 101, 118
Holiday, Justin, 269
Hornacek, Jeff, 183
Horry, Robert, 31
Houston, Allan, 19, 100, 267
Howard, Dwight, 194, 195

I

Iguodala, Andre, 30, 171, 268
Iverson, Allen, 24, 25, 26, 27, 28, 141, 199
Irving, Kyrie, 128, 150, 151, 152, 153, 155, 157, 241

J

Jackson, Mark, 180, 181, 267
Jackson, Phil, 28, 145

James, LeBron, front cover, 15, 77, 79,
 81, 162, 163, 164, 165, 166, 167, 168,
 169, 170, 171, 172, 173, 174, 175, 199,
 216, 241
Jeffries, Jared, 112
Jennings, Brandon, 40, 41
Johnson, Avery, 133
Johnson, Dennis, 159
Johnson, Larry, 100, 211
Johnson, Earvin "Magic," 85, 86, 87, 88, 159,
 160, 196, 198, 231, 248
Jokić, Nikola, 200, 201, 202, 203
Jones, Damon, 15
Jones, Sam, 196
Jordan, Michael, 4, 5, 9, 11, 22, 23, 32, 48,
 49, 99, 115, 181, 182, 183, 184, 185, 187,
 188, 189, 190, 191, 192, 193, 196, 207,
 213, 224, 233, 248, 249, 275
Joseph, Cory, 235

K

Kidd, Jason, 64, 66, 109, 199
Kittles, Kerry, 3
Kemp, Shawn, 233
Kerr, Steve, 58, 269
Kessler, Walker, 287
Kuzmić, Ognjen, 268

L

Laimbeer, Bill, 104, 119
Lee, David, 269
Lee, Spike, 279
Leonard, Kawhi, 122, 123, 198, 217, 236, 250
Lewis, Reggie, 56, 161
Lillard, Damian, 198
Lin, Jeremy, 21, 112, 113
Livingston, Shaun, 268
Looney, Kevon, 127
Love, Kevin, 171, 241
Lucas, Jerry, 196, 198
Lue, Tyronn, 157

M

Maker, Thon, 90
Malone, Karl, 197
Malone, Moses, 196
Marbury, Stephon, 2, 247
Marion, Shawn, 64
Matthews, Wesley, 93
Mbenga, D. J., 145
McAdoo, Bob, 198
McAdoo, James Michael, 269
McDaniel, Xavier, 258
McDyess, Antonio, 80
McGrady, Tracy, 254, 255
McHale, Kevin, 86, 161, 197, 199
McRae, Jordan, 153
Mikan, George, 197

Miller, Reggie, 198, 218, 219, 220, 221, 239
Mills, Patty, 234, 236
Ming, Yao, 272, 273, 275
Mitchell, Donovan, 71
Monroe, Earl, 136, 196
Morris, Chris, 188
Mourning, Alonzo, 29
Mullin, Chris, 51
Murray, Jamal, 106, 107, 202

N

Nash, Steve, 3
Nnaji, Zeke, 202
Nowitzki, Dirk, 64, 65, 66, 67, 68, 198

O

Oakley, Charles, 59, 115
Odom, Lamar, 140, 158
Olajuwon, Hakeem, 102, 103, 196, 199, 228
O'Neal, Jermaine, 3
O'Neal, Shaquille, 16, 28, 188, 199, 211, 227,
 228, 229, 230, 231, 232, 261, 273

P

Paul, Chris, 79, 199
Parish, Robert, 86, 196, 199
Parker, Tony, 178, 217, 234, 236, 237, 253
Payton, Gary, 89, 199
Petrović, Dražen, 72, 73, 74, 75
Pettit, Bob, 197, 199
Pierce, Paul, 46, 47, 140, 199, 214, 215
Pippen, Scottie, 57, 181, 188, 190, 191, 196,
 207, 224, 225
Popovich, Gregg, 235, 236, 237, 250
Porzingis, Kristaps, 166
Posey, James, 214

R

Randle, Julius, 92
Reed, Willis, 136, 197
Riley, Pat, 88
Rivers, Glenn "Doc," 214
Robinson, David, 52, 133, 196, 199, 252
Robinson, Nate, 105, 140, 194, 195
Robertson, Oscar, 197, 199, 205
Rodman, Dennis, 56, 57, 58
Rondo, Rajon, 140
Rooks, Sean, 229
Rose, Derrick, 62, 63
Rose, Malik, 252
Rush, Brandon, 268
Russell, Bill, 11, 36, 37, 118, 196, 286

S

Salley, John, 104
Schayes, Dolph, 197

Sharman, Bill, 196
Shumpert, Iman, 240
Silver, Adam, 165, 259
Simmons, Bill, 161
Smith, J. R., 171, 240
Smith, Otis, 189
Smith Jr., Dennis, 61
Snow, Eric, 230
Speights, Marreese "Mo," 268
Splitter, Tiago, 235, 236
Sprewell, Latrell, 267
Starks, John, 115, 188, 221, 258
Stern, David, 151
Stockton, John, 196, 198
Stoudamire, Damon, 25
Stoudemire, Amar'e, 260

T

Tatum, Jayson, 110, 111
Terry, Jason, 64
Towns, Karl-Anthony, 120, 121
Thomas, Isiah, 104, 119, 196, 198
Thomas, Kurt, 267
Thompson, Klay, 127, 134, 240, 243,
Thompson, Tristan, 166, 171
Thurmond, Nate, 197

U

Unseld, Wes, 196

V

Vitti, Gary, 28, 145

W

Wade, Dwyane, 67, 76, 77, 78, 80, 81
 164, 199, 216
Walker, Antoine, 3
Walker, Samaki, 3
Wallace, Ben, 35, 80
Wallace, John, 3
Walton, Bill, 197, 198
Ward, Charlie, 89, 211
Webb, Anthony "Spud," 33
Wembanyama, Victor, 259
West, Jerry, 198
Westbrook, Russell, 222
Wilkens, Lenny, 196
Wilkins, Dominique, 69, 198
Williams, Charles "Buck," 117
Williams, Jay, 105
Williamson, Zion, 277
World Peace, Metta, 140
Worthy, James, 197, 198

Y

Young, Trae, 256, 257

ACKNOWLEDGMENTS

NATHANIEL S. BUTLER

For my family. Thank you for putting up with my crazy work schedule for all of these years.

Jen, Anna, Jonah, and Jensen, I love you all so much.

To my NBA family, a special thanks to Commissioner Adam Silver, Patrick Ewing, and Spike Lee. And much appreciation to Joe Amati, Michael Bass, Dave Bonilla, Michael Brady, Kerry Caiafa, Brian Choi, Dion Cocoros, Pam Costello, David Denenberg, Tim Frank, Jarad Franzreb, Russ Granik, John Hareas, Marc Hirschheimer, Paul Hirschheimer, Jessica Holtz, Michael Levine, Terry Lyons, Julio Manteiga, Brian McIntyre, Nick Monroe, Jim Poorten, Charlie Rosenzweig, Rob Sario, David Snowden Jr., Ryan Stetz, Mark Tatum, and Gregg Winik.

I would be remiss if I didn't mention former Commissioner David J. Stern, whom I learned so much from by just being in his presence – watching and listening throughout the years. His constant demand for excellence helped mold all of us in the NBA family, and I am forever grateful.

Thank you to all of the various NBA team communications and public relations staffs – especially my "home" teams with the Knicks and Nets – that have been so helpful and supportive throughout the years.

From Getty Images, a special thanks to Carmin Romanelli and Mike Klein.

Special thanks to my friend and colleague Dave McMenamin – without his support, this wouldn't have been possible.

Much respect to my fellow NBA photographers: Andrew D. Bernstein, Jesse D. Garrabrant, Joe Murphy, and Garrett Ellwood, just to name a few.

I've made so many amazing memories with my NBA Entertainment video crew colleagues: Andy Thompson, Michael Winik, Peter Winik, and Mario Porporino.

Thanks to my numerous assistants throughout the years: David Dow, Terrence Vaccaro, Jeyhoun Allebaugh, Ned Dishman, Reid Kelley, James Ridley, and David Nemec.

A huge debt of gratitude to all of the talented folks at Abrams Books who organized and edited countless emails full of images, captions, and quotes to bring this project to life: Jan Hughes, Krista Keplinger, Connor Leonard, Iain R. Morris, and Chris Gruener. And thanks to Garrett McGrath for bringing us together.

Finally, to all of the NBA players and coaches – past and present – who were kind enough to spend some time with Dave and I discussing and reminiscing over these moments and photos that brought back countless wonderful memories, thank you. You all have pushed the game of basketball forward, and it's been an honor to be a small part of the growth of the game we all love so much.

DAVE McMENAMIN

To my family, I am nothing without your unending love and support. Malika, my everything, my partner, and my occasional quote wrangler, thank you. I love you. Mom, Dad, Melanie, Shawna, Jeffrey, Rob, Ashley, Olwyn, Conall, Caren, Mike, and Kendra, I'm lucky to have you all in my life.

Before I knew Nat Butler, I knew his work. My brother, Brian, painted a watercolor portrait of Allen Iverson based on Nat's photo on page 26. And I owned the Upper Deck card featuring Nat's photo of Michael Jordan on page 184. I have incredible respect and admiration for Nat as a person and a professional. Nat, you embody my personal basketball credo: Treat the game well and it will treat you well. I appreciate your friendship and was thrilled to work with you on this book.

I echo Nat's appreciation for all of the people who helped make this book not just a collection of his excellent photos, but a historical NBA document. Additional thanks to all of the player agents, player representatives, reporters, podcast producers, and team media staff members who offered guidance and assistance.

Additional thanks to my friends and colleagues with the NBA, the Los Angeles Lakers, and the Cleveland Cavaliers, who have been so helpful as I near twenty years covering the league. (Nat, you still got two decades on me.)

Thank you to all of my talented colleagues at ESPN who have supported my career and pushed me to be a better reporter and broadcaster.

And a special remembrance of Brian McMenamin and Kobe Bryant. I miss you both tremendously.

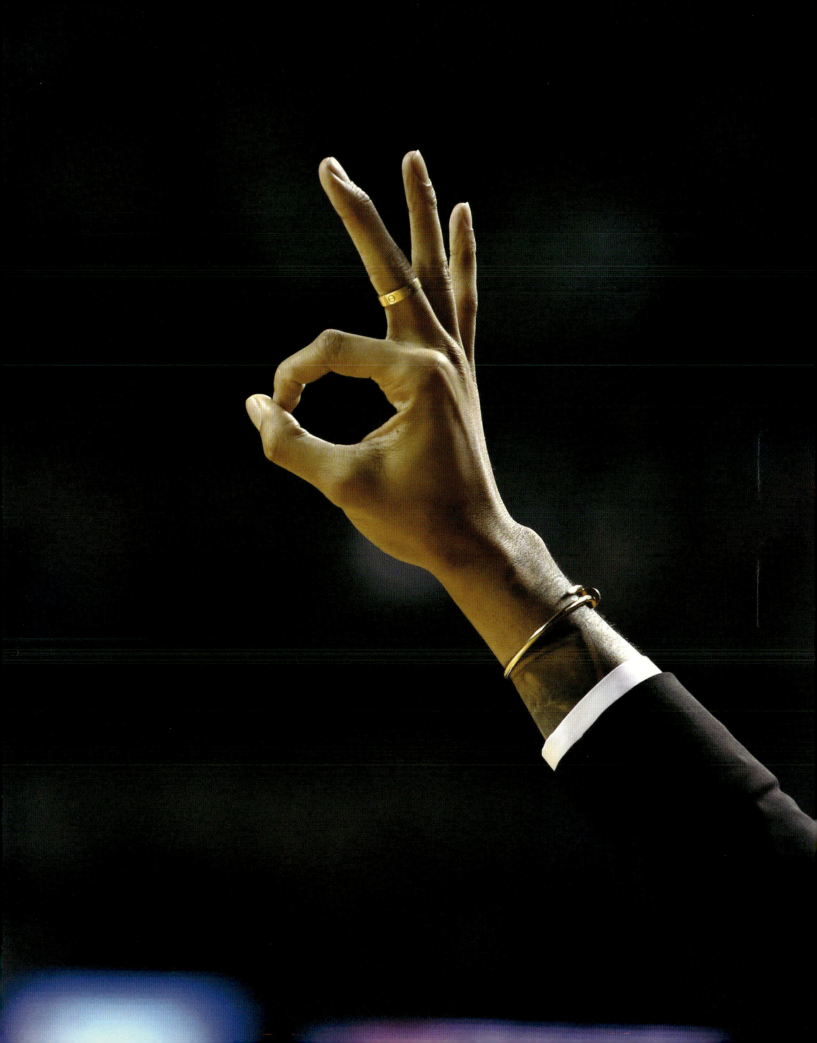

COLOPHON

EDITORS: Connor Leonard & Jan Hughes
DESIGNER & CREATIVE DIRECTOR: Iain R. Morris
MANAGING EDITOR: Jan Hughes
PRODUCTION MANAGER: Alison Gervais

Library of Congress Control Number: 2024931315
ISBN: 978-1-4197-6284-0

© 2024 Nathaniel S. Butler
Page 16: photo credit Andrew D. Bernstein/NBAE Getty Images
Foreword © 2024 Adam Silver
Foreword © 2024 Patrick Ewing
Afterword © 2024 Spike Lee

Published in 2024 by Abrams, an imprint of ABRAMS. All rights reserved. No portion of this book may be reproduced, stored in a retrieval system, or transmitted in any form or by any means, mechanical, electronic, photocopying, recording, or otherwise, without written permission from the publisher.

The NBA and individual member team identifications reproduced herein are used with permission from NBA Properties, Inc. © 2023 NBA Properties, Inc. All rights reserved.

Printed and bound in China
10 9 8 7 6 5 4 3 2 1

Abrams books are available at special discounts when purchased in quantity for premiums and promotions as well as fundraising or educational use. Special editions can also be created to specification. For details, contact specialsales@abramsbooks.com or the address below.

Abrams® is a registered trademark of Harry N. Abrams

ABRAMS The Art of Books
abramsbooks.com

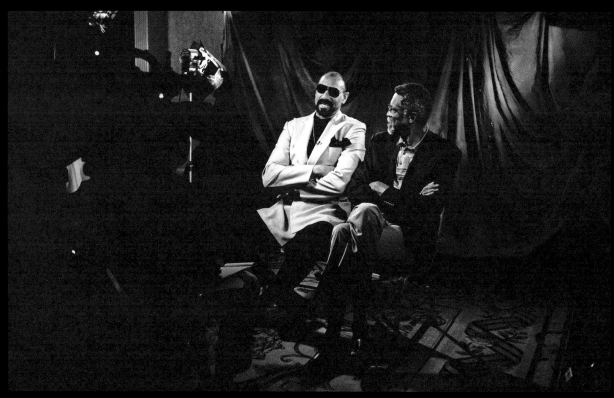

ABOVE: Wilt Chamberlain and Bill Russell; NBA at 50 interview; Secaucus, NJ; 1996
FRONT COVER: LeBron James; Cleveland Cavaliers vs. New York Knicks; New York, NY; April 14, 2004
FRONT FLAP: Stephen Curry; Golden State Warriors vs. Brooklyn Nets; Brooklyn, NY; November 16, 2021
BACK COVER: Giannis Antetokounmpo; Milwaukee Bucks vs. Brooklyn Nets; Brooklyn, NY; November 6, 2023
CASE: Ray Allen; Miami Heat vs. San Antonio Spurs; Miami, FL; June 19, 2013

Mikal Bridges; Brooklyn Nets vs. Utah Jazz; Brooklyn, NY; January 29, 2024

"As Nat knows well, there's a story behind every photo. And that's what this book is: a compelling story of the NBA told through Nat's photography."
—ADAM SILVER, NBA Commissioner; from the foreword

"It felt like for every major moment of my career, I'd turn around, and Nat would be there."
—PATRICK EWING, basketball coach and former professional player; from the foreword

"Nat takes cool pictures, man."
—GIANNIS ANTETOKOUNMPO, professional basketball player; from the interior

"Nat Butler has always been one of my favorite photographers. He's always been hospitable with the pictures, and I have a lot of them in my house...."
—SHAQUILLE O'NEAL, former professional basketball player and sports analyst; from the interior

"Nat caught me in my moment, showing love before the game—it was one of my favorite things to do."
—DWYANE WADE, former professional basketball player; from the interior

"Nat's legacy of photography is huge. Photography has definitely solidified and cemented so many parts of basketball and NBA history. We're very grateful to Nat."
—JEREMY LIN, professional basketball player; from the interior

"If you are a Knicks fan, that poster taken by Nat was on your wall."
—JOHN STARKS, former professional basketball player; from the interior

"Nat has done an unbelievable job of capturing all of our careers. It's something that we can pass down to our kids and show them, which makes it cool. To have the opportunity to play in the NBA has always been a lifelong dream, and when you're retired and you're away from the game, you cherish those moments."
—REGGIE MILLER, sports analyst and former professional basketball player; from the interior

"I know Ya Photos come from the heart, and Ya Heart's in Ya PHOTOS."
—SPIKE LEE, film director, producer, screenwriter, actor, and author; from the afterword

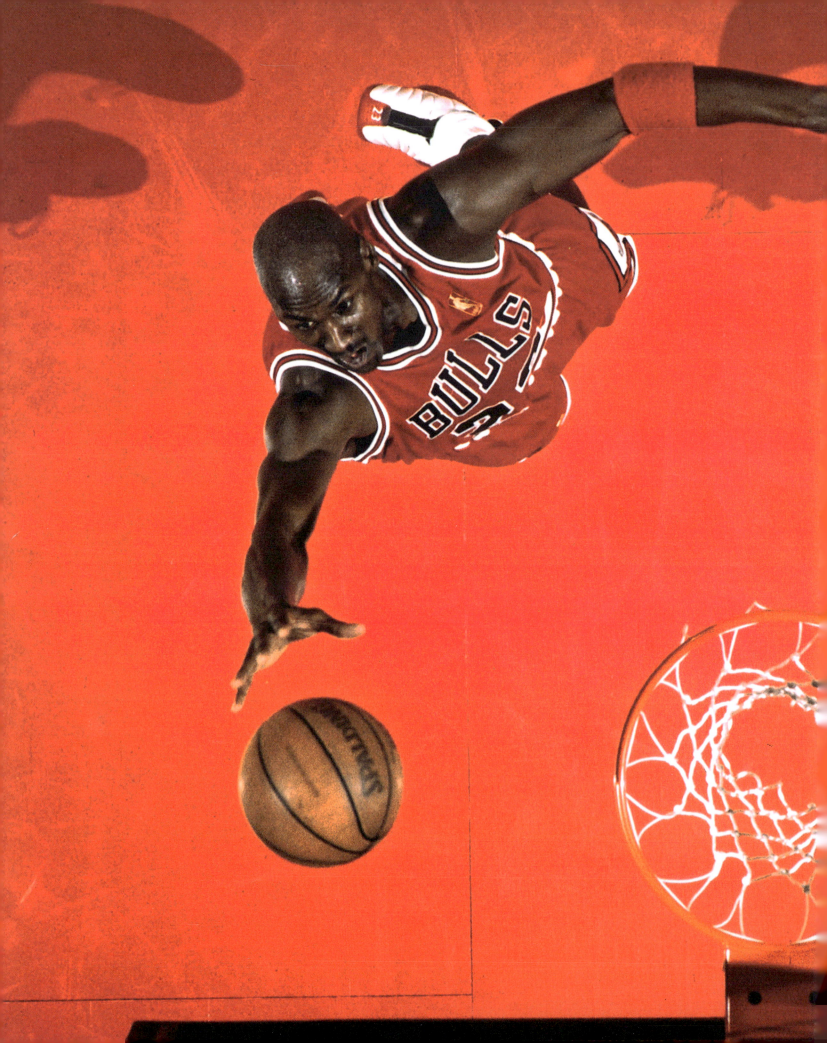